Nebraska Quilts & Quiltmakers

Nebraska Quilts & Quiltmakers

Edited by Patricia Cox Crews and Ronald C. Naugle

Color photographs by Roger Bruhn

University of Nebraska Press, Lincoln and London

Portions of "Quiltmaking
Traditions in Nebraska: An
Overview" have previously
been published in Elizabeth
Weyhrauch Shea and
Patricia Cox Crews, "The
Nebraska Quiltmaker,"
Uncoverings 1989, ed.
Laurel Horton (Mill Valley,
Calif.: American Quilt Study
Group, 1990), and are used
here with permission.

Publication of this book was
assisted by grants from the
Woods Charitable Founda-
tion; the Virginia Faulkner
Fund, established in
memory of Virginia Faulkner,
editor-in-chief of the
University of Nebraska
Press; and The Andrew W.
Mellon Foundation.

The paper in this book meets
the minimum requirements of
American National Standard
for Information Sciences –
Permanence of Paper for
Printed Library Materials,
ANSI Z39.48–1984.

Library of Congress
Cataloging-in-Publication
Data
Nebraska quilts and
quiltmakers / edited by
Patricia Cox Crews and
Ronald C. Naugle , color
photographs by Roger
Bruhn. p. cm.
Includes bibliographical
references and index.
ISBN 0-8032-1452-9 (alk.
paper)
ISBN 0-8032-6346-5 (pbk.)
1. Quilts – Nebraska –
History – 19th century.
2. Quilts – Nebraska –
History – 20th century.
I. Crews, Patricia Cox.
II. Naugle, Ronald C.
(Ronald Clinton), 1942–
NK9112.N33 1991
746.9'7'09782 – dc20
90-41995 CIP

Contents

Preface

Uncovering the Art of Common Folk: The Nebraska Quilt Project

Over the past five years the Nebraska Quilt Project has consumed my life and home. And, each of the twenty-one women from the Lincoln Quilters Guild serving on this project could say the same, for indeed, this work demanded a commitment and personal sacrifice from everyone. From our first meeting in January 1985 we dedicated our energies toward producing a work that would be useful, meaningful, and available to the public at large. The impetus for the Nebraska Quilt Project was the dearth of available information on the quilting traditions of the Midwest and the desire to document the quilts of the state (especially the nineteenth-century quilts in private hands) before they disappeared. Since 1987 several thousand Nebraskans have participated in preserving their cultural heritage through the Nebraska Quilt Project. Not only did the Nebraska-wide survey bring together quiltmakers and quilt lovers, but people of all ages, walks of life, and interests who brought their quilts to the Quilt History Days to show off their prized heirlooms, ask questions, and revel together in the beauty and craftsmanship of the quilts examined. Perhaps more important, many found, when asked, that they knew little of their own heritage and were inspired to find out more about the makers of their textile treasures and therefore about themselves.

In the initial planning stages, we consulted with Professor Ronald Naugle from the Nebraska Wesleyan University History Department and Lynne Ireland and John Carter from the Nebraska State Historical Society. They suggested that the communities in which we held Quilt History Days needed to be chosen carefully if our survey of quilts was to be representative of the state as a whole. They persuaded us to consider the ethnic, cultural, and economic makeup of communities in order to ensure that significant factors were not overlooked.

In order to select communities which were representative of the ethnic, geographic, cultural, and economic variety of Nebraska, we approached the Nebraska Committee for the Humanities for a planning grant. Under the auspices of an executive planning grant, Professor Naugle produced a demographic profile of the state circa 1900, which helped to identify ethnic enclaves and economic bases. He also surveyed print materials relating to the history of Nebraska to help isolate both unique and typical areas.

With this framework in mind, we chose thirteen nonmetropolitan areas in which to conduct Quilt History Days in 1987. We excluded the metropolitan areas of Lincoln and Omaha, since it was felt that they were much too large to be successfully included in the initial survey of quilting traditions. By June 1989 we had finished collecting our data in the metropolitan areas of Lincoln and Omaha as well.

Following the selection of possible sites, we presented a proposal to the National Endowment for the Arts—Folk Arts Program to partially underwrite the project, provide for consulting scholars, training of volunteers, and necessary materials. A grant from the National Endowment for the Arts along with thousands of dollars in cash and in-kind monies from a variety of state and local sources eventually funded the project.

Prior to the actual quilt registration, we were trained by local experts as well as nationally known quilt scholars.

Katy Christopherson of Louisville, Kentucky, and Laurel Horton of Seneca, South Carolina, shared with us insights into their experiences with their respective states' quilt history projects; Barbara Brackman of Lawrence, Kansas, conducted a workshop for us entitled "Dating Quilts by Pattern and Style"; and Suellen Meyers of Creve Coeur, Missouri, presented a workshop entitled "Dating Quilts from the Nineteenth and Twentieth Centuries." Patricia Crews, Associate Professor of Textiles, University of Nebraska–Lincoln, conducted three full-day workshops entitled "Fiber, Fabric, and Printed Pattern Analysis for the Dating and Documentation of Quilts." Roger Welsch, folklorist and author, presented a lecture, "Folk Art on the Plains"; John Carter, Curator of Photographs, Nebraska State Historical Society, conducted a one-day workshop on "Photography of Quilts"; and Professor Ronald Naugle and Margaret Cathcart, historians, Nebraska Wesleyan University, led a two-session workshop, entitled "Taking Effective Oral Histories of Quiltmakers." Lynne Ireland, Coordinator of Museum Collections, Nebraska State Historical Society, reviewed and made suggestions for the improvement of the registration forms. Following these intensive training sessions, the project members, now "para-professionals," formed the pool of data collectors for all sites. Forms were developed for use in registration of quilts and quiltmakers, modeled to some extent on successful projects in other states. Members from the trained group were used at each site in an effort to maintain consistency in the process.

With the project members trained as field-workers and the framework for site

selection well defined, we solicited assistance from County Extension Home Economists to help locate Quilt History Day chairpersons. The chairpersons selected the facility in which to conduct the Quilt History Day in each community, enlisted local volunteers to work on the designated date, and publicized the event well in advance of the date.

Each Quilt History Day followed the same format. As the participants (quiltowners and quiltmakers) entered the facility on the day of the event, volunteers greeted them and gave them printed information regarding the intent and purpose of the project. Next Nebraska Quilt Project members assigned a registration number to each quilt, pinned a muslin identification tag with the assigned number to the back of the quilt, determined its overall measurements, and asked informal questions regarding the provenance of each quilt to assess cultural or historical importance. The third step involved completion of the quiltmaker and quiltowner forms, which each person filled out individually or with local volunteer help. Trained Nebraska Quilt Project members undertook the fourth step, quilt analysis. Taped oral-history interviews were taken from selected individuals who were willing to share their own quiltmaking experiences and life experiences on the prairie or from owners who could shed light on the lives of early quiltmakers and the communities in which they lived.

The final steps involved taking a full-color slide of each quilt. To photograph the quilts, Donald and Donna Svoboda designed a lightweight collapsible yet sturdy frame especially for the quilt project. Large clamps secured the quilts to boards during the picture taking; the use of more than one quilt-hanging board ensured a continuous flow of quilts during the peak hours. The quilt and its assigned registration number, site name, date, Kodak color-control patch, and gray scale were then photographed, after which the quilts were returned to the participants along with a certificate of participation.

The Quilt History Day provided the

community an opportunity to examine one of its folk art traditions often taken for granted. Quilts were on display during the photography session, creating an informal "museum-for-a-day." Scores of participants in the Quilt History Days took advantage of available seating to revel in the beauty of the quilts. Creating an understanding between the artifact and the viewer is sometimes difficult in formal museum settings. However, this understanding existed at the "museum-for-a-day" setting of the Quilt History Days because a meaningful relationship already existed between the viewers and the quilts.

Data were collected at twenty-eight sites on nearly five thousand quilts either brought into the state prior to 1920 or made in Nebraska. We sought to limit the survey to quilts truly reflective of Nebraska's quiltmaking traditions while still allowing examination of quilts made elsewhere that undoubtedly influenced Nebraska's quilts and quiltmakers. Repositories for the collected data and photographs are the State Archives, Nebraska State Historical Society, Lincoln, and the University Archives, University of Nebraska–Lincoln, where they will be available to historians, quilt scholars, and the general public.

Following data collection, hundreds of hours were spent organizing, sorting, and computer coding the informa-

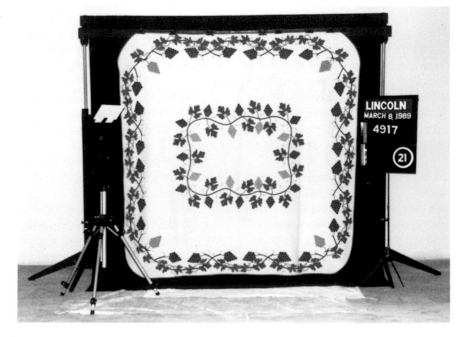

A converted music stand provided a mount for labels identifying the city, site number, and date, and for the Kodak color card, gray scale, and quilt registration number. A black fabric backdrop for the quilts eliminated background clutter.

viii

tion from the forms. Joseph Stonuey, a graduate research assistant in the Department of Textiles, Clothing and Design at the University of Nebraska–Lincoln, assigned the quilt pattern names a number for computer entry using Barbara Brackman's *Encyclopedia of Pieced Quilt Patterns* or Judy Rehmel's *Key to 1,000 Appliqué Quilt Patterns* to provide a consistent means of identification. Additional numerical codes were assigned to the body of data as needed to facilitate computer entry, sorting, and analysis. Funding provided by the American/International Quilt Association enabled staff at the University of Nebraska–Lincoln to complete data entry and initial computer programming. Professor Patricia Crews and graduate research assistants Joseph Stonuey and Elizabeth Shea sorted and summarized the data using Statistical Analysis Systems software.

After the data were collected, project members met weekly to view quilt slides. Lists were kept of the various types, such as pieced, appliqué, embroidered, and Crazy. Quilts outstanding for their visual impact were noted. Authors and project members, Patricia Cole, Carroll Dischner, MonaJeanne Easter, Mary Ghormley, Pat Hackley, Heddy Kohl, Virginia Welty, and I, then pulled slides and examined the records on each quilt. We looked especially for quilts of Nebraska origin and known makers. Care was taken to represent all the data-collection sites and to include examples of the most popular types of quilts as well as the exceptional ones. Final selection, left to the authors, was difficult; many equally fine quilts could not be included, but the Nebraska Quilt Project members feel the examples in this book represent the diversity of Nebraska quilters and their work.

The information reported in the interpretative chapters about Nebraska's quiltmakers and quilts and the descriptive information associated with every quilt illustrated herein is based on the Nebraska Quilt Project survey forms and, in some cases, interviews or correspondence with quiltmakers or their family members. To ensure the accuracy of this information, Kari Ronning consulted census and land records to supplement information or to clarify and corroborate information that was incomplete or unclear on the forms. In addition, when each quilt was sent to Lincoln for professional photography, Professor Patricia Crews and Wendelin Rich, Department of Textiles, Clothing and Design, University of Nebraska–Lincoln, confirmed by microscopic analysis the fiber content of the quilts, which had been determined by visual inspection during the fieldwork.

Acknowledgments

As this project is completed, I am reminded of those who helped along the way. It seems inadequate to place the burden of thanks upon two simple words, but they alone can express my appreciation fully. And so, thank you—

To the remarkable members of the Nebraska Quilt Project Committee who shared the responsibility and, by doing so, lightened the load. They put new meaning into the word teamwork. And to the families of project members who demonstrated patience and understanding.

To John Carter, Lynne Ireland, Margaret Cathcart, Professor Ronald Naugle, and Professor Patricia Crews, who guided us through this endeavor from beginning to end. Especially warm thanks go to Professors Crews and Naugle, who gave generously of their time over and over again. They went the extra mile that made all the difference.

To the Lincoln Quilters Guild membership, who initiated the project and who offered moral support along the way.

To site coordinators, who generated community support and made us feel welcome the moment we entered their town.

To volunteers at each site, who gave cheerfully when a job had to be done.

To Nebraskans who brought their quilts and shared their stories and without whom this project would not have been possible.

To Arsene Fauquet, Robert Von Segern, and Donald and Donna Svoboda for expert engineering when needed.

To Roger Ghormley, who good-naturedly secured quilt insurance, kept order throughout the process of photographing the quilts for this book, and otherwise put smiles on our faces.

To Jo Frey, neighbor and friend, who helped with proofreading when asked.

To Rosanne Samuelson, skilled typist, whose dedication and commitment enabled us to meet all the deadlines for publication.

To Jeanne Garvin and the Doll Quilt Auction Committee, whose energy generated revenue for this project. And to the quilters who donated quilts to the Doll Quilt Auctions and whose community spirit is exemplary.

To Louise Howey, who donated a quilt top for auction to benefit the project and whose brand of generosity is one to emulate.

To my beloved friends who took time to ask and listen and offer a pat on the back when I needed it most.

To Curt, Gavin, Nicholas, and Marit; Gretchen and Meredith; David and Seth, who generously shared their spouse's or parent's time with the project, so this book could go to press.

And to Bill, Jeane, Anne, and Paul for being such good sports.

FRANCES BEST
Director, Nebraska Quilt Project

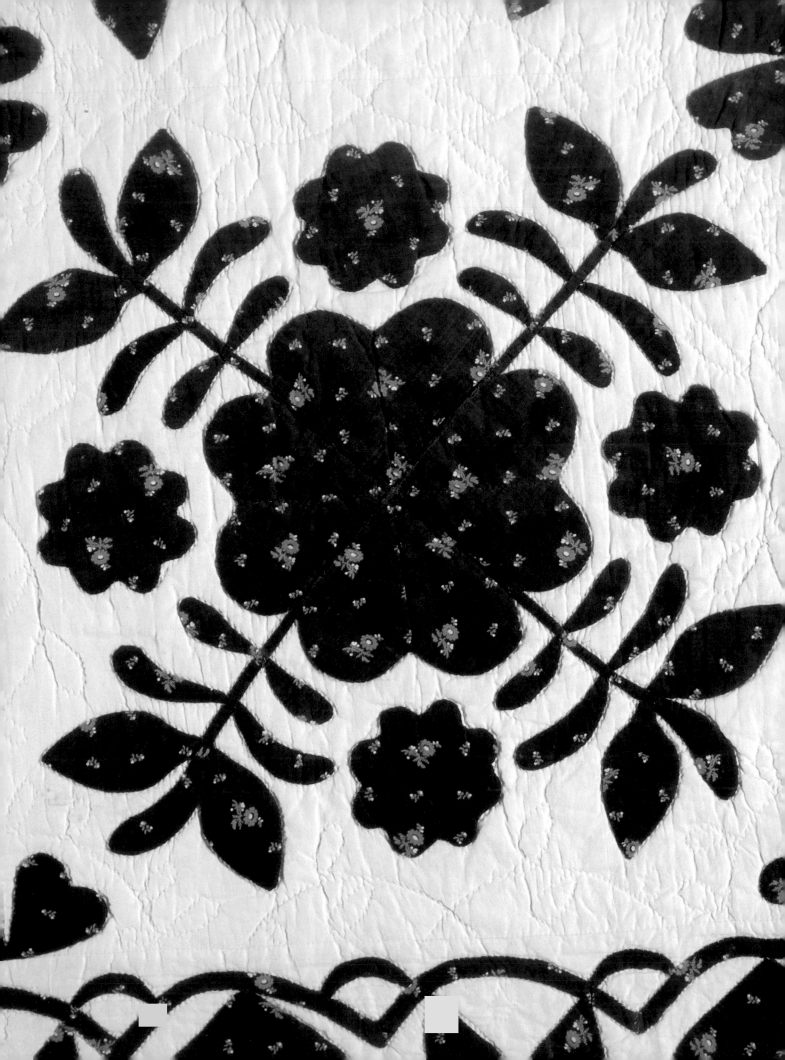

Quiltmaking Traditions in Nebraska: An Overview

by *Ronald C. Naugle,*
Patricia Cox Crews,
Elizabeth Weyhrauch Shea,
and *Joseph Stonuey*

QUILTMAKING SKILLS came to Nebraska with its earliest settlers and have been transmitted from generation to generation ever since. Despite hardships and endless demands on their time during the period of settlement and development of the state, Nebraska women and a few men found time to make quilts, many quilts. Although quiltmaking was no longer a fashionable activity for urban dwellers by the late nineteenth century, it remained a popular activity in Nebraska until the 1940s because most Nebraskans continued to live on farms and in small towns, where traditional pioneer values of industriousness, thrift, and resourcefulness dominated family life. Although quiltmaking within the state ebbed during the 1950s and 1960s, as it did throughout the nation, it was revived during the 1970s and enjoys unparalled popularity today.

Nebraska: Images of Time and Place

Regardless of the era, quiltmakers were products of their society, influenced by their culture, history, and the environment in which they lived. An examination of these influences provides a greater understanding of and appreciation for their work and the quilts they produced.

The relationships of work and art to culture, history, and environment are complex and interrelated. The origin of the name "Nebraska" itself exemplies this complex relationship. Derived from the Omaha Indian word "Nebthaska" and the Otoe term "Nibrathka," which meant "flat water," it was an appropriate designation for the Platte River, a landmark that intrigued early explorers with its unique characteristics.[1] Often pointed out to visitors as "a mile wide and an inch deep," it remains today one of Nebraska's points of interest.

Indian designations for the river became synonymous with the land itself.

From the early seventeenth century on, "Nebraski" and "Nebraska" appeared in the writing of explorers to describe not just the river but a vast area of the plains west of the Missouri River. By 1854, with the passage of the Kansas-Nebraska Act, it became an official designation for the territory that later became the state of Nebraska.

Just as Nebraska owes much of its history and character to the Platte River, its identity was also shaped by the observations of numerous explorers who sought to survey and describe this vast new area that had been added to the United States with Thomas Jefferson's Louisiana Purchase in 1803. The first expeditions, however, including that of Lewis and Clark, only skirted Nebraska as they followed the Missouri River northward. Lieutenant Zebulon Pike was the first to report officially on the conditions in the

central plains. He described the land as "desertlike" in his report to the government in 1810. Later, in 1817, the army engineer Stephen Long led an expedition up the Platte River to its South Fork. Writing in 1823 Long said that the land was almost wholly unfit for habitation. He was most concerned that it could in no way support an agricultural people.[2]

Long and others were influenced by the familiar terrain east of the Mississippi River. This new land of the central plains was undeniably flat, covered with long and blowing native grasses, and treeless except along waterways. Less than 3 percent of Nebraska was wooded. Twenty thousand grass-covered square miles made up the Sandhills alone. It was quite different from the east where rainfall and timber were much more abundant. To easterners, this was the "Great American Desert," a land fit only for Indians.

Ironically the Indians who made their homes here were basically sedentary and agricultural. While some left their agricultural compounds once a year for a buffalo hunt, the greatest number maintained an agricultural lifestyle, living in earth lodges rather than tents. The Otoes, Omahas, Poncas and Sioux had, in a sense, paved the way for later white agricultural settlement, for they themselves had relocated on the plains only a hundred years earlier.

Beginning in the 1840s and for the next three decades about a half-million people crossed Nebraska, usually in spring and early summer. Their destination was not Nebraska, but farther west, at first to Oregon, in search of their dreams, new land, and fortune. The Mormons increased the number of travelers heading west as they began their migration to Utah in 1847. The discovery of gold in California in 1848, and a decade later in Colorado, further increased the traffic that plodded across Nebraska along the Great Platte River Road.

Except for the supply centers at the head of the trail, white settlement prior to 1854 was limited to those stationed

at military posts, fur traders, and a few Christian missionaries working among the Indians. Established in 1819 by the government to protect fur traders from English encroachment, Fort Atkinson on the Missouri River above Omaha was the first of the military posts. It was abandoned in 1827.[3] In the 1860s, other posts were developed to protect the increased migration westward, but none of these would attract settlement around them except for Sidney Barracks on the Union Pacific Railroad.

Until 1854 the image of the Great American Desert, the Indian frontier, and the passage to the West along the Great Platte River Road loomed large in Nebraska's identity. Even so, the Kansas-Nebraska Act adopted by Congress that year created the Nebraska Territory and opened it to settlement. The territory stretched from the Kansas line to Canada and from the Missouri River to the Continental Divide.

Until Nebraska gained its statehood in 1867, the Great Platte River Road remained one of only a few routes into the interior. That year the Union Pacific railroad pushed across Nebraska to just west of North Platte along the north side of the Platte River.[4] The Burlington soon obtained rights to build south of the river. Settlement began to increase dramatically. The territorial census of 1860 reported a population of 28,841. By 1870 the population had more than quadrupled, to nearly 123,000. The next decade witnessed almost the same amount of growth, to over 450,000, and by 1890 the population had surpassed a million inhabitants. These thirty years were clearly the major settlement years for Nebraska. The population increases slowed in the next decade to less than 1 percent. By 1900 the census reported a population of 1,066,910.[5]

The initial growth in the post–Civil War years was spurred by the enactment of the Homestead Act in 1862. The Homestead Act was the fulfillment of an 1860 campaign promise by Abraham Lincoln and the Republicans. Except for persons who had borne arms against the United States, a head of family, male or female, who was a citizen or a "first paper" immigrant, quali-

fied for 160 acres of land, free except for a small surveying fee. The act also applied to 80-acre tracts of government land along the new railroads, alternating sections with the land granted to the railroads. Homesteaders had six months to begin making improvements on the land. Those who "proved up"—who lived on or cultivated the land for five years—were given a government patent proving their ownership of the land.[6]

Many Nebraskans got their start from homesteading, but many more bought their land from the railroads or from entrepreneurs who had homesteaded for speculation. The railroads contributed even more than the Homestead Act to the growth of Nebraska's population in these years. Railroad interests had pressured the government prior to the Civil War to hasten the development of western lands. The government had given over huge tracts of land for the railroad to sell in order to finance their construction, and it was, therefore, to the advantage of the railroads to dispose of the land as quickly as possible. Railroad entrepreneurs also knew that it was in their companies' economic interest to attract settlers to the land to farm, develop communities, and start businesses. Thus, railroad land departments sent emissaries overseas to locate groups of peoples who might pull up stakes and resettle in Nebraska. Among others, large settlements of Germans, including Germans from Russia, Swedes, Danes, and Czechs—principally from Bohemia and Moravia—formed colonies and purchased railroad land in Nebraska.[7] By 1870 over half the population had either been born overseas or were the children of immigrants. By 1900, Germans, Swedes, Bohemians (or Czechs), and Danes represented the largest ethnic groups in the state, followed closely by Irish, English, and Germans from Russia.[8]

But more than populating Nebraska, the railroads contributed much to its image, or changing image. Railroad

2

land agents and promoters quickly encountered the widely held perception that the area was uninhabitable. The "Great American Desert" had become part of the popular culture, perpetuated by eastern newspapers and magazines. To counter this image, the railroads mounted an advertising campaign throughout the 1870s that would rival the most sophisticated manipulative efforts today. The railroads teamed up with state government to produce pamphlets and broadsides selling Nebraska as a place rich with the promise of agricultural rewards. Traveling exhibits and promotional lectures followed to reinforce the image.

Buffalo Bill's Wild West show, American western novels, beginning with Owen Wister's *The Virginian*, and a plethora of western movies, have combined to create another image of the American frontier, one where only the most rugged of men, possessing individual courage, determination, and in-genuity, could survive. This image has passed permanently into the collected myths of the American experience.

Although conditions on the Nebraska frontier were harsh and challenging, the popular image of the frontier as a male domain is not supported by reality. The family unit was basic to the agrarian society of the frontier, just as it had been since the first American colonial settlements two centuries before. Studies done of census data in 1870 and 1884 indicate that most settlers were married couples who settled down on farm spreads and raised families. The true frontier society during the 1870s consisted of farm families with two or three preteen-age children.[9]

The realities of work in frontier society also challenged the myth of the man's frontier. Men generally did engage in the heaviest work—clearing the land, breaking the sod, and working the fields. The task of plowing,

Women and men at work on a farm near Kearney, Nebraska, circa 1908. Courtesy of the Nebraska State Historical Society. From the Solomon D. Butcher Collection.

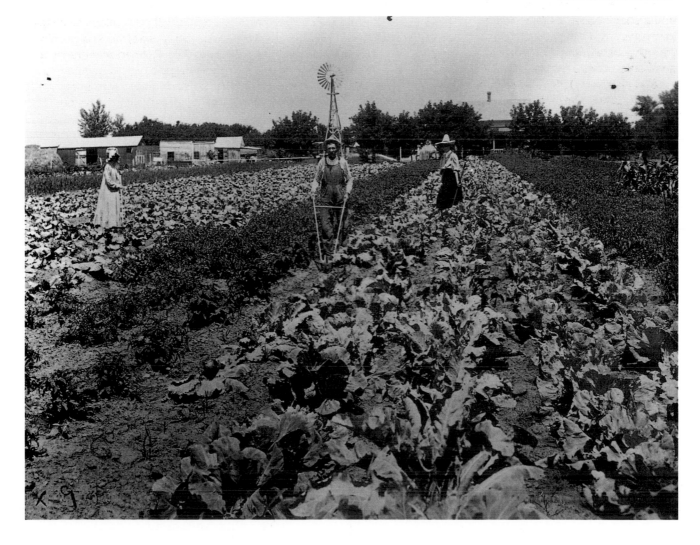

planting, and harvesting consumed by far the majority of men's time during the growing season. Still, women often worked in the fields too, particularly if planting fell behind schedule. Then work in the fields became every family member's responsibility, men and women alike. And farmers without sons had no hesitation in working the fields with their daughters.[10]

Women took responsibility for food production and preparation, including gardening, butchering, milking, and the manufacture of butter and cheese. Women also provided and cared for the family's clothing and bedding. This involved hours of soap making, washing, ironing, and mending as well as the more rewarding hours of sewing. Sewing was an essential feminine skill and one that provided for basic necessities as well as artistic expression in the coverlets and quilts.

While work in frontier society was often divided by gender, both women and men assumed an endless variety of often back-breaking chores in order to establish their homesteads. From their initial encounter with the environment of the plains, the challenge for survival and the hardships to be endured were genderless.

Faced with a lack of trees, the early settlers recognized in the prairie sod their answer to the need for building material. Baked in the summer heat at 100 degrees plus, frozen in the subzero-degree winters, and dried by the prairie winds to the consistency of concrete, "Nebraska brick" or "prairie marble" provided the first homes for many newcomers to the plains. Some dug caves into the sides of riverbanks or hills for temporary shelter. Others combined the two methods of plains architecture. Inside these soddies and dugouts light and ventilation were poor and the sod roofs usually leaked. Fleas, bedbugs, and mice were constant unwanted guests. The unpleasant if not dismal circumstances of their new homes were compounded by the harsh plains environment. Winter brought bitterly cold temperatures and sometimes blizzards, while summer frequently

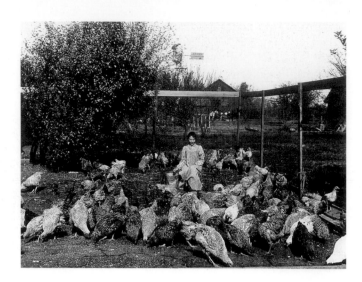

brought hot drying winds, scorching temperatures, and sometimes prairie fires and plagues of grasshoppers. Clearly, cooperative family efforts were essential to the settler's success in such an adverse environment.

Success appeared likely to the frontier families, for the 1880s were years of prosperity and progress in Nebraska. Rainfall was abundant, the population doubled, and agricultural output tripled during the decade.[11] Technological changes were also evident as more and more automatic threshers, planters, and cultivators appeared on Nebraska farms, replacing the manual methods of the frontier era. Nebraska became the focus of scientific experiments in agricultural methods after the University of Nebraska opened its College of Agriculture in Lincoln in 1882. The decade also witnessed urban growth and increased manufacturing, most of which was centered in Omaha, where the meat-packing industry had concentrated.

By the mid-1880s it appeared that Nebraska was destined for wealth and prosperity. By the end of the decade it was no longer so certain. Drought overshadowed the plains; farm production and prices declined and interest rates increased. Farmers found it increasingly difficult to make a profit. Frustrated by the power of the railroads, farmers formed their own organization, the Farmers' Alliance, in 1880. The Farmers' Alliance provided the arena in which to focus on the issues of high interest rates and costs charged by the railroads and elevators.

Mrs. Neidacorn feeding her chickens. Buffalo County, Nebraska, circa 1900. Courtesy of the Nebraska State Historical Society. From the Solomon D. Butcher Collection.

Wash day on a farm in Otoe County, Nebraska, circa 1905. Courtesy of the Nebraska State Historical Society.

Dugout home. Courtesy of the Nebraska State Historical Society. From the Solomon D. Butcher Collection.

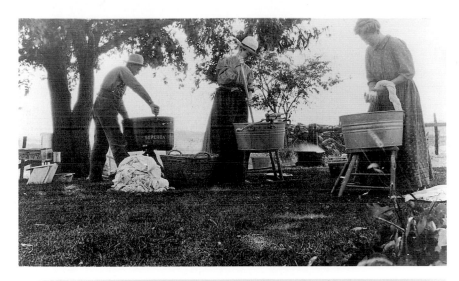

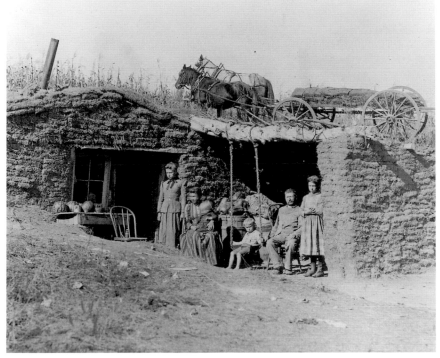

Prosperity, mobility, and a spirit of optimism that problems were not insurmountable characterized the people of Nebraska during the early part of the twentieth century. World War I had a sobering effect as the idealism associated with the recent reform era was lessened by the overzealous persecution of German-Americans and other groups whose loyalty was called into question during the war.

With the end of the war, the demand for U.S. agricultural products ebbed. Exports declined early in the 1920s and farm prices fell. The war years had been good for Nebraska agriculture, but farm prosperity and resultant optimism led to overexpansion. During the decade 650 banks closed because of the vast amount of credit extended to farmers.[12] Twenty-five percent of Nebraska farmers failed between 1921 and 1923.

Drought conditions, which returned to the plains in the 1930s, compounded the worsening situation for farmers. The dust storms, which occurred with increasing frequency, tried the strongest of souls. Many left the farm and moved to town, generally to work on federally funded projects. Many left the state entirely, moving west to California. During the decade, the state's population declined by sixty-five thousand people.[13]

It took tremendous reserves of strength, both physical and mental, to survive the extraordinary distress. Family and community solidarity helped to buoy up spirits and provide the strength and courage to continue. Farm women who had always worked alongside their husbands worked even harder to bring in a bit of income for the family larder. Many found that raising chickens was a way to earn a few dollars, and the "egg money" became a precious resource. Others separated cream and milk and took the products into the local creameries. For virtually all, times were austere. People made do and did without.

Events in Europe by the latter half of the 1930s foreboded war. Many Americans remembered World War I and, frustrated by the experience, hoped to avoid further entangling associations with Europe. This isolationist impulse

Agrarian protest swept the plains states throughout the 1880s. Nebraska, however, became the central focus of the movement in 1890. Dissatisfied with both major parties, the Nebraska Farmers' Alliance called for the formation of an agrarian political party and issued a call for a people's convention to focus the issues. The Populist, or People's, party which emerged held its first national nominating convention in Omaha in 1892 and remained a force in Nebraska and midwestern politics throughout the decade.

Nebraska became further identified with agrarian reform in the Midwest as the Populists in the state led the movement for initiative and referendum legislation, the secret ballot, and for state regulatory commissions to regulate the railroads and utilities. By the end of the decade that association became national in focus as the Populist party threw their support behind a Lincoln lawyer, William Jennings Bryan, a congressman and Democratic candidate for president in 1896, 1900, and 1908. While populism never achieved national victories and ultimately waned as an organized movement, agrarian and political reform prevailed within the Midwest, influencing both major parties.

was particularly strong on the plains. Nebraskans, as well, were apprehensive about a new "involvement." The Japanese bombing of Pearl Harbor on December 7, 1941, settled the issue. The country was at war again.

The war meant the return of prosperity to the nation. The Great Depression was over. Nebraska experienced the economic upturn as well. There was a renewed demand for food. Agricultural production was, once again, in demand. In addition, air bases, ordnance plants, and a large naval ammunition depot were established within the state. Nebraska was contributing to the war effort and employment opportunities abounded. Prosperity had returned.

Since World War II, agriculture has remained the mainstay of the state's economy. Farm sizes have increased, though the number of farms have declined. Productive farming still relies on irrigation, and the development of center-pivot irrigation systems has meant that more acres can be put into production. Water has remained an issue in Nebraska, as it has in most of the plains states, and will continue to be. Cities are larger now, but Nebraska remains basically a rural, agrarian environment. The themes of its past continue to identify it. The association with the land and the environment persist.

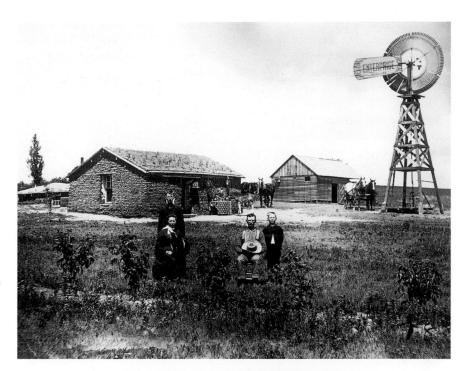

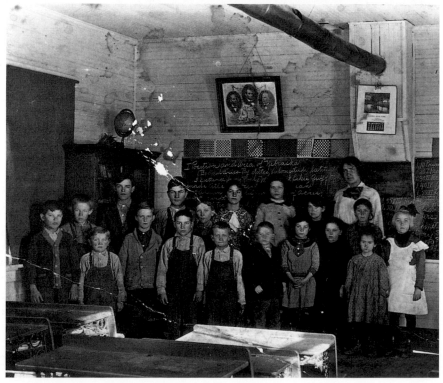

Family in front of their Custer County, Nebraska, sod house in 1887. A degree of prosperity is suggested by the windmill and wooden shed. A quilt is airing by the front door. Courtesy of Nebraska State Historical Society. From the Solomon D. Butcher Collection.

Schoolteacher with her pupils, Emerson, Nebraska, about 1900. Courtesy of the Nebraska State Historical Society.

6

Nebraska Quiltmakers, 1870–1940

During the years of Nebraska's settlement and development, the majority of Nebraska quiltmakers were rural women with a grade school education living on farms or in small communities. Most were married and had two to four children, the norm for American women between 1870 and 1950. Although some novelists and historians have characterized the plains pioneer woman as a mother of ten to twelve children, most women settling the plains during the last quarter of the nineteenth century had only three or four children.[14] The typical Nebraska quiltmaker was no exception. Although some Nebraska quiltmakers did have large families, as many as fourteen to sixteen children, most did not.

Nebraska quiltmakers participated in a variety of occupations, including teaching, dressmaking, farming, ranching, nursing, retailing (hardware stores, general stores, antique stores, and department stores), domestic services (housekeeper, hired girl), and clerical services. A few were telephone operators, beauticians, or bookbinders. One was a postmistress. Most were ranch wives, farmwives, or housewives, as were most married women of the nineteenth century and the first half of the twentieth. Teaching and dressmaking were the predominant occupations of the Nebraska quiltmakers who worked outside the home. This reflects the times: in 1880 four-fifths of all American women who were engaged in nonfarm employment worked as teachers, servants and laundresses, clerks and salespersons, or dressmakers, milliners, and seamstresses. The majority of white working women throughout the nineteenth and first half of the twentieth centuries were young and single; women usually abandoned or were required to quit work for pay when they married.[15] A number of Nebraska quiltmakers mentioned that they, too, abandoned paid work when they married.

Many of the quiltmakers or their parents came to Nebraska in the two decades following the Civil War, when a wave of migration populated the remaining western territories. The majority of Nebraska quiltmakers identified their ethnic background as German, with English, Czech, Irish, Scots, Danish, Swedish, and Norwegian heritages following in that order. The ethnic background of the quiltmakers reflects the ethnic background of Nebraska's immigrants in the late 1800s, most of whom were Germans followed by smaller but significant percentages of Swedes, Irish, Czechs, English, Danes, Russians, Scots, and Norwegians.[16]

Religious groups were particularly active in the settlement of Nebraska during the 1870s and 1880s. For example, Lutheran pastors led many groups of Scandinavian immigrants; Congregationalists founded York; and several Mennonite communities were established near Lincoln under the leadership of Peter Jansen.[17] Most Nebraska quiltmakers were Methodists or Lutherans. Of the remaining quiltmakers, most identified themselves as Catholic, Presbyterian, Christian (Disciples of Christ or United Church of Christ), Congregational, Baptist, or Mennonite. Methodist and Lutheran religious preferences are generally associated with those of English, German, and Scandinavian descent, while Catholicism is often associated with those of Czech and Irish descent.

Although Nebraska had a diverse population in which national or religious groups frequently dominated rural communities and maintained their language and customs, strong ethnic influences on quilt construction and patterns were not observed in the quilts and quilting practices of Nebraska quiltmakers. If distinctive quiltmaking traditions existed among the immigrants when they arrived, they did not survive for long. In fact, differences may not have existed at all. The basket quilt of Mary Novotny Lahowetz (Plate 3), which according to family tradition was pieced in Bohemia and quilted after her arrival in America, is similar in pattern and construction to other Nebraska-made pieced quilts of the period. Her quilt and another one made by a German quiltmaker for her brother to take to Nebraska (Plate 49) stand as evidence that immigrant women not only brought the necessary sewing skills for quiltmaking with them to America, they brought quilts and even pieced blocks to their new homes. If any differences in quilt styles and construction existed, the sharing of patterns and construction techniques quickly obscured them.

In general, quiltmaking was a lifelong activity. The hardships of relocation and settlement in a sometimes hostile land did not interrupt quiltmaking activities for long, if at all. For example, Clarissa Griswold made a beautiful Crazy quilt (Plate 62) while she sat her claim in Sioux County, Nebraska, between 1885 and 1886. Sophia Hinrichs and Helena Hinrichs Prange, mother and daughter, provide yet another example of the many women who made quilts while living under most unfavorable conditions during homesteading years. They pieced their fan quilt (Plate 8) while living in a dark, dank dugout, which, although little more than a cave, was their temporary home for more than five years.

MOTIVATIONS FOR QUILTMAKING

The majority of Nebraska quiltmakers began quiltmaking because it was a form of self-expression and a pastime that they enjoyed. Quiltmaking allowed women to escape the rigors and drabness of their everyday routines into a kaleidoscopic world of color. The personal satisfaction derived from this pastime was an important motivation for Amelia Barbe, who continued piecing quilts even after she started to lose her eyesight. Her granddaughter relates, "I have some of her tops that she pieced together on the treadle sewing machine after she lost most of her eyesight. She was blind in one eye and had about only twenty percent vision in the other eye, but she kept on piecing. Some of the pieces don't meet, some of the seams kind of go off all over the place, but it's interesting that she kept on trying to do the handiwork after she lost her eyesight."[18]

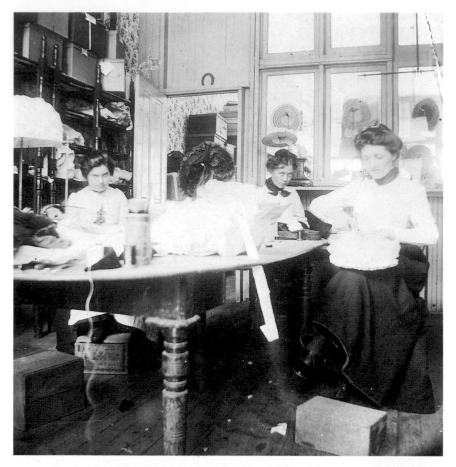

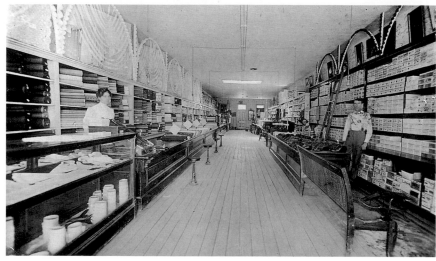

Young women at work in a millinery shop, circa 1900. Courtesy of the Nebraska State Historical Society.

Retail clerks in a general merchandise store in Nebraska about 1900. This store boasted a wide variety of fabrics on the shelves behind the woman. Courtesy of the Nebraska State Historical Society.

Ellen Maxwell found quiltmaking therapeutic. She made a Crazy quilt (Plate 66) to overcome grief following the death of her baby girl from diphtheria during an epidemic in the winter of 1892. According to her granddaughter:

Grandmother was so laid out by the death that she was unable to go on with her life. And so Grandpa ran or took a horse over to the neighboring couple, an older couple, who had lost their only child many years ago. [The neighbor] gathered up scraps of velvet and silk and old linsey-wool and strands of thread and showed Grandma how to fashion pieces and then embroider flowers and birds and so forth on it. [Grandma] patiently put them together. . . . She tacked the flowers or fruit from a seed catalog and then embroidered over it, then picked out the paper behind. That's how they did; they didn't have patterns in those days, you know. And so, she featherstitched around each piece. . . . Each night she would work by the light of the kerosene lamp. . . . gradually she got better. . . . Grandma got hold of her life again and finished the quilt and folded it up and put it away. . . . When we'd ask to see the quilt, she'd get it out, but she never used it because the memory in each scrap would just tell her about her baby daughter.[19]

Special occasions such as birthdays, graduations, marriages, and births prompted a great deal of quiltmaking. Of these, the occasions that mark new beginnings, weddings and births, inspired the most quiltmaking. Family members usually received the quilts made for these occasions. Lena Burger of DeWitt was one of many Nebraska quiltmakers who described the number of quilts that she made for members of her family when they married. "All twenty of my grandchildren, they all got their quilt, or are getting it. When they get married they get their quilt."[20]

Some quiltmakers quilted because they needed warm bedding and they found quiltmaking an economical way to meet this need; some quilted to demonstrate their thriftiness and care-

ful use of scarce resources. Perhaps the words of Genevieve Young from Nebraska City best express many quiltmakers' reasons for saving scraps: "I have collected fabrics all my life, and I just never thought it wise to throw away even an inch of fabric. I always collected all of the tiny pieces that nobody else wanted. And, I always thought it would be awfully nice if you could just put all those pieces, roll them all together like you do pie dough, then roll them out and have one piece." Others made quilts because they had little money to do other things. According to her daughter, Gertrude Scudder made her Trip Around the World quilt (Plate 30) during the depression of the 1930s: "you didn't have any money . . . you made quilts."[21]

Although many maintain the popular notion that pieced quilts were born out of hardship and economic necessity, most Nebraska quiltmakers did not cite that motivation. Some quilts are so complex and the needlework so fine that it is clear that the quiltmakers did not hastily assemble them to provide warm bedding. Instead, the quiltmakers created objects of beauty and pride that displayed their exquisite needlework skills and artistic abilities. Certainly pioneer values of thriftiness and industriousness motivated virtuous women to devote their free time to quiltmaking or other forms of needlework, but necessity was not the quiltmaker's primary reason for making quilts. Instead, most respondents noted that the reason for making quilts was the pleasure and satisfaction derived from making a useful and beautiful item for their family.

For rural American women, especially those settling the frontier, there were few opportunities for artistic expression. Painting, sculpture, and other fine arts were considered far too frivolous for most rural women to undertake. Quiltmaking, which produced a useful item for their families, afforded women an acceptable avenue for their creativity. From the numbers of outstanding quilts that have survived, it is clear that many women exercised this option.

QUILTMAKING PRACTICES

Some women learned to make quilts as children because in rural households children and adolescents were expected to participate in the household work of their families. Household responsibilities included learning needlework skills. Throughout the nineteenth century, girls frequently learned to sew before they learned to read and sometimes pieced simple quilt blocks at an early age, as young as two or three, to practice and improve their sewing skills.[22] Many quiltmakers related stories about their childhood experiences in quiltmaking. Belle Frasier of Parks, Nebraska, the youngest quiltmaker registered in this survey, started her first quilt when she was three and a half years old. It was a simple Four Patch (Plate 21). "Just little squares," as she described it. "My mother would cut them out and pin them together and mark where I was supposed to sew." Peg Kildare of Ogallala remembers how her mother "insisted every afternoon that I sit down at a certain time and put that quilt together. Oh I got so I hated it . . . but she made me finish. . . . I had to sit there and now I'm glad she did because I never start anything but what I finish it." Another quiltmaker said, "I think my mother learned me to quilt when I was twelve years old. She started me out sewing carpet rags. Just kept on, kept on until I learned to quilt."[23]

These anecdotes illustrate that quiltmaking skills, like most needlework skills, were transmitted by adult women to young girls or young women. Almost 70 percent of the quiltmakers surveyed learned their quiltmaking skills from family members, usually mothers, but occasionally from grandmothers, aunts, or sisters. About 20 percent indicated that they taught themselves to quilt, but they probably learned the necessary sewing skills from other women. Only two women said that they learned to make quilts in classes. Quiltmaking in Nebraska reflects a widespread feminine skill that was usually transmitted from mother to daughter in the home. While this may be typical of the transferral of quiltmaking skills in rural families across America

during the time, it contrasts with the eastern tradition in affluent urban families, where girls often learned needlework skills through special ornamental needlework classes in private finishing schools or boarding schools.[24] It also contrasts with contemporary patterns, where women often learn quiltmaking skills in classes.

While some quiltmakers began to quilt as children under their mother's close supervision, and the majority of Nebraska quiltmakers began to make quilts as young adults, a few began later in life (after sixty years of age). One of these, Marie Jahnke of Bancroft, noted: "I lived on a farm for thirty-five years. . . . It was a little while before I moved to town when I started quilting. When my husband quit farming then I didn't have to help as much, but otherwise I was always out there helping him with everything, plus going to work everyday."[25]

Surprisingly, about one-third of the Nebraska women surveyed made most of their quilts during mid-life, when their children were still at home. Although they had many demands on their time during these years, they found time to quilt. Almost an equal number indicated that they made most of their quilts after their children were grown, when they had more time to devote to quiltmaking.

Some women quilted into their eighties, and a few women were ninety years old when they completed their quilts. Whether the motivation to quilt was to satisfy their desire to create a thing of beauty for themselves or their descendants, to satisfy their sense of the proper way to use their time and scarce resources, or to provide warm bedding for their families, many women made quilts throughout their lives.

Many Nebraska quiltmakers believed they made their best quilts after their children were grown. They not only had more time then; they also had a lifetime of experience in quiltmaking and sewing to apply to the task. Surprisingly, an equal number of quiltmakers believed they made their best quilts during mid-life, when their chil-

dren were at home. Although women had fewer responsibilities and demands on their time when they were younger, few women thought they made their best quilts as young adults. Sewing was a measure of a woman's ability as a homemaker and the consummate feminine skill during the nineteenth century. Apparently most women believed that their skills continued to improve over the years, and they continued to devote the time required for meticulously crafted quilts although burdened by a multitude of chores as farmwives and mothers.

When asked about the frequency of quiltmaking, 70 percent responded that they quilted often, while 30 percent said they quilted only sporadically. The frequency of quiltmaking often depended on factors like the time of year, how much time was available to quilt, and the occasion for which the quilt was made. An upcoming birth, marriage, or high-school graduation in the family often provided the impetus for more frequent quiltmaking. The time of year affected the frequency of quiltmaking for those who lived on farms because seasonal work influenced the amount of time available for needlework. Responsibilities during the spring, summer, and fall, were particularly demanding. Wintertime was frequently mentioned by quiltmakers as the time of year that they could devote to their quiltmaking activities. But women made quilts year round and in many unlikely settings. Irene Alexander recalled that her mother always wanted her children to have something to do while they were herding the cows. "We would piece the blocks by hand and use our time that way. We also did embroidery work while we were there."[26]

Very few Nebraska quiltmakers made more than one hundred quilts; most made fewer than fifty and many made fewer than ten. Some women, however, were truly prolific. Minnie Geise Sukraw made about thirteen hundred tied quilts, largely for overseas relief.[27] While tying took less time than quilting, this accomplishment is nonetheless remarkable. Quiltmaking is a time-consuming task. Although some quilts were completed in six months and others spanned a lifetime, the average Nebraska quiltmaker completed a quilt in about two years. In general, quiltmakers devoted the time necessary to make products that reflected meticulous care and craftsmanship and that would reflect well on their needlework skills. The amount of time required to produce each quilt is another argument against the popular notion that the major impetus for quilting during the nineteenth century was the urgent need for warm bedding by penniless settlers who had little other than scraps and rags from which to make it.

Nebraska quiltmakers used about as much new fabric as they did dressmaker cuttings or scraps. This was apparent in the number of registered quilts that had a matching sashing, border, or backing, which required larger amounts of material than available from the scrap basket. Usually the only parts of the quilts that came from dressmaking cuttings were the colorful and varied prints in the pieced blocks. Because scraps could be so effectively used in pieced quilts, Nebraska quiltmakers made this type of quilt in far greater numbers than appliqué quilts, which generally required larger amounts of matching fabrics. Surveys in other states also note the bountiful number of pieced quilts.[28] Worn-out clothing was rarely used by Nebraska quiltmakers. Recycled flour, salt, sugar, tobacco, and feed sacks, however, were sometimes used, as were, on occasion, old neckties and political ribbons.

Most Nebraska quiltmakers had no favorite pattern according to the recollections of family or quiltmaker. Those few who did identify a favorite pattern usually mentioned the Double Wedding Ring, Dresden Plate, or Grandmother's Flower Garden. More Double Wedding Ring and Grandmother's Flower Garden quilts were registered in the state during the Nebraska Quilt Project than any other pattern, which further supports their favored status among Nebraska quiltmakers.[29] When asked why a pattern was a particular favorite, quiltmakers or quiltowners responded that it was economical to make (Double Wedding Ring, friendship, and Log Cabin), colorful (Nine Patch), appropriate for the quiltmaker's grandchildren (Sunbonnet Sue and Overall Sam), and beautiful and meaningful to the quiltmaker herself (Double Wedding Ring). When Abba Jane Johnston found a pattern that suited her, the Barn Raising variation of the Log Cabin (Plate 16), she "never strayed from it." According to her great-granddaughter: "It was a trait that carried through into many aspects of her life and gave real meaning to the word *method* in Methodist. She was not known for deviating from the straight and narrow! But she was known for her good deeds, and no doubt her sewing skills came in especially handy when she stitched up the lip of a woman cut in a butchering accident—a legendary story in the family."[30]

Family, friends, and neighbors were among the most often mentioned sources of patterns for Nebraska quilts. Quiltmakers exchanged patterns much as they traded recipes. During the 1930s and 1940s Louise Howey of Lincoln exchanged patterns with about twenty-five quiltmakers across the United States and Canada through round robins.[31] Another important source of patterns among the quiltmakers was the print media: books, women's magazines, and newspapers. Surprisingly, almost a quarter of the respondents indicated that their quilts were original designs. Traditional quiltmakers, however, often called any quilt pattern "original" if they drew it out themselves rather than buying one already drawn or in template form. Careful scrutiny of the quilts identified as a quiltmaker's own design revealed that only a few were truly original. Over half of them were Crazy quilts or album or friendship quilts cooperatively made of blocks contributed by as many as thirty to forty women. A third were variations of traditional appliqué and pieced patterns.

Nearly two-thirds of the quilts registered were quilted by the quiltmaker

herself rather than by someone else. This is not surprising, since quiltmakers, like many artists, nurture the vision of their quilts from selection of the pattern to completion in the quilting frame. Therefore, they wanted to control each step of their quilt's development from the first to the last stitch. Some women preferred to quilt alone because they were very particular and did not want irregular quilting stitches to spoil their carefully pieced or appliquéd tops. When asked if she ever quilted with groups, Jessie Hervert of Kearney replied, "No, I like to make the stitches myself. Even the twins never helped me stitch my quilts. Not because they couldn't do it good enough, but because I don't sew like they sew."[32]

While Nebraska quiltmakers spent many hours quilting alone, some also participated in quiltmaking activities for fellowship and fund-raising at church, at community clubs, and even in their homes. The majority of those who quilted with groups usually did so in church groups or a friend's home, perhaps because of similar traditions, language, interests, and philosophies. Katheryn Thomsen of Omaha remembered that when she lived in the country her mother would have quilting parties. "It was complete enjoyment for these people to come over. . . . Sometimes after they quit my mom would go over and look at the quilting and she would take out [stitches made by] the person in the club who made large stitches."[33] Obviously fellowship was more important than progress in the quilting. Her mother held the parties despite the fact that some of the quilting did not meet her standards.

Quiltmaking in Nebraska was a practice of thriftiness, a well-regarded feminine pastime, and an enduring form of self-expression. Nebraskans prided themselves on their hard work, frugality, and resourcefulness. These values are clearly reflected in their quiltmaking. Consequently, quiltmaking remained a popular activity among rural women throughout the years of Nebraska's settlement and development and well into the twentieth century. Despite the difficulties and hardships that Nebraska women surely

encountered during the early years of settlement, they found time for quiltmaking.

The quilts that Nebraskans made and their reasons for making them mirror women's many and varied roles. As nurturers, women made quilts for their own infants and grandchildren; as social communicators, women made album or friendship quilts for their friends and families; as moral guardians of the family, women made quilts to raise funds for their churches and for other worthwhile causes; as accomplished seamstresses, women made quilts with incredible numbers of pieces and quilted them with stitches so tiny that they sometimes require a magnifying glass to see. Quilts are valuable artifacts because they elicit memories of their makers, family members, and special occasions; because they are symbols of family heritage and traditions; and because they are beautiful examples of women's art.

Nebraska Quilts

The quilts registered in the Nebraska Quilt Project survey range in date from 1792 to 1989 and include pieced quilts, appliqué quilts, embroidered quilts, Crazy quilts, and a few whole-cloth quilts. Seventy-five percent of these quilts were made in Nebraska. Eighty-two of Nebraska's ninety-three counties were represented in the survey.[34]

The oldest quilt registered in the survey was a glazed-wool whole-cloth quilt (Plate 1) made in Northampton, Massachusetts, by Nancy Clark Phelps in 1792 and brought into Jefferson County, Nebraska, by her namesake and granddaughter Nancy Maria Phelps Forshay in the 1850s. Very few other whole-cloth quilts were registered. Glazed-wool quilts were quite typical of the American federal era but rare after the first quarter of the nineteenth century.[35] They showcased the quilter's skills, because quilting was the source of design on the quilt in the absence of pieced or appliquéd designs.

Often the quilting designs were quite elaborate. The Phelps quilt with its generous wool batting had a simple quilting design of concentric diamonds.

This quilt held a special meaning to its owners, for according to family tradition, the fabrics were woven from homespun yarns from the wool of the family's own sheep. The quilting thread was coarsely spun wool as well, instead of the more usual linen. The quiltmaker did not use two or three lengths of fabric sewn together to create the whole-cloth top as was customary; instead she stitched together by hand many blocks of fabric of a variety of sizes. The fabrics for the dusty-rose–colored top appear to be leftovers from other sewing projects, because some of the fabrics are simple plain weaves, others twill weaves, and they vary in shades of rose as well. Either the fabrics were colored at different times, possibly with madder, or the fabrics of different weaves and different types of wool responded to the dye differently yielding the various shades. Clearly, the quiltmaker did not have fabric in the abundance that some of her eastern sisters did; therefore she saved each precious piece until she had enough for a quilt top. The backing for the quilt is a gold-colored homespun, plain-weave fabric.

Pink glazed-wool whole-cloth quilts were not unusual during the last quarter of the eighteenth century. In fact, a brilliant "watermelon pink" glazed-wool quilt with a striking yellow backing made in New England about 1775 is shown in *America's Quilts and Coverlets*, by Carleton L. Safford and Robert Bishop.[36] Unlike the simply quilted whole-cloth quilt of the Nebraska survey, it is quilted in an elegant and ornate floral design.

The oldest surviving quilt known to have been made by a Nebraskan is a red-and-green appliqué quilt (Plate 93) completed by Martha Allis in 1860. It is a lovely variation of the Wreath of Roses pattern made for her dowry. Red-and-green appliqué quilts were a favored style between the 1840s and 1870s. The fashion for red-and-green quilts began in the late 1830s when colorfast fabrics in those colors became more widely available.[37]

11

While appliqué, whole-cloth, embroidered, and Crazy quilts were registered at most sites in the state, pieced quilts accounted for 75 percent of all the quilts in the Nebraska survey. Thus most were made of simple cotton muslins and calicoes rather than the more expensive glazed cotton chintzes, fancy silk velvets and brocades, or woolen fabrics. Cotton muslins and calicoes were inexpensive and have been widely available in North America since the 1840s. The establishment of American textile mills with roller printing capabilities ensured a widely varied supply of printed cotton fabrics for the nineteenth-century American seamstress and quiltmaker and resulted in a fashion for pieced and appliqué quilts using the small floral cotton prints known as calicoes. Because most of Nebraska was settled after the railroad was completed, there was never a shortage of calicoes and other needlework supplies for those who could afford them.

Although the earliest quilts in the Nebraska survey dated from the 1790s, most were made between 1890 and 1940 and after 1970. This is not surprising, for the period 1890 to 1940 follows Nebraska's most active period of settlement, while the 1930s and 1940s and the period since 1970 coincide with the years when quiltmaking enjoyed increased activity nationwide. Fewer quilts were registered from the 1950s and 1960s, when quiltmaking activities declined nationwide. More quilts dating from 1970 to 1989 than from any other period were registered in the survey. The quilt revival that began in the early 1970s may account for the higher number, but also it should be remembered that the more recent the quilt, the more apt it is still to be in existence.

Pieced quilts composed of straight-edged geometric shapes were the favored type throughout all periods in Nebraska. Not only could odd-shaped scraps of fabric be more effectively used in pieced quilts than in appliqué or embroidered quilts, but pieced quilts were less time consuming and less difficult to make than appliqué quilts, which required larger amounts of matching fabrics and more often necessitated the purchase of fabric specifically for the quilt top. Unlike appliqué or embroidered quilts, most pieced quilts required only one type of stitch—the running stitch—for piecing and binding the top, batting, and bottom layers together. The running stitch was basic to plain sewing, easy to master, and practiced by most women from an early age.

Because so few quilts made before 1870 were registered, no attempt has been made to describe the "typical" Nebraska quilt of the decades preceding 1870. After the Civil War and the completion of the Union Pacific Railroad across the state in 1867, settlement of the state proceeded at a more rapid pace. With more settlers, more quilts were either made in the state or brought into Nebraska.

The most frequently observed pieced patterns from the 1870s in the Nebraska survey were star patterns (see, for example, Plate 5). Because so few of the registered quilts were made during the 1870s and fewer still were made in Nebraska in the 1870s, it is impossible to say conclusively that star patterns were the most widely used patterns in Nebraska at the time. On the other hand, star patterns are among the most frequently used patterns in American quilts and for that reason are likely to have been the most frequently made pieced patterns in the 1870s in Nebraska.[38] Star patterns enjoyed continued popularity through the early 1900s in Nebraska.

Also popular in Nebraska during the late 1800s were the Log Cabin, Four Patch, and Nine Patch, all relatively easy patterns to make and ones that made good use of small and varied scraps. In fact, the Four Patch and Nine Patch were often used to teach children to piece because of their simplicity. Nine Patch quilts were a favorite for utility quilts throughout the nineteenth and twentieth centuries. Log Cabin quilts were so popular in the 1870s nationwide that some state and county fairs opened categories specifically for them. The source of the Log Cabin design is elusive, but it emerged as a new quilt type during the 1860s.[39]

Crazy quilts were beginning to appear in greater numbers by the 1890s. Almost 25 percent of the surveyed quilts made between 1880 and 1910 were Crazy quilts, reflecting the popularity of that style. While quiltmakers continued to make pieced quilts in about the same proportions throughout the state's history, the rage for Crazy quilts was so great that appliquéd and embroidered quilts, previously used to showcase a needleworker's skills, were made in far fewer numbers during that era. Crazy quilts were popular nationwide during the Victorian era in America; Nebraska was no exception.[40] Women's magazines in the 1880s and 1890s capitalized on the fad by publishing patterns, how-to articles, and teasing women in print about their compulsion to work on these quilts. Entrepreneurs even made up Crazy-quilt kits with an assortment of new silk scraps and sometimes included a schematic drawing showing the size and shape of each supposedly random piece, patterns for small embroidered motifs with recommended decorative stitches, and lengths of gold tinsel cord.[41]

Although Nebraska quiltmakers were enamored of the Crazy quilt, most tended to keep theirs modest and simple in style and material. While most eastern quilts of the period were made of luxury fabrics such as silk brocades, taffetas, and velvets and were lavishly embellished with virtually every embroidery stitch imaginable, Nebraska Crazy quilts were often made of simple woolen fabrics and only modestly embroidered. At times their pictorial embroidery included prairie flowers and other elements of the frontier setting. Of course, some Nebraska quilts emulated those made in the more prosperous eastern states; when quiltmakers had access to more luxurious materials, they did not pass up the opportunity to make a spectacular show quilt.

Both the fancy silk and simple

1 Whole Cloth

Wool
75" × 69"
NQP 1987

1792
Made by Nancy Clark Phelps (1772–1845)
Made in Northhampton, Massachusetts, and brought to Steele City, Jefferson County, Nebraska during the 1860s.
Owned by Lois Schultz

13

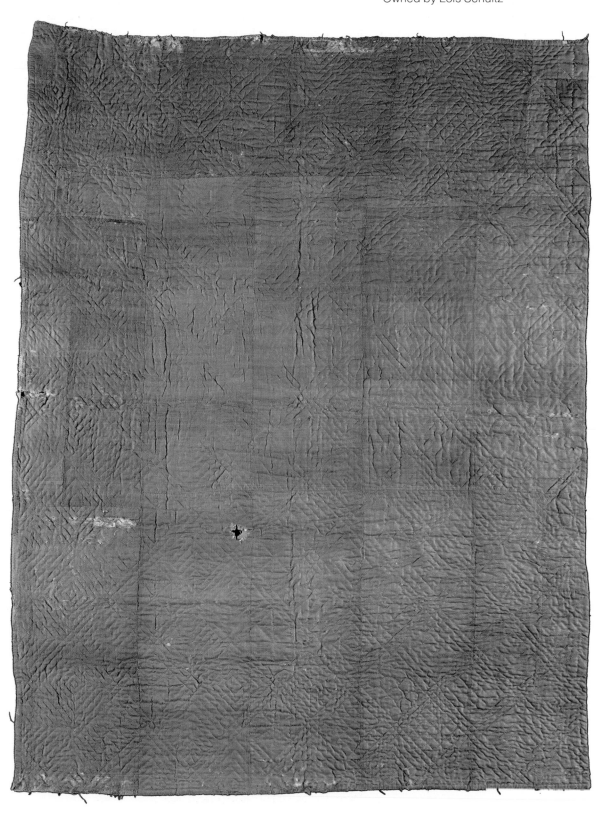

14 Women tieing quilts at a Federal Emergency Relief Sewing Center, Beatrice, Nebraska, in 1934. Courtesy of the Nebraska State Historical Society.

Federal Emergency Relief Agency sewing center established in Omaha, Nebraska, during the depression of the 1930s. Courtesy of the Nebraska State Historical Society.

woolen Crazy quilts employed the same methods of construction. Scraps were placed on a foundation block to be joined with other blocks when all were completed, or they were stitched to a foundation the desired size of the finished product. The raw or turned-under edges were covered with decorative embroidery of which the feather-stitch and herringbone stitch were the most common. The quilts were backed, but unlike most pieced and appliqué quilts, were neither filled nor quilted. Instead, they were tied or tacked invisibly from the reverse side to secure the layers of the quilt.

The Nine Patch, Log Cabin, and star patterns continued to be the most prevalent pieced patterns among Nebraska quilts during the first two decades of the twentieth century. By 1910 the Crazy-quilt vogue had waned, and during the 1910s, 1920s, and 1930s embroidered quilts, especially those with alternating embellished blocks, rose to popularity in Nebraska. The predominant type of embroidery work was outline embroidery, which resembles a line drawing. It first appeared in this country about 1880 and became very popular during the first decades of the twentieth century.[42] The popularity of the outline, or stem, stitch for embroi-

dered quilt blocks can be attributed to the simplicity of the technique. It was, in fact, recommended to women "who have neither time, eyesight nor means to indulge in intricate and elaborate needlework."[43] Particularly popular embroidery themes among Nebraska quiltmakers were scenes from history (Plate 57) and state flowers and birds (Plate 56), and most appeared to be purchased patterns. The charming figures of the British book illustrator Kate Greenaway, so popular in American needlework of this era, were rarely seen in Nebraska-made quilts.

More quilts registered in the Nebraska survey were made in the 1930s than any other decade before the 1980s, which reflects the renewed interest in quiltmaking that occurred nationwide at that time. The severe economic depression of that decade revived national concerns for thrift and economy. Women everywhere were encouraged to sew and to undertake a variety of crafts, including quiltmaking, weaving, embroidery work, and block printing in an effort to develop home-based and community industries. Capitalizing on the renewed interest in

quilting, farm journals, women's magazines, and newspapers of the 1930s carried numerous advertisements for quilting kits and patterns—reproductions of the nineteenth-century patterns as well as new ones.[44] Quilt shows and contests were held throughout the country and were enthusiastically attended.

The two most popular pieced-quilt patterns of the 1930s and 1940s among the surveyed Nebraska quilts were Grandmother's Flower Garden (Plate 29) and Double Wedding Ring (Plate 25). Their statewide popularity at the time is confirmed in the September 19, 1931, *Nebraska Farmer*, a weekly newspaper, that reported, "The popular quilt of last year [at the Nebraska State Fair], the Double Wedding Ring, gave way this year to the Flower Garden pattern."[45] Other pieced patterns observed in large numbers in the Nebraska survey were the Dresden Plate and Irish Chain.

Following pieced patterns in popularity during the 1930s and 1940s were appliqué quilts. Sunbonnet Sue (Plate 42), Colonial Lady, Butterflies, and a variety of floral appliqués (Plates 43 and 44) were among the most popular patterns. The popularity of the Sunbonnet Sue appliqué pattern reflected the

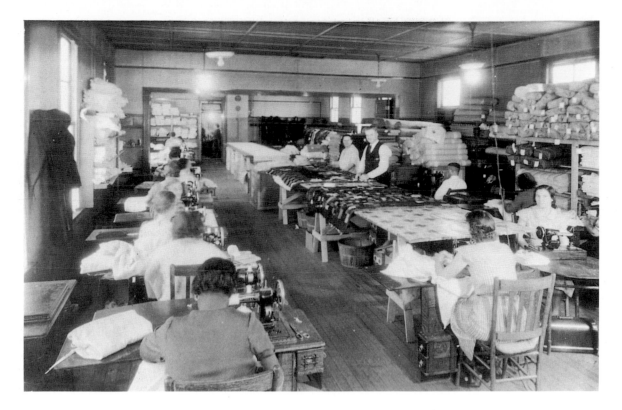

nationwide fad for quilts with juvenile themes that peaked in the 1930s.[46] Commercial patterns were available for Sunbonnet Sue and her partner, Overall Sam; however, judging by the many variations observed in Nebraska quilts, women made their own templates for the designs they saw and liked in a variety of magazines as often as they purchased the commercial pattern or template.

For the popular floral appliqué quilts with naturalistic morning glories, water lilies, tulips, and roses in pastel colors, medallion format, and scalloped edges, commercial patterns or kits were usually purchased and carefully followed. This was characteristic of twentieth-century American appliqué and, therefore, most floral appliqué quilt designs can be traced to a commercial pattern.[47]

The 1950s and 1960s were years of far less quiltmaking in the state and nation. While pieced quilts continued to be made in greater numbers than any other style of construction, a strongly favored pattern did not emerge. Embroidered quilts, usually from kits, followed pieced quilts in popularity during those decades.

Quiltmaking experienced a revival during the 1970s that grew during the 1980s and is clearly reflected in the numbers of quilts registered in the survey from those two decades. Nearly twice as many quilts were registered from the 1980s than from any other decade. This revival of quiltmaking in the latter half of the twentieth century will be discussed in a later chapter. Nebraska's pieced, appliquéd, embroidered, and Crazy quilts are presented chronologically in the following chapters. A chronological arrangement of the quilts by construction type was chosen to depict more clearly the evolution of patterns and changing taste in color, design, and construction.

The pattern name for each pieced and appliqué quilt is given in the heading. If the maker's name or the family's name for the quilt is used and it is an unconventional name, then the pattern name is placed inside quotation marks.

The date for each quilt is preceded by "circa" if it is an approximate date based on such factors as quilt style, construction, pattern, fabrics, and family history. If the quilt has a date marked by ink, embroidery, or some other means, this is noted by the word "marked" in parentheses after the date.

Some quilts did not have a marked date on them; however, the year or years in which they were made could be firmly established. Those quilts have a date that is neither preceded by "circa" nor followed by the word "marked."

The fiber content for each quilt *top* also is given in the heading. The fiber content of the batting and backing may be included in the description of each quilt; however, the fiber content of the batting could not always be determined. The fiber content of the quilts was confirmed by microscopic analysis to ensure accuracy of the notations. Some contemporary quilts contained broadcloths, muslins, and calicoes that were blends of polyester and cotton rather than 100 percent cotton. Blends were denoted polyester-cotton regardless of the percentages of polyester and cotton present.

Finally, the number assigned to each quilt by the Nebraska Quilt Project (NQP) committee is given in the heading to assist those persons wishing to consult project materials for additional information. Unless otherwise noted, the information about each quilt and maker comes from materials gathered at each site and filed with project documents.

"Love Was in the Work": Pieced Quilts

by *Kari Ronning*

STRENGTH and simplicity, the ideals of eighteenth-century art, are evident in this well-preserved and beautifully quilted and stuffed quilt. The red and blue printed diamonds, alternating with brown or brown and white floral-strip diamonds, blend harmoniously. A small red sawtooth border frames the central image and is repeated on the outside edge.

Crosshatching and parallel-line background quilting a quarter inch apart, with ten to twelve stitches per inch, throw the stuffed work into relief. Each of the four corners has a stuffed basket filled with foliage, grapes, roses, or pomegranates. The twelve-inch-wide white border is filled with an undulating feather vine. The star itself is simply crosshatch quilted in straight lines.

The quilt's family came to Nebraska in 1895; the quilt itself came about 1911. An uncle of the present owner recalls it's being hung with the hundred-year-old quilts at the Douglas County Fair about 1920. Perhaps that public display was part of the revival of softly shaded Lone Stars and Broken Stars in the 1920s and 1930s. Certainly some of the quilts of that era were copies of heirlooms such as this one, as people sought "colonial" accessories for their colonial-revival homes.

Sara Boyd Waugh, the present owner's great-great-great-grandmother, was born in Pennsylvania in 1774. Her father, David Boyd, had been captured by Indians as a boy in 1756 and was adopted into the tribe. He was eventually returned to his father; his mother had been killed in the same raid. According to a family history recorded by his grandson, he was never really comfortable in "civilization" afterward. David Boyd married and had children before joining the revolutionary army and serving with Washington at Valley Forge. Sara grew up on the family farm in eastern Pennsylvania. Perhaps she acquired her father's taste for frontier life, for after her marriage in 1794 the couple joined her father when he moved farther west to live on what was then the Pennsylvania frontier. She had eight children before her husband died in 1813. She, the child of the American Revolution, lived into the Victorian age and died during the Civil War.

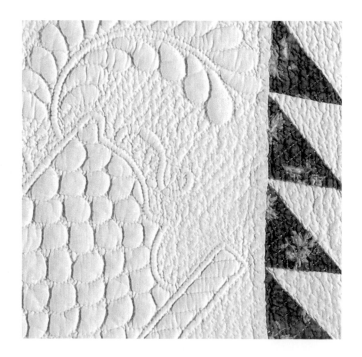

2 Star of Bethlehem

Cotton
94" × 94"
NQP 747

Circa **1830**
Made by Sara Boyd Waugh (1774–1863)
Made in Pennsylvania and brought to Nebraska in 1911
Owned by Jean Wardell Dorsey

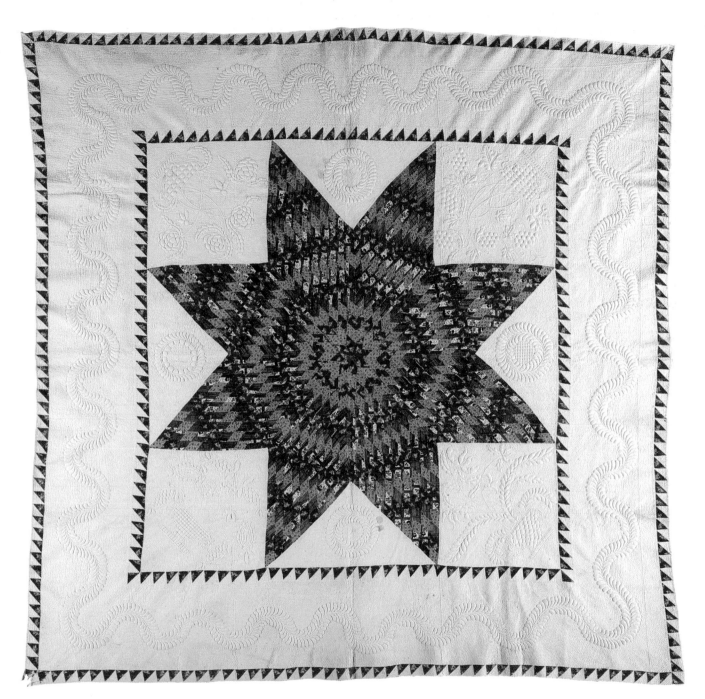

BASKETS have been among the most popular quilt patterns for many years. A presentation quilt marked 1814 in Patsy and Myron Orlofsky's *Quilts in America* includes six different kinds of baskets among its many designs. This basket quilt, however, is unusual in design. The piecing of the basket proper continues into the space usually left open below the handle. In this quilt the dark and light contrast of the basket's triangles is muted by the dominating deep pink background which frames it.

Although the color plan looks simple—pink, tan, black, and white—a variety of checks, dots, stripes, and geometric prints enlivens the eight-and-one-half-inch blocks. The blocks were set on point; the maker solved the problem of a one-way pattern by orienting the blocks in four different directions. The two outside rows point inward, so the baskets are upright when viewed from each side of the bed. In the center row the baskets are turned so the bottom three are upright when viewed from the foot of the bed; viewed from the head the other three center baskets are in their proper position. The maker clearly cared how her work would be seen from different directions.

The diamond-square border, three inches wide, echoes the pattern of the center with its tan print squares on point, bordered with deep pink. Not a very common border design, it recalls a parquetry frame. Hanging diamonds are quilted in the border and in the alternate plain blocks, while the pieced blocks have parallel lines quilted with six stitches per inch. The quilt is hand pieced and assembled, but the two machine-sewn seams of the printed tan backing support the family's story that the top was quilted at a later date, when the maker's family was more settled and prosperous.

Mary Novotny, the maker, was born in Radamovic, Bohemia, in 1835. In 1854, about the time she began the piecing, she married Thomas Lahowetz. In 1855 the couple came to America. According to family history, the blocks traveled across the ocean in a small handwoven basket which she always kept at her side; hence the family name, "Basket Quilt," describes both the pattern and the circumstances of its making.

The couple settled in Wisconsin, where their four children were born. Thomas served in the Civil War and was wounded in the chest; he never completely recovered. Mary tried to keep the farm going while he was away. As recorded in a family scrapbook: "The cattle got into the corn fields, ate some of the green corn and became ill, and many of them died. The remaining were sold, a few at a time, but the price had dropped drastically. The garden dried up and there was little produce to can and preserve. The corn crop was good, but everyone else had a good corn crop also, and there was not much market for corn. By the time Thomas returned . . . Mary and the children had been existing chiefly on corn. She had cooked it in every way she could think of, but they were all sick of the sight of corn." They were malnourished as well; it took Mary some time to recover her health.

In the early 1880s Mary quilted her basket quilt with the help of her three daughters. In 1884, the Lahowetz family moved to a farm near St. Paul, Nebraska. Thomas died before 1890; Mary and her unmarried daughter, Lizzie, went to live with her son, also named Thomas, and his family. Thomas kept a general store and Lizzie clerked for him. Mary died in 1907.[1]

Mary Novotny Lahowetz

3 Basket

Cotton
81" × 66"
NQP 1266

Circa **1854** (top); 1880 (quilting)
Made by Mary Novotny Lahowetz
(1835–1907)
Made in Radamovic, Bohemia, and
Wisconsin; brought to St. Paul, Howard
County, Nebraska, in 1884
Owned by Margery Zamzow

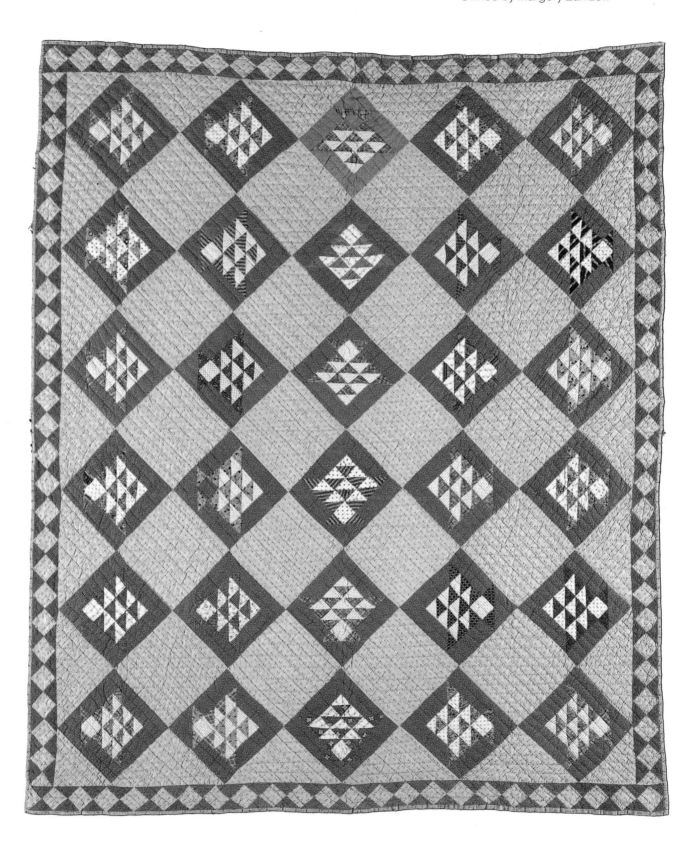

LIKE ROWS of tops suspended in mid-air against a striped wall, the blocks of this variation of the Log Cabin show one of the pattern's possible optical effects. Since the lights and darks in the Courthouse Steps blocks are arranged on opposite sides, the design is arranged horizontally and vertically, not diagonally as in the usual Log Cabin quilt.

Brown madder-style calicoes dominate the design of this quilt. The maker chose a brown-and-white checked fabric for the large center square of each of the fourteen blocks, instead of the usual solid red or black. The check serves as a neutral spacer between the dark sides, especially since the first row of strips on the dark sides is usually a light or medium color. The dark "tops" are effectively separated from each other vertically, surrounded by light background strips.

The maker used an interesting variety of fabrics, ranging from small and large floral prints to a variety of checks and stripes. She was not always able to match the stripes when she needed to piece out the length of a strip. The borders on three sides of the quilt use the check of the center squares, a blue-green floral stripe that often appears in the light areas, and a stripe of dark red and brown, which pleasantly unify the scraps. The fine orange-and-white binding adds to the prevailing orange tone of the light areas, which, in fact, are composed of tans, pinks, and the blue-green floral stripe.

Like most Log Cabin quilts of this period, this one is hand pieced and assembled. Unlike many Log Cabin quilts, it is not pieced on a foundation, and it has been quilted. Gentle waves of six-stitch-per-inch quilting curve across the surface, reflecting the horizontal motion of the dark shapes.

Wilhelmina Meyer Kemper was sixteen when she made this quilt for her hope chest in 1874. She was born in Hanover, Germany, in 1858; when she was six she came to the United States with her family, first to Illinois and then to an eighty-acre farm in southeastern Lancaster County. In the early days her father had to walk the forty miles to Nebraska City to buy sugar and other supplies.

Louisa Meyer taught Minnie, as she was called, and her other daughters to sew, knit, and crochet, among other domestic skills. The family had a spinning wheel and spun their own wool. According to family tradition, the girls had to knit socks for their father and three brothers before knitting a pair for themselves. The girls made and embroidered sheets and pillowcases for their hope chests, as well as quilts.

In 1876 eighteen-year-old Minnie fell in love with Charles Kemper, a widower of twenty-six with a young daughter. One fall day she told her parents that she was going out to pump a bucket of water. Instead, she eloped with Charles. Minnie taught her husband, who came from St. Louis, all she knew about farming, and they were successful. Five children were born to them. Charles Kemper died in 1912.

Wilhelmina was wise in the ways of nature; she was also a midwife. Among the babies she helped deliver was her first great-grandchild, Winona Francke Ketelhut, to whom she later gave this quilt as a high school graduation gift. In 1985, Winona gave the quilt to her daughter Connie Ketelhut Heier, the present owner.[2]

Wilhelmina Meyer Kemper is on the far right in this five-generation family photograph taken in 1941. *Left to right:* Winona Francke Ketelhut holding her daughter Patricia Ann Ketelhut, Adeline Ellithorpe Francke, and Louise Kemper Ellithorpe.

4 Log Cabin—
 Courthouse Steps

Cotton
83" × 68"
NQP 3062

1874
Made by Wilhelmina Meyer Kemper
(1858–1945)
Made in Bennet, Lancaster County,
Nebraska
Owned by Connie Ketelhut Heier
Detail on page 16

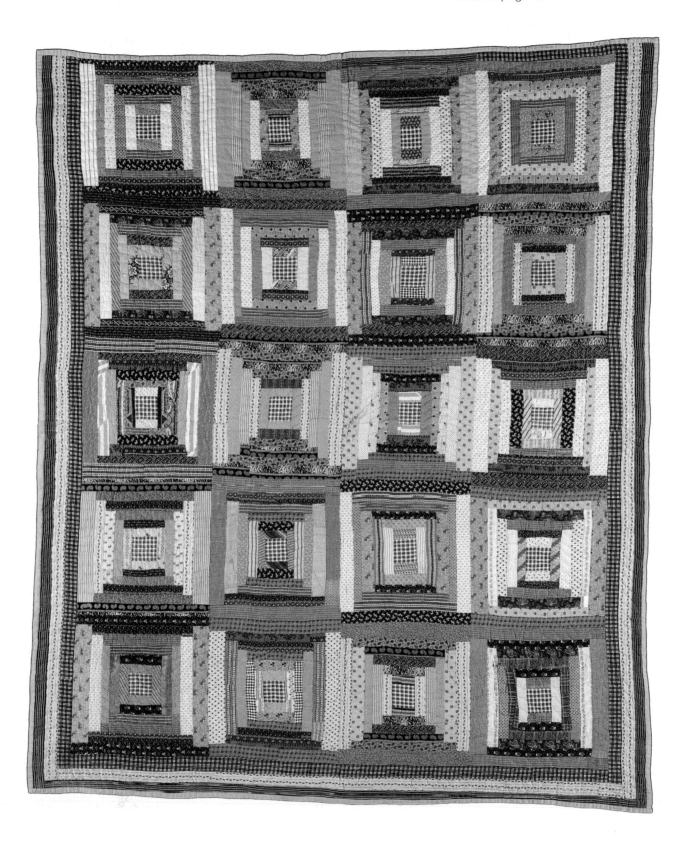

A SOLID Le Moyne Star seems to have fallen into the center of each twinkling white star in this unusual Feathered Star quilt. A third star appears to be underneath the white one, most visible in the cone shape at the end of each point. That shape, in fact, is composed of two dark triangles and a diamond of a different dark print. Logically this diamond should be white, since it finishes the rows of white triangles. The different print for the diamond distinguishes it from the dark triangles. The similar color values reinforce the illusion of an underlying dark star.

Ruby McKim's *101 Patchwork Patterns* (1931) showed a very similar design more than fifty years after this quilt was made. McKim's coloration, however, made the "feathers"—the little triangles attached to the larger triangles of the star's points—dark; the white triangles which completed the square then simply became part of the background. Most feathered stars use this approach of dark feather attached to dark point. By transposing the lights and darks, the maker has created secondary and tertiary images.

Ordinarily a quilt with strong but separate images like this one leaves no place for the eye to begin. Here the smaller Le Moyne Stars in the centers of the alternating plain blocks help to focus the eye on the central star. This central medallion effect is subtly reinforced by the colors: soft blue stars in the center and four corners, brown stars in a variety of prints between them. The eye can organize the quilt in several different ways—by following the X of the blue stars diagonally across the quilt, or by following alternate blue and brown stars around the center, or by perceiving first the central star, then an inner border of small stars, then an outer border of large ones.

Jane (known as Jennie) Bawden Seymour, was born in Jo Daviess County, Illinois, in 1869. Her father and uncles had come from Cornwall, England, to run a lead-smelting operation in Galena, Illinois, home of Ulysses S. Grant and many immigrant Cornish tin miners. Jennie's mother died when she was six; her father remarried a year later. For the next ten years Jennie had to struggle to get an education against her stepmother's wishes. She was kept at work before and after school and often was kept home on washing and ironing days. When she was sixteen her stepmother told her to put away her schoolbooks, saying, "There's no sense in your father's working hard to send you to school to make a lady out of you." Soon after, she ran away to live with relatives and attend school.

In 1890 Jennie came to Norfolk, Nebraska, to live with an aunt and uncle. She began attending classes at the University of Nebraska in Lincoln, where she met and married Victor Seymour, a court reporter who became a lawyer, in 1896. They had two children who survived; when those two were in school, Jennie returned to the university and finally received the degree of bachelor of arts in 1914.

The large Feathered Star blocks were made by a neighbor, Mrs. Wilson, according to a tag Jennie made for the quilt. Eleanor Wilson had come from England in 1874, which is probably why Jennie called this the "English quilt." Jennie probably made the smaller stars and set the quilt together, quilting it in 1928. The present owner, Jennie's daughter-in-law, still has Jennie's quilting frame and sewing machine. This quilt, however, is pieced and assembled by hand. The finely done quilting, with nine to ten stitches per inch, is composed of crosshatching, outlining, parallel lines, and feather wreaths in the outer fill-in triangles.[3]

Jane Bawden Seymour, 1932

5 Feathered Star Variation

Cotton
90" × 79"
NQP 3717

Circa **1876** (top), 1928 (quilting)
(marked)
Made by Eleanor Wilson (1852–1929)
and Jane Bawden Seymour (1869–1938)
Made in Lincoln, Lancaster County, Nebraska
Owned by Margaret R. Seymour

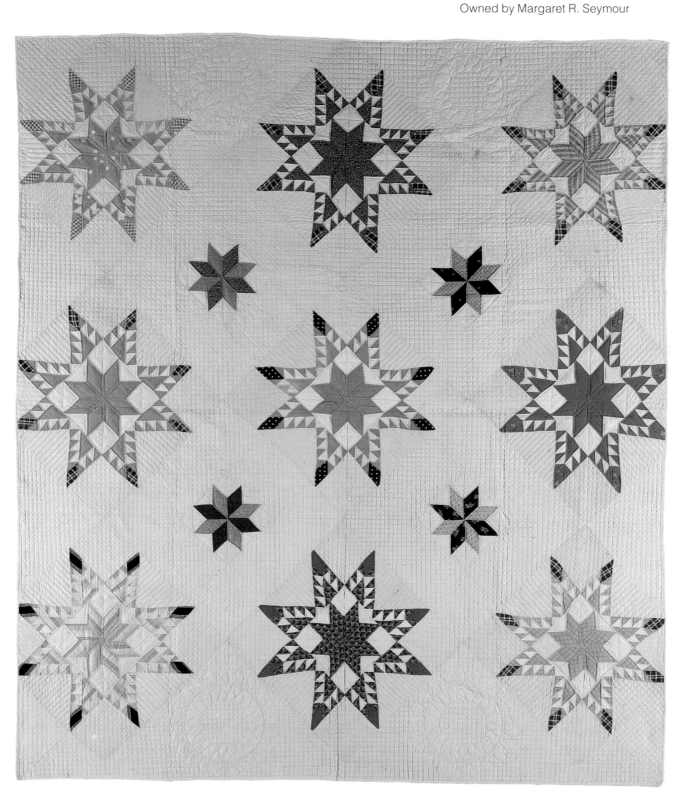

ONE OF THE simplest of designs, this Four Patch doll quilt takes on new charm in the hands of its young maker. Set on point, the Four Patch acquires grace and balance. Enclosed by the pink print setting triangles which return the block to square, it acquires importance. The sashing in brown and two green prints is carefully arranged, recalling a large all-over patchwork design called Strips and Squares. The wide border with its large corner squares recalls Amish design. Possibly a common root in Central European folk design was passed on to the maker by her immigrant mother.

Scraps from clothing made by her mother were used, but the maker valued this piece enough to give it a lovely backing—cream flowers and stems on a soft brown field. The quilting was done in parallel lines with six stitches per inch.

The family has preserved three of Mary's doll quilts, and according to them, the quilts were practice pieces to prepare her for making a large quilt. If so, she was well on her way.

Mary Elizabeth Aron was born in 1871 in a dugout on the Blue River two miles south of Crete on her father's homestead. Tomas Aron, Mary's father, had been born in Czechoslovakia in 1839 and had come to America in 1867. He met and married his wife, Elizabeth Nedela, in Chicago. The couple came west by train looking for land, crossed the Missouri River on a raft, and joined the growing Czech community in Saline County, Nebraska. Their first home was a dugout; the next year Tomas built a log cabin and later a fine brick home. In the early years the farm was tended by his wife and young family while Tomas, trained as a stone mason, walked twenty-six miles to Lincoln every week to work on the new university buildings and the first state capitol. He returned home on weekends bringing supplies for his family.

Mary, the eldest daughter of seven children, must have learned household duties early.

Tomas tried to make sure that Mary and her siblings did not forget their Czech language and heritage; at the same time he wanted them to be Americans. The Fourth of July was an especially important event for them. One family story tells how a neighbor drove to Nebraska City to buy hats and bonnets for the family. They felt truly American to be able to go to the Fourth of July celebrations in the city of Crete in their American headgear.

In 1888 at the age of eighteen, Mary married Joseph Shebl, a cabinetmaker. They had one child. Widowed early, she continued to quilt. Her family estimates that she made between fifty and one hundred quilts before she died in 1962. Her favorite patterns were the favorites of her adulthood—Dresden Plate, Grandmother's Flower Garden, and baskets. Her family says, "She liked the pretty patterns . . . and she escaped the doldrums of pioneer living through the quilts because she wanted to have the pretty things, the pretty colors, not the drab colors." This simple Four Patch of her childhood has been carefully preserved by her descendants and is now in the hands of her great-grandson.

Mary Elizabeth Aron Shebl

6 Four Patch

Cotton
36" × 34"
NQP 3423

Circa **1880**
Made by Mary Elizabeth Aron Shebl
(1871–1962)
Made near Crete, Saline County,
Nebraska
Owned by Dr. and Mrs. Daniel F.
Moravec, Jr.

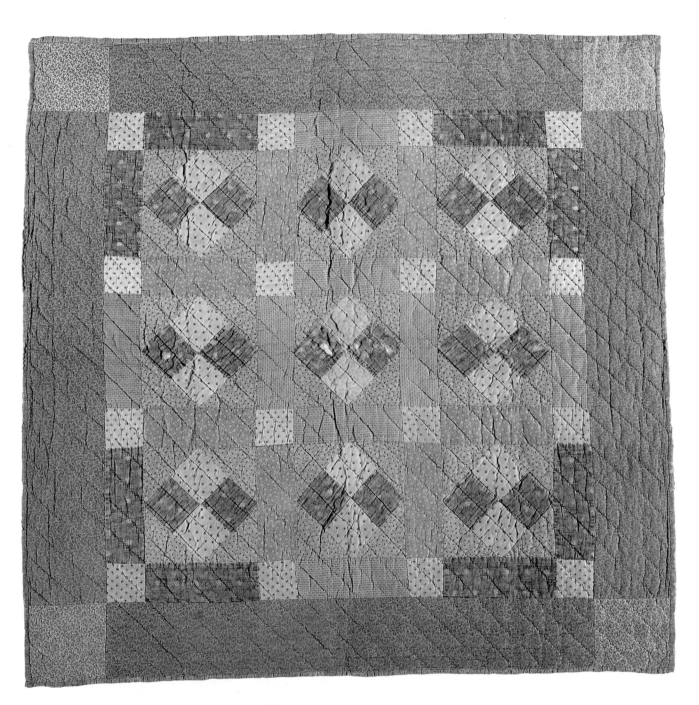

IGZAGGING lines of orange dominate the surface of this quilt; the pieced blocks are subordinated to the set, though they have their own interest. The setting, called a picket-fence set by Carrie Hall in *Romance of the Patchwork Quilt in America*, is an unusual one. Gold triangles are set on opposite sides of the block, creating a rhomboid. Rows of these then are staggered to create the zigzag.

The handsewn blocks show the many colorations of the seemingly simple Nine Patch. One row has several traditional light and dark blocks. Many other blocks use the same form—dark squares in the corners and center— but the other fabrics offer little contrast, disguising the basic form. In other blocks U and H shapes emerge. Some blocks have a light center surrounded by dark fabrics, creating a square within a square. In many other blocks the browns, grays, pinks, and tans blend in no particular pattern. The great variety of blocks and fabrics gives special life and interest to this quilt—the viewer's eye is drawn on to find new patterns.

All this movement and variety is framed by two sets of plain rust-and-gold borders. The first border on all four sides is sewn on by hand; the others are machine stitched. Two edges

are bound, one side has the front turned to the back and the opposite side has the top and backing edges turned in and machine stitched. Possibly the different treatments are the result of repairs, as the quilt has seen wear over the years.

The quilting is in sets of parallel lines about one inch apart with four to six stitches per inch; the border is quilted with diagonal lines. Some of the knots are visible on both front and back. The maker's penchant for variety extended to her quilting thread, which is gold and brown as well as the usual white. The backing fabric is a narrow dark stripe.

Cross-stitched on one of the gold triangles of the top are the initials WN. According to the family the quilt was made for William Nutt's twenty-first birthday in 1881 by his mother. Mary Gamble was born about 1840 in Hampshire, England. Little is known of her early life. Her son William was born in 1860. A few years after receiving the quilt, William left Illinois. He homesteaded near Madrid, Nebraska, in 1886 in what is now Perkins County. He and his wife, Alice, who had come from Indiana, were the last couple to be married in the old courthouse in Ogallala, in December 1887, according to family tradition. Mary died in Illinois in 1894. This quilt has passed through the male line to her great-grandson, Robert H. Nutt, the present owner.[4]

Mary Gamble Nutt

7 Nine Patch—Picket Fence Set

Cotton
84" × 75"
NQP 91

Circa **1881**
Made by Mary Gamble Nutt (ca. 1840–1894)
Made in Kankakee, Will County, Illinois, and brought to Perkins County, Nebraska, in 1886
Owned by Robert H. Nutt

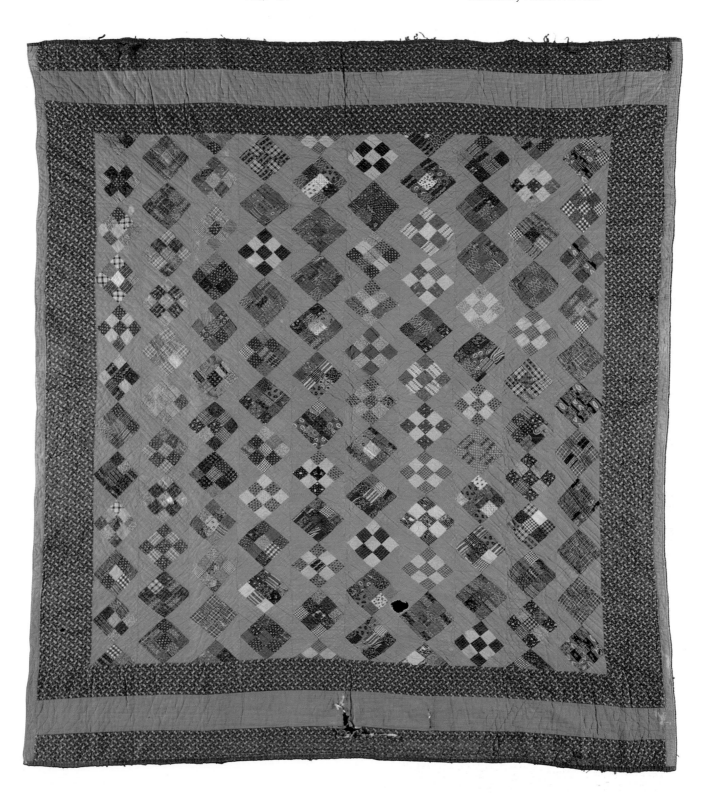

FANS DANCE across the surface of this striking quilt. Seemingly arranged at random, they are in fact structured in groups of four, with each fan oriented to successive corners. In places where two quarter circles touch at their centers, a new figure is formed that recalls the fashionable woman's silhouette of the 1890s—wide shoulders and skirt flaring from a tiny waist. The tilt of these figures adds to the dancing effect. Around the figures twists a sinuous gray shape, almost a design element in its own right, recalling Drunkard's Path patterns. The fan "sticks," arranged for maximum contrast—black and white, black and red, black and tan—give straightness and strength to the prevailing graceful flow.

The eleven-inch blocks of dark colors are pieced by hand on a foundation of flour sacks, then decorated with herringbone stitches in paler colors. The checked flannel backing is brought to the front and stitched down by machine. The rest of the quilt is inconspicuously tied at three-inch intervals to a thick cotton filler.

In Crazy quilt tradition, the fans are constructed of a variety of fine wool fabrics, including serges, gabardines, plaids, and figure weaves. Family tradition says that some of the fabrics were brought from Illinois and Germany. Certainly the elegant worsted-wool dress fabrics hardly seem to belong in the dugout where this quilt was said to have been made. The quilt may well be a statement of defiance of their circumstances: a recollection in fabric of their former lives, and a sign that they could follow the fashion and create beauty wherever they might be.

Sophia Brunken was born in Germany in 1839. There she married Diedrich Hinrichs and had three daughters. They emigrated to America in 1869, when the youngest, Helena, was only six weeks old. They settled at Alton, Illinois. After the two elder daughters died of malaria in 1874, the family came by covered wagon to Nebraska. Settling near Hallam, they lived with the family of Sophia's brother, Frederick Brunken. The three of them stayed in the little one-room summer kitchen in the Brunkens' yard. In 1884 they purchased eighty acres of land west of Hallam and moved into a dugout built into a creek bank. Water had to be carried from a well some distance away. Here it was, family tradition says, that Sophia and Helena made the fan quilt, sitting outside the door on a plank bench, since the light inside the one-windowed dugout was so poor. In 1886, at age eighteen, Helena married Diedrich Prange. He bought a tract of land across the road and built a four-room house. In 1889 after five years in a dugout, Helena and Diedrich and her parents moved into this house.

Quiltmakers Helena Hinrichs, standing, and her mother, Sophia Brunken Hinrichs. Seated next to Sophia is her husband, Diedrich.

8 Fans

Wool
88" × 78"
NQP 990

Circa **1885**
Made by Sophia Brunken Hinrichs
(1839–1908) and Helena Hinrichs
Prange (1868–1929)
Made near Hallam, Lancaster County,
Nebraska
Owned by Ora D. Speth

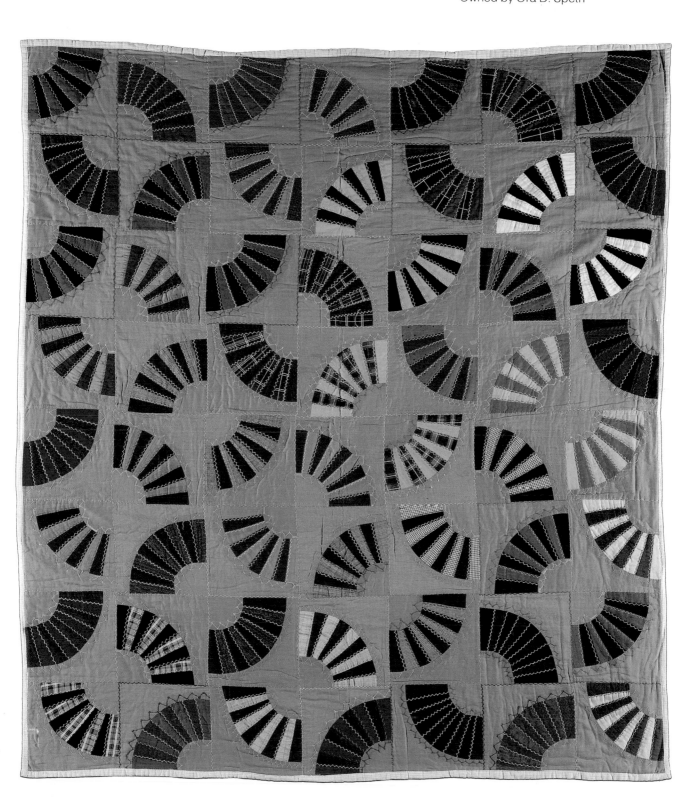

IN THIS VERY graphic design, the strong elements recombine to form different images with each fresh look. The red baskets, set on points and oriented to be upright on each side of the bed, seem to flame at the handles, contrasting sharply with the muslin ground. The alternate plain squares, red instead of the more usual bleached or unbleached muslin background color, are strong enough to form a checkerboard over the whole surface. With another visual orientation, the sawtooth handles of the baskets form a double zigzagging line up and down the length of the quilt. In the center, the basket handles feather the edges of the red squares. The solid baskets also emerge as a separate design, appearing as two halves of a more complex shape held apart by magnetic repulsion by the force of the half-square triangles. The sharp angles of the baskets echo the triangles of the basket handles, while their solidity contrasts with the delicacy of the sawtooth triangles.

The forty-two blocks, pieced and assembled by hand, are all a solid red. The quilting on a thin batt and muslin backing has eight to ten stitches per inch. It alternates crosshatching and parallel lines on the plain and pieced blocks. The back has been brought to the front as the edge treatment forming a delicate but firm finish to the quilt.

Martha Ann Creason Burger, then about forty, made this quilt with the help of her mother, Martha Creason, and her daughter Flora Ann Burger, for Flora's wedding. The Creasons and Burgers were pioneer families who came from Illinois and Iowa to Plattsmouth, in Nebraska Territory. William J. Burger supplied meat to army forts in the territory, hunting buffalo in western Nebraska and Colorado. He returned to central Nebraska after he married the young Martha Creason. He established a supply station with a corral large enough for four hundred oxen for travelers on the Oregon Trail, close to the Platte River, near what is now Doniphan.

Indians were still a danger. Martha lost her first child when she was forced to hide under brush near the Platte River to escape an Indian raid. When she was pregnant a second time, she returned to her family in Plattsmouth. After the baby was born, she went as far west by rail as the road was built. To reach home she had to cross the flooding Platte on a flatbed wagon. The family story says the wagon was floating away downstream in the flood when William Burger managed to rope it and pull it to shore.

Martha lost five children to the hazards of prairie life. Four children, of whom Flora was the eldest, survived. As central Nebraska became more settled, the elder Martha Creason moved to Doniphan to be near her daughter and grandchildren. All three generations worked on this quilt to prepare for Flora's marriage to Benjamin F. Scudder, who had followed the Union Pacific railroad from Indiana, supplying mule teams for its construction. After marrying Flora, he chose to stay in Doniphan, where he became a grain merchant. He and Flora had two children.[5]

Flora quilted for pleasure most of her life. Her family says she rarely made more than one quilt of the same pattern. She had a frame set up in the front parlor, where her church group quilted with her. She always pieced by hand, and usually bought fabric specifically for her quilts. Her granddaughter, the present owner, remembers that Flora always shopped at Wolbach's in Grand Island. She passed her love of quilts and piecing to her own daughter, continuing her family's tradition.

Flora Ann Burger Scudder and her mother, Martha Ann Creason Burger, 1914. Standing are Flora Ann's sons, LeRoy and Chester, holding their firstborns.

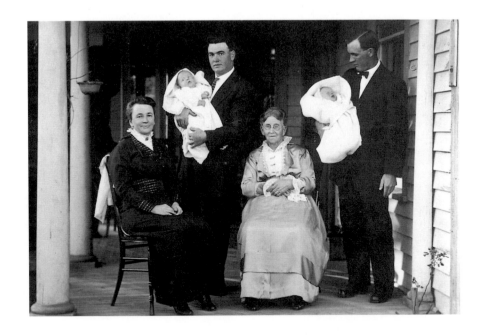

9 Cake Stand

Cotton
78" × 68"
NQP 1485

1886
Made by Martha Ann Creason Burger
(1846–ca. 1925), assisted by Martha
Creason and Flora Ann Burger
Scudder (1867–1952)
Made in Doniphan, Hall County,
Nebraska
Owned by Ruth Scudder Sisler

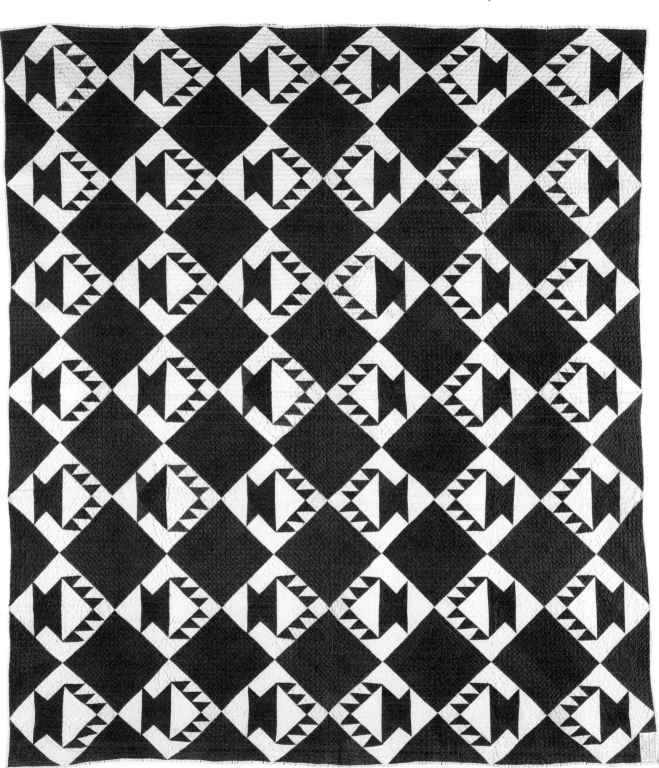

THE DIVERSITY of patterns, with the blocks signed with names or initials, shows this quilt to be a sampler album quilt.[6] Album quilts, with blocks of a single pattern signed by friends and relatives, first became popular in the 1840s and continue to be made today. Pieced sampler album quilts, especially dated ones like this, are much rarer; they are especially valuable as a record of what patterns were in use by ordinary quiltmakers.

There was little attempt at arrangement of designs or colors in early pieced sampler album quilts, and many appear as a jumble. The Orlofskys in *Quilts in America* show an early sampler album quilt dated 1814 with large and small blocks mixed together, some cut off to accommodate larger neighbors, others with pieced or plain strips added to fill the block out to the required size. The blocks of this quilt are neatly arranged in rows, but since they are unseparated by any sashing, the overall effect is still that of a hodgepodge of colors and shapes. The maker of this quilt had to deal with two sizes of blocks: note that the bottom two rows have eight blocks instead of seven. The difference is made up by two narrow borders on just one side. Since the folk-art tradition of which this quilt is a part abhors an empty space, the borders are not plain strips but are pieced in dogtooth and checked patterns.

The names Louisa and her friends gave these patterns are not recorded, but many appear in the *Ladies' Art Catalog* of 1898, the first published compendium of names and designs. Some of the patterns in this quilt may be original. Others were already old in 1890. Six of the patterns in this quilt appear in the 1814 album quilt mentioned earlier: basket, Capital T, Rolling Stone or Single Wedding Ring, Courthouse Square or Album, Sixteen Patch, Old Maid's Puzzle.

Louisa Matthews, born in 1872, was the daughter of Milton and Charlotte Matthews, who had come from Indiana to be among the early settlers of Howard County. She probably learned to quilt from her mother and from the friends who contributed to this quilt. The diversity of patterns and fabrics must have served as reminders of the personalities of the makers. According to family tradition, it was made for her dowry before her marriage to Ralph Burger about 1893. Originally from Illinois, Ralph worked for the railroad. The couple lived in St. Paul for some years but had moved to Pawnee City in Pawnee County by 1910 and finally moved to Grand Island. Ralph and Louisa had three children; Louisa taught her two daughters to quilt and she continued to make quilts until her death in 1959.[7]

10 Sampler Album

Cotton
78" × 77"
NQP 1342

1890 (marked)
Made by Louisa Matthews Burger
(1872–1959) and friends
Made in St. Paul, Howard County,
Nebraska
Owned by Darlene Jensen Jeppeson

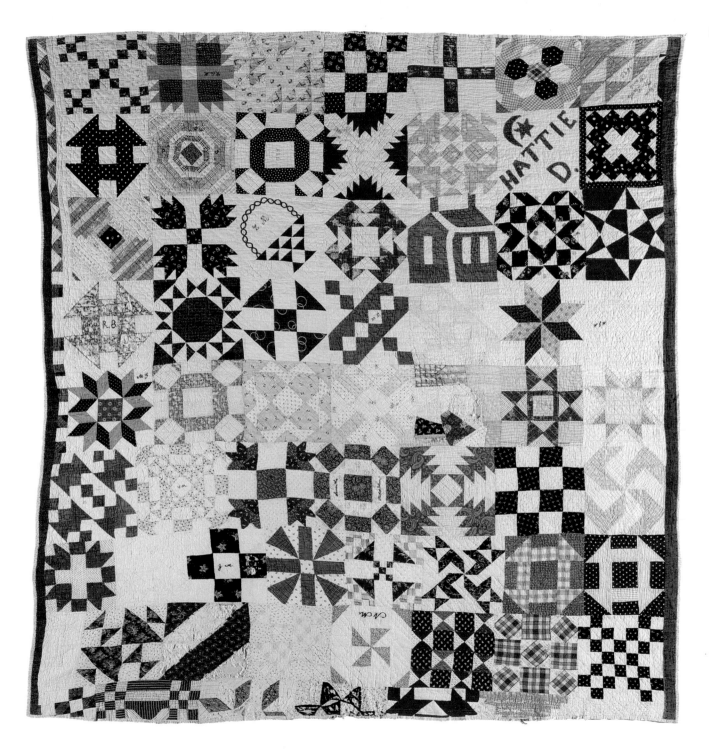

Mary Charlotta Bromer Marquardt, circa 1920

HE MARINER'S Compass, according to the noted quilt scholar and pattern expert Barbara Brackman, is one of those patterns, like the Le Moyne Star, Variable Star, and Double Irish Chain, "as old as piecing."[8] Still, the Compass or Sunburst design, as it is also called, has never been as popular as the others because of its complexity. For that reason it has been and still is used for masterpiece quilts (Plates 89 and 103). Early-nineteenth-century Mariner's Compass quilts were often done in a great variety of chintzes and other prints. Here colors have been pared down to that favored late-nineteenth-century combination, creamy white and Turkey red.

The twelve-inch circles are hand pieced and joined in rows with a squeezed square. The red-and-white borders along two sides are machine sewn. The compasses are quilted in the ditch and the entire background is filled with double-line crosshatching, spaced one inch apart, with five stitches per inch.

Usually Mariner's Compass blocks are designed to appear more solid, with points layered around a central circle; here the long narrow points have their bases on arcs of white, giving an open-work look. This block is closely related to blocks Carrie Hall and Rose Kretsinger called Sunburst in their 1930s book.[9] These designs were often appliquéd, thus requiring fewer pieces to cut and sew than this all-pieced version.

Mary Charlotta Bromer was born to a German family in southern Illinois in 1854. In 1856, when she was two, her family came to Nebraska, crossing the Missouri River at Omaha, which was then not much more than a trading post. Six weeks later the oxen had pulled their wagon to Cuming County near West Point. She and her family lived in the wagon until their one-room log cabin was built. A few years later the Pawnee Indians, their only neighbors, helped them build a four-room house with sod roof.

When Mary was nine, her mother died in a prairie fire. Mary became the mistress of the house, in charge of her seven-year-old sister. When their father had to go to Omaha, she and her sister were left alone for as long as two weeks at a time. Later the family moved to West Point, Nebraska, where she met and married Bernard C. Marquardt in 1882. That spring they moved to the newly founded railroad town of Avoca, Nebraska, to start a general merchandise store. The following year they bought a three-room house, which formed the nucleus of what was to be a large home.

The large front parlor of their house became an institution. The quilting frame was nearly always set up there, and friends and neighbors met weekly to quilt for nearly forty years. This quilt may well have been quilted at one of these gatherings.

Mary Marquardt died in 1943 at the age of eighty-nine. Her daughter, Emma Rawalt, who had lived with her parents and taught school after being widowed at the age of thirty-five, "never could get interested in cutting good material into small pieces, then sewing it all together again." Nonetheless she treasured quilts like this and passed them on to Mary's descendants.

11 Mariner's Compass

Cotton
89" × 74"
NQP 515

Circa **1890**
Made by Mary Charlotta Bromer
Marquardt (1854–1943)
Made in Avoca, Cass County,
Nebraska
Owned by Doris E. Rawalt

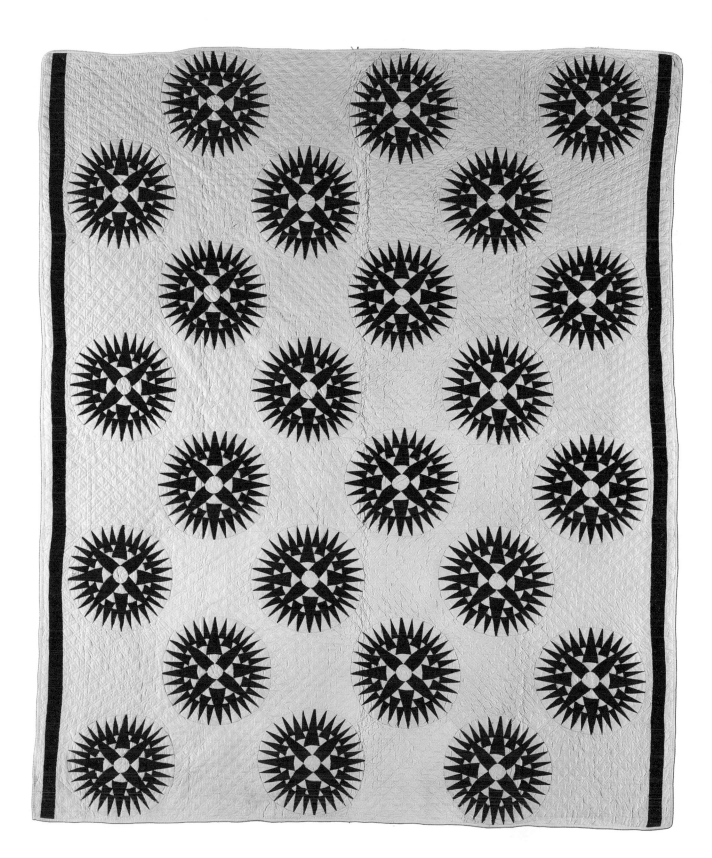

TINY BLOCKS in a variety of nineteenth-century fabrics in browns, dark blues, and reds alternate with plain squares. The tan setting squares are lovely with their delicate black sprays of flowers and small black dots on a tan ground with wavy white lines. Most of the seventy-one pieced blocks are embroidered with the name of a friend, neighbor, or relative of the schoolgirl maker, showing the wide web of relationships around the small country village of Brock, Nebraska.

The quilt began as a friendship project among a group of twelve- and thirteen-year-old girls. Blocks made by the girls themselves show that most had reached a fair degree of proficiency in their sewing. The album block, though not complex, is not particularly easy, especially since its thirty-one pieces must fit in a five-inch square.

Sarah (known in childhood as Sasie) Adaline Potard was born in Nebraska in 1877, the first child of Adaline and Emile Potard. Emile was a native of France, and his name was later anglicized to Porter. Her mother must have taught Sarah to sew as a young child, as she later taught Sarah's daughter. Sarah may have set some of the blocks together, but the quilt was still unfinished when she married Henry Rogge, a German immigrant, in 1897. Nine years later Sarah died giving birth to her sixth child, Alice, the present owner.[10]

About 1910, Sarah's mother finished her daughter's schoolgirl quilt top for Alice. This may be when the lighter setting squares on the outside rows were put on; the material Sarah used was probably long gone. Adaline then quilted the top with hearts and hanging diamonds in the pieced blocks and double circles and parallel lines in the plain blocks, with five to seven stitches per inch. It was a work of love for both her dead daughter and her living granddaughter, to whom she gave the quilt as a tangible legacy of her mother. As an intangible legacy Adaline passed the sewing skills she had taught Sarah on to Sarah's daughter; Alice began piecing her first quilt, a Four Patch, when she was five years old.

Sara Adaline Potard Rogge
and her husband, Henry

12 Album

Cotton
82" × 67"
NQP 2669

Circa **1891** (top); 1910 (quilting)
Made by Sarah Adaline Potard Rogge
(1877–1906)
Made near Brock, Nemaha County,
Nebraska
Owned by Alice Rogge Epperson

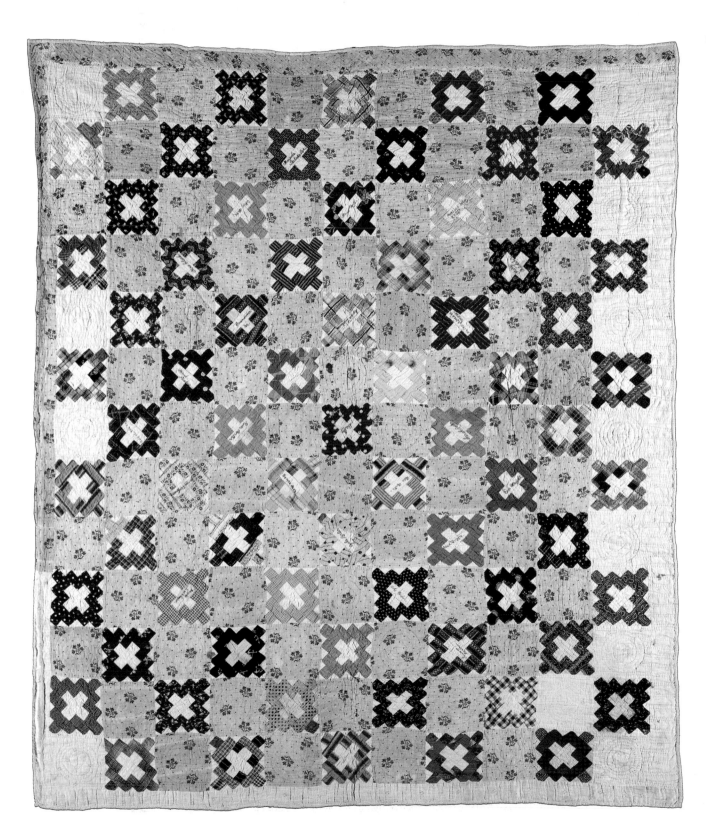

THIS STAR of Bethlehem seems to be bursting apart at its points, spinning off secondary and tertiary stars in new configurations on a field of light. A central sunburst in red, white, green, and pink shimmers as the darker points fall away, broken apart by the light band of diamonds. Rather than repeating the circular pattern of the main star, the Blazing Stars in the four corners appear as two four-pointed stars piled aslant on each other. One of these stars blends alternating blue and white diamonds, but because of the high color contrast, the blue diamonds dart out across the white field. The red diamonds of the four Le Moyne Stars in the background triangles echo the slanted four-point star motif. The pieced sawtooth inner border frames it all.

Two traditions of Star of Bethlehem, or Lone Star, quiltmaking meet in this quilt. It has links to the classic simplicity of the 1830 Star of Bethlehem in Plate 2. It also recalls the exuberant Lone Stars of the early nineteenth century, whose background blocks are covered with appliquéd stars, vines, flowers, and birds until often the central star is lost in the abundance of pattern. The plain background and the skillful handling of color make this star sing.

One of the most durable of women's organizations in Nebraska is the church quilting group. This quilt attests to the early establishment of quilting as a money-raising as well as a social activity, for quilted in the border of this quilt is the inscription: "Quilted by Mt. Zion Aid Society April 24, 1894." The society members were evidently proud of their work on this quilt. The rest of the quilting is done in outlining, cross-hatching, parallel lines, and feathers, with six to eight stitches per inch.

Maria (pronounced Ma-rye-a) L. Gear was born in Mendon Center, New York, in 1833. When she was about twenty-six, she married David Mook, a farmer. Their eight children were born in New York. When the railroads opened up in Nebraska, they came by train in 1873 to Johnson County. This quilt was given to her daughter Florence, whose marriage in 1885 to a Chicago, Burlington and Quincy Railroad man took her to live in many places in Nebraska, Colorado, and South Dakota as the rail network expanded. Thus this quilt may have served as one of those tangible links between the separated women of a family or community which the quilt scholars Ricky Clark and Jane Bentley Kolter have documented.[11] Her family was important to Maria; in 1910, at the age of seventy-seven, she moved to Kansas to be near a son. She occasionally returned to Tecumseh, Nebraska, to visit her daughter. In 1914 she died in the Tecumseh railroad station waiting for a train to take her back to Kansas. The quilt is now owned by her great-great-granddaughter.[12]

13 Star of Bethlehem

Cotton
84" × 75"
NQP 3518

1894 (marked)
Made by Maria L. Gear Mook (1833–1914)
Made in Johnson County, Nebraska
Owned by Cheryl Christensen Beery

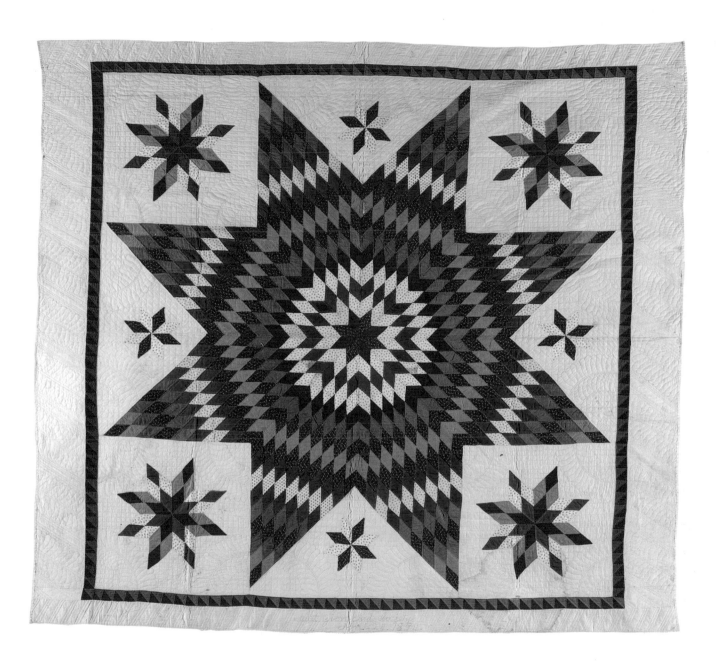

A HEAVY net seems to have been laid over the surface of this unusual quilt known in the family as "World's Wonder." Tiny white equilateral triangles adjoin the hexagons on each side, creating the illusion of a network of white advancing visually from the darker pieces. The concentric arrangement of hexagons is related to nineteenth-century mosaic patchwork; frequently rosettes were joined with diamonds or equilateral triangles, but rarely the individual hexagons.

The 25 large hexagons, each composed of 59 hexagons and 157 triangles, are set with large white triangles, creating a larger pattern of interlocking six-pointed stars. The openwork of the centers contrasts strongly with the plainness of the points.

Except for a few fabrics with large stripes, placed randomly in a way that enhances the intricacy of the center, most of the blue and warm red and brown fabrics read as solids. Some are solids, but many are patterned—checks, dots, florals, geometrics, paisleys, and stripes. The maker chose them carefully so their values would be the same.

Born in 1851 in Pennsylvania, Armina Dunlap, the daughter of John and Penina Zilafro Dunlap, had the opportunity to grow up in a golden age and place of quilting. Little is known of her life except that she married Alfred McCall, a farmer, in 1870. She came west with him first to Iowa, and then to Webster County, Nebraska, about 1872. She had eleven children, of whom ten survived, and was remembered as an "exemplary mother and homemaker." This top is believed to have been made for the dowry of the third of her four daughters, Lucy, who was a schoolteacher before she married. After a shopping trip to Red Cloud one evening in 1898, Armina became ill. The doctor who was called said she would recover, but she died a few hours later at the age of forty-seven, of typhoid, according to the death certificate. The top was laid away for many years. It was quilted by Lucy's niece, Armina's granddaughter, in 1970.[13]

14 "World's Wonder"

Cotton
90" × 78"
NQP 1850

Circa **1895** (top); 1970 (quilting)
Made by Armina Dunlap McCall
(1851–1898)
Made in Webster County, Nebraska
Owned by Pauline F. Koon

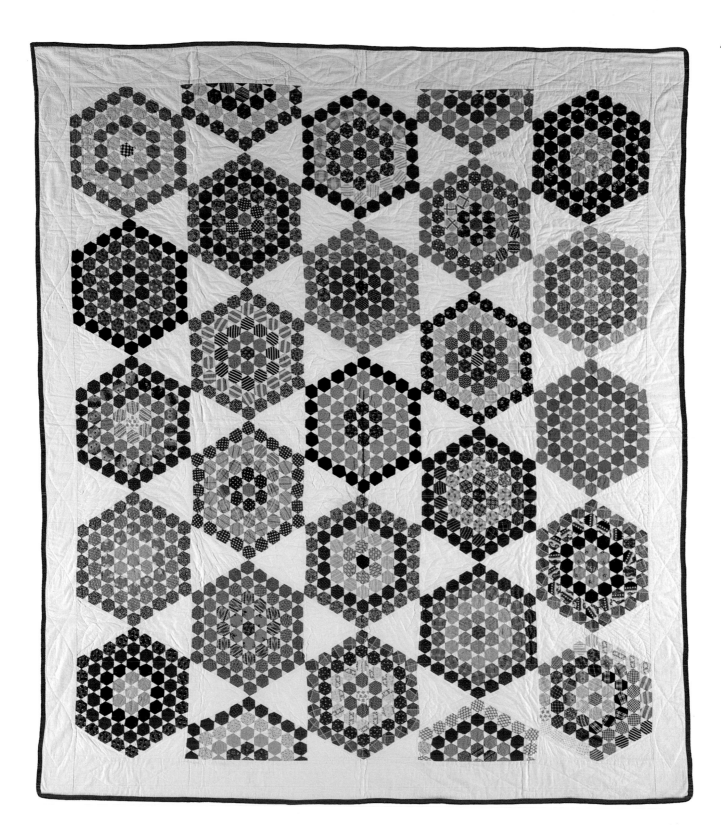

AN EXPLOSION of triangles greets the new century in this quilt, which proudly proclaims "1900" in red outline stitches at its center. The organization of the colors into dark and light rows expanding outward creates a three-dimensional effect. The sharply pointed shapes and the light and dark contrasts of the triangles make the quilt sparkle like cut glass.[14]

The subdued colors are beautifully handled. Rows of dark triangles provide successive frames. The colors in the new rows soften gradually to pink or tan, to end in another dark row. The sides of the quilt (meant for the top and bottom of the bed) are finished with neutral borders that do not distract from the visual impact of the quilt. Even the colors—blacks, blues, pinks, browns, and reds—normally so important to a quilt's effect, are subordinate. So is the quilting, finely done with nine stitches per inch, but in simple parallel lines.

Gertrude Helen Orme, one of the three children of George and Minerva Orme, was born and lived most of her life in Saunders County. Her father had been brought to Illinois from England as a child; later, as a young man, he moved his family to Nebraska.[15]

In 1897 Gertrude married Dwight Cash of Rising City, who had come to Lincoln to attend the university. This quilt was probably made in the few years she lived in Lincoln. When they returned to Wahoo, Dwight joined a hardware company as a salesman, a job that required travel. Gertrude was alone much of the time, so she pieced quilts and did other handwork. Widowed in 1936, she stayed in her own home until shortly before her death in 1975, a few weeks before her ninety-ninth birthday. Childless, she gave several of the quilts she made to her friend and neighbor Connie Lillie, the present owner.[16]

44

Gertrude Helen Orme Cash and her husband, Dwight, 1912

15 "Triangles"

Cotton
94" × 70"
NQP 2444

1900 (marked)
Made by Gertrude Helen Orme Cash
(1876–1975)
Made in Lincoln, Lancaster County,
Nebraska
Owned by Connie Lillie

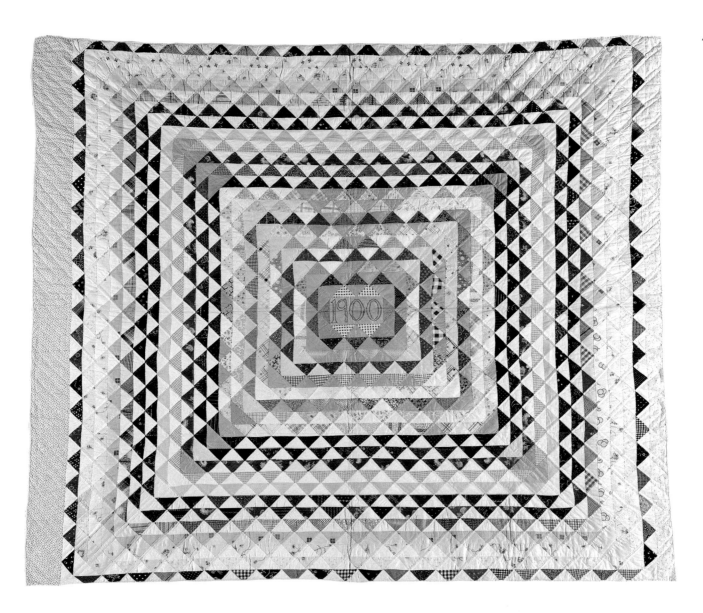

LOG CABIN quilts depend on the manipulation of light and dark fabrics for their effect; here, in an everyday quilt, the contrast is almost textural. The light fabrics, in a variety of checks, stripes, and small prints, blend together softly in muted tones of pink, pale blue, tan, and white. The wines, blues, browns, and blacks are hard edged, each strip of color distinct. The maker carefully distributed her scraps making a small amount of wine-colored fabric go a long way. The dark centers of the blocks stand out, unifying the quilt. Although the maker did not have enough wine-colored fabric for all the blocks, most have one set of these strips, and these blocks have been placed where they are most effective. The dark areas are so clearly defined that the maker could afford to use a few of the same fabrics, such as a blue gingham, for both light and dark without blurring the effect.

One of the blocks was sewn in the wrong position, probably by accident. The maker was a busy, thrifty person who was unlikely to take the time to rip out and resew an everyday quilt. Quilt scholars have not found much evidence to support the belief that nineteenth-century quilters deliberately made mistakes to avoid angering God by making a perfect thing. The maker was certainly a God-fearing woman, but she knew the quilt was imperfect already; some of the strips had to be pieced to the necessary lengths and she was not always able to match the fabric pattern.

The symmetry of Log Cabin designs usually calls for a square quilt. The maker of this quilt made hers rectangular by dropping two rows of strips from the blocks on the two side edges. The outline quilting ranges from four to eight stitches per inch.

Some quiltmakers have a favorite pattern, but few have worked so exclusively with just one design as the maker of this quilt. Abba Jane Blackstone Johnston, to the best of her great-granddaughter's knowledge, made only Log Cabin–Barn Raising quilts. She was born in McComb County, Illinois, to parents who gave her the unusual biblical name of Abba. As a young woman she was present at one of the Lincoln-Douglas debates. She married Norris Johnston of Kentucky, a Civil War veteran, in 1869. The couple's first two children were born in Illinois, but they were living in Wilbur, in Saline County, Nebraska, by the time the third of their six children was born in 1876. As strict Methodists, however, they were unhappy in that predominantly Catholic and Czech community; in the 1890s they moved west to Curtis in Frontier County. Abba's husband died in 1916. In the late 1920s, Abba began to lose her sight. She moved to Wyoming to live with a daughter and made no more quilts. When she died at the age of 103, her body was brought back to Curtis for burial.[17]

The present owner and her family say that the Johnstons were the ones who put the "method" in Methodist. Their religion was strict: they did not work on the Sabbath, though they saw to it that the hired men and the children did what was necessary. The family sees an analogy between the straight and narrow pieces of her chosen design and the straight and narrow path she chose for her life: "We don't think she did it for fun!" None of her daughters became a quilter. The many quilts that have survived in her family show that she made more than was strictly necessary for use. Apparently, Abba took seriously the biblical injunction to be fruitful in good works.

Abba Jane Blackstone Johnston

16 Log Cabin—Barn Raising

Cotton
80" × 75"
NQP 385

Circa **1910**
Made by Abba Jane Blackstone
Johnston (1844–1947)
Made in Curtis, Frontier County,
Nebraska
Owned by Mary Oba

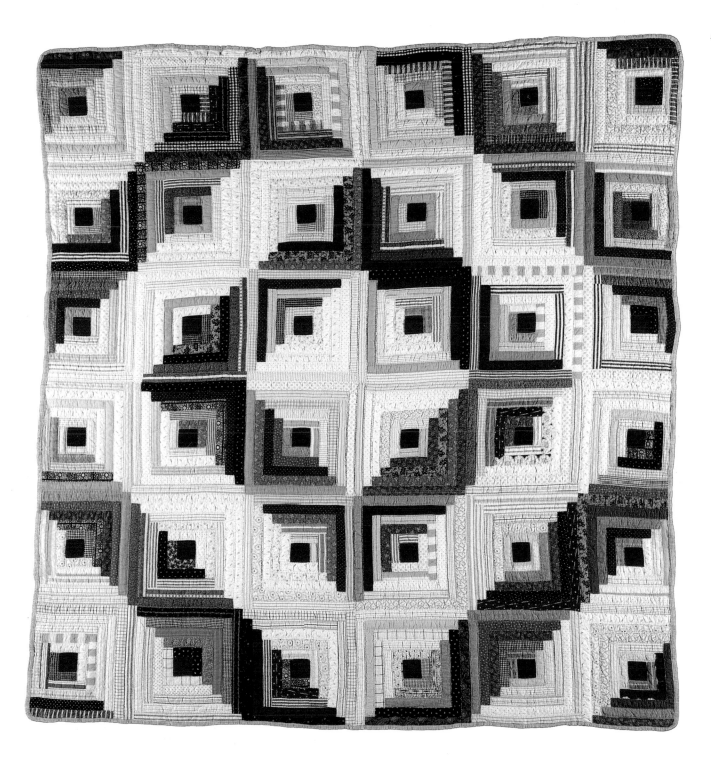

THIS HAND-PIECED quilt is a simple pattern but set and colored with imagination to create complex optical effects. Laura Fisher in *Quilts of Illusion* discusses how the use of color creates images that seem to be on different planes, although we know the quilt top is only two dimensional. Here the eye first perceives a strong dark lattice of large squares joined to each other with dark bars. At closer look the lattice appears to be on top of large brown squares. Behind this dominant image is a delicate-looking network of smaller, lighter squares hanging over open space—the light ground.

Creating this illusion is simple. The basic block is a Nine Patch; the center square is twice the size of the small squares, giving variety to the network. The blue-green sashing becomes a part of the overall design because the small corner squares of the nine patches blend with it visually, creating a relatively large square that comes to dominate the design. Ordinarily, of course, sashing is meant to separate and contain each block or to blend into the background. Here it lifts a simple design into the unusual. The zigzag border is unusual too. Although it is re-lated to the body of the quilt mainly by color, it creates its own illusion of a twisted ribbon, reversing in color each time it turns a corner.

The village of Ragan, where this quilt was made, is located in the Scandinavian Township area of Harlan County, where many Swedish immigrants settled. Lottie came to America from Sweden in 1871, when she was in her early twenties; she married Frank Johnson, another Swedish immigrant, not long afterward. The first of their five children was born in Illinois in 1873; by 1878, when their next child was born, they were living in Nebraska. By the mid-1880s they had a prosperous farm; 250 pounds of butter were churned in 1884, probably by Lottie. Sometime between 1900 and 1910, Frank and Lottie divorced; Lottie's youngest daughter, Bertha, stayed with her mother and in 1910 was working as a saleswoman in a store. This quilt may have been pieced during that time, before Bertha's marriage to a local farmer, Maurice McNiel.[18]

A number of quilt tops from Lottie's family eventually passed to Bertha's daughter-in-law, who offered them to a church quilting group in Milford. Judging them to be too old and fragile for charity use, the present owner, a relative of Bertha's daughter-in-law, took this top and quilted it herself in 1976.

17 Nine Patch Variation

Cotton
80" × 73"
NQP 3450

Circa **1910** (top); 1976 (quilting)
Made by Lottie Johnson (1849–ca. 1920)
Made in Ragan, Harlan County, Nebraska
Owned by Lillian Eicher

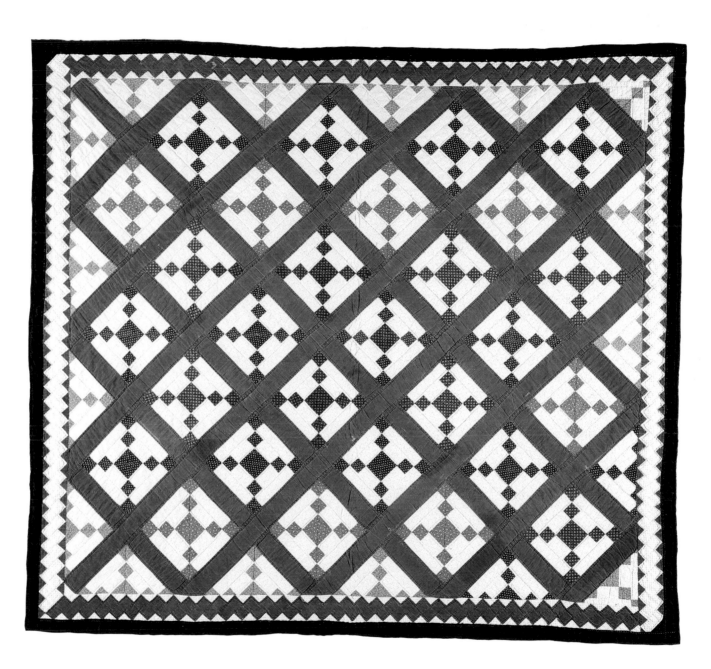

THE LONE STAR explodes in a circular burst of red, white, and blue in this exuberant quilt, made for the birth of the maker's grandchild and namesake in Nebraska.[19] The red and blue diamonds alternate with rows of white diamonds, a plan recommended by Ruby McKim in *101 Patchwork Patterns* (1931)—though she suggested the fashionable pastels. The white star at the center contributes to the feeling that the star is in the process of exploding; nothing is left at the center, just a rim of red fire.

Blazing stars in the background reverse the color pattern. The solid-red star at the center suggests fireballs being spun off. The blue diamonds at the points are like sparks being thrown off. Two of the sparks in each small star link visually with a row of two diamonds in the main star point, creating the largest circle of all. The entire explosion is barely contained by a border of alternating white and colored diamonds. The white, outside border adds to the fragility of this enclosure and the sense that the star will explode outward.

The star is quilted in parallel lines, with crosshatching in the background. This seems to be a convention for Lone Stars. The quilts in Plates 2 and 13 have this plan, though the crosshatching is used as a background for wreaths and feathers.

Mary Christine Boullion Ward was nearly sixty when she made this quilt. Born in 1854 in New York, where her father farmed, she was of French-German descent and, in fact, spoke French as well as English all her life. She lived in Indiana before settling in St. Joseph, Michigan, about 1870. She married William L. Ward, a commercial artist and Civil War veteran, and had five children. She was always frugal and hard working, as well as independent. Raised a Catholic, she became a Methodist in later life. Her husband designed and marked the quilting pattern for the quilt, made for their infant granddaughter. It's vibrancy shows Mary's unconventional approach to life.

After the death of her husband in 1913, Mary Ward lived with one of her children. Another daughter kept a hat shop and saved scraps for her; Mary always kept a ragbag as a source for projects. The present owner, her granddaughter, remembers especially how meticulous she was in her dress. On an income of fifty dollars a month, she had all her clothes and shoes made for her. Every afternoon she would bathe and put on a black dress with a fancy white apron. She would spread a large napkin over her lap to protect her clothes while she did her handwork. She made other quilts and taught her daughters to quilt. The owner's mother, however, used comforters on her beds, regarding quilts, including this one, as treasures and taking them out only once a year to air.[20]

Mary Christine Boullion Ward

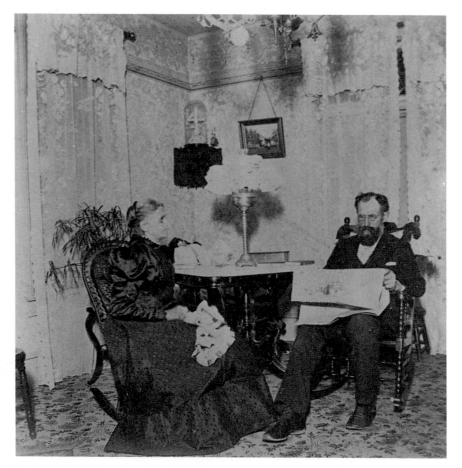

Mary Christine Boullion Ward with her husband, William, about 1900

18 Lone Star Variation

Cotton
80" × 75"
NQP 2508

Circa **1912**
Made by Mary Christine Boullion Ward
(1854–1936)
Made in St. Joseph, Michigan, and
sent to Lincoln, Nebraska, in 1913
Owned by Christine Nygren

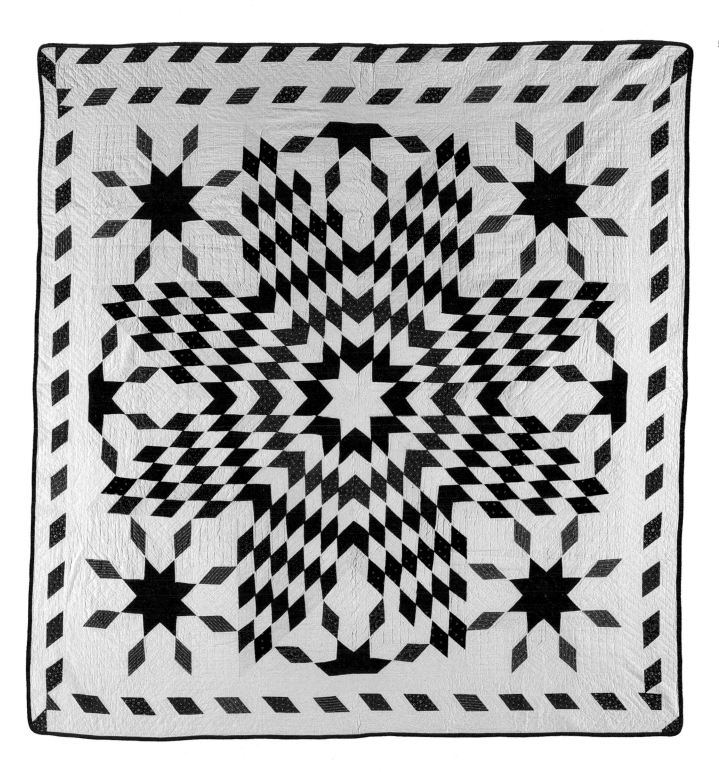

STRONG VERTICAL and horizontal rows with red, flashing stoplights at the intersections crisscross the effective design on this quilt. At first glance the pattern looks like a Double Irish Chain set on point. A second look shows puzzling features; instead of the expected grid of equally sized red, green, and white squares, there is a large red square in what should be the center of the block, with blue-green rectangular borders and red corner squares—a kind of Puss in the Corner block. A close examination shows white triangles attached to all the red-and-green squares. Then the mystery clears—the quilt was constructed of white print squares with a pieced sashing of red and green squares set like interlocking four patches, a design called Aunt Lucinda's Double Irish Chain. Where the sashing intersects, four red squares meet in the center and two green squares join on each side. Slight differences in the green dye in places show where two green squares are joined.

Hanging diamonds are quilted in the square blocks, parallel lines in the chain. The quilt is inscribed "RRL 1913." It is finished with a red binding and a print backing.

David Larrick was born in Winchester, Virginia, in 1843, the son of a farming family. He became a teacher and in 1876 he married another teacher, Anna Richards of Hayfield, Virginia. That same year they moved to Nebraska, where their three children were born. David retired from farming and moved to Red Cloud in 1908 when he was sixty-five. There he began to make quilts for his eight grandchildren. The present owner, his grandson, remembers him working on these. Like so many women quilters of the time, he did not sign his work. That he was proud of his work might be inferred from the fact that he dated his quilt and inscribed it with the initials of the grandchild for whom it was made. A spirited man, he climbed Flagstaff Mountain to celebrate his eightieth birthday while on a trip to Colorado, four years before his death in 1927.

His grandson does not know how his grandfather learned to quilt, but his wife might well have been the teacher. Mrs. Larrick came from a family whose men also took pride and interest in quilts. Among the family possessions is a red-and-green pieced star quilt. On it is quilted, "H. P. Richards, October the 27, 1853;" in another block "Pieced and quilted by E. Richards." The quilt was valuable enough to Anna's father, Henry P. Richards, to have his mark put on it. The quilt was passed on in the family to go to the first descendant to bear the name of Richard. Quilts in this family were of interest and value to both sexes.

David H. Larrick

19 Irish Chain

Cotton
90" × 74"
NQP 1762

1913 (marked)
Made by David H. Larrick (1843–1927)
Made in Red Cloud, Webster County,
Nebraska
Owned by Richard Ray Larrick

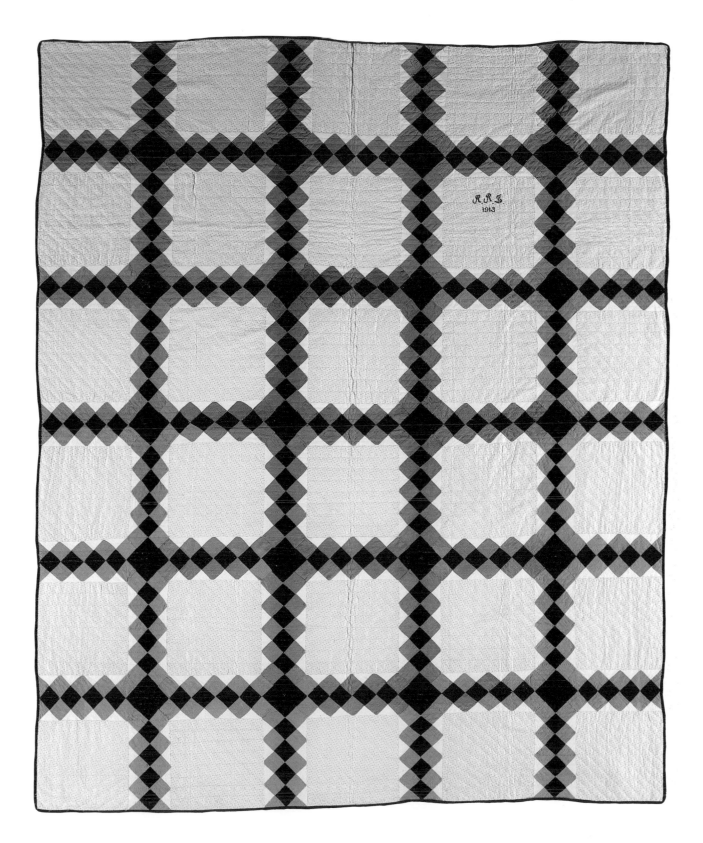

MAROON-AND-WHITE flowers dance across the surface in slanted lines. The pattern, sometimes known as Lazy Daisy, Springtime Blossoms, and Wheel of Fortune, is simple in principle: two petal-shaped pieces are cut from a dark triangle and replace two petals from a white triangle. This counterchange principle is the basis of many all-over quilt designs, many under the name of Rob Peter to Pay Paul. This particular design is more difficult technically than most, since the petal shapes require fitting in a sharply curved seam. The quilters initialed the blocks as they outline quilted them with four to seven stitches per inch.

The quilt came to Nebraska from the Oaks Indian Mission in Oklahoma, where the maker, Abelone Nielsen, had been a housemother for several years. "Miss Abbie," as she was known, was born in Herning, Denmark, in 1891. When she was about fifteen, she heard a founder from the Danish Evangelical Lutheran Church's mission at Oaks, Oklahoma, speak at her school. As she later wrote, she "felt a calling."[21] Her parents made financial sacrifices and the local church helped to pay her way to America in 1911. She went to Chicago to begin her training and to learn English. Since the missionaries needed to be self-supporting, Abbie worked that first summer in a Chicago garter factory in order to pay her way to Oklahoma. She would have to return periodically to earn more.

Because of the sacrifices her parents made to send her to America, she felt she could not return. She was often lonely, even after her marriage. Her family never came to see her; in fact, she advised her brothers against coming to settle in America, saying it was not so easy to start all over in a new country. She did visit Denmark in 1961 and again in 1976.

At the Oaks Indian Mission, Abbie did whatever was needed, being housemother to some of the children, helping with harvest in the summer, nursing the sick during the great influenza epidemic of 1918–1919. Wednesday was normally quilting day. Indian girls at the mission were taught to quilt as part of the "Americanization"

process. The girls, staff, and neighbor women quilted two hours in the morning, broke for dinner, then resumed for several hours in the afternoon. The cotton for the batting was homegrown; the seeds were removed by hand and then it was hand carded. The quilts, always of the same pattern and always maroon and white, were sold for three dollars each to raise money for the mission. The pattern was probably chosen by Mrs. Gertrude Nielsen, the wife of the founder of the mission and supervisor of the work.

When Abbie came to Blair, Nebraska, to attend Dana College, the Danish Lutheran Church's school, she brought this quilt with her. At Dana she met another Danish immigrant, Dr. C. B. Larsen; they were engaged in 1917. They married in 1921 and went to Australia as missionaries. This quilt went with them. Two of their four children were born there.

In the early years of her married life Abbie made practical quilts of squares for her family. Grandmother's Flower Garden became her favorite and her best quilts were of that pattern. She made them for her daughters and granddaughters. She continued the custom of using quilts for fund-raisers, which this quilt represents. She donated a quilt to Dana College for a silent auction and another to help the Dana band go to the National Bicentennial parade in Washington, D.C. She was proudest of the latter—the best she had made. Her daughter-in-law remembers that she always had her quilt pieces with her so she could do her piecing. "All her life quilting was important to her."[22]

Abelone Nielsen Larsen, 1976

20 Hearts and Gizzards

Cotton
77" × 65"
NQP 2292

Circa **1915**
Made by Abelone Nielsen Larsen
(1891–1977) and Oaks Indian Mission
residents and staff
Made in Oaks, Oklahoma, and brought
into Blair, Washington County,
Nebraska, about 1917
Owned by Philip and Florence Larsen

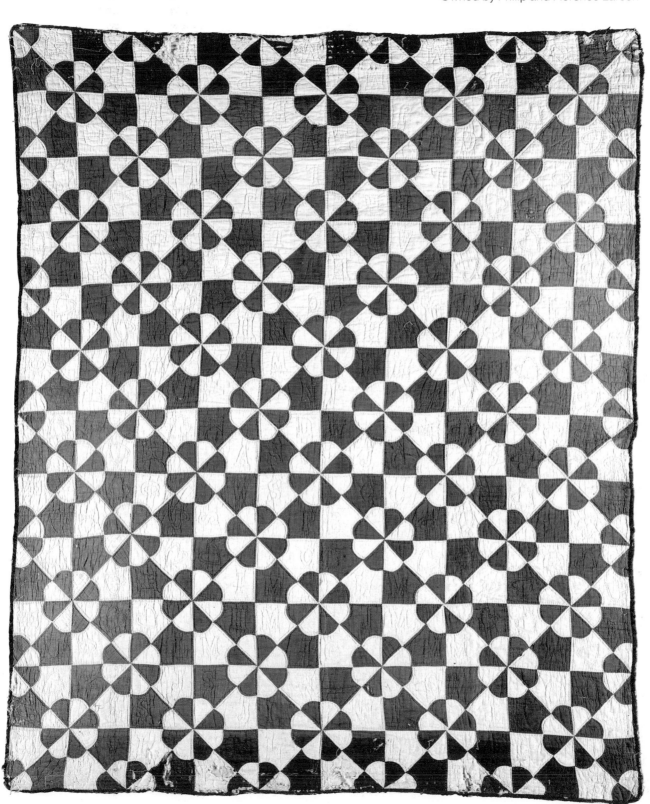

REMARKABLE FOR the youth of its maker and its good condition, this simple quilt constructed of Four Patch blocks shows what many Nebraska quilts probably once looked like. Utility quilts of this type often were washed and worn to death, but before they faded into oblivion they must have brought the same simple pleasure to ordinary life as this one.

The fabrics are those of everyday life—shirting plaids, apron checks, and small prints from the family scrap bag. The four blue-and-white checkerboard blocks may have been made first, before the supply of blue ran low; thereafter blues were used more sparingly, sometimes only one or two to a block. The consistent use of blue unifies the random arrangement of the scraps that compose the rest of the quilt.

The setting is simple and well proportioned. Sashing strips, twice the width of the basic square, are quilted in diamonds. The border, three times as wide as the basic square, is a darker blue quilted with square diamonds. The quilting was done some twenty years after the quilt was pieced.

Edith Belle Sims, known as Belle, was born in Chase County, where her parents' families had come in the 1880s. The Sims family bought a seven-room sod house built in the early 1870s by one of the earliest settlers in the area. They brought with them quilts made by Belle's great-grandmother in the 1830s and 1840s. Belle's mother continued the family's quilting tradition by teaching Belle and her sister to sew at an early age. Her mother cut the pieces, marked the sewing lines, and pinned them for three-year-old Belle. As she grew older, Belle persuaded her mother to let her use the sewing machine, so she was able to finish this quilt top by the age of six. Possibly her mother was not as interested in the actual quilting—Belle has several of her mother's unquilted tops. This top was put away until after Belle's marriage to Wilber Frasier in 1936.

For many years Belle quilted every winter, by herself or sometimes with a quilting group. Despite (or because of!) her early piecing experience, she prefers appliqué work. She has made many quilts, signed and dated, for her children and other family members. In 1975 her husband died of smoke inhalation in a prairie fire. Since then Belle has run their 3,700-acre ranch and quilted and traveled as much as possible.

Edith Belle Sims at age three, when she started her quilt, 1919

56

21 Sixteen Patch

Cotton
83" × 67"
NQP 236

1919–1921 (top); circa 1940
(quilting)
Made by Edith Belle Sims Frasier
(1916–)
Made in Wauneta, Chase County,
Nebraska
Owned by Edith Belle Sims Frasier

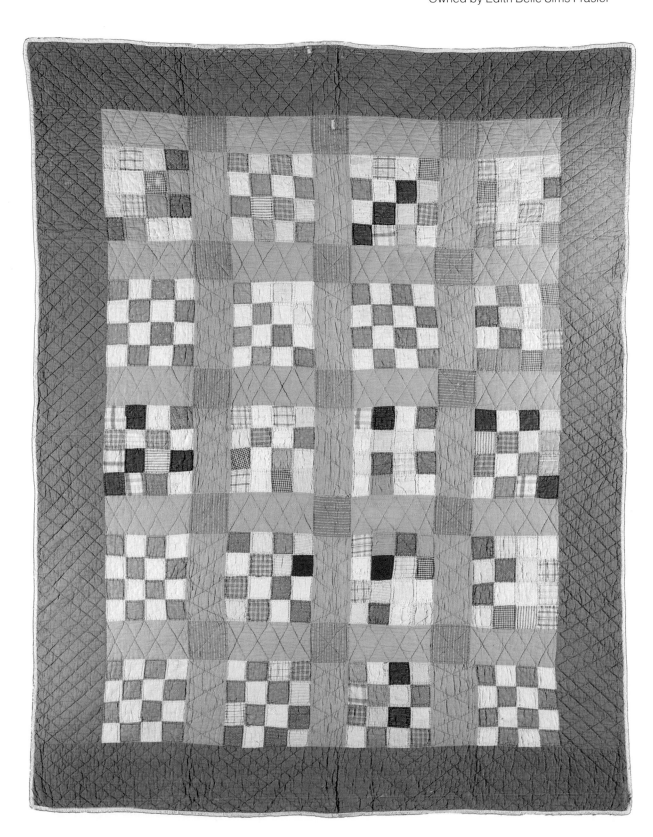

THIS QUILT is striking in its coloration, simplicity of means, and powerful optical effects. Although wool was used by Nebraska quiltmakers primarily for utilitarian comforters, Lucy Bell Jordan Lyle shows how decorative it can be in the hands of an imaginative quiltmaker. The fabrics in this quilt, mainly wool serges, gabardines, and fancy suiting fabrics with a few cotton prints, were dressmaking cuttings from materials bought by the maker's daughter with her first earnings as a schoolteacher.

Eight narrow strips were sewn by hand on a foundation of sixty-degree diamonds. The strip at the wide part of the diamond defines a central hexagon, since it is usually the darkest. One of the overall effects is that of concentric hexagons. The central stars glow with light. The outer stars are dimmer, but each is fired by the red hexagon at its center. Most of the star points fade away into the dark blue diamonds which link the stars. These blue diamonds are technically the background, but they have a life of their own, moving in slanted rows across the surface of the quilt.

All the movement is contained by the wide brick-red border, which echoes the red of the star centers. The backing, glimpsed as it is brought to the front to finish the edge, is a plaid flannel; such flannel backings are common in wool quilts after 1875.[23] The quilting was done with pearl cotton in straight lines.

Lucy Bell Jordan Lyle, 1949

Lucy Bell Jordan, born in West Virginia in 1875, began quilting as a child. Her family moved to Missouri in 1885, when she was ten. In 1897 she married Robert Lyle, a blacksmith, and came to southeastern Nebraska, where her four children were born. Although working mothers are often assumed to be a modern phenomenon, they were certainly not unknown in earlier times. Lucy worked as a seamstress from 1900 until 1918, when she became the telephone operator for the town of Elmwood. The family lived in the telephone building, since she was required to stay at the telephone board in the evenings. There at the board she knitted, crocheted, and pieced quilts. Her husband died in 1925. In the early 1950s she came to Lincoln to live with her daughter, Floy Buell, herself a notable quiltmaker (Plate 80), who always maintained that she was never the quilter her mother was.

22 "Strip Star"

Wool and cotton
83" × 67"
NQP 2670

Circa **1920**
Made by Lucy Bell Jordan Lyle (1875–1964)
Made in Elmwood, Cass County, Nebraska
Owned by Wanda Buell Ross

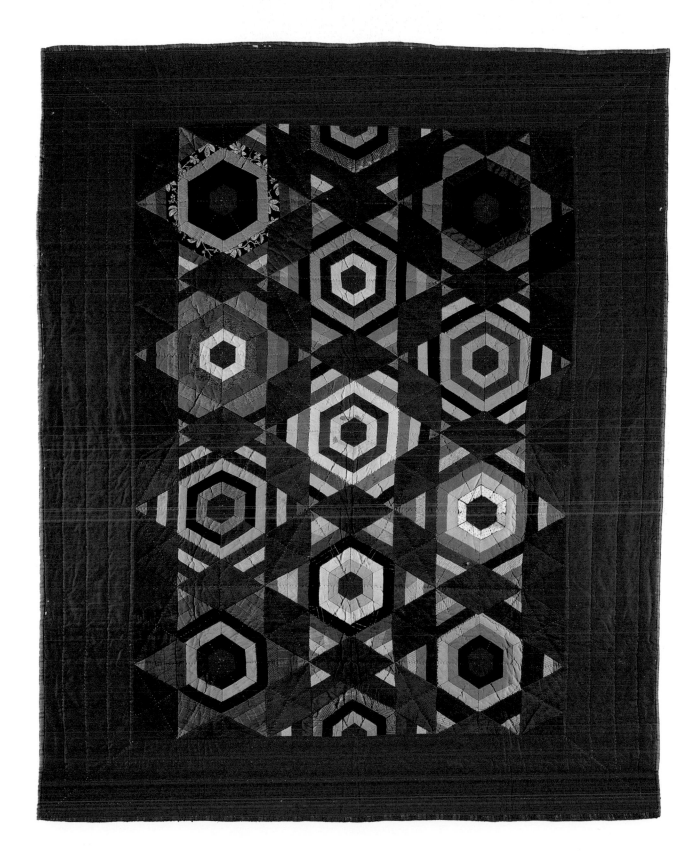

THE CRISP geometrical lines of the pieced center are set off admirably by the graceful lines of the wide appliqué border. The swags of the border, applied with nearly invisible running stitches, are topped by three leaf forms; the corners are expertly turned. Although the Double Irish Chain was often done in only two sharply contrasting colors, the maker of this quilt softened the hard edge lines of the squares by using a soft blue-and-pink print for the center chain. The mistiness of this print suggests depths—another plane beyond the blue and white one we see so clearly.

The combination of pieced center and appliqué border is not unusual for blue-and-white quilts. The popularity of this style and color dates to the 1830s through the 1860s, when Turkey red and white eclipsed blue and white. At the turn of the century the taste for blue and white revived; these later blues tended to be brighter than the dark indigoes favored in the mid-nineteenth century.[24] Clearly the maker of this quilt was aware of the blue-and-white quilt traditions.

Early blue-and-white quilts were often showcases for elaborate quilting; Single and Double Irish Chains, with their large open spaces, were popular for this purpose. Later makers simplified the quilting; in this example the quilting is an overall crosshatching in lines three-quarters of an inch apart.

Mary (known as Marie) Bednar was born in Nebraska in 1873. Her Bohemian-born parents came to Nebraska from Wisconsin in the early 1870s to settle near the Bohemian community of Wilbur. Marie grew up in a sod house on a farm, probably learning the domestic arts from her mother. She never went to school, being kept home to herd cows. When there was nothing else to do, she sewed quilt blocks, crocheted lace edgings for white dress-up aprons, and embroidered. Friends and neighbors exchanged patterns for these handworks. In 1890, when she was about sixteen, she married Thomas Vosoba, a neighboring farmer. They had two children.[25]

At Christmas in 1920, Marie told her nineteen-year-old niece Georgia Spinar, who had lost her mother when she was two, that she would make Georgia a quilt for her wedding. In that time and community, weddings were private and not announced ahead of time. Georgia knew that she was to be married on January 26; she told her aunt, "You'll never get it done in time!" The quilt was in time—for the birth of Georgia's second child in 1924. Marie made many quilts for herself and her family. She died of a stroke in 1941, when she was sixty-eight.

23 Double Irish Chain

Cotton
75" × 69"
NQP 761

1920–1924
Made by Mary Bednar Vosoba (1873–1941)
Made in Wilbur, Saline County, Nebraska
Owned by Melva Spinar Mach

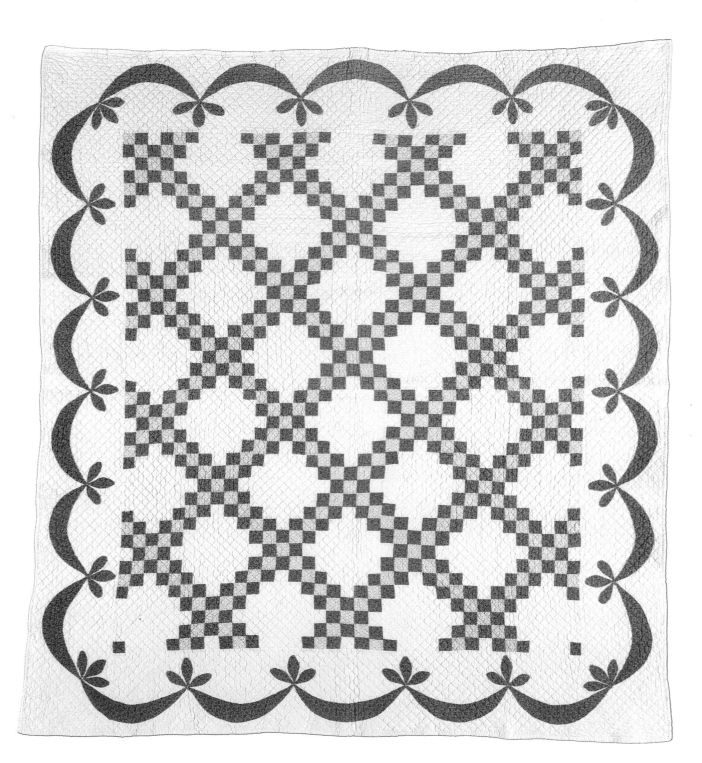

THAT MOST popular of 1920s patterns, Grandmother's Flower Garden, received new life in the hands of a nine-year-old girl. Inspired by their cousin and closest neighbor, Genevieve and her sister Rosella each decided to make a quilt. Rosella made the conventional hexagonal Flower Garden; Genevieve arranged her two-and-one-half-inch hexagons in a diamond, which she called Field of Diamonds. Each diamond has a yellow center, a solid color row, and a print row; the pattern is more often known as Rainbow Tile. Usually Rainbow Tiles are placed side by side, giving a flat floor tile effect. The effect of this quilt is anything but flat! The eye sometimes sees baby blocks from the top and from the bottom and, at other times, stars interlocking with neighboring stars in a dazzling kaleidoscope. All are held together by the yellow centers of the diamonds, the yellow hexagons at the intersections, and the white "paths," which seem to reflect light off the edges of the blocks.

The maker, Genevieve (Genie) Zurn, was born in 1919 near the Nebraska-Wyoming border. Her father was a farmer and carpenter whose family had come to Nebraska in the 1880s. She was taught to sew at an early age by her mother, Catherine Meyer Zurn, an accomplished seamstress. Genie remembers sewing on the quilt on long winter days and evenings when blizzards kept her home from school. The fabrics for the quilt were mostly scraps from a cousin's scrap bag and cuttings from homemade school dresses. Genie remembers wearing the dress of the peach print when it was new; coming home the mile from school, she tore the back when she had to crawl through a fence. She arrived home crying, but her mother put a new back in the skirt—and the torn piece went into the scrap bag.

Later, in adolescence, Genie made another quilt top—an appliquéd Bride's Bouquet for her dowry. In 1942 she married an artist, Joseph LaMay, and they had five children. For many years she worked for the Alliance, Nebraska, *Times Herald* as a compositor, retiring in 1986. In 1975 she had this top from her childhood quilted by Eileen Moravec, and bound it herself by hand, so that every stitch in it would be by hand. To Genie, this is her "Memory Quilt," filled with tangible scraps of the past. Many memories are bound up in quilts such as this, made from the fabric of the family's life. For others, quilts like this show how a fresh eye and hands can turn a usual pattern into a visual delight.

Genevieve Mary Zurn LaMay

24 Rainbow Tile

Cotton
96" × 74"
NQP 412

Circa **1928** (top); 1975 (quilting)
Made by Genevieve Mary Zurn LaMay
(1919–)
Made in Harrison, Sioux County,
Nebraska
Owned by Annette Marie LaMay
Davies

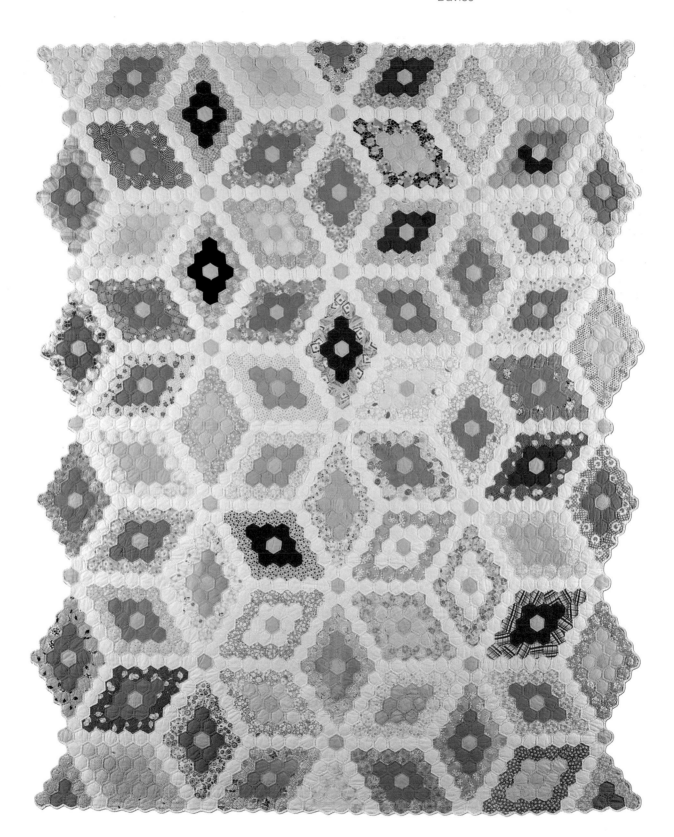

EACH-AND-ORCHID Four Patches mark the intersections of the interlacing rings of this favorite pattern of Nebraska quilters. Although these colors were fashionable at the time the quilt was made, the other color choices were more unusual. Instead of a blending of pastel prints, strong and light prints generally alternate, setting up a rhythm that moves the eye along the paths.

Each section of the ring is composed of eleven small segments, suggesting a quilter who was not afraid of work. Other versions of the Wedding Ring pattern were simpler; one shown in Ruby McKim's *101 Patchwork Patterns* of 1931 requires only six of the wedge-shaped segments on each side.

The edge of the quilt follows the curve of the rings, forming a strong version of the fashionable scalloped edge. Many quilters preferred to appliqué the rings to a straight-edged border to simplify the binding process. Those who retained the curved edge dealt with the Four Patch intersections in various ways. Some cut the outside square across to create a flat edge and a shallower scallop. Others left the Four Patch whole, making a complex edge of curves and v-shaped points. The maker of this quilt removed the outer square completely, making the scallops as deep as possible, which left a sharp inverted point to deal with.

Quilt scholars are still discussing the age and origins of the Wedding Ring design. Oral traditions claim it to be an old pattern, but most examples are from the second quarter of the twentieth century. A few Double Wedding Ring quilts are attributed to the 1870s, but the earliest date-inscribed examples and the first published patterns are from the late 1920s.[26] The design apparently existed before then, possibly under different names now lost. The design was considered one for virtuoso quiltmakers; many depression-era quiltmakers took on the challenge to keep their minds off their troubles. The pattern name also appealed to quilters of varying degrees of experience.

Jessie Mae Case Carter made few quilts before the 1930s. The Case family, of Scots-Welsh descent, came to Hamilton County, Nebraska, in 1873. Jessie, an only child, was born in a sod house in 1885, according to her family.

As a young child she fell and dislocated her right elbow. Naturally right-handed, she learned to use her left hand for everything except writing. Even in adulthood she still sewed with her left hand.

Jessie's mother was born in Scotland, where she learned to sew as a young child. She had a "stint," a yard of seam each day; if she made a mistake she had to take out the whole yard and redo it. Mrs. Case became a quilter in America, and Jessie's daughter believes Jessie learned to quilt from her mother. It was not until the 1930s, when, as her daughter says, she needed to "keep her sanity" during the hard times, that Jessie really started to make quilts.

In later years Jessie made velvet Crazy quilts for each of her six grandchildren. Her husband, Phillip Carter, whom she married in 1910, embroidered some of the blocks with his own designs. After her husband's death in 1947, Jessie ran an antiques store from 1950 to 1970, retiring when she was eighty-five. She died in 1982, a few years short of her hundredth birthday.

Jessie Mae Case Carter with her grandfather, Thomas D. Case, and her father, William H. Case, holding Jessie Mae's baby, Jeanie Iola Carter. The baby is the mother of the present quiltowner.

25 Double Wedding Ring

Cotton
93" × 80"
NQP 1430

Circa **1930**
Made by Jessie Mae Case Carter
(1885–1982)
Made in Hamilton County, Nebraska
Owned by Janet Marie Groelz

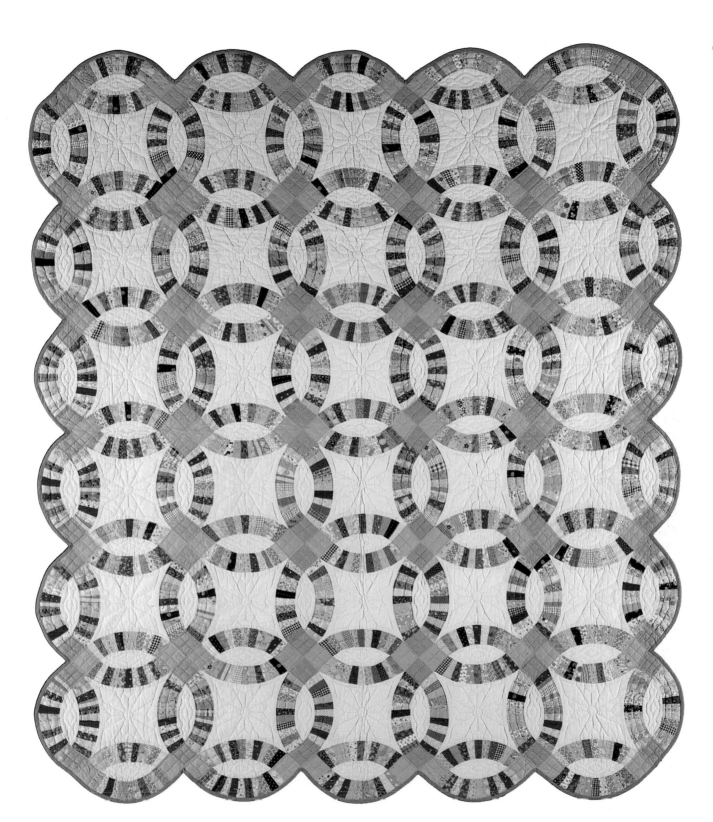

LESS WELL known than Grandmother's Flower Garden or Double Wedding Ring or Dresden Plate, this Periwinkle, or Four Point, design came after them in popularity with Nebraska quiltmakers in the 1920s and 1930s. Like the other popular patterns, it was almost always done in many different fabrics, to show off a varied collection or to make use of scraps.

This charming example uses the print and plain combination so favored by quilters when post–World War I dyes made such coordination possible. Greens, clear yellow, blue, orchid, orange, and pink—the colors are all the favorite new pastels. The blending of color values is particularly well done in this example; nothing fades into the background or stands out too darkly.

Framing it all is an eight-strip border of all the solid colors (including the white background) used in the piecing. The borders and the blocks are all hand sewn. The closely crosshatched border, the outlining, and the leaf motifs of the blocks were quilted with nine to twelve stitches per inch.

Zella Andrews, the fourth of Adelbert and Sarah Andrews's six daughters, was born in 1879 on the family farm south of Pawnee City, Nebraska. It is no longer known why she was given so unusual a name—her sisters all had more conventional names. She grew up to be an independent woman, as her niece recalls. She became a teacher, first in country schools while she attended the Normal School for Teachers at Peru about 1900. At a time when few women received advanced degrees, she earned a master's degree in history in 1927 from the University of Nebraska.

In the mid-1920s, Zella visited Europe, bringing silk from Paris for her niece's high school graduation dress in 1925. She never married. Her niece, the present owner, recalls that Zella had a reputation as a master teacher. She taught in high schools in southeastern Nebraska and northeastern Kansas, where she spent the last part of her life.[27]

Zella Andrews

26 Periwinkle

Cotton
77" × 63"
NQP 3076

Circa **1930**
Made by Zella Andrews (1879–ca. 1960)
Made in Pawnee County, Nebraska
Owned by Alice Vanden Bosch

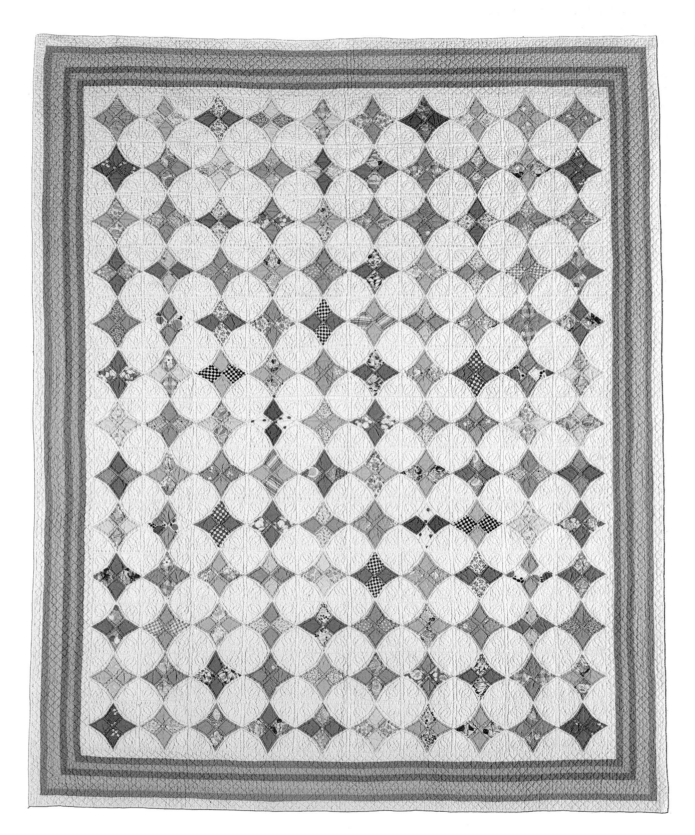

THE DARK center of the star pulses with light as the five colors of cotton sateen shade from red-orange to a creamy yellow, then repeat, forming a double sunburst. The creamy yellow at the widest point of each large diamond blends with the sateen background, softening the edges of the octagon nearly to a circle.

The whole star is simply framed by a plain machine-sewn border in a related apricot shade and a scalloped white border bound in apricot. Feather wreaths and half wreaths, with six-pointed stars in their centers, are quilted in the background squares over a crosshatched grid with nine stitches per inch.

In many ways this quilt is firmly in the Star of Bethlehem tradition seen elsewhere in this volume: the large star, the single-color inner border, the crosshatch quilting. Far from being a copy or a pastiche, the quilt clearly shows its twentieth-century origin by the way the maker chose to emphasize the star by simplifying or eliminating subordinate elements such as satellite stars and a pieced border.

Instead of elaborating the design, the maker chose to work with a new element—the colors of the twentieth century. Anthraquinone vat dyes available after World War I made a wide range of colors and their tints and shades available. Combinations based on the various values of a single hue became fashionable in dress, interior decoration, and quilts.[28]

Thus the latest in technology and fashion helped Minnie Richardson Throckmorton create a quilt as the expression of an ageless emotion—grief at the loss of a child. Minnie's only surviving son died in France on November 12, 1918, one day after the Armistice. The colors of this quilt symbolize her grief and pride as a Gold Star Mother.

Minnie Throckmorton, who was born in Iowa in 1870 but lived most of her life near Red Cloud, was involved in Red Cross work, which included quiltmaking, during the Great War. She went to France in 1930 with the first contingent of mothers to visit the graves of their sons. On the ship coming back, the women decided to form the Gold Star Mothers—mothers of soldiers killed in war. She was elected the first president. According to her obituary, she was the first mother to lay a wreath on the grave of the Unknown Soldier. She also made this quilt before her death three years later.[29]

27 Star of Bethlehem

Cotton
90" × 90"
NQP 1768

1930–1933
Made by Minnie Richardson
Throckmorton (1870–1933)
Made in Red Cloud, Webster County,
Nebraska
Owned by Helen Kent

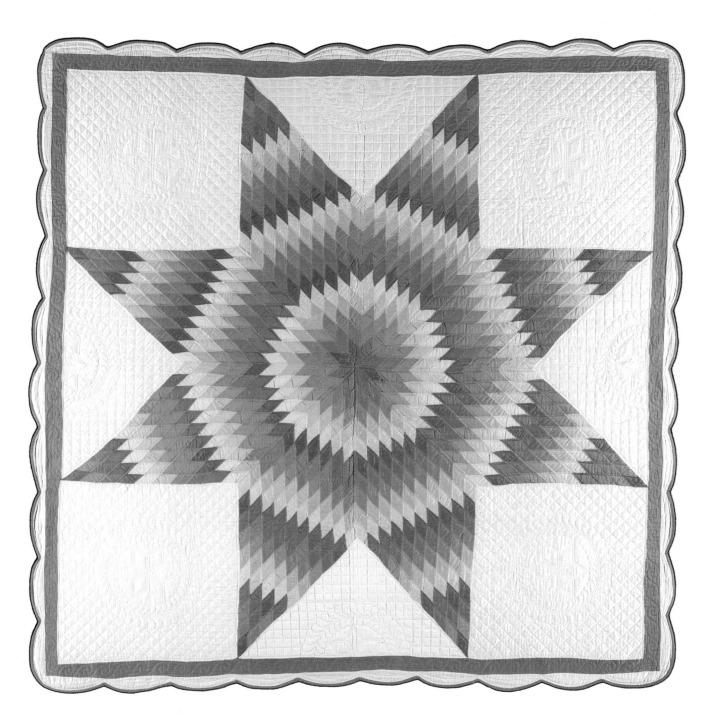

VIGOROUS COLORS distinguish this Dresden Plate top, made by an adolescent girl, from the delicately blended pastel versions of her contemporaries. Here solid red spokes thrust from a red-and-yellow curved-seam center, quartering the circle of checked, dotted, striped, plaid, and flowered petals. The dominant red of the spokes, set off by the muslin background, is repeated in the red of the sashing, which needs to be strong to contain the energy of the blocks. Imperfect though the sewing may be, the quilt shows ambition and a love of strong color and form not often seen in the standard versions of this favorite twentieth-century pattern.

Irene E. Baird Jessop

Irene E. Baird, born in 1921 on the Arthur County farm where her Canadian-born mother had homesteaded, began this quilt when she was about twelve. Her father was a farmer, rancher, blacksmith, justice of the peace, road overseer, well-driller, and more. Growing up on the farm, twenty-eight miles from town, Irene and her two brothers kept busy. Before leaving for school in the mornings, they milked cows and fed the livestock, which included calves, horses, and hogs. Sometimes they also hauled hay for cattle in the pastures.

Occasionally the schoolteacher would save Irene the half-mile walk to school by picking her up in a Model-A Ford (with a rumble seat, Irene remembers). As the only girl in school, Irene

helped the teacher build the fire, pump the water, clean the schoolhouse, and get lunch ready to be heated on the stove at noon—all before the other students arrived.

In those hard depression years, Irene earned money by hunting and trapping animals for fur. She hunted rabbits with a .22; they were so thick, she says, "you could go out and get as many as you [could] skin a day." The hides brought ten cents each.

Despite the hardships of the 1930s, which brought drought, hailstorms, dust storms, a tornado, grasshoppers, and fire to their farm, Irene's family found the time and means to create beauty. Her grandfather, Conrad Walker, cut his old overalls in squares, painted flowers on them, and embroidered around the flowers. Her mother, Clara, quilted, and Irene began to work with her at the age of eight, cutting out pieces; it was especially important to learn how to save material. They were careful to get the best material they could afford, fabrics that would not shrink or fade. They used sugar and feed sacks and saved all the cotton scraps they could. Irene also remembers sending to Sears Roebuck and Montgomery Ward for bundles of ten or twenty yards of assorted prints and plains for one dollar.

Quilt patterns cost ten cents, but trading with friends increased the variety available to them. Irene remembers laying the blocks out on the beds to get the size right or to get the colors to match or contrast. When times were hard, she remembers people filling comforters with flannel sheets, cornhusks, goose down, or with old sweaters, caps, and mittens overlapped and sewn down.

The beauty that they could create with what they had put joy and meaning into quiltmaking for Irene and her mother and so many other women. As she wrote, "Quilts is something that home made should be cherished. Loved and Protected Because the Time, Work and Beauty that it takes to make. It shows ambition, Love and Workmanship that cannot be replaced. . . . Quilting is a great art and also quite a togetherness project. Love was in the Work."

28 Dresden Plate Variation

Cotton
87" × 67"
NQP 100

1932–1936
Made by Irene E. Baird Jessop (1921–)
Made in Arthur County, Nebraska
Owned by Irene E. Baird Jessop

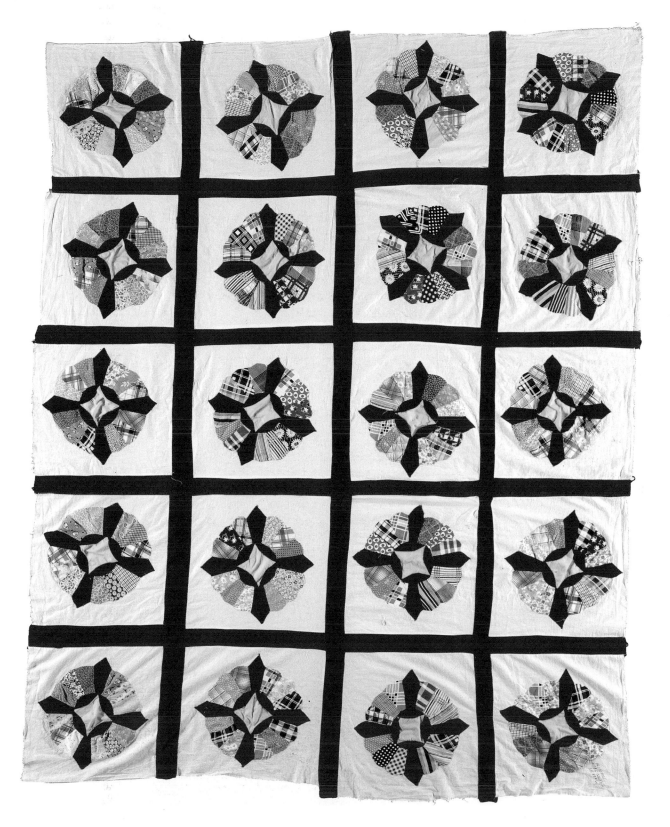

THE GRANDMOTHER'S Flower Garden design beloved by twentieth-century quiltmakers has been transformed into stars in this glowing quilt. Six-pointed stars within stars in shades of yellow seem to bloom around the familiar rosettes of hexagons in the middle. The yellow centers, set off by the darker prints and plains of the flowers, are like bright sparks of light scattered across the quilt's surface. Each star is circled by six planetlike rosettes, outlined by paths of white hexagons.

Unusually large for the 1930s, the more than 6,600 three-quarter-inch hexagons of this quilt were all hand sewn by the running-stitch method. The paper-template method—basting the fabric over precisely cut paper patterns, then whipping the edges together—customary in the first half of the nineteenth century, had generally been abandoned.[30] Ruby McKim in her *101 Patchwork Patterns* of 1931 does not even mention paper templates; she even suggests machine sewing straight rows of hexagons first.

Each hexagon is outline quilted with six to eight stitches per inch. The batting is a thin cotton, with a few seeds or other debris visible when the quilt is held to the light. The pale yellow broad-cloth back was brought to the front as edge treatment. The maker quilted this quilt with a group of friends and relatives, which was the custom in the Mennonite community of which she was a part.

Barbara A. Schweitzer lived all her life near Milford, Nebraska. She was born in 1889 to a farming family of German-Russian descent and attended the local grade school. She probably received her education in the domestic arts from her mother; her granddaughter remembers that she always had various kinds of handwork around the house for her "idle" moments. When she was about twenty-eight, in 1917, she married Ed Burkey, a farmer. They had one child.

Quilting was an important part of women's activities in the Mennonite community. Barbara made many quilts in her life, and must have helped with many more made by friends, family, and neighbors. A caring and giving person, she made quilts for children, dolls, family weddings, her grandchildren, and the grandchildren of friends. She died in 1970. This quilt is now owned by her granddaughter, who values it both for its beauty and as the work of a beloved grandmother's hands.

Barbara A. Schweitzer Burkey with her husband, Ed, 1951

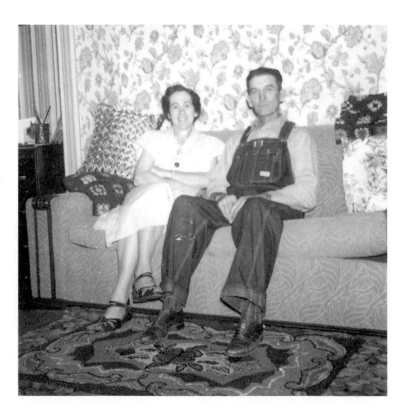

29 "Flower Garden Star"

Cotton
99" × 92"
NQP 930

Circa **1935**
Made by Barbara A. Schweitzer Burkey
(1889–1970)
Made near Milford, Seward County,
Nebraska
Owned by Joan Schweitzer

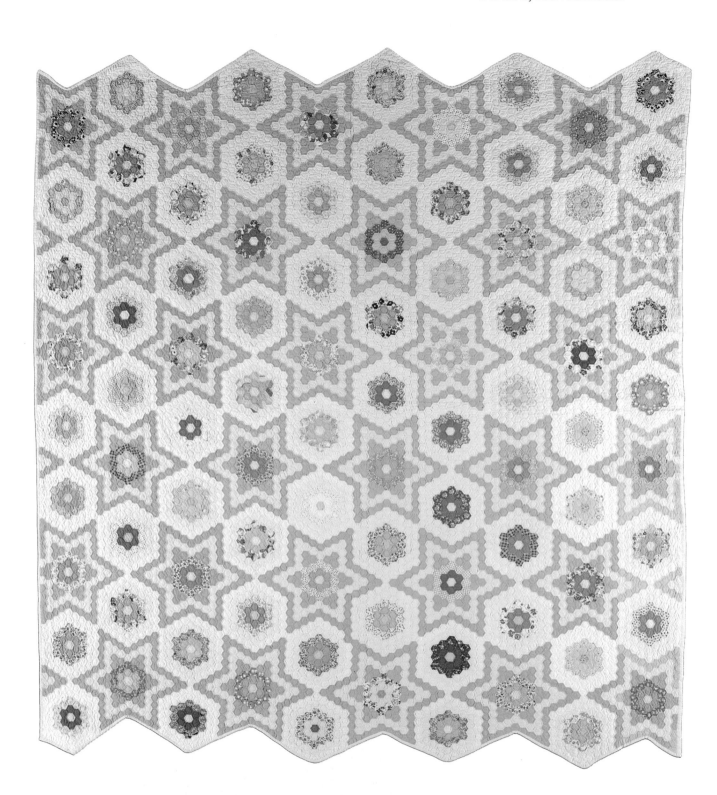

SUFFUSED WITH sunshine, a rainbow of colors combat the depression. Carefully selected prints and solids move from light to medium shades in orchid, pink, blue, yellow, and green. In every other color group the solid is dark enough to stand out clearly, defining the concentric rectangles of squares set on point. The color order does not repeat, but each is used for two "trips" around, except for the yellow, which is used a third time for the final round. The last row of squares was left uncut and faced with yellow to make the fashionable shaped edge. The blending of colors and the lavish use of yellow make this quilt glow.

The floral and geometric prints and solids used in the quilt are characteristic 1920s and 1930s pastels that were made possible by post–World War I dyes. Many earlier quilts used shades of these colors, of course; however, the yellows in the nineteenth century tended to gold or orangey tones and were most often used as an accent. The new twentieth-century yellows became popular among quilters, especially in western Nebraska, or so it seemed to quilt project workers.

Frances Gertrude Otto Scudder (called Gertrude), the maker of this quilt, had always dreamed of taking a trip around the world. The depression made that impossible, so she turned to quiltmaking. She was born in 1887 near Malcolm in Lancaster County. Her father, Ernest Otto, had come to Nebraska from Illinois as a young child in the 1860s; his family spent their first winter in an underground shelter on the site of Lincoln, according to family tradition. Gertrude's mother, Frances Whillock Otto, came from England in 1867, when she was three. Frances Otto and her mother were both gifted seamstresses and probably taught their skills to young Gertrude. The family still has their set of English sewing tools with mother-of-pearl handles.

Gertrude became a country school teacher in 1908 and taught until her marriage in 1913. Her husband was Leroy G. Scudder, the son of Flora Ann Burger Scudder (Plate 9). The couple lived in Doniphan at first, near the rest of the Burger-Scudder clan, and then moved to Sumner, in Dawson County. Her daughter says that Gertrude began to piece quilts during the depression, sending the tops to others to quilt. This quilt was quilted with ten stitches per inch in a crosshatching design by Nellie J. Shadley and her daughter. Before she died in 1957 Gertrude had passed her love of quilts on to her daughter and granddaughters.[31]

Frances Gertrude Otto Scudder

30 Trip around the World

Cotton
84" × 70"
NQP 1487

Circa **1935**
Made by Frances Gertrude Otto
Scudder (1887–1957)
Made in Sumner, Dawson County,
Nebraska
Owned by Ruth Scudder Sisler

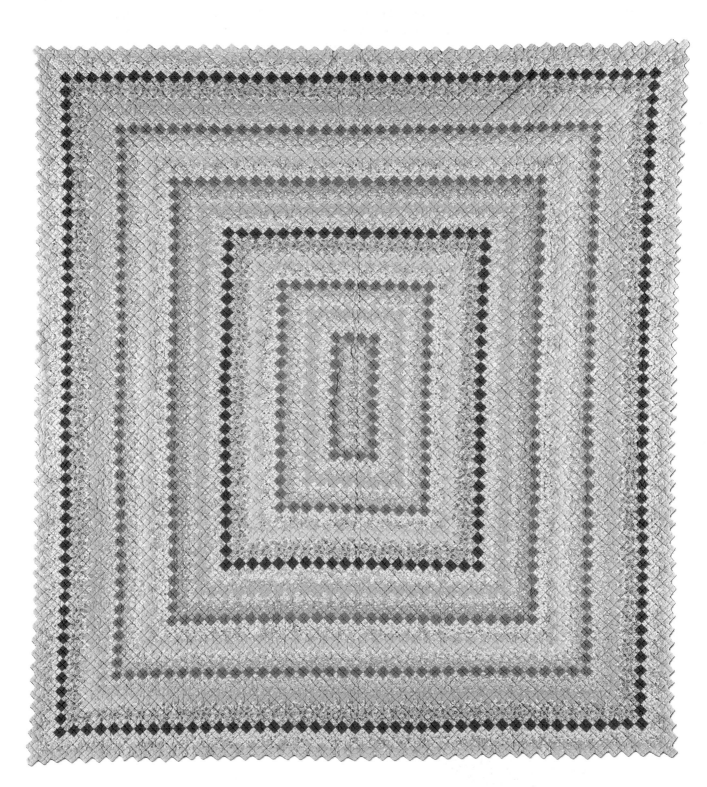

AS NEW FASHIONS in quilt patterns and colors came and went in the 1920s and 1930s, many of the older styles persisted, seemingly unchanged except for the fabrics. Fans done in silks and wools had been popular in the Crazy quilt era of the 1880s and 1890s; they were popular again in the 1930s in cotton pastel prints. The maker of this quilt chose to update her dark mixed-fabric fans by giving it a more contemporary setting, on point. The purple-and-white plaid silk-crepe sashing gives a most unusual effect; like the balls of light which flash along a theater marquee, it highlights the blocks.

Variety marks the fabrics of the fans. There are plaids, checks, and stripes plus floral and geometric prints. The quilt gives a sample of the everyday materials of the time.

The fans are entirely pieced on a background square, the edges finished with herringbone and feather stitching. The slightly differing colors of the background squares, black, dark green, blue, and blue-gray, give a sense of depth.

The eleven-inch blocks were sewn together by machine. The triangles which fill in at the edges of the quilt are a medium-green corduroy, effectively framing the blue and black blocks. Although this quilt does draw on the Crazy quilt tradition, unlike most Crazy quilts it is quilted over a medium thickness of batting, with three to four stitches per inch. The quilting, done in pink crochet thread, is in straight lines about five inches apart.

Bertha Ustina Roeder Plambeck

Bertha Ustina Roeder was just a child when the dark quilts and Crazy quilts which her fan quilt resembles were at their peak of popularity. She was born in Forrest, Illinois, in 1883, the daughter of a farming family of German descent. In 1885 the family came to Adams County, Nebraska, where Bertha spent the rest of her life. In 1906 she married Walter Plambeck, a farmer, and they had three children.

Their grandson, Vernon Plambeck, remembers Bertha working on this quilt when he was a child in the early 1940s. Failing eyesight in the 1950s forced Bertha to give up her quilting. When Vernon married in 1958, she gave him and his bride this quilt from his childhood.

31 Grandmother's Fan

Cotton, silk, wool, rayon
77" × 81"
NQP 1473

Circa **1940**
Made by Bertha Ustina Roeder
Plambeck (1883–1969)
Made in Adams County, Nebraska
Owned by Vernon and Marlene
Nicholas Plambeck

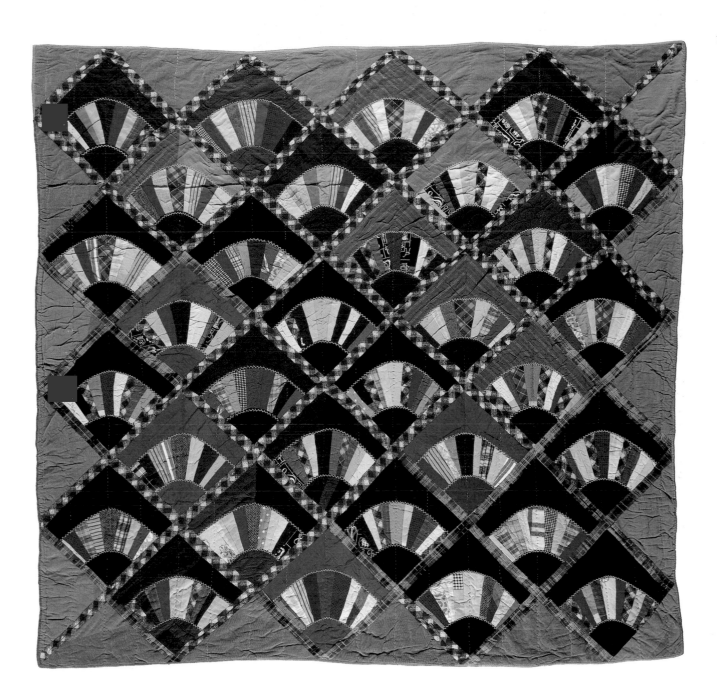

THE CLEAR pastel colors and complex graceful design of this quilt rival that of the fine appliqué quilts of the period. This quilt is entirely hand pieced, primarily of one-inch squares; even the plain white background areas are pieced. The designer Anne Orr, who showed quilts of this style in her *Good Housekeeping* columns in the 1930s and sold the patterns through her design studio, called it a "gros-point effect."[32]

Surrounding the central quilted panel is an open wreath composed of green "leaves" and flowers in yellow and orange and two shades of pink and lavender, set off by a flowing blue-ribbon bow. The format is typical of the high-style appliqué quilts of the period: a rectangular medallion to fit the top of a bed, a pillow motif, and borders meant to be seen hanging down the sides. Fleurs-de-lis are quilted in the plain panels, with diagonal crosshatching quilted with ten stitches per inch through the centers of the pieced squares.

Lillian Mae Bourne was born in 1871 near Alaska, Indiana. Her father died five years later. In 1883 her mother came to Buffalo County, Nebraska, leaving her three children with her family in Indiana until she could send for them. The next year a friend escorted the children to Gibbon, Nebraska, by train; the fare was nineteen dollars. In 1886, the family, with their stepfather, went by covered wagon west to Chase County. Some of their belongings were sent ahead by train. Unloaded and laid along the tracks at Ogallala, their goods and those of many other settlers were left for nearly a week until they could come with wagons to pick them up; according to family tradition nothing was lost or stolen.

When they arrived at their homestead in Chase County, the first need was for a house. They dug in three feet deep, then laid sod high enough for people to stand up. Boards and tar paper were laid over the top as a foundation for the sod roofing. This was their home for the great blizzard of 1886.

The next year Lillian, age fifteen, got a teaching certificate; she taught five terms of three months apiece. On New Year's Eve of 1891 she married Andrew E. Smith. They began their life together as farmers on his homestead the next day. They had six children; one died in 1910 when he was three months old. Their frugal living habits enabled them to buy the home of the banker when they retired to the town of Lamar in 1930; the bank had failed in the stock-market crash the year before.

A granddaughter who stayed with them in the summers remembers Lillian being active in church, Sunday school, and the Ladies Aid Society. Quilting was an important part of her life; she always had a quilt in the frame, for herself or for Ladies Aid fund-raising. Women came to her home frequently to quilt, as well as for the weekly meetings of the Ladies Aid. The women were proud of their work; every year they held a quilt show and ice cream social at the Christian Church to display the results.

Lillian delighted in her garden, and her love of flowers is reflected in this quilt. Also an accomplished dressmaker, she taught her daughters to sew and later made coats and dresses for her grandchildren. She loved beautiful fabrics and believed in getting the best quality possible so the clothing could be remade again and again. The scrap bag she kept in her closet was a source of many projects. She was generous with her time and talents. When two granddaughters went away to college, she made Sunbonnet Baby quilts for their dormitory beds. This Wreath and Bow quilt is one of three made for the weddings of three sisters, her granddaughters. Lillian died in 1968, at the age of ninety-six. Her granddaughter says, "Her family, friends, flowers, and quilts were legion."[33]

Lillian Mae Bourne Smith, 1943

32 Wreath and Bow

Cotton
98" × 87"
NQP 347

1941 (marked)
Made by Lillian Mae Bourne Smith
(1871–1968)
Made in Lamar, Chase County,
Nebraska
Owned by Dorothy Smith Weiss

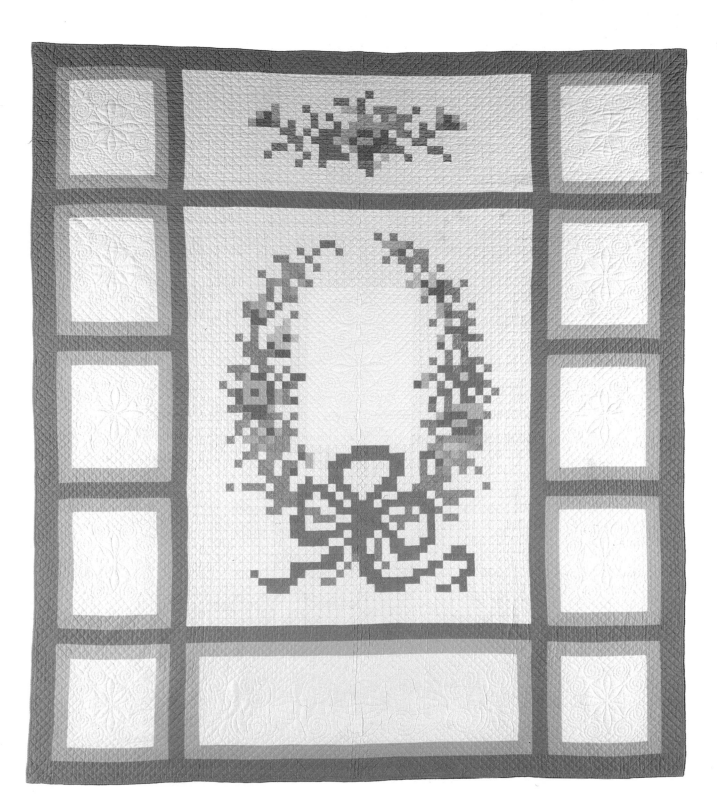

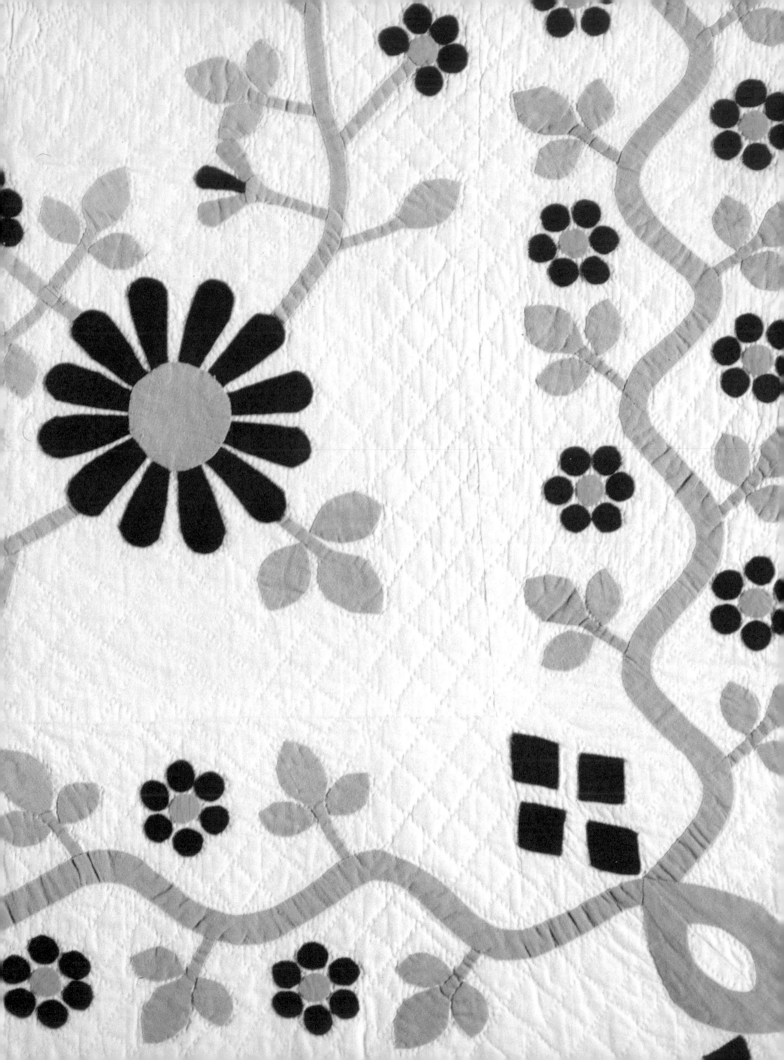

Labors of Love: Appliqué Quilts

by *Patricia Cox Crews*
and *Kari Ronning*

THE PATRIOTIC theme of this appliqué quilt is subtle but intentional. It has thirteen red and white stripes and thirty-three blue stars like the American flag in 1859. Oregon was the thirty-third state admitted to the Union that year; however, the reason for commemorating that event is unknown, since neither the quiltmaker nor her family ever lived in Oregon. Her motive may have been merely a patriotic spirit coupled with a desire to create a symbol of her country and her flag in quilt form.

The pattern that she chose for her quilt, a Whig Rose variation, or Democrat Rose, as it is sometimes called, was typical of the genre of red-and-green appliqué quilts so popular between 1850 and 1880. This quilt is unusual because navy blue was used in addition to the customary red and green, with accents of yellow. The floral forms are simpler than most; the challenging task of appliquéing thirty-three stars may have caused the quiltmaker to simplify the rest of the design. The single red leaf (perhaps intended as a bud) adds another unusual touch of color. While the shapes are simple, she has carefully turned under all edges

and used a tiny blanket stitch to secure them to the creamy muslin ground. All fabrics are solid-colored cotton except the navy blue polka dot print used for the stars. The quilt is stitched entirely by hand and the background is expertly quilted in a fan design with nine stitches per inch over a thin cotton batting.

Isabella Lucy was born in Columbia County, Ohio, in 1827, one of seven children of Charles and Mary McGavran Lucy. The family moved to St. Clair County, Illinois, in 1841, where she lived until her death in 1912 at eighty-five years of age. She was thirty-two years old when she made this striking quilt. Not much is known about her life. The family members in general were great readers and correspondents. Several of the men in her mother's family were in politics and others were ministers in the Church of Christ. At the time of her death, Ira Lucy, her nephew, traveled from his home in Nebraska to her old home place in Illinois. When he returned he brought with him two quilts (including the one pictured here) and a set of silver spoons. This special quilt remains in the family and now belongs to Ira Lucy's youngest daughter, Mary Lucy Bennett.[1]

33 Whig Rose Variation

Cotton
88" × 90"
NQP 744

1859 (marked)
Made by Isabella Lucy (1827–1912)
Made in St. Clair County, Illinois, and
brought to Brown County, Nebraska, in
1912
Owned by Mary Lucy Bennett

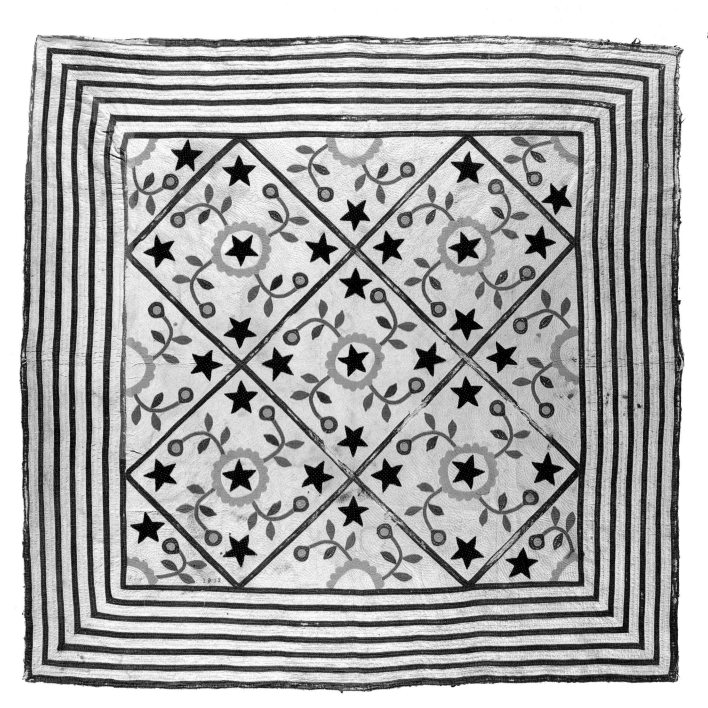

THIS QUILT features a complex appliqué design known as Princess Feather, which became popular early in the nineteenth century and was carried across the country. Quilts of this pattern are now found in every region. According to Ruth McKendry in *Traditional Quilts and Bed Coverings*, the Princess Feather derives its name from a design based on the emblem of the Prince of Wales. Therefore, it is also called Prince's Feathers, Prince of Wales Feathers, and even George Washington's Plumes. Traditionally, the Princess Feathers had a flower or star appliquéd in the center over the point where the quill end of the feathers met. When an eight-pointed star was used, as in this quilt, the pattern was sometimes called the Star and Plume. It seems particularly appropriate that this mother and daughter of English ancestry chose the Princess Feather. According to family tradition mother and daughter were quilting on this quilt when a rider came by and informed the family of the assassination of President Lincoln.

This quilt of red and green solid cottons is beautifully hand appliquéd with a blind stitch to a muslin top and then splendidly hand quilted with nine-stitch-per-inch diamond crosshatching accented by feather medallions. The pattern is very difficult to appliqué, so many quilters forgo the border, but not these women. The feathered vine border is the crowning touch to their handsome quilt.

Both mother and daughter were born in Ohio; later the family moved to Iowa. About 1871 Isabella (known as Belle) married John L. Rhodes, a native of Virginia. He was not only a farmer, but a beekeeper, a teacher, and a lay preacher as well. By 1875, when the second of their four children was born, John and Belle were settled in Nebraska, making their home near Beatrice in Gage County.[2]

84

Isabella Irene Wilson Rhodes

Rebecca Gouffin Wilson with her husband, Alex

34 Princess Feather

Cotton
85" × 85"
NQP 4635

Circa **1865**
Made by Rebecca Gouffin Wilson
(1829–1899) and Isabella Irene Wilson
Rhodes (1850–1929)
Made in North English, Iowa, and
brought to Beatrice, Gage County,
Nebraska, in 1881 or 1882
Owned by Sara Rhodes Dillow

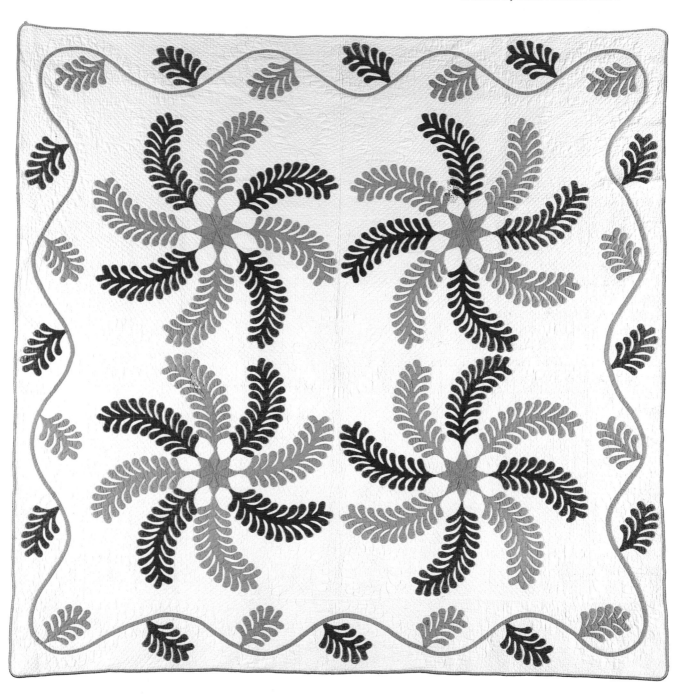

THIS CLASSIC appliqué design in classic appliqué colors of red and green has been handled with freshness and confidence. Five large blocks are set on the diagonal; the flower stems form generally upright crosses, but a stronger secondary effect is that of double rows of red roses moving diagonally across the quilt. Red rosebuds which almost touch form another visual link between the blocks. Flowers and green cockscomb shapes are bold and flat; the yellow-and-red centers are intricately pieced, then appliquéd in place.

The fill-in half and quarter blocks add new but carefully related elements to the design. Corner blocks use two rosebud branches similar in form to those in the blocks but introduce a small yellow flower with a red center. This new flower echoes the shape and reverses the colors of the large red flowers.

Motifs from the central rose are rearranged in the half-block fill-ins. The green cockscomblike shape, which is a distinguishing feature of this pattern, has been simplified, becoming a sort of pot or vase to hold the flowering branches. The rosebuds are the same; this time the flower is taken from the intricate center of the block, ending with scalloped yellow petals. Against the creamy white of the muslin, the yellow petals seem to give the effect of a halo or glow, very different from the angular red-and-yellow contrast of the blocks' centers.

The running-vine border uses conventional elements in a way that may have been the maker's own design.

She seems to have been unsure how many undulations to have on each side, though the corners are fairly smoothly turned. It is also unusual to have all the foliage growing on one side of the vine, as if the other side had been pruned. The double branches with a terminal rose echo the double rosebud branches of the corner blocks. In three of the corners adjacent branches share a rose—the maker's solution to a space problem.

Exceptional stitching skills mark this quilt. The red, green, and yellow calicoes are finely appliquéd and outline quilted; the teacup quilting on the background is done with ten stitches to the inch. All hand stitched except for the machine stitching joining the front to the back along the edge, this quilt shows the level of needlework skills which women brought to Nebraska.

The maker, Susan Isabell Cherry Fellers, was born in Illinois; she came with her mother and twin sister by covered wagon in 1870 when she was fourteen. According to Nebraska Historical Society records, she lived near Clatonia when she worked on this quilt. Although elaborate appliqué quilts such as this are usually associated with affluence, the 1870 census records indicate that her mother worked as a maid. The endless vine border, which symbolized a bride's hope for unending love in marriage, may indicate that the quilt was made in anticipation of her marriage, though it does not have the hearts traditionally associated with brides' quilts. In 1876 Susan married Wesley Fellers of nearby De Witt. The couple farmed for the next twenty years near De Witt, where their four children were born. They moved to Chester, near the Kansas border, in 1896, and were still there at the time of the 1910 census.[3]

35 Whig Rose Variation

Cotton
90" × 86"
NQP 4055

Circa **1870–1875**
Made by Susan Isabell Cherry Fellers
(1856–after 1910)
Made in Swan Creek Precinct, Saline
County, Nebraska
Owned by the Nebraska State
Historical Society (#9349-1)

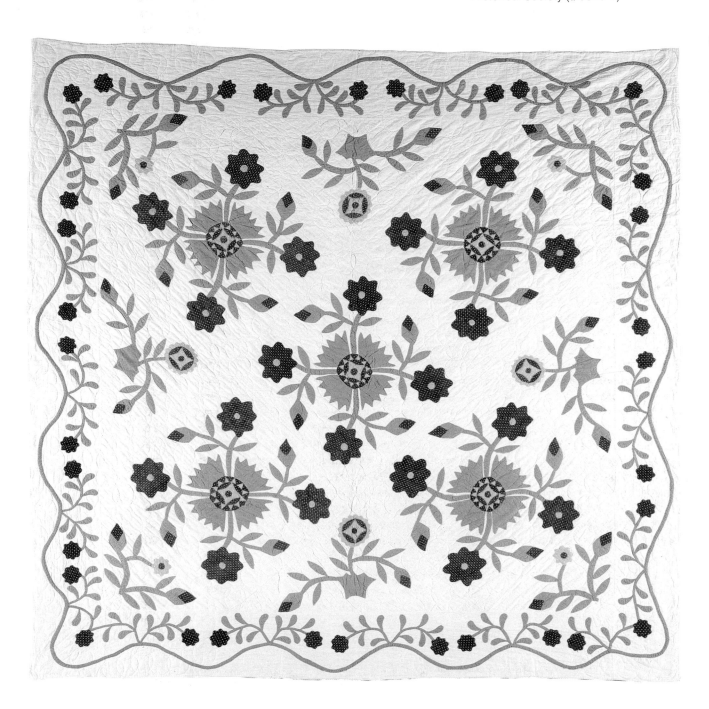

HIGHLY UNUSUAL in both color and design, this striking quilt testifies by its profusion of hearts to the family tradition that says it was a bride's quilt. Hearts adorn the border and the block corners and intersections. More subtly, the large central flower, which resembles the basic Rose of Sharon in its outline, is made from four heart shapes joined together.

The four leafy branches which ally the block to the Rose Cross appliqué types are also unusual. Instead of leaves tapering from large to small at the branch tip, the smallest leaves are closest to the central flower, showing the maker's sense of proportions. The two sets of smaller leaves curve slightly, echoing the curve of the flower petals, creating an effect of ripples around the flower. The small flowers set between the branches join with the small leaves to suggest a circle around the flower. Different in shape and the angle at which it is set, the third pair of leaves forms an octagonal frame around the quatrefoil of hearts at the block intersections.

The five-inch border, on three sides, is also a rare design. Instead of the usual undulating vine, narrow bias strips form large and small scallops, which face the center rather than the edge of the quilt. Hearts alternate with pairs of diamond-shaped leaves in the curve of the large scallops.

In *Romance of the Patchwork Quilt in America*, Carrie Hall associates diamondlike leaves with simpler designs from the first half of the nineteenth century. Although this quilt shows an unusual design sensibility, it may be that the quiltmaker, who was born in 1823, was harking back to the quilts of her youth for inspiration. The color scheme of indigo blue and white is another consideration. Although blue and white have always been a favorite combination for pieced quilts, red and green would have been a far more likely choice for someone making a fashionable appliqué quilt in 1874. In fact quilt historians like Barbara Brackman have called the period 1850–1875 the era of red-and-green appliqué.

Quilting with eight stitches per inch outlines the designs blind-stitched to the muslin ground. The close packing of the appliqué shapes on the nineteen-by-twenty-inch blocks does not leave much room for the fancy quilting designs favored in the more open appliqué quilts of the period.

The maker of this unusual quilt was born Rachel Armstrong in 1823 in Newfield, New York, the daughter of a farming family. In 1846 she married Mial D. Chase, a farmer, and spent the rest of her life near Sullivanville, New York. She had six children. According to the family, this quilt was made in 1874 when her fifth child, Sarah Maria, married Stephen V. Parrott in nearby Elmira, New York. In 1881 Sarah Maria brought the quilt with her when she and her husband came by train to Albion, Nebraska, where they were pioneer settlers. Although little more is known of Rachel except her death in 1907, she probably passed on her skills and love of quilting to her daughters, for Sarah Maria made many quilts throughout her life. The quilt is now owned by Rachel's great-grandson.

Rachel Armstrong Chase with her husband, Mial

36 Indigo Appliqué

Cotton
89" × 72"
NQP 1184

1874
Made by Rachel Armstrong Chase
(1823–1907)
Made near Sullivanville, New York;
brought to Albion, Nebraska, in 1881
Owned by George H. Allen, Jr.
Detail on page x

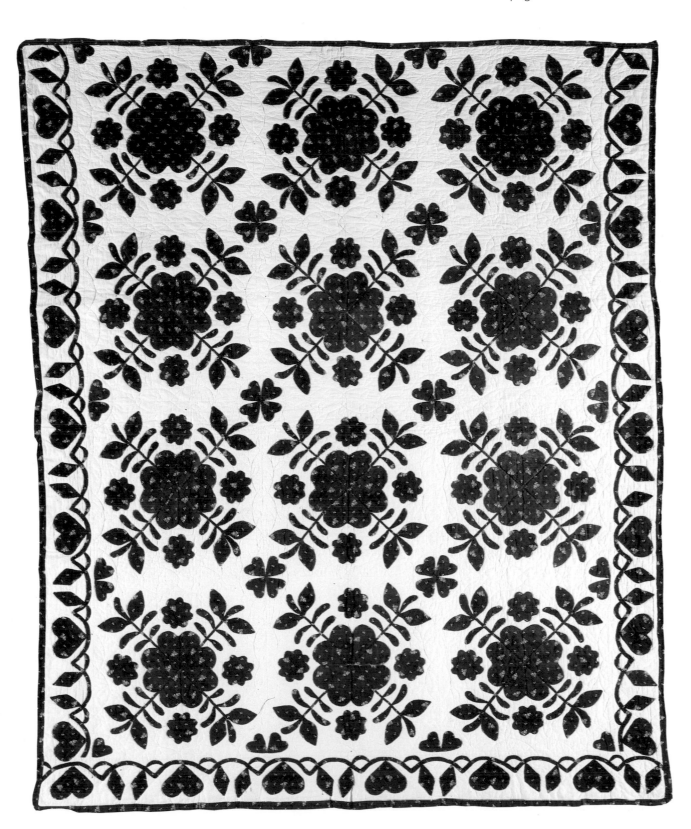

William A. Hutchison, for whom the quilt was made, and his wife, Anna Hookstra Hutchison

QUILTS WITH messages, that is, quilts whose dominant images are letters and words, are very rare. Patsy and Myron Orlofsky in *Quilts in America* show a pieced quilt from New York with pieced names, date (1833), and town. Very few quilts carry a message of such length as this, and perhaps only the Kentucky coffin quilt, with its name-inscribed coffins awaiting placement in an appliqué graveyard, has such a doleful perspective on life. The verses are similar to early-nineteenth-century hymns and the verses inscribed on mid-nineteenth-century album quilt blocks; this maker has enlarged the message to full quilt status.

The verses are believed by the family to be original to the maker, Anky Trump Ellison Hutchison, of Lindside, West Virginia. What her grammar and spelling lack in precision is made up for by the fineness and precision of her appliqué skills—there are no reversed *n*'s or *s*'s, those banes of the appliqué letter writer. The letters are not simple block print letters, either; though the styles vary, some resemble printing fonts, especially the *A*'s, *E*'s, *T*'s, and *V*'s. The lines of verse are kept straight by being appliquéd on horizontal strips of varying widths, rather than on a whole-cloth background. The red-lettered rhyming lines are embellished with red circles, eight-petaled red-and-green flowers, and a few crosses.

A narrow border, also probably original, surrounds three sides of the un-quilted top. The two sides have curved green plume shapes with red-and-green-petaled cockscomblike shapes, which recall the Princess Feather or Star and Plume designs.

William A. Hutchison, whose name runs up the right side of the top, was born in 1853 and reared by Anky Hutchison, his step-grandmother. The family believes the quilt was made as a wedding gift for William's marriage to Anna Hookstra on November 29, 1882; however, that leaves the February 1 date unaccounted for. Moreover, the marriage took place, according to the family, in Schuyler, Nebraska. The family does not know exactly when William came to Nebraska to join some of his uncles, but February 1 may have been the day set for departure; known long enough in advance for Anky to inscribe it on the quilt to be packed with William's things. Given the cautionary nature of the message, it is possible that the quilt was conceived as a going-away gift, a permanent letter of advice and warning to a young man setting off into the wilderness. Just why Anky thought the advice was needed is not known either. William became one of the important pioneers of Butler County. He played the violin, kept a set of law books, taught school, and owned and operated a grain elevator.[4]

The subsequent history of the quilt in the family furnishes an illustration of Marshall McLuhan's dictum, "The medium is the message." Despite the ominous warnings of the overt message, the red, green, and white cloth which constituted Anky's medium are so closely associated with Christmas and the holiday season that the quilt is known in the family as "The Christmas Quilt."

37 Verse Appliqué

Cotton
81" × 76"
NQP 101

1882 (marked)
Made by Anky Trump Ellison Hutchison
Made in Lindside, West Virginia;
brought to Edholm, Butler County,
Nebraska, in 1882
Owned by Lois M. Wolfe

ATTEND YOUNG FRIENDS WHILST I RELATE
THE DANGER S YOU ARE IN • :
THE EVILS THAT AROUND YOU WAIT
WHILE SUBJECT UNTO SIN • ✽
ALTHO YOU FLOURISH LIKE THE ROSE
WHILE IN ITS BRANCHES GREEN
YOUR SPARKLING EYES IN DEATH MUST CLO
NO MORE FOR TO BE SEEN • ✽
IN SILANT SHADES YOU MUST LAY DOWN
LONG IN YOUR GRAVES TO DWELL •
YOUR FRIENDS WILL THEN STAND WEPING ROUND
AND BID A LONG FAREWELL • ✽
HOW SMALL THIS WORLD WILL THEN APPEAR
AT THAT TREMENDOUS HOUR • +
WHEN YOU JEHOVAH VOICE SHLL HEAR
AN FEEL HIS MIGHTY POWER • ✽
O COME THIS MOMENT AN BEGIN
WHILE LIFE SWEET MOMENTS LAST
TURN TO THE LORD FORSAKE ALL SIN ✽
AN HE L FORGIVE WHAT S PAST 1882

HISON THE 10 OF FEB

WILLIAM A HUTC

HANDSOME IS the word that describes this dark, formal, finely made quilt. It is related in design to the more conventional red-and-green appliqué quilts of the nineteenth century. Originally, it would have been more closely related in color—the khaki leaves and stems were probably originally a brighter green and have faded over the last century. Still, it combines beautifully with the dark red and blue of the flowers. The dark blue is very unusual—the usual choice for an accent color in red-and-green appliqué would have been yellow.

Appliqué quilts of this type called for a maker's finest workmanship. This maker chose to display her exceptional skill with a sewing machine; the quilt is entirely machine appliquéd. No evident attempts have been made to simplify the design for machine sewing.

The design is very balanced and well proportioned. A central wreath of leaves surrounds the maker's chain-stitched signature and the date—"Etta Yinger. October. 24. 1883." Four triple-branched tulips grow from the wreath, balancing the small urns of tulips on the sides and filling the space between the large blocks. Two similar tulips grow from a blue ground in the four corners.

The urns that hold the large love apples and the smaller urns are in unusually good proportion to their contents. They are also unusual in their two-color design, suggesting a terracotta pot inside a navy cachepot, on a red base. The smaller urns have a similar inner liner on a smaller scale.

Although the maker's name for this quilt is not known, the round five-part "flower" is very like the Love Apple design shown by Hall and Kretsinger in *Romance of the Patchwork Quilt in America*, though it has a larger and more elaborate green calyx at its base. It is said to represent the fruit cut vertically in half, showing the core and seed areas. Usually the Love Apple was made as a single motif in a repeat block format. The combination of fruit, tulips, and urns may be original with the maker.

The quilting, on a very thin filler, is exceptionally fine, varying between ten and thirteen stitches per inch. There is a great variety of quilting designs filling all the open spaces—a cross, hearts, feathers, flowers, stars, as well as the outlining of the appliqué designs.

Henrietta (known as Etta) Yinger was born in 1860 in Hanna City, Peoria County, Illinois. She was one of the seven children of John and Rebecca

Rynerson Yinger, who farmed in the area. Her father, of German descent, had come from his native Virginia as a boy in 1836. When Etta was two, he joined an Illinois Regiment and served in the Civil War for three years, seeing action from Vicksburg south to Mobile. The family farm prospered after his return from the war, enabling the family to buy the sewing machine which Etta used to make this quilt when she was about twenty-three. Her deep religious faith is evidenced by a poem, possibly original, which she inscribed in her sister Fannie's autograph album:

Blest they who seek,
While in their youth,
With spirit meek,
The way of truth.

Never married, she lived in her parents' home until her death in 1924.

Her niece and namesake, Fannie's daughter Etta Mae Van Arsdale, came to Nebraska as a young child. After her mother's death, she returned to Illinois, where she was cared for by her aunts for a time until she returned to Nebraska to help keep house for her father on a farm near Inland, Nebraska. The quilt may have come with her at that time. It was kept in a trunk for many years, passing to the second Etta's daughter, Wilma Chatterson Hartzell, who gave it to her niece De Etta, the present owner and the third Etta, whose favorite color is the deep blue of this quilt.[5]

Henrietta Yinger, standing, with sisters, seated left to right, Fannie, Winnie, and Ada, 1882.

38 Love Apples and Tulips

Cotton
70" × 70"
NQP 3394

1883 (marked)
Made by Henrietta Yinger (1860–1924)
Probably made in Hanna City, Peoria
County, Illinois, and brought to Clay
County, Nebraska
Owned by De Etta Chatterson Edgar

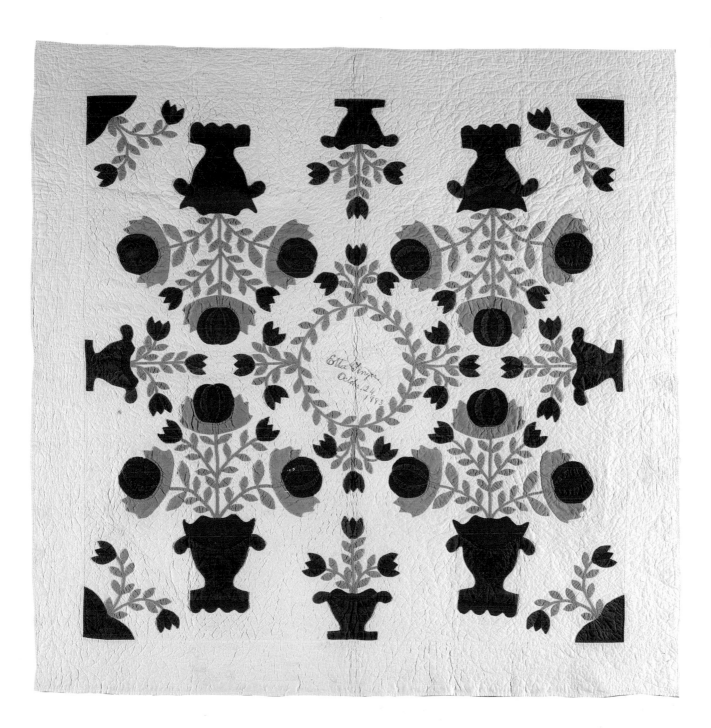

THE NUMBER of hours required to complete this exquisite medallion-style floral appliqué quilt is beyond imagination. There are over eight hundred tiny, near-perfect red circles alone, as well as yellow circles, countless leaves, and yards of slender trailing vine hand appliquéd with hidden stitches to the fine muslin top. A tiny red heart caps the point of the vine in each corner and midway along each side. The unbroken vine and hearts, customary in a bride's quilt, probably seemed very appropriate to the newlywed when she made this quilt. The quilt is unusual because it is a whole-cloth, medallion-style quilt. Red-and-green appliqué-style quilts were usually made as repeated blocks. Repeated blocks were much easier to handle because of their smaller size, but nothing was too tedious or time consuming for this labor of love. The quiltmaker did use her sewing machine to stitch the borders to the central medallion and the binding to the edges, but the hidden appliqué stitches and quilting stitches at eight to ten per inch are all by hand.

Maria started this quilt in 1894 and completed it during the first year of her marriage to Franz Suhr. The design harks back to the mid-nineteenth century, because she copied one of her mother's quilts. It is in very good condition, since she used it only on Sundays and special occasions. One of her daughters remembers hurrying to her parents' bedroom on Sunday mornings so that she could help make the bed on that one day each week when this special quilt was used!

Maria's father came from Prussia as a boy in 1853. He and his wife, Louisa, born in Prussia also, had their first child in Iowa in 1869. The second of their eleven children was born in 1870 in Nebraska, where the family had come in an ox-drawn wagon. Like many other early settlers they came from a nearby area and settled in the eastern part of the state.

Maria spent most of her life on a farm near Staplehurst, where she and Franz raised twelve children, four of whom were born in the first five years of their marriage. In addition, Franz's elderly father, a stone mason, lived with them in those first years. Although the elder Suhr was literate in German, he did not speak English, though he had lived in America since 1850. The demands of motherhood did not interfere with Maria's quiltmaking and other needlework activities. According to one of her daughters she made all the family's clothing, saving the scraps to make quilts in the winter months when the demands on a farmwife, such as gardening and canning, were lessened. While the family does not know how many quilts Maria made, they know she made a lot because they never had any "store bought" blankets in their home, only quilts. In addition, she made quilts for her children and grandchildren.[6]

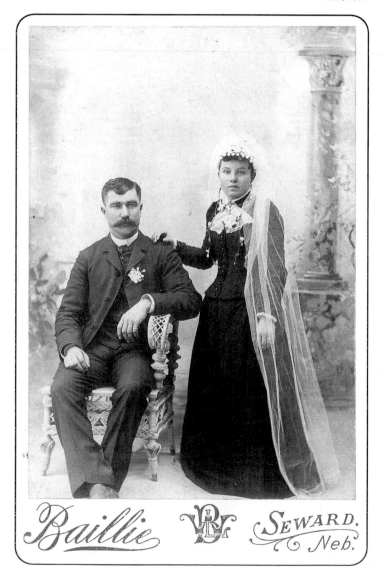

Maria Louise Rucksdaeschel Suhr with her husband, Franz, in their wedding portrait, 1894

39 Floral Wreath

Cotton
77" × 72"
NQP 2690

Circa **1895**
Made by Maria Louise Rucksdaeschel
Suhr (1875–1968)
Made in Staplehurst, Seward County,
Nebraska
Owned by Alma Suhr Knop and Evelyn
Knop Boyd
Detail on page 80

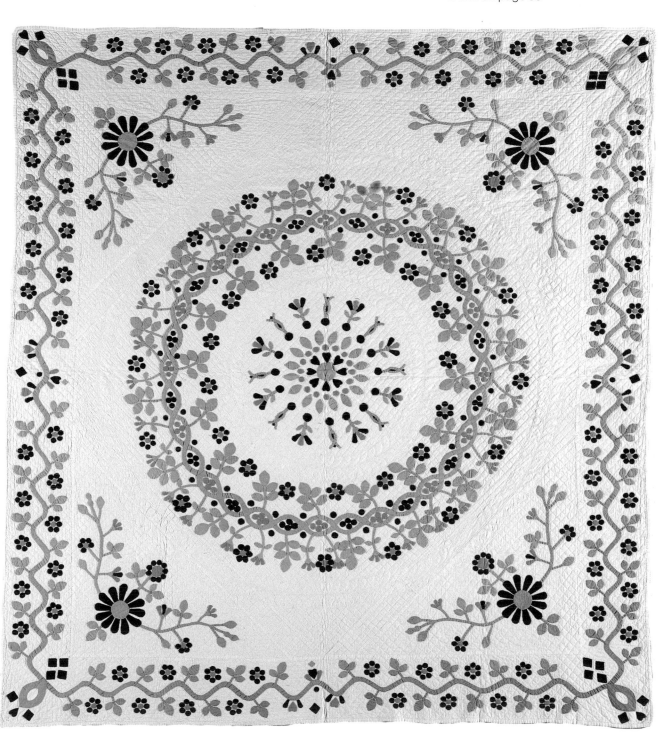

ENGULFED BY the "sunshine" of the warm yellow sashing, charming pots of colorful tulips bow to each other from the corners of each block. The quiltmaker used blanket stitches to attach the pots of tulips to the bleached muslin ground, but she assembled the repeated blocks by machine and set them together with a matching sashing purchased expressly for the quilt. The background of each block is crosshatched with quilting, while the tulips are outline quilted by hand. Quilted leaves grace the sunny yellow sashing. The pattern appeared in a magazine and appealed to Helen Catherine Ulrich and her mother, who made the templates for the appliquéd pots of tulips and then carefully cut them out of dressmaker's scraps. The pattern is similar to some of the triple-flower appliqué patterns shown in Judy Rehmel's *Key to 1,000 Appliqué Quilt Patterns*.

Helen was about fourteen years old when she made this quilt, with the help of her mother, for her dowry. She learned to quilt and to sew from her mother and began making quilts with her mother and three sisters when she was about twelve years old. Helen and her mother found quiltmaking a satisfying pastime and a good way to use up scraps.

Helen was born and raised near Creighton, Nebraska, on her parents' farm. Her father, Ferdinand (Fred) Ulrich, was born in Germany and came to Nebraska with his grandparents in the 1880s, when he was only four years old; he never saw his parents again. Little is known about Helen's mother, Mathilda Renner of Westpoint, Nebraska, except that she faced all the challenges common to a farmwife and mother of seven children. Helen married Henry Chalupnik in 1935 and moved to Verdigre, Nebraska, where their only daughter was born. Helen did not have as much time to quilt after her marriage because she was the bookkeeper for the family business, a car dealership. Still, she occasionally quilted through the years with a church group to raise funds for the Catholic church in Verdigre.[7]

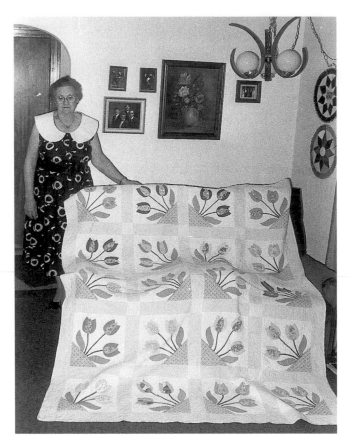

Helen Catherine Ulrich Chalupnik

40 Tulips

Cotton
81" × 66"
NQP 4632

Circa **1926**
Made by Helen Catherine Ulrich
Chalupnik (1912–)
Made near Creighton, Knox County,
Nebraska
Owned by Helen Catherine Ulrich
Chalupnik

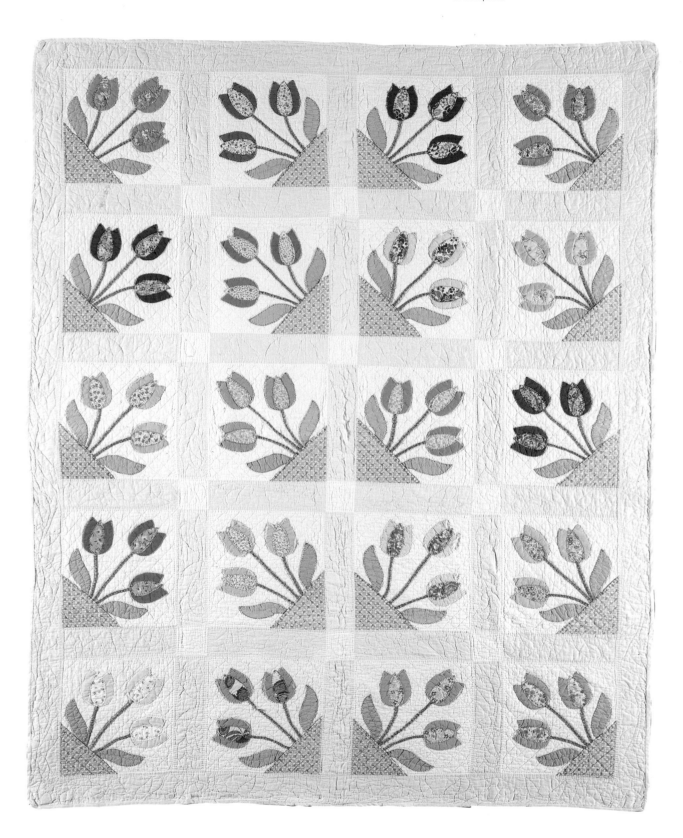

Ivy Speidel, circa 1935

ANY OF the favorite motifs of 1920s and 1930s needlework appear in the forty-two blocks of this appliqué and embroidered quilt. The Colonial Lady appears in several guises, holding a fan or parasol or flowers; crossed flags strike a patriotic note; a peacock spreads its art deco tail. Flowers and baskets filled with flowers were the favorite motifs; roses, poppies, tulips, morning glories, sunflowers, irises, water lilies, and more appear. A few roses are in the nineteenth-century appliqué tradition, but most are in the flat conventionalized style of the 1930s.

Most of the blocks are hand appliquéd, then finished with a decorative stitch, running or buttonhole, usually in a contrasting color. Even the block that is machine stitched has handwork covering it. Details are generously filled in with embroidery. Blocks are signed in running or outline stitch, and two are dated, 1934 and 1935.

The blocks were set together by machine, the seam covered with green herringbone stitch to match the border. Butterflies and abstract motifs are quilted on the blocks at the whim of the quilters. The six-inch border is crosshatched, with quilting at nine stitches per inch.

Members of the Kensington Club of Arbor, a social group still in existence, made quilt blocks for whichever members requested them. Several similar quilts were made, but some are now very worn. Some of the blocks in this quilt were made by relatives of Ivy Speidel—sisters and sisters-in-law—who were not members of the club but who knew of the project. The group met monthly; if the hostess had her quilt ready in the frame, the club members would quilt on it. Not many of the Kensington Club members were frequent quilters, but it was a skill they all possessed, regardless of their ages. The style of block does not seem to relate to the age of the maker—almost all the blocks are "modern."

In the depths of the depression, women needed to make friends and create things of beauty. This quilt represents women doing both. Because Ivy Speidel treasured the quilt and the memories of her friendships, the quilt is little worn, the colors still delicately fresh. Ivy gave her quilt in 1989 to Anne Parrott, who lives in the house Ivy lived in when the quilt was made. In fact, at least two other women who made blocks for this quilt have lived in that house, so the quilt has come home.[8]

41 Appliqué Album

Cotton
87" × 78"
NQP 4915

1935 (marked)
Made by Ivy Speidel (1899–) and
members of the Arbor Kensington Club
Made in Arbor, Lancaster County,
Nebraska
Owned by Anne E. Parrott

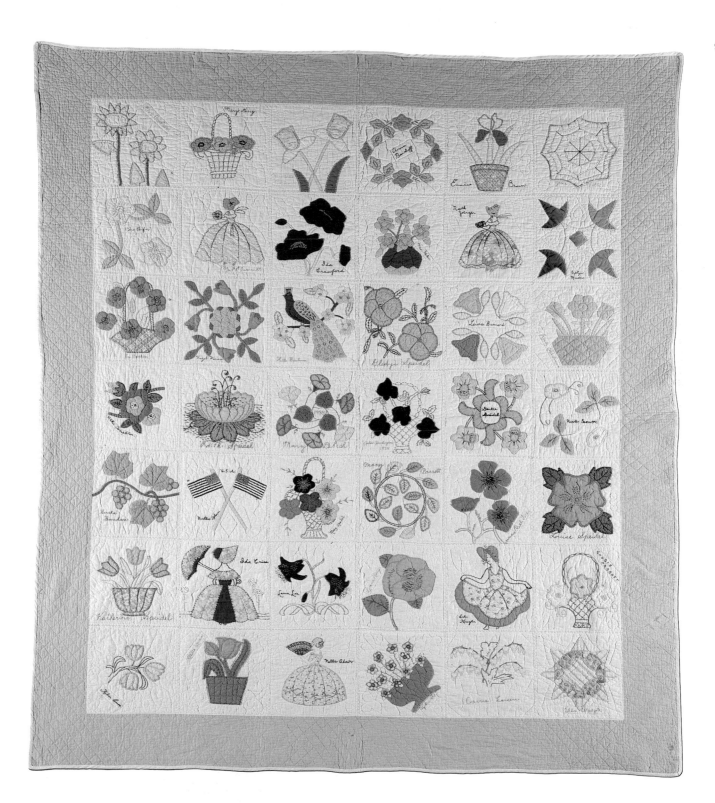

WINDBLOWN but demure, this variation of Sunbonnet Sue must have seemed very appropriate to a quiltmaker of the plains. The colorful hand-appliquéd and embroidered figures for this ambitious quilt are dainty in scale compared with many traditional Sunbonnet Sue appliqué patterns. Some of Sue's dresses were made from scraps of the quiltowner's dresses when she was a little girl; memories abound when the owner peruses her quilt. The eye never tires of looking at the figures because each dress is slightly different from the others in color and calico print. Hand-embroidered and -appliquéd pink flowers are repeated at the intersections of the green sashing and provide another visual treat for the viewer. Expertly hand quilted, each Sunbonnet Sue is appliquéd in place using a blind stitch, outlined with a decorative black running stitch, and then outline quilted on a background quilted in parallel lines. A scalloped edge with a quilted leaf design completes the quilt with the same attention to detail and fine needlework skills demonstrated in the embroidered and appliquéd blocks and quilting.

Sunbonnet Sue was one of the most popular appliqué patterns among the quilts registered in the Nebraska survey. This one is remarkably similar in appliqué and quilting pattern to one shown in Hall and Kretsinger's book. Many newspapers and magazines published variations of Sunbonnet Sues (also called Little Dutch Girl) during the 1930s. In fact, one variation is called the Kansas City Star Sue.[9]

Martha Louise Hinrichs was born on a farm in Adams County, Nebraska. Her German ancestors came to Nebraska in the last quarter of the nineteenth century and German was still spoken in the home when she was a child. When Martha was about eleven years old, her father, who was "never enthused about farming," gave it up and moved the family to Glenvil in nearby Clay County, where he went into "car sales." Because Glenvil had only ten grades of public school, Martha finished her last two years in Hebron, where she met her future husband, Edwin Grueber, a grain elevator operator and later a state patrolman.

Martha made this appliqué quilt for her first child, Donna, when her daughter was a small girl of three or four years. Grandmother Frances Schlachter Hinrichs, "a beautiful quilter," agreed to quilt it, making it a family affair. Grandmother Hinrichs had quilted for as long as her granddaughter, the present owner, could remember. Martha Grueber, like her mother, also quilted most of her life, beginning to make quilts as an adolescent and making her last quilt when almost eighty years of age. Failing eyesight forced both quiltmakers to give up a pastime from which they derived great personal satisfaction and one which allowed them to use up the scraps that accumulated in their homes, because they made most of their family's clothing.[10]

Martha Louise Hinrichs Grueber and Frances Schlachter Hinrichs, seated

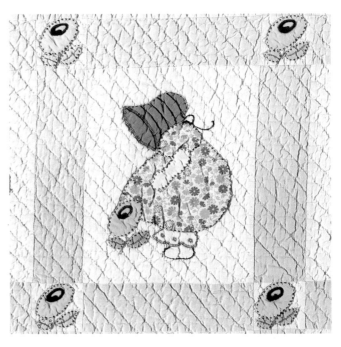

42 Sunbonnet Sue

Cotton
92" × 80"
NQP 3667

Circa **1935**
Made by Martha Louise Hinrichs
Grueber (1906–) and quilted by
Frances Schlachter Hinrichs (1887–
1975)
Made in Glenvil, Clay County,
Nebraska
Owned by Donna Grueber Christensen

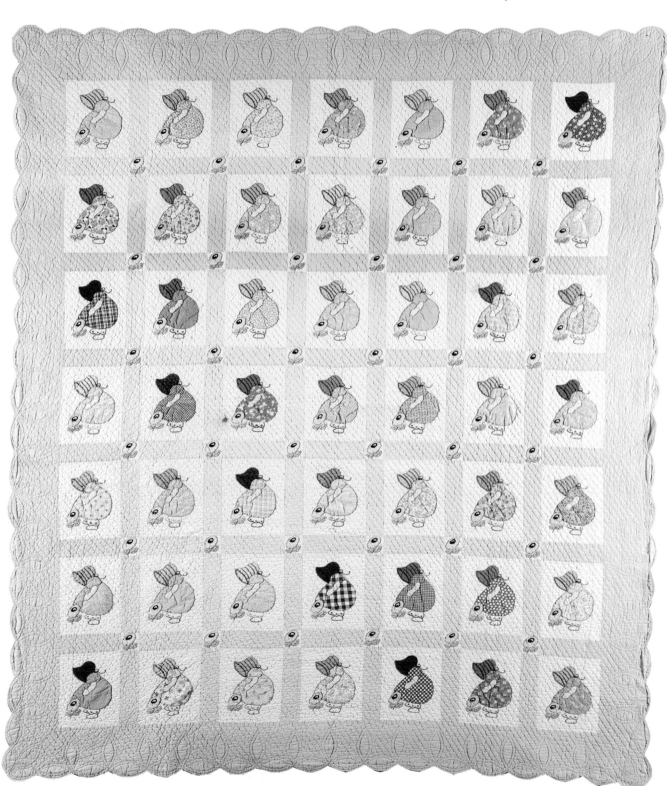

YELLOW-CENTERED scrap print flowers mark the intersections of the flowing diagonal lines of this strong yet graceful quilt. The sinuous twists of the cable, in two shades of a characteristic 1930s green, let the white ground show through at the centers, giving an openwork effect. The cable also borders the quilt, forming the scallops of its edges. A particularly interesting feature is the way the flowers extend over the apparent edge of the quilt; the flowers are rounded down to three petals at the corners, where three lines of cables meet. A close examination reveals that the darker green strand always twists over the lighter green in all the diagonals running one way; the lighter green strand crosses on top in the other set of diagonals.

The flowers and cables were basted on a whole-cloth top, then held down by the five-stitch-per-inch quilting. The large white spaces with their shaped edges were filled with a related quilted motif—a dahlia or sunflower with a double set of petals and a circular center. The eight-petaled dahlia probably came from a printed pattern source, but the overall combination of flower and cable may well have been original to the maker. The cable may have been inspired by the well-known quilting design; another possible source may have been Rose Kretsinger's famous Orchid Wreath quilt, featured on the cover of Hall and Kretsinger's *Romance of the Patchwork Quilt in America* (1935), which has a similar outer border in shades of orchid. The maker of this quilt made a similar one for the owner's sister, with the cable in shades of lavender.

Carrie Schlechte Stuhr, circa 1900

Carrie Schlechte was born in 1879 near Waco in York County. In 1901 she married Heinrich R. Stuhr, a native of Germany and a nephew of the present owner's grandfather. He was known as "Uncle Railroad Henry" from the railroad that ran near their farm, and she was known as "Aunt Carrie" in the large, closely knit Stuhr family. The present owner remembers her as a pretty, fun-loving, hard-working woman from weekly Sunday visits to all the relatives. She had a large garden, with fine strawberries and beautiful flowers.

As she grew older, problems with her legs limited her physical activities. As she directed her girls in the housework from her chair, she crocheted tablecloths and bedspreads and made quilts. Carrie made many quilts for her children, grandchildren, and others. Some were utilitarian, but she loved to do appliqué; her love of flowers was reflected both in her appliqué work and in her big flower garden. The present owner is not sure how she and her sister rated so special a gift as one of Aunt Carrie's quilts, but hers came to her on the occasion of her confirmation in the Lutheran church in 1935. It has been a special quilt for her ever since.[11]

43 Dahlia and Cable

Cotton
84" × 84"
NQP 3281

Circa **1935**
Made by Carrie Schlechte Stuhr
(1879–1942)
Made in Waco, York County, Nebraska
Owned by Irma Stuhr Cary

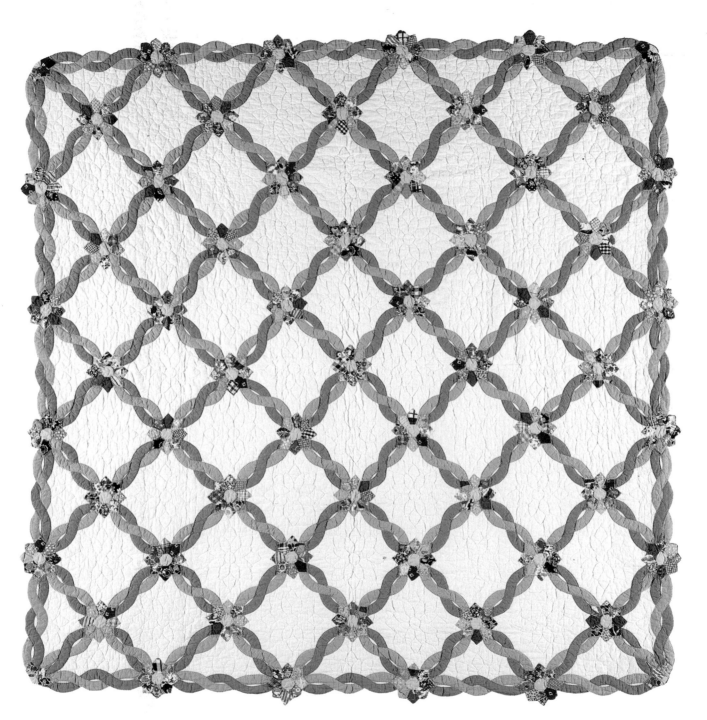

THIS QUILT has the joy and freshness of summer, created out of the depths of the basement in which the quiltmaker worked during the winter of 1936. The charming mixture of roses, purple morning glories, and yellow daisies is beautifully balanced without being at all formal or stiff. The daisy at the top turns shyly away, leaning slightly to the left, which helps to counteract the visual weight of the extra leaf on the right side. So does the solid-shaded three-layer rose, which contrasts with the white veins of the morning glory on the right. The bouquet tapers gracefully to fit the corners of the diagonally set squares with a pink Chinese lantern pod on one side, and a spray of bluebells on the other. Two of the stems curve in nearly perfect arcs, but one is slightly longer than the other. This quilt is a beautiful example of asymmetrical balance; the "art that hides art" makes it appear natural.

The colors of the bouquet run through the characteristic 1930s pastels. The bouquets on their fine percale grounds are set with alternate plain squares of a dusty rose—a color not found in the bouquets, but one that enhances them. The quiltmaker had the confidence to resist the safety of matching. This rose and cream field is surrounded by a creamy border with a floral vine, perfectly balanced. Although only the daisies actually "grow" on this vine, the placement of the other flowers seems to allude to old folk-art designs, where flowers and fruits of every description grow on one vine or tree.

The quilting is lavish, yet understated, subordinate to the appliqué. Bouquets are echoed in the quilting of the alternate plain blocks, with roses or morning glories repeated in the side triangles and daisies in the four corners. These motifs are set against a background of diamond crosshatching, which in the context suggests a fine lattice or trellis. The border is simply done in diagonal lines.

The revival of interest in appliqué in the 1920s and 1930s produced a profusion of new appliqué patterns from the designers of the period. Although the source of this unusual design is not known, the maker probably obtained it from a periodical or a mail-order source. The quality of the design, color, and workmanship earned the quilt a blue ribbon in a 1938 *Omaha World-Herald* contest. The ribbon remains attached to the back of the quilt, evidence of the pride the maker and her descendants have in her work.

Anna Rosacker was born in 1890, probably in the Fort Calhoun area where she spent her early years. Her father was a farmer and carpenter of German descent, her mother a homemaker. In 1911 Anna married William Wenke and lived with him in Pender until her death in 1970. They had three sons. An excellent seamstress, she made quilts for the love of the beauty she could create.

Anna Rosacker Wenke on her fiftieth wedding anniversary

44 Appliqué Flower Bouquet

Cotton
90" × 72"
NQP 1979

1936
Made by Anna Rosacker Wenke
(1890–1970)
Made in Pender, Thurston County,
Nebraska
Owned by Geneva Teare Wenke

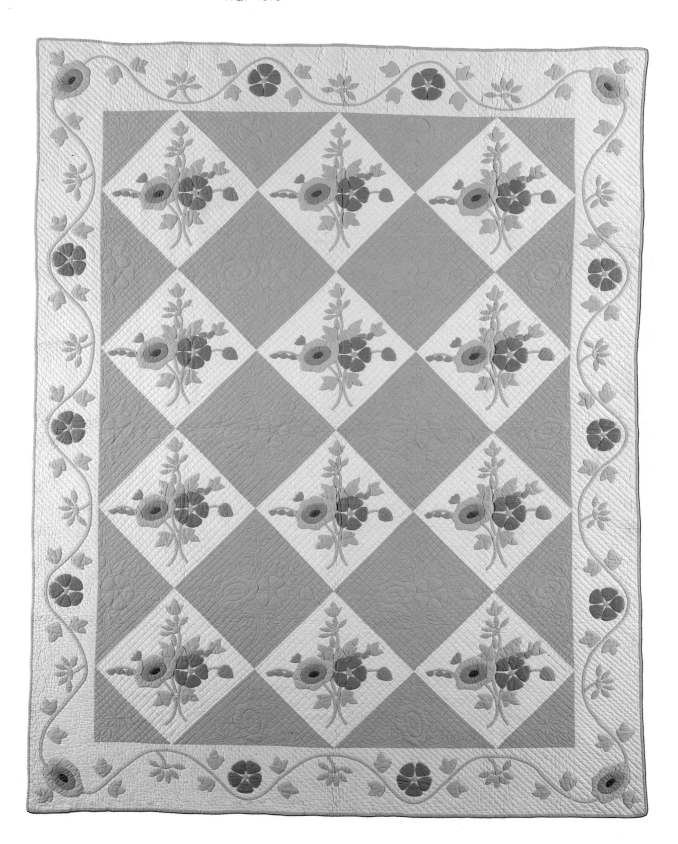

ROW AFTER row of gay tulips appear to bow to a wind like the one that sweeps across the plains. With a childlike simplicity each tulip and leaf was cut freehand, or so it appears, for the outline of each leaf and tulip is irregular, differing slightly from the others. The maker cut the central tulip for her original design from brightly printed feed sacks or dressmaking cuttings. She cut a few tulips from a solid-red cotton fabric and carefully positioned them so that each bleached muslin block contained only one bright red tulip. This splash of red leads the eye on a dance across the quilt, enlivening the pattern of repeated shapes in repeated blocks.

Irregular blanket stitches in a variegated thread outline and secure each tulip and pot. The leaves and stems are whipstitched in place. Set together in checkerboard fashion by machine, the appliqué blocks, hand quilted in a crosshatch pattern, alternate with a warm yellow block quilted with a floral design. The scalloped edge attached by machine gracefully completes the quilt.

Anna (Annie) Lucinda Sadilek was born in 1869 in Prague, Bohemia (now Czechoslovakia). She came to America with her parents during the fall of 1880, arriving in Red Cloud on the Burlington railway's "immigrant car." Her father, Anton Sadilek, was a violinist in the Prague Symphony, evidence once again that the land and opportunities of the American West had broad appeal and brought many unlikely homesteaders to farm the West. They struggled during those early years through the trials of life in a dugout and later a sod house. Annie, the oldest child, began doing fieldwork at twelve years of age after her father's sudden death during their first winter in Nebraska. Her formal schooling was over forever. After that she worked in the fields in the spring and summer and as a hired girl during the fall and winter until she married John Pavelka at the age of twenty-six and moved to a nearby farm. As a farmwife and mother of thirteen children, her days must have been full. She sewed and knitted all her life and made a number of quilts in later years for her family, including this one for her granddaughter, who was Willa Cather's namesake.[12]

Annie was a lifelong friend of Willa Cather, whom she met while working as the hired girl for the Cather family's neighbors near Red Cloud. She served as inspiration for the stalwart Czech pioneer of Cather's novel *My Ántonia*. The *Life* magazine writer who interviewed Annie in 1951 when she was eighty-two was struck by her vitality, so like the character, Ántonia, whom Cather described as having the "full vigour of her personality battered, but not diminished."[13] This quilt, finished when she was over seventy years of age, accurately reflects its maker's spirit with its vigorous flowers, bowed but unbroken.

Anna Lucinda Sadilek Pavelka. Courtesy of the Willa Cather Pioneer Museum Collection, Nebraska State Historical Society.

45 "Czech Tulip"

Cotton
86" × 71"
NQP 4354

Circa **1940**
Made by Anna Lucinda Sadilek
Pavelka (1869–1955)
Made near Bladen, Webster County,
Nebraska
Owned by Antonette Willa Turner

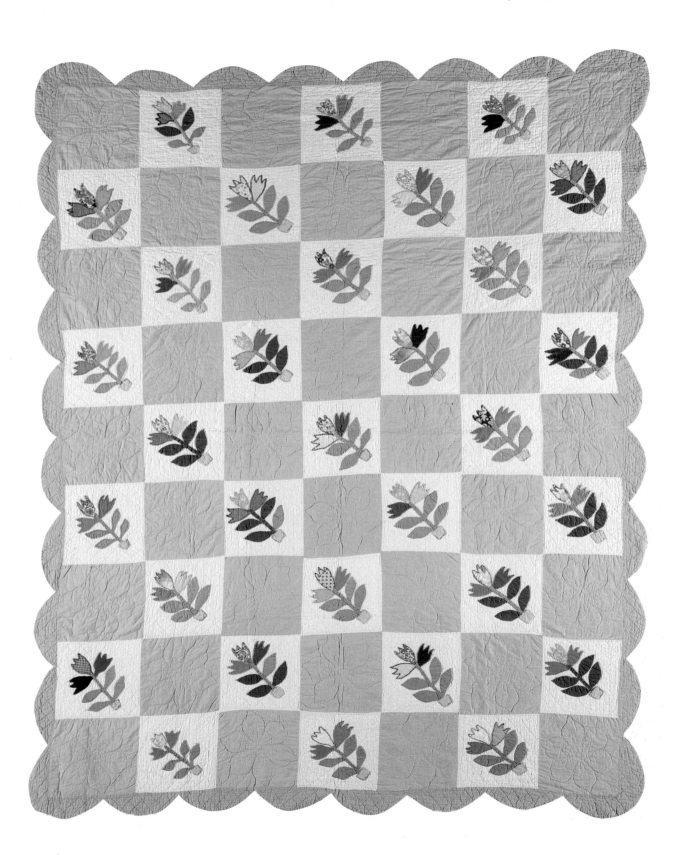

LARGE GRACEFUL sprays of warm red and yellow gladioli dominate the central field of this striking appliqué quilt. Smaller sprays, repeating the central theme, accent each of the four corners, carrying the eye round and round the scalloped edge. The gladioli and foliage were all hand appliquéd to the muslin ground then quilted with six top stitches per inch in parallel lines that radiate from the central spray to each corner. A quilted variation of the feather pattern frames the central spray and, as a thoughtful finishing touch, the scalloped edges are echo quilted to form a very subtle border.

Juliamae Duerfeldt, 1946

Juliamae Duerfeldt purchased this Progress kit no. 1355 for $5.98 from the May Company in Denver during the summer of 1946 while on a "working vacation" in Colorado with her older sister. Both sisters bought quilt kits as souvenirs of their trip and planned to make them for their "hope chests." But Juliamae did not enjoy the somewhat tedious and very time-consuming appliqué work and "kept putting off getting it done for forty-two years."

Juliamae comes from a family of quilters; her grandmothers, mother, aunts, cousins, and daughters all quilt. Juliamae estimates that she has made about a dozen full-size quilts and over a dozen baby quilts. Since she retired from schoolteaching she has regularly quilted for three hours twice a week with another quilter for their church.

Juliamae Duerfeldt was born and reared on a farm near Barada in Richardson County. Her German grandparents were among the early settlers of Richardson County. She graduated from nearby Falls City High School and returned to Falls City as an elementary school teacher after two years of teacher's training at Peru State College. In 1947 she married Marvin Dunn, and her teaching career was interrupted for a number of years by marriage and the birth of three daughters in four years. In 1958, when her children were of school age, Juliamae returned to the elementary classroom in Omaha, where the family had moved, and in 1961 completed her bachelor of science degree by attending evening classes and summer school at the University of Omaha. She taught second grade in Omaha Public Schools for twenty-five years. Although motherhood and teaching delayed the completion of her appliqué quilt, her determination prevailed and she finished the appliqué work and "quilted every stitch herself" in 1988.[14]

46 Gladiola

Cotton
93" × 78"
NQP 4448

1946 (started); 1988 (finished)
Made by Juliamae Duerfeldt Dunn
(1925–)
Made in Omaha, Douglas County,
Nebraska
Owned by Juliamae Duerfeldt Dunn

109

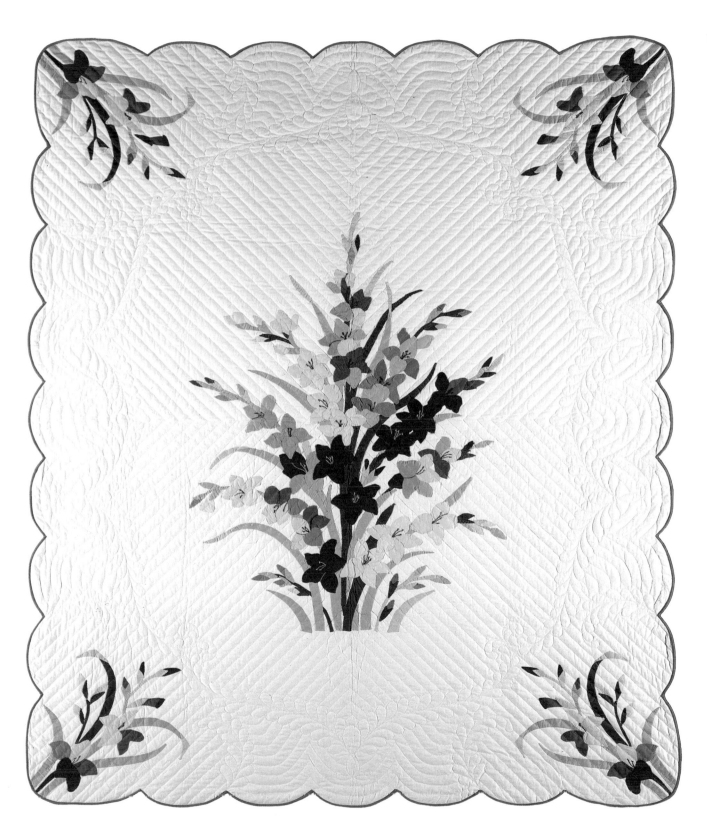

THE STIFFLY formal irises that form prim rows across this appliqué quilt reflect their times—the 1950s. Although each flower is identical in shape, no two are identical in color. Dressmaker scraps appear to have been used for the appliquéd petals that are buttonhole stitched to the creamy background of flour- or feedsacks. The variation in color among the flower petals was just the touch needed to offset the restrained repetition of shapes in the rest of the quilt and prevent it from becoming visually static. Large yellow French knots embellish the center of each iris adding an element of texture. Fabric may have been purchased for the solid green leaves and green gingham sashing.

The quilt is typical for this period in that it was probably made from a purchased pattern. While the actual pattern source is unknown, Sterns and Foster, a batting manufacturer, show this pattern in their *Mountain Mist Blue Book of Quilts* during the 1950s. Most quilters of the era were very familiar with the Mountain Mist patterns and their fine Mountain Mist quilt batting.

Laura Augusta Westerlin was born in Sweden but spent most of her life in Nebraska because her family immigrated to America in the 1890s when she was only two years old. Her family was a part of the wave of European immigrants who came to Nebraska in the late 1800s when "land fever" was at its height. Swedes were one of the largest ethnic groups to settle in the state during that period.

Married at sixteen to Adelbert Porter Miller, a farmer, she spent most of her married life on a farm near Overton, Nebraska. Because of the demands of child rearing and the many and varied tasks that befell a farmwife, she made most of her quilts after her four children were grown. Like many older quiltmakers she made a quilt for each of her granddaughters to serve as a memory and link to the family's past. According to her granddaughter Sandra Hanson, she quilted because it made good use of scraps from other sewing projects and because of the satisfaction she derived from creating a beautiful keepsake for her grandchildren.

47 Iris Appliqué

Cotton
88" × 74"
NQP 392

Circa **1950**
Made by Laura Augusta Westerlin
Miller (1889–1966)
Made in Overton, Dawson County,
Nebraska
Owned by Sandy Miller Hanson

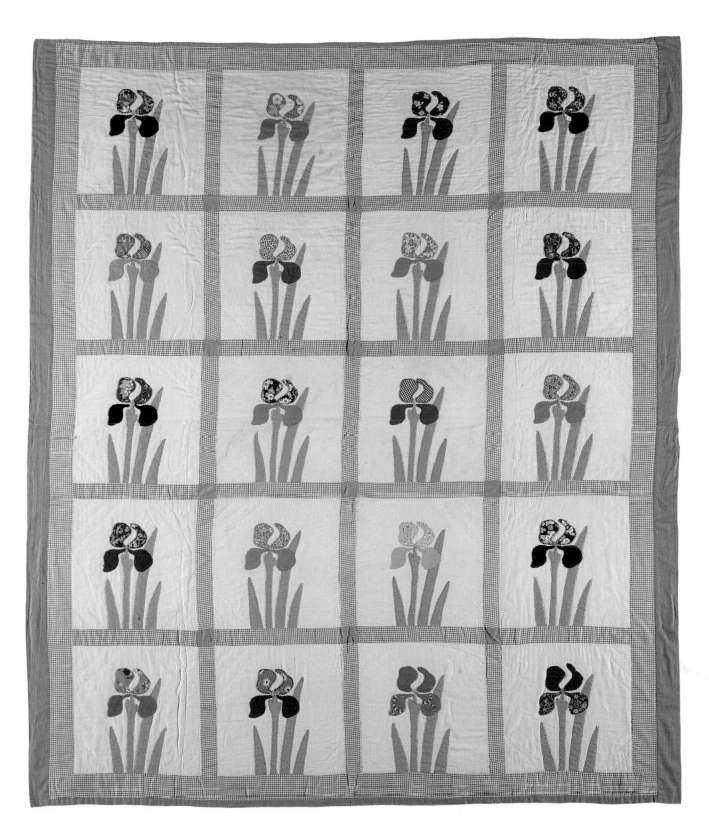

A GARDEN of golden roses recalls a golden age of quilting, the 1920s and 1930s, in its open, understated appliqué design, fine workmanship, and lavish quilting. The original design combines the straight lines and square corners of the trellis work and appliqué, which is

Martha Dortha Ostrander Peters

echoed in the crosshatch background quilting along the borders, with the gentle curves and natural forms of the roses and leaves. The graceful oval of the central medallion blends the two types; the straight lines are softened to a gentle curve and the irregular natural shapes are formalized into a geometrical shape. The maker's original approach to design is especially evident

in the way she has filled the central oval with the latticework and with a border of large and small buds. A more conventional designer would probably have chosen a full-blown rose for this focal position.

Form follows function beautifully in this quilt. Designed for a bed, the different areas—top, pillow tuck, pillow cover, and drop (border)—are clearly defined, yet all related. The double rose sprays on the pillow cover balance the one at the foot of the bed. The rose buds of the central medallion edge the top and bottom of the borders. A characteristic modern feature, the pillow tuck area is (usually) an open area to ensure that no part of the design is lost when the quilt is on a bed and tucked under the pillows. Here the empty space is filled with quilted feather wreaths and sprays which balance those below the center oval. Seldom has the tuck area been handled so elegantly.

The same care and attention to detail can be seen in the quilt's workmanship. The hand-appliquéd roses are subtly shaded. Stem stitching defines the petals of the roses and adds veining to the leaves. Exquisitely executed buttonhole stitches outline all roses and flowers. The lavish eight-stitch-per-inch quilting outlines the appliqué areas, crosshatches the border, and adds new designs to the texture of the

quilt in the feathers, wreaths, and swags and tassels. The shape of the edge of the quilt is defined by the swag-and-tassel border quilted just above it (which in turn repeats a design at the edge of the lattice border), so it is not simply scalloped but has scallops within the scallops as each one is cut around and bound.

This is Martha Dortha Ostrander Peters's fourth quilt, one she completed in less than a year when she was seventy-six. She was born in 1913 as one of a large family in Sheridan County, Nebraska. Although the women of the family were excellent seamstresses and made much of the family's clothing, the only quilts they made were utilitarian—usually tied comforters. Martha married Charles Richard Peters, a farmer, when she was eighteen, in 1931. In the hard years that followed, with four children to raise, quilts played no part in her life. After the death of her husband, she took her first job outside the home and farm when she was in her fifties.[15]

Later, after her children were grown, Martha bought a box of quilt pieces and Grandmother's Flower Garden blocks. After setting this together in an innovative way, and learning to quilt in a hoop, she resolved to make a different quilt for each of her daughters. The Rose Garden quilt was a gift to her daughter, the present owner.

48 Rose Garden

Cotton
112" × 99"
NQP 4794

1988
Made by Martha Dortha Ostrander
Peters (1913–)
Made in Gordon, Sheridan County,
Nebraska
Owned by Patsy J. (P. J.) Peters Timken

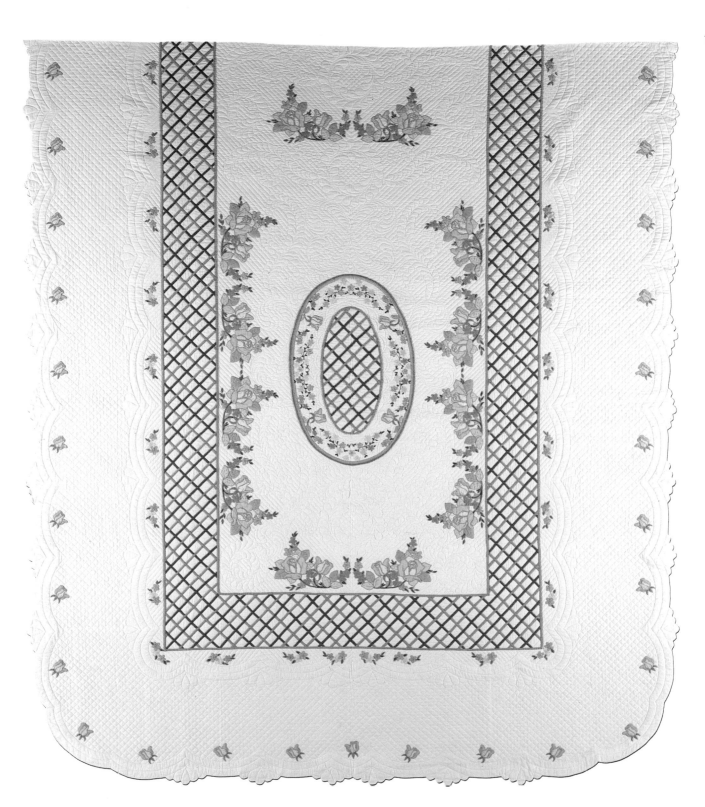

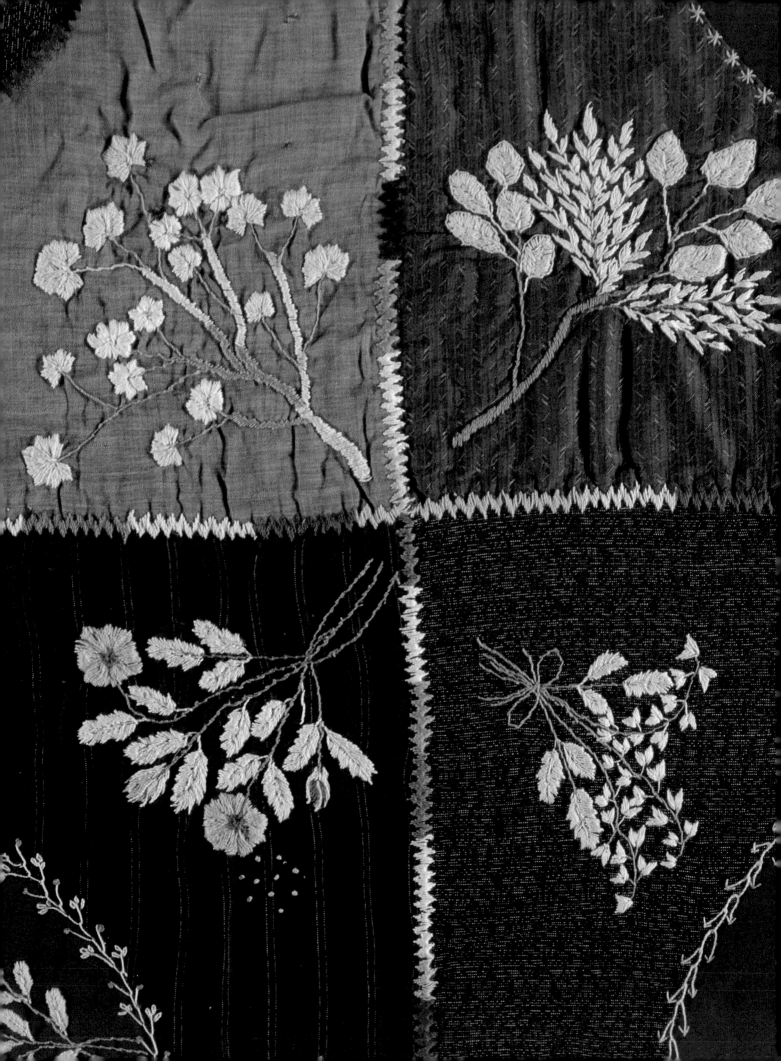

Stitches in Time: Embroidered Quilts

by *Kari Ronning* and
Patricia Cox Crews

FORETELLING THE heavily embellished Crazy quilts that would become the rage of needleworkers fifteen to twenty years later, this charming repeated-block quilt is quite distinctive in materials, design, and color. Freehand circles, dominating each block, are profusely embroidered with floral bouquets, fanciful birds, and horses, apparently at the whim of the maker, for a planned arrangement of embroidered figures is absent. The complementary colors of rich reds and wines on a background of dark olive greens further add to the powerful overall effect of this unique quilt. The quilt top is constructed of fine worsted wools in plain, twill, and fancy weaves. Each twenty-four-inch block is heavily embroidered along all sides with a long and short stitch reminiscent of a flame stitch. Inside each block, Mrs. Schacht formed the whimsical figures and embellished the block mainly with satin stitches and many variations of the featherstitch.

The printed cotton twill backing fabric is machine stitched together, indicating that Mrs. Schacht was an early owner of a sewing machine or that the quilt was rebacked at a later date. A minimal amount of quilting is used to secure the three layers along the seams. No one associated with the Nebraska Quilt Project had ever seen a quilt similar to this one, and we found no published illustration of a quilt resembling it, so the design traditions out of which this quilt was created are a mystery. In construction, however, it resembles a comforter. Comforters, or haps, as they were called in Pennsylvania German communities, used scraps of various materials, primarily woolens, and were often embellished with featherstitching.[1] Filled with a thick wool batting, they were usually tied or coarsely quilted.

The quilt was brought to Nebraska in the 1870s by Mrs. Schacht's son Ludwig (whose first name was later Anglicized to Lewis) Schacht. Lewis and his older brother, Henry, came to America in 1864 as young men of eighteen and twenty, seeking land and economic opportunities. Henry settled in Missouri, where he married an American-born daughter of German-born parents in 1868. They had twelve children. In 1878 Lewis married a young German-born girl who had come to the United States that same year. Family tradition says he returned to Germany to marry her. Lewis brought her to his farm in Nebraska, where the first of their eight children was born. About 1883, Henry and his family moved to Nebraska, settling on a farm adjacent to his brother's.[2] Their families have treasured this quilt, but little is known of its maker's life. Mrs. Schacht's great-grandson, Ken Dermann, is the current owner of the quilt.

49 Embroidered Wool Quilt

Wool
78" × 72"
NQP 2699

Circa **1864**
Made by Mrs. Schacht
Made in Westphalia, Germany, and
brought to Cook, Otoe County,
Nebraska, during the 1870s
Owned by Ken Dermann
Detail on page 114

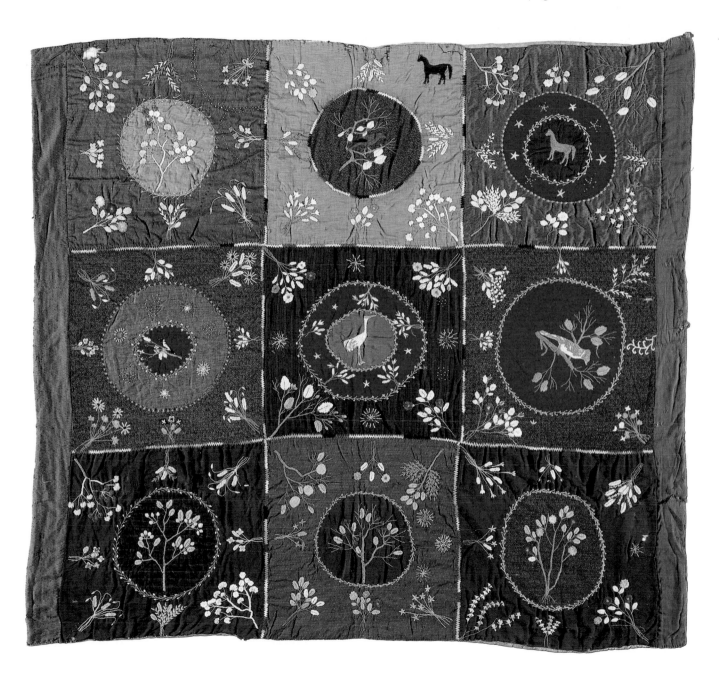

BEAUTIFUL COLOR, fabric, and fine stitchery make this whole-cloth spread unique among the quilts registered in Nebraska. The play of light where the smooth texture of the satin stands above the heavily textured background areas resembles stuffed work.[3] The designs are outlined by backstitches of silk embroidery thread so small and so uniform they look like machine stitching from the top. The backstitched outlines and additional embroidery stitches that embellish or stipple the background join all three layers; the thickness of the cotton filling gives the quilt a stuffed appearance.

The interplay of shapes and textures is fascinating. The central double squares form the base for four large daisylike flowers with palmlike leaves. The centers of the flowers and leaves are closely stitched while the surfaces of the petals and leaves are smooth and raised. The background of this area resembles stipple quilting in the close rippled texture, an effect created by a multitude of closely set tacks.

The central medallion area is framed by a new shape, an octagon with gracefully curved sides, which follows the outlines of the flowers and leaves. The center of this triple border echoes the design of the center square, and the whole is repeated in the square outside border.

Flowers in footed urns fill the corners of the intervening space, which somewhat resemble the urns of traditional American appliqué designs. Long branches reach out to fill the space and link with the smaller pots of foliage in the center. The background of this area has the same stippled effect.

According to a fragment of a letter in the family's possession, the quilt was made by four nuns in a German convent. Two nuns sat in chairs and two sat on the floor to push the needle back to the top; in this way the quilt was finished in two months. The thickness of the cotton filler may have made this method of working necessary. The fine quality of the stitching seems all the more remarkable for the way it was done, although it is probable that this was not the first such quilt made by these nuns.

The quilt was brought to the United States in 1891 as part of the dowry of Katherine Louise Kindsvater Pinnecker. She was born in Denhof, Germany, in 1867, the daughter of well-to-do parents. She may have attended school at the convent where the quilt was made, learning to sing and play the piano. Late in 1882, shortly before her sixteenth birthday, she married Henry Pinnecker, wearing a rich satin-and-lace wedding dress, which she also brought when the family came to Kansas in 1891. In 1892 they moved to Nebraska, where at least two of her eight children were born. Katherine went to the Mayo Clinic for surgery in 1909, and the next year the family moved to the new town of Dupree, South Dakota. Three years later she died and was buried in her wedding dress. The quilt, the other symbol of a very different kind of life, passed to a daughter and thence to one of her great-granddaughters, the present owner.[4]

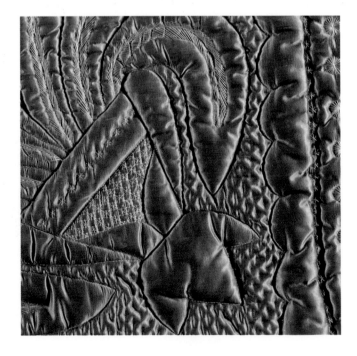

50 "Nun's Quilt"

Silk and cotton
82" × 80"
NQP 3860

Circa **1882**
Four nuns in a Roman Catholic convent
Made in Denhof, Germany; brought to
Nebraska in 1892
Owned by Karen Truesdell Schneider
Detail on page vi

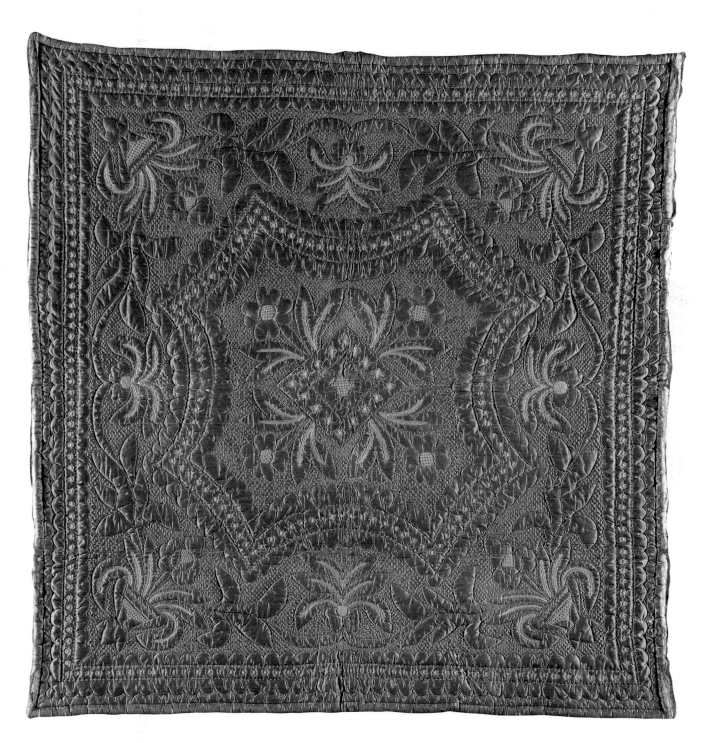

ADIATING SPOKES of red-embroidered signatures suggest wagon wheels on a bleached muslin background. There is no other color or design, no piecing or appliqué to distract the viewer from the impact of the three hundred names on display.[5] Their placement in groups not only forms the design but mirrors the society which made the quilt, in which individuals came together in groups such as families, churches, and communities.

This quilt is typical of the many signature fund-raising quilts made in the early twentieth century. Women had been making fund-raising quilts in a variety of patterns since the 1850s; but, by the turn of the century, quilts featuring signatures alone, usually in wheel-spoke arrangements like this one, were most popular and continued to be made into the 1930s.[6] Most quilts had at least 150 names and a few had more than 1,000; one such quilt is pictured in Patsy and Myron Orlofsky's *Quilts in America*. Red was the color of choice for the embroidery thread, perhaps because it was so visible as well as so colorfast.

Members of the Ladies Aid Society of the Wahoo Presbyterian Church dedicated their efforts on this quilt to a good cause—raising money for their minister's salary. They charged their friends, family members, and neighbors ten cents for the right to have their names embroidered on a block. Many early settlers of the Wahoo area contributed to the cause. Often many of the

signatures on a block share the same surname, suggesting family groupings. One block contains the names of several American Indians, including Ira Yellowfish, Wallace Whitebean, and Cameron Longlooks. In addition, a young lawyer and magnetic orator from Lincoln who had spoken in Wahoo on a number of occasions bought the right to have his name on the quilt: both Colonel William Jennings Bryan and Mrs. Bryan contributed to the quilt. Bryan was made a colonel when he headed a regiment of Nebraska volunteers in the brief Spanish-American War of 1898. He used the title of colonel only for that brief period, so the date for the quilt is firmly established.[7]

Fund-raiser quilts in the nineteenth century were often raffled, but by the turn of the century many churchgoers disapproved of raffling as a form of gambling. This quilt was sold at auction. Mary and Robert McClean, homesteaders about one and a half miles north of Wahoo, bought the quilt at the auction and kept it in the family until 1978, when Verna (Mrs. Knox) McClean willed it to the Saunders County Historical Society. Signature quilts preserve the memory of relationships that once existed, serving as historical documents of communities and as cultural artifacts that reflect community values.

120

51 Signature Quilt

Cotton
75" × 64"
NQP 2420

Circa **1898**
Made by members of Wahoo
Presbyterian Ladies Aid Society
Made in Wahoo, Saunders County,
Nebraska
Owned by Saunders County Historical
Society

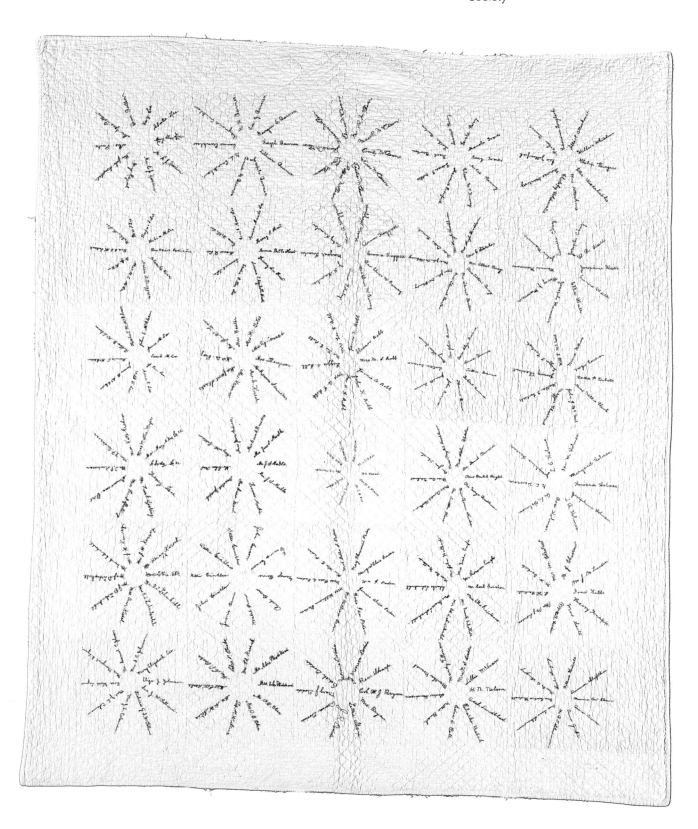

AN UNUSUAL combination of strength and charm sets this quilt of Turkey red and white apart. The strength lies in the visual impact of the checkerboard squares with their sharp contrast of color and simplicity of form. The charm is in the delicate and often amusing images on each of the five-inch blocks, for which the strong patchwork is meant to be the background.

Outline-embroidered quilts in red and white (or less often, blue and white) were popular in the last quarter of the nineteenth century and into the twentieth. Kate Greenaway figures were a popular design source, but this quilt is unusual in that there are few human figures. There is a child rubbing his or her eyes, and a more crudely drawn profile of a boy wearing a hat and tie (eleventh row, eighth from left), but most of the rest of the blocks seem to reflect the maker's taste for natural images—birds, butterflies, flowers, leaves, fruits, and animals. A few are of everyday objects—an anchor, a flag, teapots and other pots, names or initials, and dates. Some images are repeated, but often they are not done on the same colored block and thus the repetition is not apparent. Most quilts of this genre have only the white blocks embroidered; embroidering the red blocks is quite rare.

The variety of images is also noteworthy. There are many flowers in sprays, wreaths, or single blossoms. The birds are seen perching on branches, flying straight, swooping up or down, or in the case of the swan, swimming. The dogs lie down, sit on their haunches, or walk through the grass; the cats wash their faces, their paws, or sit with their backs to the viewer.

Probably most of the patterns for the embroidery came from commercial sources, women's magazines or pattern companies who advertised in them. The professed aim of these sources was to raise the standards of design of the public in reaction to the excesses of mid-Victorian tastes. One of the most important principles of the new movement in art was simplicity; outline quilts can show the charm of this quality. As a writer in *Peterson's Magazine* observed in 1880, outline embroidery was popular because it was "very effective, very rapidly done, and very cheap."[8] Those were all important considerations for the ordinary quilter, but note that the aesthetic consideration came first.

Most of what we know about the maker, Sarah Jane Lively Fugate, is from the quilt itself, called by the owner simply, "Sarah Jane's quilt." The red on white and white on red embroidery may indicate someone who could see and do things in somewhat unconventional ways. She could also persevere in a task that others might have chosen to do much more quickly—with larger blocks and alternate plain blocks, for example. Most evident in the quilt is a love of nature and the simple things around her.

Sarah Jane Lively was born in 1856 in Iowa, where her parents had come from West Virginia and Kentucky. In 1880 she married Robert M. Fugate, a farmer. Their first child, a girl, was born in 1882 in Iowa, but they moved to Nebraska sometime before their son was born in 1888. They had one more child. When Robert Fugate retired from farming, he established a creamery in town; Sarah Jane had a millinery shop in the front of the building. The family's circumstances were probably not particularly easy, which may help account for the time it took Sarah to make this quilt.[9]

Sarah Jane Lively Fugate with her husband, Robert, granddaughter, and neighbor's son in front of their shop, 1920. Sarah Jane operated a millinery business and sold laces and ribbons from the front part of this store. Her husband, also a drayman, conducted his creamery business in the rear of the shop.

122

52 Embroidered One Patch

Cotton
80" × 67"
NQP 4589

1909—1913 (marked)
Made by Sarah Jane Lively Fugate
(1856–after 1937)
Made in Johnson, Nemaha County,
Nebraska
Owned by Harriet L. Cook Hanson

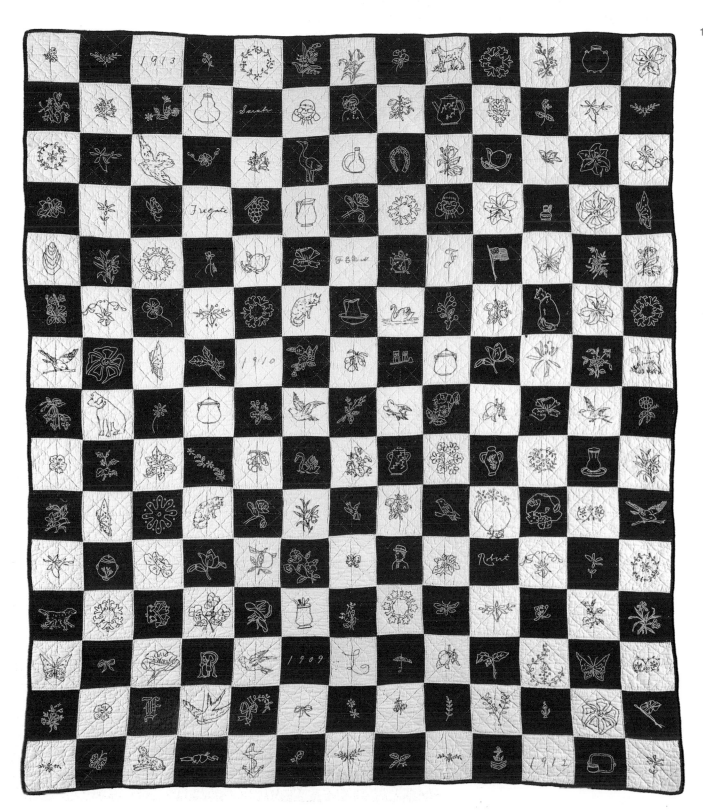

EACH OF the forty-two blocks of this black-and-white quilt is cross-stitched in black embroidery thread in a different design. At the top, four blocks contain the letters of the maker's married name in Old English—style lettering. The date, 1912, is in the fifth row down.

The designs vary in type from the letters to floral motifs, from abstract geometrics to stylized figures such as a cat washing its paw or a "colonial" woman. Some of the designs are reminiscent of patchwork, though they certainly do not try to imitate it. A commercial pattern from the women's magazines that encouraged gingham cross-stitch around the turn of the century or a mail-order company was probably the source of the design. Interest in cross-stitch at the turn of the century may have revived with the interest in things "colonial," such as samplers. If even-weave canvas or linen was not readily available, gingham, even the imitation printed gingham used here, made a suitable alternative. In the mid-twentieth century, gingham cross-stitch, sometimes called chicken-scratch embroidery, became popular again.

After each block was cross-stitched, it was backed with a coarse unbleached muslin and machine quilted, although there is no batting. The machine-quilting design differs in each block. Then the quilt was assembled, making this quilt an early example of both machine quilting and what is now called "quilt-as-you-go."

Susie Zadee Clute was born in Illinois in 1857. She married John M. Buck, a bucketmaker, in 1877. A Civil War veteran, according to family history he had lied about his age to enlist in the Union Army. While Susie was pregnant with her only child, lightning destroyed the farmhouse in which they lived. Ever afterward, her granddaughter remembers, she was terrified of electrical storms. In 1888, the family came to Sutton in Clay County, Nebraska.

Susie quilted with other women in the community. When a woman had a quilt ready, her friends came to work on it daily until it was done. She did embroidery and other kinds of handwork as well. Her granddaughter remembers that she changed clothes after the noon meal and put on one of her embroidered aprons; then she was ready to do handwork and entertain callers or to go calling on her friends.

After her husband died in 1925 Susie shut her house up and moved one block south to live with her son. When he died in 1940 she moved to Lincoln to live with a younger brother whom she had helped rear after their mother died. She died in Lincoln in 1952.[10]

Susie Zadee Clute Buck

53 Cross-Stitch Sampler

Cotton
78" × 61"
NQP 1082

1912 (marked)
Made by Susie Zadee Clute Buck
(1857–1952)
Made in Sutton, Clay County, Nebraska
Owned by Kathryn L. Buck

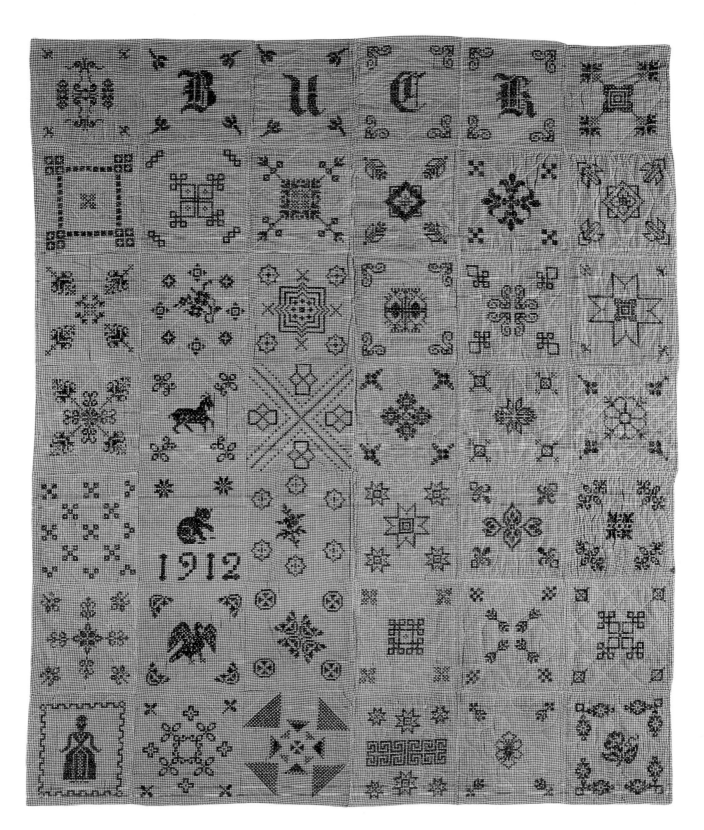

"THE NINE Patch Goes to War" would have been an appropriate title for this quilt, which conveys its purpose so simply and graphically. The red nine-patch cross which dominates the quilt is surrounded by a square composed of signature blocks, names neatly lined up. Blocks placed in the corners extend the outer squares; blocks placed in the center of this border extend the arms of the cross visually. Symbolically the signature blocks show how the Red Cross reaches out through and to people.[11]

Even before the United States entered the war in 1917, the Red Cross appealed to Americans for help for victims in the war zones. Many women's magazines campaigned to involve women on the home front. Since signature quilts had long been a popular fund-raising device, it was natural to enlist them in the war effort.

The Modern Priscilla, a popular women's magazine, featured a Red Cross signature quilt in its December 1917 issue. It had a large red cross centered on a muslin ground, surrounded by six-inch appliqué cross blocks with signatures. The article suggested a goal of one thousand dollars at ten cents a name.[12]

The same article mentioned the founding of the Junior Red Cross, listing the kinds of work that could be done by girls of various ages, from knitting comforters for French babies to making gun wipes, sweaters, and socks. Boys, the article said, "can make knitting needles and splints."

Mrs. Edith Wing's fourth-grade Sunday school class at the First Methodist Church in University Place, now part of Lincoln, was more ambitious. Guided by Mrs. Wing, they undertook a quilt project. Each child collected signatures at ten cents each, then embroidered the names in outline stitch and added his or her name at the bottom of the block. The present owner, a member of the class, remembers that the boys did their own embroidery. When the blocks were finished they were machine sewn together. Some of the women of the church did the quilting with crosshatching and parallel lines. When it was finished the quilt was presented to Mrs. Wing.

Most of the names were collected from relatives of the children: parents and grandparents, aunts and uncles. The quilt thus not only serves as a record of a particular cause in American history, it also records family and church ties.[13]

The Sunday school teacher
Edith Wing, 1944

54 Red Cross Quilt

Cotton
78" × 67"
NQP 3075

Circa **1917–1918**
Made by nine-year-old Sunday school
students of the First Methodist Church
Made in University Place (now Lincoln),
Lancaster County, Nebraska
Owned by Alice Wing Vanden Bosch

LARGER-THAN-life-size poppies embroidered in stem stitches with appliquéd centers dominate this quilt top. The entire quilt is made of a beautiful cotton sateen. The nine repeated blocks are bound together by white sashing with bright-red cotton sateen squares where the strips of sashing meet. The central blocks are simply quilted in diagonal lines, but each border boasts a successively more complex quilting pattern—crosshatching on the red border and a double cable in the outer white border.

The pattern source for this poppy design is unknown; however, it is unlikely that it was an original design. Embroiderers were not encouraged to create new and original designs until the latter half of the twentieth century. Many authors of nineteenth- and early-twentieth-century needlework magazines actually advised readers against trying to make changes in patterns.[14] Fannie apparently heeded such advice, for each embroidered poppy is identical to the other including the veining in each of the leaves. Outline work, as this type of embroidery is called, was first seen in this country in the late 1800s and soon became very popular because of the simplicity of the technique.

Fannie Medora Byerly was born in Roanoke, Virginia, on December 25, 1873. At an early age she came west with her family. In 1894, Fannie graduated from the Normal School in Shenandoah, Iowa, and later completed her education at the University of Nebraska in Lincoln. She taught school before and after her marriage to Frank D. Tecker in 1900. They had two sons, Ned and Max. Seeing no future in a "month-to-month" salary, they left Lincoln in 1902 to start a new life. Their love for the outdoors brought them to Dundy County where they bought a ranch near Parks. The early 1900s were a difficult time to start farming, but they were determined. To help with expenses Fannie began raising large flocks of turkeys for the Thanksgiving market. Although maintaining a happy home was her first priority, Fannie was very interested in the community, and she became active in the church, schools, and several organizations including P.E.O., Parks Club, and Eastern Star.

In 1917 while on a fishing trip to Estes Park, Colorado, Frank and Fannie were told the government had land to lease in Rocky Mountain National Park. They decided to take the lease and build a lodge for tourists in partnership with another couple. When the first lodge, called Forest Inn, burned down, the partnership dissolved, and Frank wanted to give up the lease because the ranch had expanded from a few hundred acres to several thousand and demanded most of his time. But Fannie said, "We never give up. I'll take over." And she did until her death in 1931.[15] Her quilt with its bold design from nature reflects its maker's ambition, determination, and love for the outdoors. It was a beautiful legacy for her family.

Fannie Medora Byerly Tecker

55 Embroidered Poppy

Cotton
85" × 77"
NQP 333

Circa **1925**
Made by Fannie Medora Byerly Tecker
(1873–1931)
Made near Parks, Dundy County,
Nebraska
Owned by Inez (Mrs. Ned) Tecker

GREEN AND yellow, the colors of growth and sunshine, frame the flowers and birds hand embroidered on the white muslin blocks of this impressive quilt made by Beulah Laughlin for her brother's high school graduation in 1940. The state birds and flowers of forty-eight states were lovingly and skillfully executed in a compact buttonhole stitch according to patterns published in the *Omaha World Herald*. The pattern for the first block was published on January 5, 1938, and the last on December 7, 1938, according to notes Beulah made on the patterns that she carefully saved. The buttonhole stitch adds a nice texture and creates a crisp outline for birds and flowers.

Beulah was only one of many Nebraska quiltmakers captivated and challenged by the state bird and flower patterns. Embroidered blocks of state birds and flowers set together in alternating blocks were among the most prevalent quilt types, following pieced quilts, registered in the Nebraska survey. Most dated from the second quarter of the twentieth century. That she devoted countless hours to each embroidered figure, no viewer would contest. In fact, she was so weary of the project when she finished the embroidered blocks and assembled them with matching sashing and borders that she decided to tie the layers together instead of embarking on the more time-consuming process of quilting them. Her brother Howard Laughlin, the proud recipient of this special quilt, treasured it and never used it, so it is just like new.

Beulah Bernice Laughlin was born on the family farm near Herman, Nebraska. Beulah's mother made quilts all her life and taught all of her daughters to sew, embroider, piece, and quilt. Judging from the results pictured here, Beulah's mother was an excellent teacher. When grown, Beulah moved to Omaha, where she worked as a housekeeper for a doctor for many years.

Years later when Christina Hagge Wilson, Howard's mother-in-law, saw the quilt, she thought it deserved to be properly quilted. So, she removed the ties and quilted it, although she was almost ninety years old. She had quilted for others for many years. In fact, she quilted more than one hundred quilts after she started keeping records of her work. Although an expert quilter, this was not her best work because of her age at the time. It has only five top stitches per inch. Christina Anna Hagge was born in Blair, Nebraska, to a family of German ancestry. In 1905 she married Edward Wilson at Blair, where they had two girls, Elsie and Harriet. In 1944 they moved to Herman after a cyclone devastated their farm and buildings. Harriet, their youngest daughter, married Howard J. Laughlin, the special person for whom this quilt was made.[16]

Beulah Bernice Laughlin

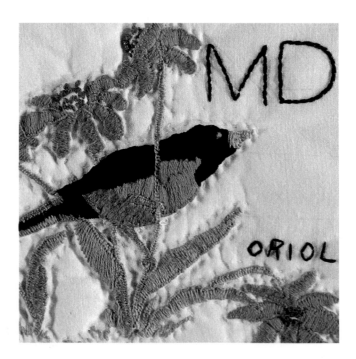

56 State Birds and Flowers

Cotton
88" × 69"
NQP 2210

Circa **1940** (top); circa 1970 (quilting)
Made by Beulah Bernice Laughlin
(1911–1982) and quilted by Christina
Anna Hagge Wilson (1886–1982)
Made in Herman, Washington County,
Nebraska
Owned by Howard J. Laughlin

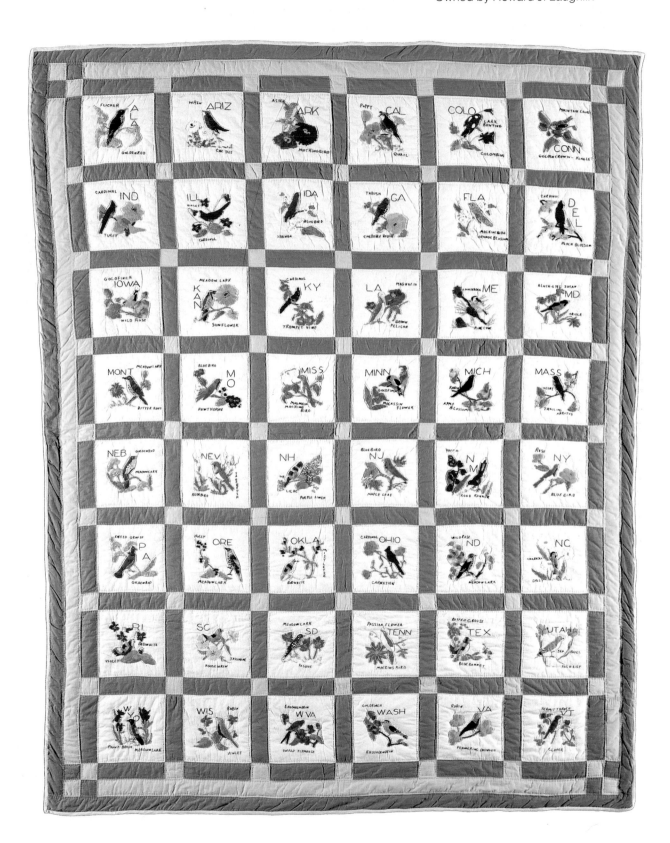

CAPPER'S WEEKLY was the source of the pattern for this patriotic quilt as it was for many midwestern quilts between 1930 and 1970. *Capper's* began as a farm periodical in 1879 and usually had one page for children, one or two pages for women, and the remainder devoted to agricultural news and advice. It is still being published on a bi-weekly basis, although it is now a newspaper with a human interest slant written for small-town families rather than farm families. About 1927, *Capper's* began printing quilt patterns.[17] Readers like Anna Rosfeld, maker of this quilt, could send in fifteen cents to receive an actual pattern. Anna was not the only Nebraska quiltmaker who was charmed by this pattern with its romantic scenes from America's past. Grace Snyder also made a quilt from these patterns and refers to it in *No Time on My Hands* as her "United States History Quilt."[18] Mary Ghormley, a Lincoln quilt collector and member of the Nebraska Quilt Project, has a slide of Snyder's quilt. The two quilts are identical in pattern and set in every respect, except that Anna embroidered all the American eagle blocks in black stem stitches, while Grace Snyder chose to outline quilt the eagle design on her white eagle blocks.

Outline embroidery, that simple but popular style, was chosen by Anna for the scenes from America's past such as the *Mayflower*, Betsy Ross stitching the flag, the Pony Express rider, and a covered wagon. Although she splurged and bought the red and blue cotton muslin to set it together, the embroidered blocks are salt sacks that she carefully bleached and washed. Their use embodies our pioneer mothers' ideals of thriftiness and resourcefulness.

Anna Magdelene Jungck and her family moved to Sheridan County in 1888. In 1908 she married Philip Rosfeld. They farmed and ranched in the area for the rest of their lives. During the winter months, Anna quilted frequently in her home and occasionally with church groups. Her practical and thrifty nature was the main reason for her quiltmaking. According to her daughter, she wanted to "use up left over materials from other sewing projects."

The quilt top remained unfinished until the 1970s, when the nation's bicentennial served as an impetus for her daughter, Margaret Wittig, to complete it. She backed it with a beautiful cotton sateen and finished quilting it in 1976. It was entered in the 1984 Dawes County Fair, where it was awarded a prize.

Anna Magdelene Jungck Rosfeld

57 American History Quilt

Cotton
104" × 89"
NQP 530

Circa **1940** (top); 1976 (quilting)
Made by Anna Magdelene Jungck
Rosfeld (1883–1951) and quilted by
Margaret Wittig
Made in Rushville, Sheridan County,
Nebraska
Owned by Margaret Wittig

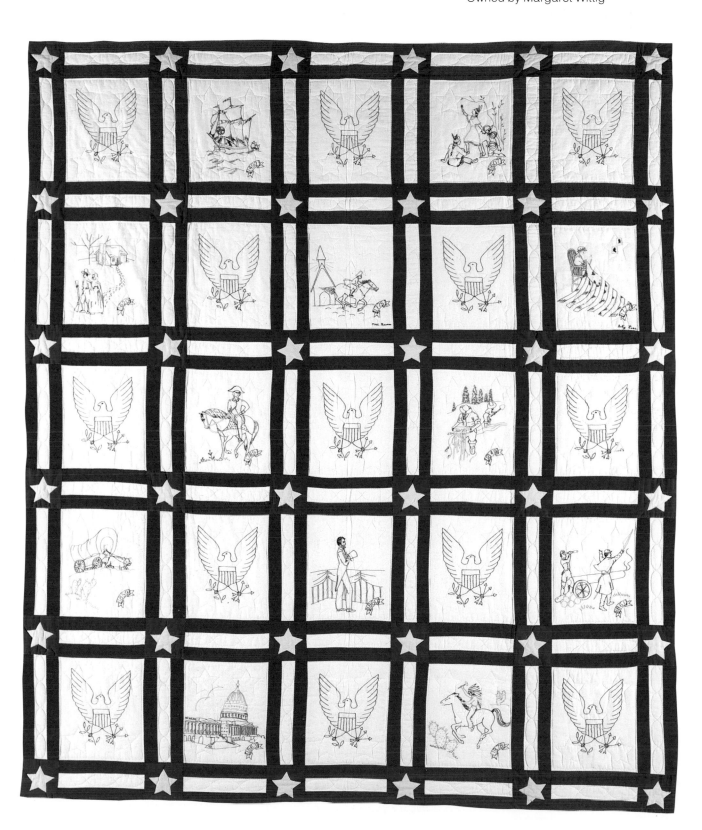

MODELED ON the popular rose appliqué designs, this example of the popular cross-stitch quilt kits of the 1960s is particularly pretty. The cross-stitching is dense enough to have the visual impact of appliqué fabric. The shaded stitches within each rose outline the unfurling petals; thus the embroidery makes effects possible that would be very difficult to achieve in appliqué.

The overall design of the top is similar to many of the high-style floral appliqué quilts of the 1920s through the 1940s.[19] It has a central medallion in an oval, framed by a border outlining the edges of the bed top; another border ornaments the drop at the bed's sides and foot. Scallops, whether in the quilt's physical edge or in the border design, were also popular throughout the period.

The open spaces between the center motif and the border motifs offer scope for lush quilting—feathers on a background of parallel lines, quilted with nine stitches per inch in this example. The grace of the whole top's design, and its suitability for a bed, help to account for its lasting popularity even when quilts were not generally fashionable.

Dolores Masur Lyne says she is working on handwork all the time. She was born in 1920 to a farm family of German-Polish ancestry in Johnson County. Dolores was one of six children. Her mother, busy with children and farm duties, did not have much time to teach needlework to her four girls. One of Dolores's aunts taught her to embroider when Dolores was a child; she says she is grateful every day for the pleasure her skill has brought her.

In 1945 Dolores married John S. Lyne. She was widowed six years later. The embroidery work she has done all her life has helped to sustain her. She has made seven or eight cross-stitch quilt tops. The kit for this quilt was purchased in 1967 at a department store in Lincoln for fifteen dollars. Dolores was interested in quilts mainly as a showcase for her embroidery skills, so when the work was finished four years later, she looked for a quilter. She found one in Hebron, Nebraska, who did fine work; the fee for quilting was sixty dollars.

Dolores remembers her mother making patchwork quilts—mostly everyday patterns such as "Bowtie." Now Dolores is becoming interested in patchwork herself. She took a quilting class and recently finished her first quilt that was all her own work, from color selection to quilting.[20]

58 Cross-Stitch Roses

Cotton
98" × 82"
NQP 3638

1967–1971
Made by Dolores Margaret Masur Lyne
(1920–)
Made in Lincoln, Lancaster County,
Nebraska
Owned by Dolores Margaret Masur
Lyne

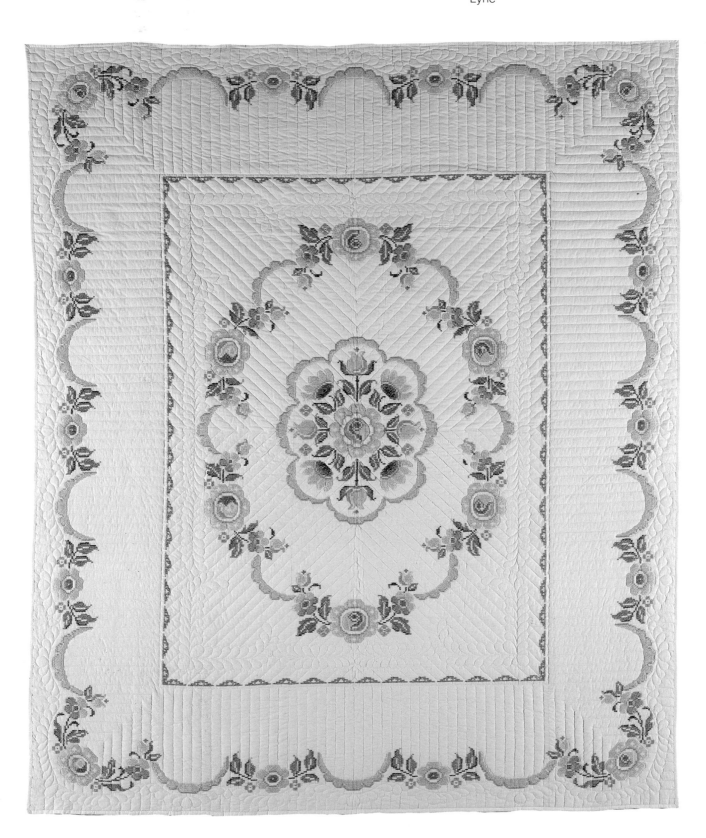

EW EMBROIDERED quilts have the vivid impact of this beautifully executed example. The twenty-four flower groups, consisting of one rose, three lilacs, and six leaves, are simple in form but varied in color. Each stands on its own against the creamy-white broadcloth background, inviting closer scrutiny of its beauty.

Each rose is done in satin stitch, with padded satin stitching of a darker shade defining each overlapping petal. Closely packed French knots of a lighter shade contrast in texture with the predominant satin stitch. The leaves are also satin stitched, forming a clean central vein; in some blocks the thread is a variegated green creating subtle shaded effects. The roses and leaves are all edged with tiny French knots—a very unusual feature—which softens their outline.

In contrast the lilac sprigs, done in tints and shades of blue, lavender, mauve, and the rare but botanically correct yellow, are formed of a lacy openwork of lazy-daisy stitches in groups of four-petaled florets. French knots are sprinkled more loosely around the lilacs, adding to the airy effect. The arrangement of lilac sprigs gives the design its basic triangular form.

The delicate effect of embroidered blocks is often overshadowed by the sashing. Here the sashing is marked entirely by the rope quilting, which subtly contains the crosshatching of the block backgrounds. The wide border with its gracefully scalloped edge is also crosshatched around the very elaborate feathered wreath motifs on the two sides.

The maker of this lovely quilt, Martha S. Tonjes Krueger, was born in 1904 in Pender, Nebraska. She was one of the younger members of a family of ten brothers and sisters. Her mother, a skilled needlewoman, taught her daughters many forms of handwork, including embroidery, knitting, and crocheting. Martha particularly enjoyed embroidery and developed her skills throughout her life, passing them on to her two daughters. She has made many quilts for herself and her family; the pieced quilts, generally regarded as utility quilts, were tied.

Her patterns come from many sources; her daughter Bonnie found this Rose and Lilac in a newspaper, and other patterns came from periodicals such as *Capper's Weekly* and the *Nebraska Farmer*. Her first Rose and Lilac quilt was made in shades of pink and rose for Bonnie. When she asked her daughter Beverly what color to make hers, Beverly said to take the seed catalog and make each flower a different color. Martha let her imagination free to mix colors, with the result seen here. Her best quilts, the ones which show her embroidery skills, are quilted, sometimes by a church quilting group, as was this fine example, which won Best of Show at a Cuming County Fair in West Point, Nebraska.[21]

Martha S. Tonjes Krueger

136

59 Rose and Lilac

Cotton and polyester/cotton
96" × 90"
NQP 1943

Circa **1970**
Made by Martha S. Tonjes Krueger
(1904–)
Made in Bancroft, Cuming County,
Nebraska
Owned by Martha S. Tonjes Krueger

137

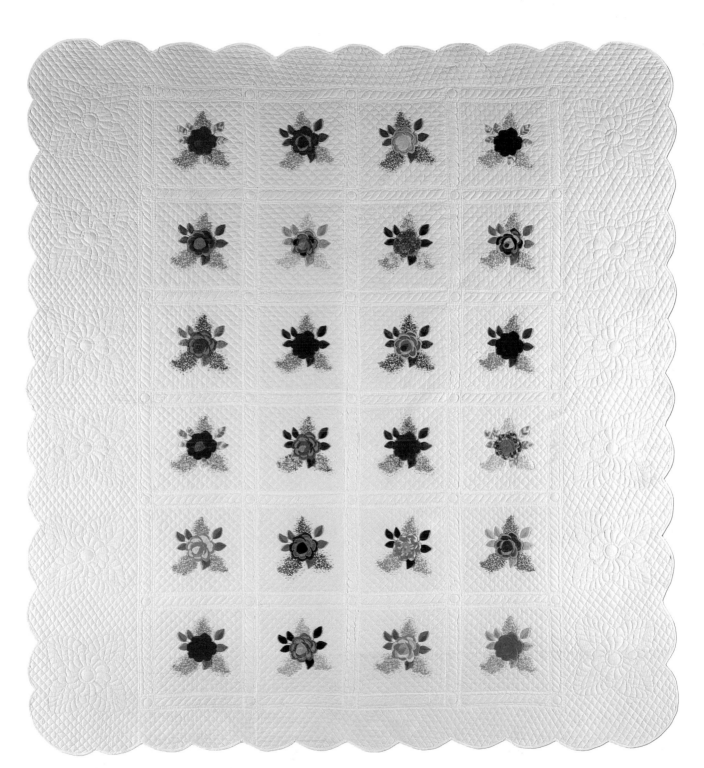

WOMEN'S HANDICRAFTS, women's activism, and women's literature are all part of the background of this truly Nebraska quilt. Traditional women's skills of fine embroidery and quilting have been called upon in the service of a civic cause, the Bess Streeter Aldrich Foundation, which helps support the public library of the city of Elmwood. This raffle quilt is one of a series illustrating the novels of Mrs. Aldrich, who lived in Elmwood for many years and whose novels often are set in Nebraska.

The embroidered thirteen-inch blocks, framed in a dark-green sashing and bordered in quiet calicoes and white muslin, show key moments and themes from Aldrich's *The Rim of the Prairie* (1925). Elaine Bornemeier and Mary Miller designed the blocks, which they and eleven other Elmwood women executed, mainly in stem and satin stitches.[22] The title block, which shows the rolling prairie hills, and a block depicting a tornado use appliqué.

When the blocks were completed and set together, the quilt was quilted by the Elmwood Quilters, a group which has been quilting since the early 1950s.[23] Along with outline quilting, the key motif is of hearts. Hearts in sprays of leaves are on the sashing; double hearts are in the intersecting blocks; hearts and parallel lines are in the border, all with six to eight stitches per inch.

The scenes of the story and the blocks are characteristically Nebraskan—the pioneer's cabin, the rolling plains, the fields and birds. The people of Elmwood like to think that Bess Streeter Aldrich was writing of her hometown, so they show the real Elmwood depot as it looked in the early part of the century, complete with the big cottonwood which still stood in 1986, to represent the fictional Maple City depot. The central characters of the novel have a deep love of nature and the homes they have made on the prairie. One of them, Jud Moore, often talked of trees and of the interconnectedness of nature; a block on the quilt shows four characteristic Nebraska trees, the apple, osage orange, maple, and cottonwood, all intertwined together, symbolizing both nature and the interconnected lives of the story's characters.

The history of the quilt itself demonstrates the Aldrich theme. The owner, Maechelle Clements, was the fortunate holder of the winning raffle ticket which gave her this quilt. Her husband, Richard Clement, grew up in the Aldrich house in Elmwood; his parents have lived there since they bought it when the Aldriches left Elmwood. Richard is now president of the American Exchange Bank in Elmwood, which his grandfather co-owned with Mrs. Aldrich's husband and brother-in-law.[24] Seldom does a commemorative quilt find such an appropriate home.

The Elmwood Quilters. *Left to right:* Florence Stolz, Elsie Wendt, Lavina Backemeyer, Martha Vogt, Ella Kunz, Mary Halvorsen.

60 "Rim of the Prairie"

Cotton
100" × 81"
NQP 2688

1986 (marked)
Made by women of Elmwood
Made in Elmwood, Cass County,
Nebraska
Owned by Maechelle Clements

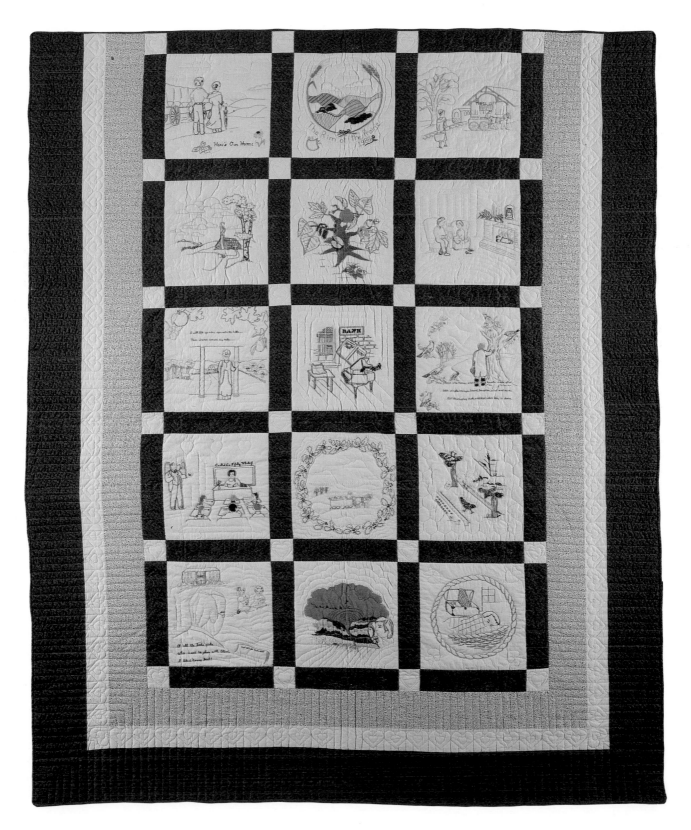

ELABORATE AND meticulously detailed embroidery distinguishes this quilt and repays close and careful scrutiny. This type of pattern, popular since the 1920s, is usually done in simple outline stitch on a commercial transfer pattern. The maker is a keen birdwatcher who felt the usual method did not do her beloved birds justice. With the help of her handbooks on birds, she redrew the patterns where necessary and filled in the outlines to reproduce as closely as possible the plumage of each species. A variety of stitches were used: French knots, satin, outline, and chain. The maker's favorite was the split satin stitch, which enabled her to achieve fine shading effects.

The blocks are set on point, alternating with plain blocks of a blue microdot. Blocks in the outer rows are turned so the birds are upright when the quilt is on a bed. Outline quilting around the birds and a multipetaled-flower motif in the plain blocks are done with seven stitches per inch on a thin polyester batting. The lattice separating each block is appliqué and the scalloped edges are bound with matching fabric; the entire quilt is sewn by hand. Set edge to edge, the central blocks feature the states that have been important in the lives of the quilter and her children. Thus by its structure the quilt serves as both an ornithological and family record.

The maker's interest in birds probably began in rural Lancaster County, near Malcolm, where Shirley Ruth Sturdevant was born in 1925. She attended country schools until her mother persuaded her father, during World War II, to move the family to Wichita, Kansas, where the family could find work in the aircraft factories.

Shirley met Lloyd Taylor there and married him in 1945. They had four children before returning to Nebraska in 1969. They had begun to restore her family homestead when Lloyd died. In 1978 she married Glenn Donaldson, moving with him to Canistota, South Dakota, where the bird quilt was begun. There she made her first quilts— two large Cathedral Windows and an all-white baby quilt. Widowed again, she returned to Lincoln. While finishing the bird quilt, she met and married John Sweet, a waterfowl specialist with the Nebraska Game and Parks Department. They feed birds in their yard and watch and listen to them in their yard as well as in the field.

Shirley comes from a family of strong, active, hardworking women. Her maternal grandmother was a schoolteacher who went west to Colorado to the silver-mining camps. Widowed young, she supported her family by teaching; the family has a Crazy quilt made by her. Two of Shirley's aunts, one single, the other a widow, ran the family farm, raising turkeys and making quilts. Like the aunts and like so many other pioneer women, Shirley has known sorrow and hardship, yet made beauty with her quilts.[25]

Shirley Sturdevant Taylor Donaldson Sweet

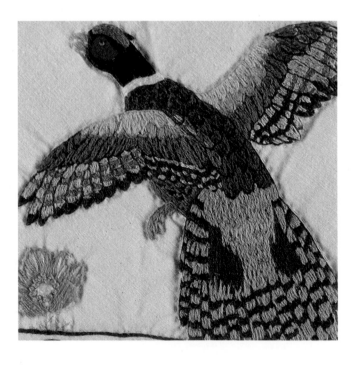

61 State Birds and Flowers

Cotton
109" × 83"
NQP 3917

Circa **1988**
Made by Shirley Ruth Sturdevant Taylor
Donaldson Sweet (1925–)
Made in South Dakota and Lincoln,
Lancaster County, Nebraska
Owned by Shirley Ruth Donaldson
Sweet

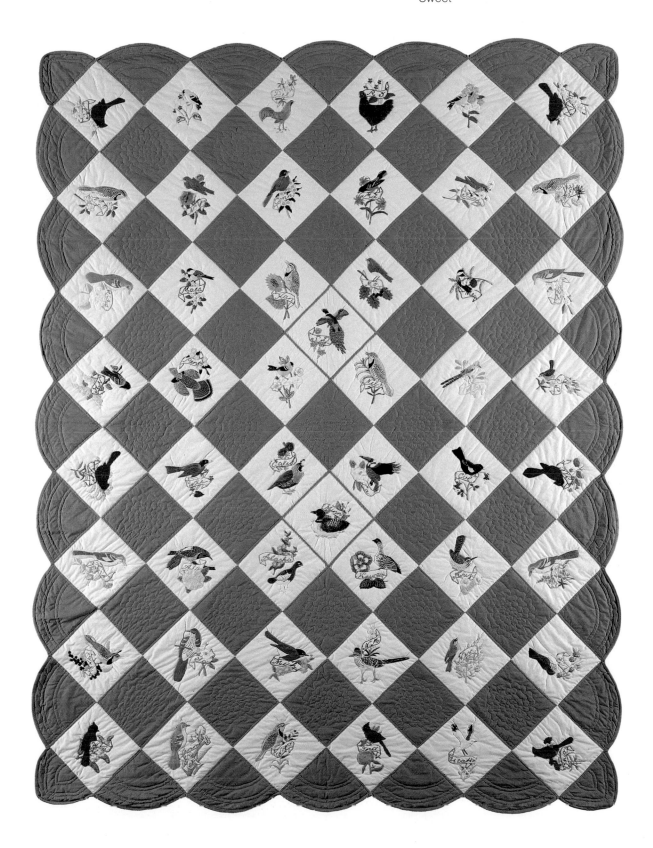

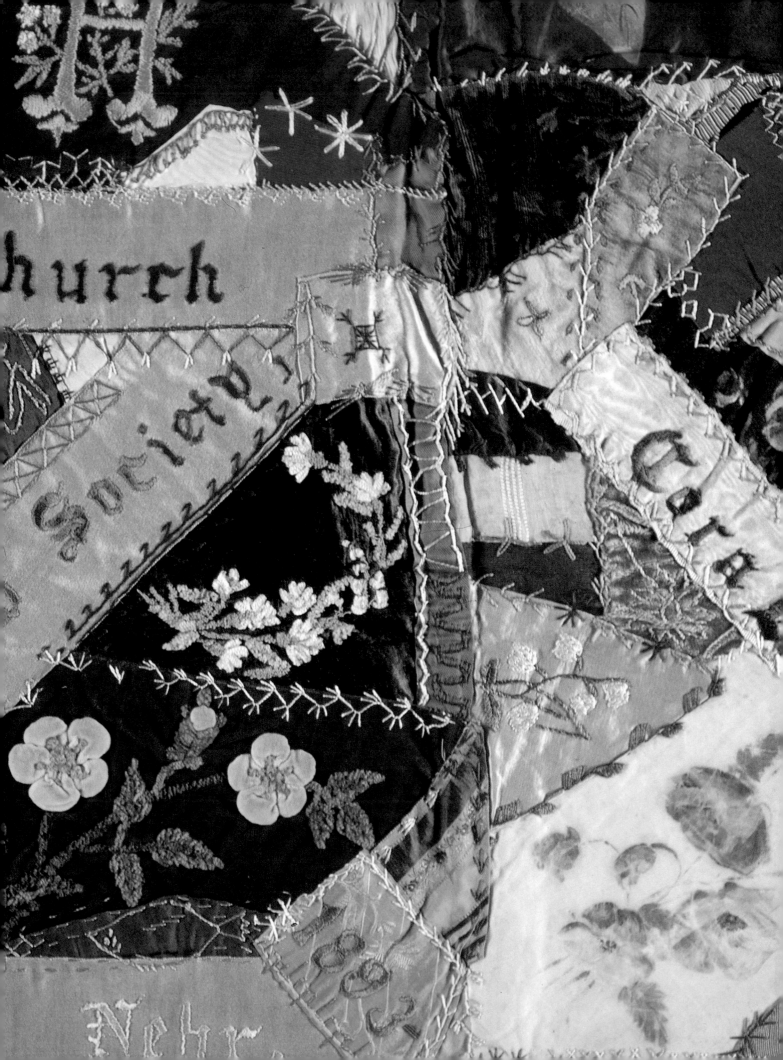

"Little Pieces of Our Lives": Crazy Quilts

A HOMESTEAD claim in the Sandhills of northwestern Nebraska seems an unlikely site for stitching a delicate silk Crazy quilt, but according to family tradition Clarissa made this quilt during the year that she "sat" her claim in Sioux County. Clarissa stitched her quilt from a variety of silk fabrics sent to her by friends and family members from her former home in Minnesota. The multicolored scraps of velvets, taffetas, brocades, and damasks, as well as prints, plaids, and stripes, combine in a montage of pattern and texture that become subtly darkened blocks of color against the brilliant scarlet sashing. Designed to fit a double bed, the vivid colors and elegant craftmanship made an outstanding and fashionable quilt.

Nebraska's grasslands and wildflowers provided inspiration for the young artist and quiltmaker. Spring brought a blaze of blossoms to the prairie, and Clarissa used nature's wildflowers as well as familiar garden flowers for the twelve thoughtfully and skillfully painted pictures at the lattice crossings.

A variety of embroidery and stitchery techniques decorate the pieced blocks. French knots, satin, and stem stitches combine to form flowers, and featherstitching covers the seam lines. Tinsel cord adds sparkle and Victorian elegance to Clarissa's quilt; stuffed bunches of grapes with fuzzy leaves embroidered with chenille yarns give this quilt additional singularity.

Clarissa Palmer was born in 1862 into a cultured, relatively affluent family which had felt the lure of the West for generations, coming from England to New York, from New York to Wisconsin; from there her immediate family moved to Iowa and then Minnesota. Her father, a lawyer and Civil War veteran, became a superintendent of schools. Her mother died in 1870 in a typhoid epidemic which also left Clarissa herself in frail health.[1]

Clarissa recalled in her memoirs that as she grew up, her imagination was fired by stories of young people finding their fortunes in the West and of girlfriends living together in a cabin built on adjoining claims, homesteading together. A friend, Mrs. Sellers, invited Clarissa to visit her home in Ainsworth, Nebraska, to see the West and recover her health after three years of teaching school. Clarissa arrived in September 1885. Hearing of land and opportunities farther west, she went to Valentine in October and filed for a claim, sight unseen, near what was to be Harrison, Nebraska. That fall she also met Dwight Griswold, a friend and partner of Mr. Sellers, who was going to Harrison to start a store.

After ordering supplies and commissioning Mr. Sellers to have a house built for her, Clarissa spent the winter in Denver with an uncle. She made the return journey by train, stagecoach, and wagon to Harrison, chaperoned only by her revolver. A log cabin, rare in that new country of dugouts and soddies, had been built for her. She made it cozy, using newspapers to paper the walls and gunnysacks for carpeting.

As an affluent single woman, able to buy supplies and to hire the necessary work to be done, Clarissa had a life very different from that of most homesteading women. With no livestock or family to tend, she wrote letters, gathered wildflowers, painted them on pieces of fabric sent from home, and made this Crazy quilt.

In December 1886 Clarissa married Dwight Griswold at Mrs. Sellers's new home in Rushville. They lived for several years on Clarissa's claim while Dwight ran his store and later the bank. Their friends and business interests linked them more with men associated with the great cattle ranches of western Nebraska—notably the Brewster, the Coffee, and the Spade ranches.

The Griswold family moved in 1900 to Gordon, where Dwight owned a bank. The second of their three children, Dwight Griswold, Jr., later became governor of Nebraska and a United States senator. After battling arthritis and ill health for much of her long life, Clarissa died in 1946, at the age of eighty-four.

The Nebraska State Historical Society is the quilt's new owner; it makes a lovely addition to the society's collection. Senator Griswold originally owned the quilt. After his death, his wife, Erma Elliott Griswold, held it for their son, Dwight Elliott Griswold. Dwight died in his youth, so the quilt passed to his sister, Dorothy Griswold Gayer, who donated it to the State Historical Society in 1987 after registering it with the Nebraska Quilt Project. Mrs. Gayer told the Nebraska Quilt Project director that she had felt for some time this historic quilt should be in a museum, since there were no Griswolds left to inherit it. Her generosity now makes it possible for all to enjoy this remarkable quilt.

Clarissa Palmer Griswold

144

62 Crazy Quilt

Silk
56" × 73"
NQP 2402

Circa **1886**
Made by Clarissa Palmer Griswold
(1862–1946)
Made near Harrison, Sioux County,
Nebraska
Owned by the Nebraska State
Historical Society (no. 5891-5)

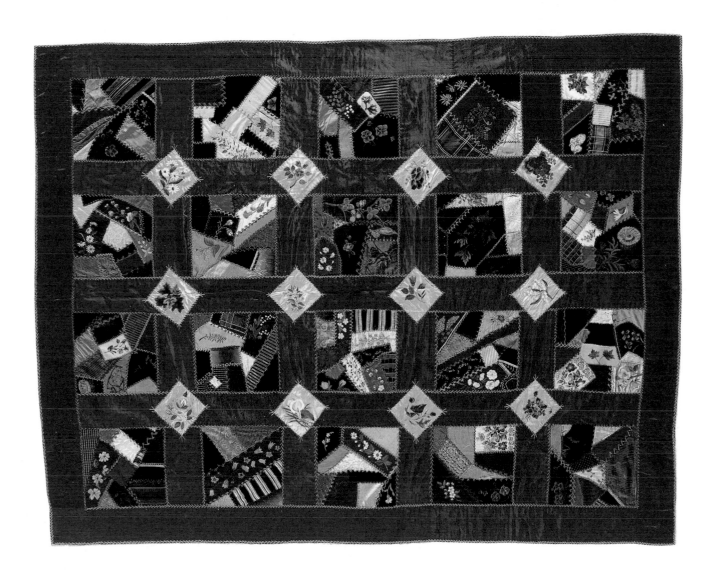

THIS WAGON-WHEEL Crazy quilt certainly provided emotional, as well as physical, warmth for the Boldon family, and it serves as an enduring symbol of the covered wagons which left permanent tracks across nineteenth-century Nebraska. The coming of the Union Pacific Railroad in the 1860s changed transportation across America, but some families looking for a new life on homestead land continued to use the prairie schooner for moving their meager store of possessions. The wagon held valued possessions for the brave young couples looking ahead to settlement in territories where there was enough land for all but little else. The wooden-spoked wheel symbolized this westward movement of peoples before the close of the century and has been used extensively as a design element in folk art.

Sara and James Boldon were the right ages and in the right place to make such a move in such a way, more than one hundred years ago. Sara, born in Pennsylvania in 1851, and her husband, ten years older and from Indiana, followed the trail west across Iowa, as did so many after the Civil War. They settled in the rich farm country of Burt County in eastern Nebraska near the Logan River. There they farmed and raised a family of nine children.

One of Sara's grandsons inherited the quilt from his mother, Kate Boldon Maxwell; his wife, Dorothy Elaine Maxwell, is the current owner.

Four blocks centered with twenty-four-and-one-half-inch wheels make up the main body of the quilt, which is lengthened top and bottom with a pieced strip. A wide variety of fine worsted wool scraps of gabardine, serge, and fancy suiting fabrics is seen in the random Crazy pattern, but the wheels with their fabrics and embroidery show careful planning and fine craftsmanship.

Sara's talented fingers provided a treasury of sampler stitches. Wool yarn in a chain stitch delineates the spokes of the wheels, centered with embroidered lugpins. The variations of herringbone, feather, blanket, and daisy stitches in imaginative patterns and a variety of shades of fine worsted wool yarns provide a true key to Sara's love of pretty colors. A painted flower decorates one scrap piece and little bunches of embroidered flowers grow out of each corner. The quilt was tied to its plaid cotton flannel backing with knots approximately four inches apart.

The visual beauty and design subject of this outstanding quilt, made by a busy nineteenth-century farmwife and mother, is a reminder of our Nebraska heritage. The worn and frayed pieces on its top denote, perhaps, the greater heritage of the continuity of life—the care and nurturing of all our children.

63 Wheel Crazy

Wool
74" × 65"
NQP 2294

Circa **1890**
Made by Sara Barbary Good Boldon
(1851–1908)
Made in Craig, Burt County, Nebraska
Owned by Dorothy Elaine Maxwell

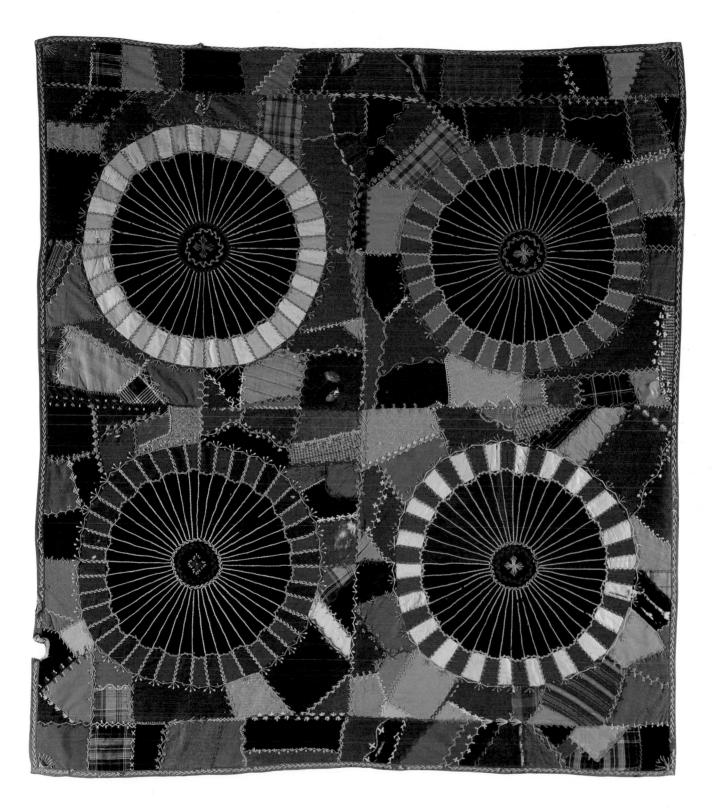

Clara Elizabeth Lusted Frady

A FEISTY YOUNG school-teacher, Clara Elizabeth Lusted, left Clarksville, Iowa, for Neligh, Antelope County, Nebraska, in 1883. She was to become the second wife of Charles Frady, a Civil War veteran and homesteader, Nebraska state surveyor, member of the Nebraska State Constitutional Convention in 1875, author of the preamble to the state constitution and coauthor of the original school laws, state legislator, and for twenty-five years a frontier missionary along the upper Niobrara River for the American Sunday School Union.[2] Clara was "about the size of a banty hen," but Parson Frady, fourteen years her senior, recognized the strength and indomitable spirit of this little woman, who was the first cousin of his deceased wife. Clara's school-teaching career, begun at age sixteen, ended at twenty when she left Iowa for Nebraska and took on the responsibility of stepmothering four children. Eleven more children were born to Clara and Charles, two of whom died of diphtheria in 1898.

Clara pieced her Crazy quilt during the stolen minutes away from household chores and child care. Her husband was gone for extended periods from the homestead as he traveled west establishing Sunday schools and bearing the gospel to frontier towns. The daily concerns of keeping a house and raising a large family were a massive responsibility but did not serve to quiet Clara's innate creativity. With nimble fingers and an artist's eye, she put together a fashionable parlor throw.

Clara planned her quilt carefully, as can be seen in the strong diagonal pieces placed across fifteen of the sixteen squares. Grosgrain and commemorative ribbons; a piece of red, white, and blue ribbon; silk velvets, brocades, taffetas, and satins combine comfortably with a lustrous cotton velveteen in this quilt. The wide variety of fabrics suggests that Clara collected her pieces from many sources over a period of time.

Undulating featherstitches in lustrous silk thread decorate the quilt surface, with blocks joined by exquisite herringbone stitches. Chenille yarn was used sparingly as was metallic thread; Clara centered one flower with French knots of a metallic thread. A painted butterfly rests on a scrap of burgundy velvet, and a deep red silk heart stands out as the single appliqué in the entire quilt. Polished cotton sateen backs the quilt that is bound in a silk grosgrain ribbon. This small quilt appears to exemplify all that was desirable during the height of Crazy quilts' popularity.

In 1915, Clara Frady and her husband bought a retirement home in Long Beach, California, where the precious quilt was placed pristinely on their bed. Grandchildren were invited to look but admonished never to touch. One small grandaughter, Margaret Jane, possessed some of her grandmother's creative genes and begged to be taught sewing and embroidery skills in order to make something special for her doll's bed. Granddaughter and grandmother labored over sewing lessons. Straight stitches were manageable, but the featherstitch drove both teacher and her eight-year-old student to tears before Margaret Jane was finally able to meet her grandmother's standards.

Margaret Jane, whose father was the tenth of Clara's many children, inherited the quilt in 1974. Grandma Frady's quilt is one of her most treasured possessions, and memories of the sewing lesson are as vivid as yesterday.

64 Crazy Quilt

Silk and cotton
58" × 58"
NQP 3935

Circa **1890**
Made by Clara Elizabeth Lusted Frady
(1861–1945)
Probably made in Neligh, Antelope
County, Nebraska
Owned by Margaret Frady Cathcart

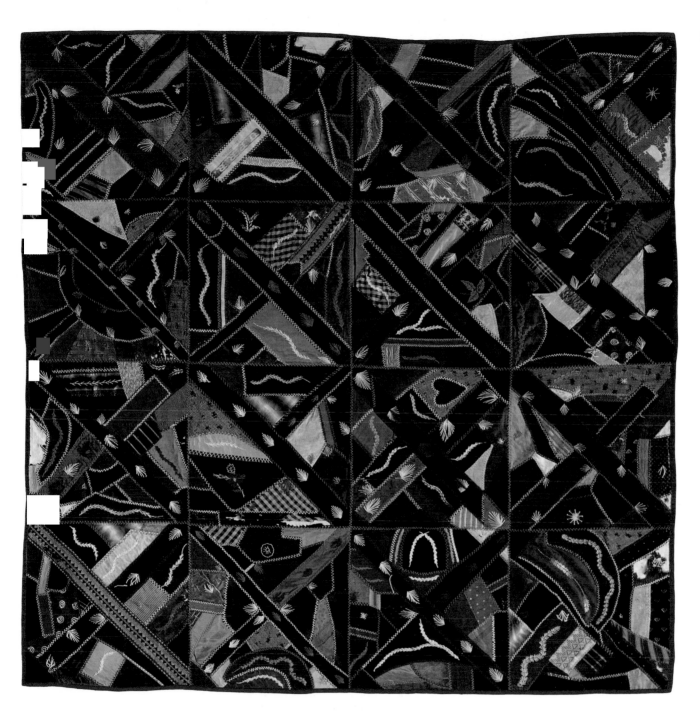

THE FILLEY Ladies Aid Society employed a novel method for raising money during the summer of 1893. Members of the Methodist group made twenty blocks for a Crazy quilt. Nineteen women embroidered or painted their names or initials on a ribbon and then stitched it into their square. The inscription, "M.E. Church / Ladies' Aid Society / Filley, Nebr. / 1893," was also embroidered on ribbons and then placed in a center block.[3] The participating needleworkers raised money by selling the privilege to have one's name on the quilt back for ten cents each, and the woman who collected the most names won the quilt.

A winsome young bride discovered just how good a saleswoman she was. Daisy Williams, newly married to O. E. Filley, collected names and dimes from people whom she met and visited on her honeymoon trip to the Chicago World's Fair and the East Coast and back during August and September. She easily outsold her stay-at-home confederates. The quilt was hers, as was the responsibility to back it.

Back in Filley, Daisy cut the pale yellow cotton backing into seventeen-inch strips to fit into a typewriter. She typed the names each participant had secured in an order so that when the quilt was finished each quiltmaker's square would be backed by her own list of names. Thus a permanent record was kept of all who had been part of a community activity one golden summer at the end of the nineteenth century.

The squares are a hodgepodge of silk fabrics in all shapes and sizes. Each is decorated with embroidery and some with painting. Daisy embroidered her name in ruby red on a golden ribbon. Several small portraits in outline embroidery adorn adjacent blocks. Stuffed flowers with embroidered leaves of chenille yarns are featured on several blocks. Dainty pink grosgrain ribbon bows that tie the yellow back with its typed names to the colorful top continue the cheerful mood of this quilt and add a nice touch to the otherwise unadorned quilt back. It is a Crazy quilt that evokes laughter and good fellowship, happy times, and happy people.

In 1867, Elijah Filley, who became Daisy's father-in-law, took up the first upland homestead in what is now Gage County and gave his name to the town. Her own father, Major John Williams, a Civil War veteran, purchased his farm when he came to Nebraska in 1871. Daisy and her husband left Nebraska for Muskogee, Indian Territory, now Oklahoma, about 1900, where they raised their family. Her Ladies Aid quilt won prizes at the Nebraska State Fair before the young Filleys left the state and later won ribbons and premiums at the New State Fair in Indian Territory. The last first premium tag from 1906 remains on the back of the quilt.

In 1965, the Filley's daughter, Mrs. K. L. McGill of Lindsborg, Kansas, returned her heirloom quilt to Nebraska to the care of the State Historical Society. It holds a prominent position in the Society's collection.

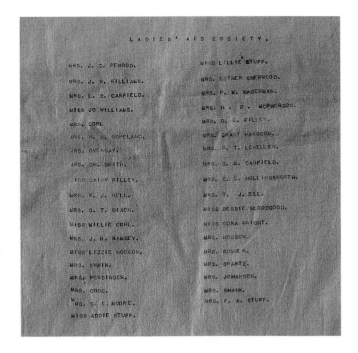

65 Crazy Quilt

Silk
86" × 69"
NQP 4107

1893 (marked)
Made by the Ladies Aid Society of the
Methodist Episcopal Church
Made in Filley, Gage County, Nebraska
Owned by the Nebraska State
Historical Society (no. 8636-1)
Detail on page 142

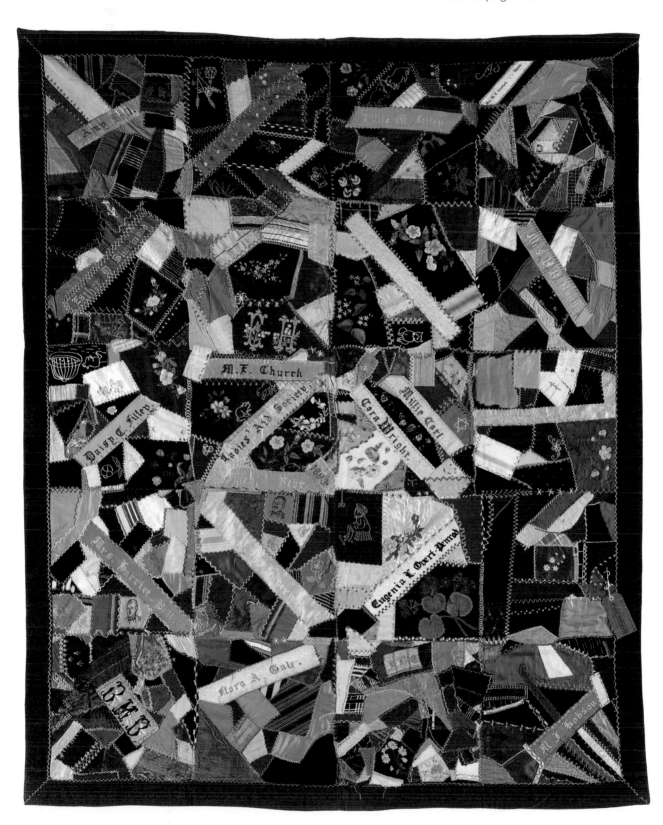

A POIGNANT family story accompanies this embellished and ruffled Crazy quilt. Ellen Franklin Gillihan Maxwell, a mother about thirty years old, lost her baby daughter, Bessie, in a diphtheria epidemic that swept across Nebraska during the winter of 1892. The Maxwells were young farmers who settled in Saunders County in the 1880s and were also parents of two older girls, who escaped the disease. Ellen seemed unable to break through the enveloping sadness following little Bessie's death, so much so that she felt unable to go on with her life. Her husband, Alfred Mites Maxwell, realizing that Ellen needed help, appealed to elderly neighbors who had lost their only child on the wagon train west many years earlier. Their compassionate understanding of the young couple's grief, and the perceptive inspiration that something creative might ameliorate Ellen's despair, led to the making of this beautiful quilt.

The kindly neighbor woman gathered up scraps of wool plaids, gabardines, and flannels along with a few prized silk velvets and satins, carried them to the Maxwell home, and began to show Ellen how to fashion a Crazy quilt and make the requisite embroidery stitches. Good teaching plus the patience and tenacity of the bereaved quiltmaker served to produce a lovely quilt. According to her granddaughter, "Each night she would work by the light of the kerosene lamp, at first with tear-dimmed eyes. . . . And gradually she got better."[4]

According to her family, Ellen tacked pictures of flowers and fruit from an old seed catalog to her quilt blocks for patterns, and embroidered over them. After the embroidery was completed to her satisfaction, she carefully picked out the paper pieces behind the stitches. She also embroidered around each piece using herringbone, feather, cross, and star stitches as well as countless improvisations to embellish her quilt further. The copper-colored cotton sateen ruffle provides an individual and personal touch; the back of the quilt is of the same fabric. The quilt was finished within a year, and is marked "A M M 1893," the initials of her concerned and loving husband.

Ellen never used this quilt, for it held too many memories of her beloved baby daughter. She folded it up and put it away after it was finished but would take it out to show her children and grandchildren when asked to do so. The quilt was given first to the older daughter and then to her sister, the mother of the present owner, who is also a quiltmaker.

Ellen Franklin Gillihan Maxwell

66 Crazy Quilt

Wool and silk
73" × 75"
NQP 2591

1893 (marked)
Made by Ellen Franklin Gillihan
Maxwell (1861–1945)
Made in Saunders County, Nebraska
Owned by Dorothy Ellen Boettner

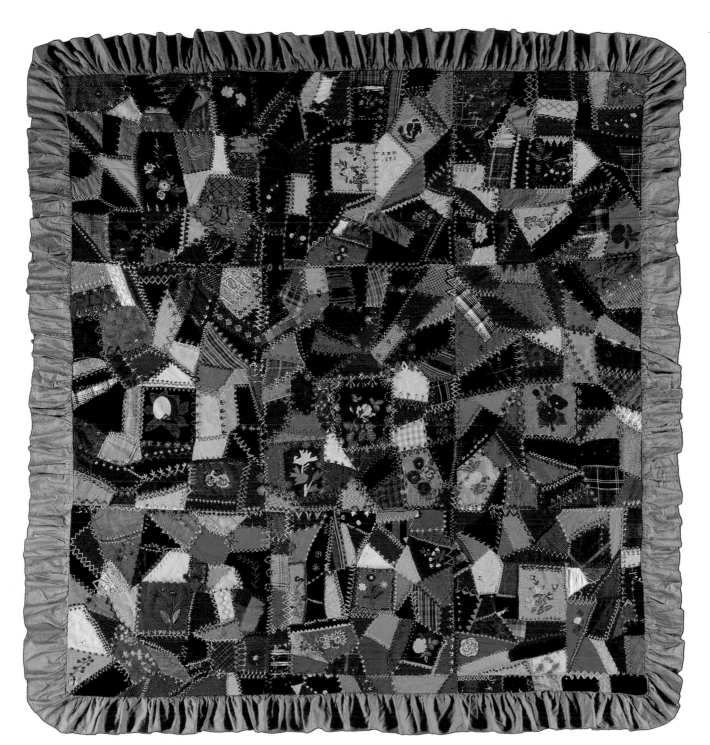

THIS UNPLANNED scrap quilt contains forty-two blocks made largely from wool serges, gabardines, and fancy woolens, with some silk satins, velvets, taffetas, and failles occasionally included. The quiltmaker set the blocks together and embroidered over the seams with a row of herringbone stitches, after which she backed the quilt top with a blue-and-white-striped cotton. Some designs were painted, but it is the profusion of embroidery that catches the eye.

All the names, dates, places, events, and comments refer to friends and family to make this a memory or friendship quilt. The comment, "O, see the fair Oscar Myers [sic]," refers to Oscar Meyers, the young man whom Edith married in 1898. Edith apparently began her quilt when she was eighteen, in 1894 and was twenty-two when she embroidered the inscription "12 1898 / done at last." Could the quilt be the diary of a courtship?

Edith was born in Mount Morris, Illinois, in 1876 and came with her family to a homestead near Lodgepole, Nebraska, in 1885. Her father, Andrew Jackson Withers, was a veteran of the Civil War. Her brothers Tom and Oley are remembered in embroidery, as are her sisters, Hattie, Myrtle, Lou, and "Little Jack," the nickname of Elsie Leola, her youngest sister, who insisted on being called Jack. Another brother, Logan Andrew, was omitted for some reason from the embroidered record.

Edith's quilt records a social history of one young woman, her family, and her friends, who lived in the panhandle of Nebraska just before the turn of the century. Her sense of humor is captured in several blocks, such as the "snipe" block, where the names of the victims or perpetrators of the snipe hunt, Ed Stimpson and Frank Dobbin, were recorded. "Hidden Center" designates the neighborhood schoolhouse and site of many activities; the bridge is at the Oshkosh crossing on the North Platte. This and some of the other inscriptions can be firmly associated with people and places, but much remains a mystery or, at best, reasonable conjecture.

Social gatherings, or what occurred at such gatherings, were important to Edith, as they are to most young people of any era. The first 1898 reference is to Will Duffin, a fortune teller, who spun his charms at the Allington residence on January 27; dancing on the bridge came three days later. Young people needed festive activities during the long winter months. They got together for a skating party on North River, February 5, 1898. Harm's Dance on March 12, 1898, saw Mert and Bert, Jennie and Lutie, as partners. The next event for 1898 was the Swede Dance, November 12, when "Ada was mad" about something, and Thanksgiving Eve, November 23, is the last date recorded before the quilt's completion in December.

Politics did not go entirely unnoticed by young people in Nebraskaland, for the presidential election of 1896 received an embroidered "Hurrah for McKinley and Gold," but no mention was made of his opponent, William Jennings Bryan, who himself was a Nebraskan! The romantic outlaws Frank and Jesse James and the Younger brothers, who traveled through Nebraska, received a place on the quilt as well.

Edith's quilt provides a glimpse into the life of a popular and fun-loving nineteenth-century young woman who lived on a homestead in western Nebraska. We are fortunate that her daughter, Edith Meyer, wanted her mother's quilt to stay in Nebraska and donated it to the State Historical Society.

67 Friendship Crazy

Wool and silk
76" × 65"
NQP 4118

1898 (marked)
Made by Edith Withers Meyers (1876–
1953)
Made in Lodgepole, Cheyenne County,
Nebraska
Owned by the Nebraska State
Historical Society (no. 9925-1)

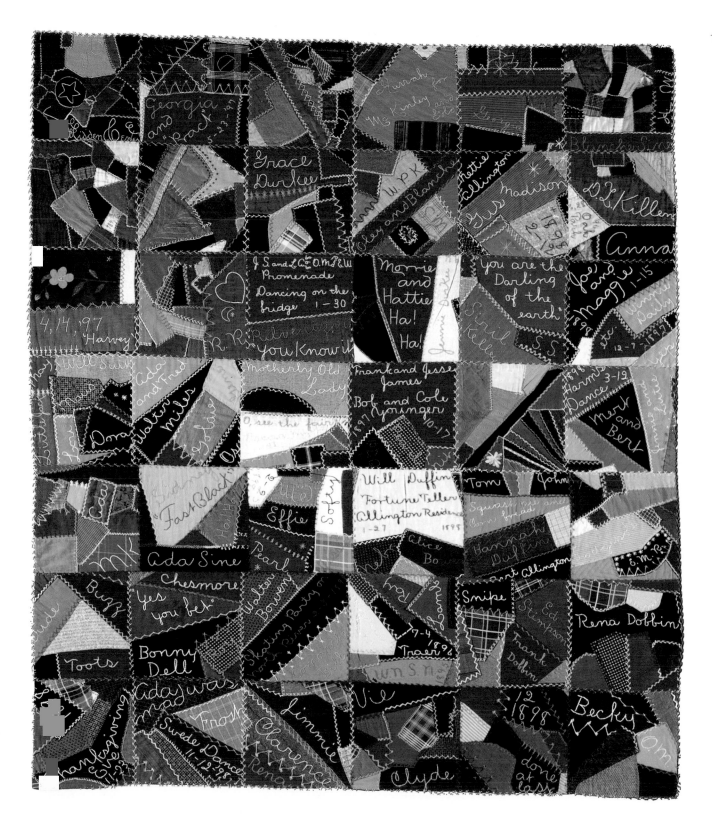

A KALEIDOSCOPE, both in shape and color, this quilt is planned with all of the nine blocks cornered with flower-embroidered triangles. Four blocks in particular stand out because of the many light-and-dark contrasts of a variety of brilliant silk scraps. The hexagonal shapes of these four blocks almost leap from the quilt's surface. Alice placed the most carefully designed block in the center. Here a pinwheel of pastel spokes emerges from the center of the block like the mirrored pieces of broken glass in a kaleidoscope.

The quilt borders of brown silk velvet are delicately embroidered with sprays of lily of the valley. Pieces are set together with many variations of the featherstitch. The flowers stitched in silk thread are a sampler of daisy, chain, satin, and straight stitches. A printed cotton backs this large quilt, and loose tacking holds the two layers together.

Alice Dorr was forty-two years old when she made this striking quilt and had traveled many miles before settling near Creighton in northeastern Nebraska. The quiltmaker was born between De Witt and Clinton, Iowa, in 1857 to immigrant parents who had been brought to America as children. Her father came to the United States from England in 1827; her mother, born in Paris, France, sailed across the Atlantic in 1839. Alice and her husband, George, moved by covered wagon from De Witt, Iowa, to eastern Montana. Montana may have been too rugged for the young couple, since their tenure there was a short one. They packed up their little children and possessions once again, this time settling in Creighton, where they lived and farmed until the children finished high school.

An inscription in pink and green embroidery on this beautiful Crazy quilt reads "A. Present to Ernest on his 12 Birthday. 1899. Mama." Robert Ernest

Dorr died in a silver mine accident shortly before he was to have been married, and his eldest sister, Sarah Mae Dorr, became the owner of "Ernest's Quilt" by sad default. Upon Sarah's death in 1964, her daughter, Myrtle Dorr Rubendall, received it but later sold it to an antique dealer. Although the quilt is no longer in family hands, Marjean Sargent, the current owner, treasures it and has corresponded with Myrtle, securing a photograph of little Ernest and his mother, as well as historical and genealogical information so that the quilt's history can be preserved. In the photograph, Alice is wearing a dress she made herself, illustrating again the quiltmaker's superb needlework skills.

Alice M. Dorr with her son, Ernest, for whom the quilt was made

68 "Ernest's Quilt"

Silk
79" × 76"
NQP 4280

1899 (marked)
Made by Alice M. Dorr (1857–1935)
Made in Creighton, Knox County,
Nebraska
Owned by Marjean Sargent

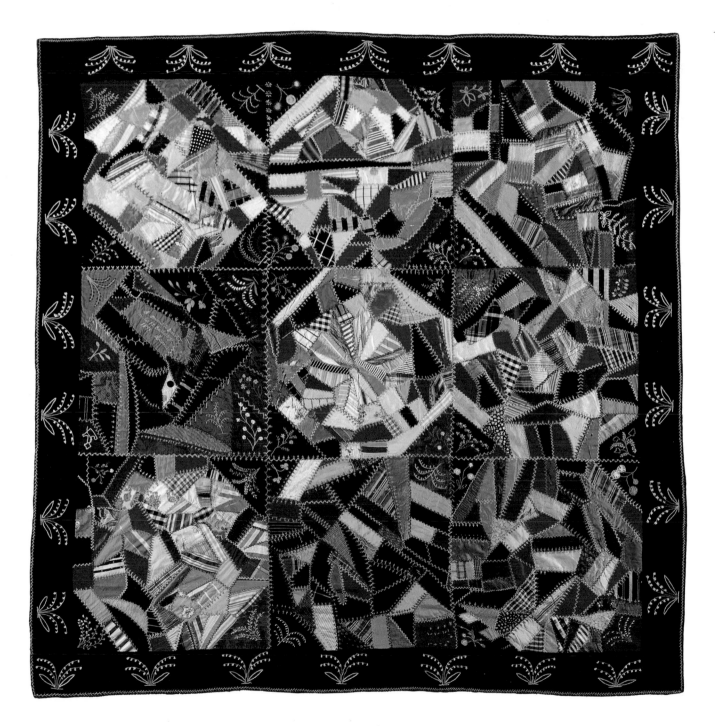

ALTHOUGH WOOL Crazy quilts are often utilitarian bedcovers, hastily assembled from dressmaker's scraps and worn-out clothing, this colorful wool Crazy quilt was stitched carefully and lovingly by its elderly maker, who lavishly embellished it with embroidered figures of every sort imaginable. She perhaps thought of it as an example of her artistry and embroidery skills and as an heirloom of her making.

Late Victorians collected the romantic and colorful postcards that exemplify the sentimentality of the era, and many of these postcards became the patterns for Catherine's embroidered blocks. Idealized children join the many animals, birds, and flowers pictured in stitchery. While meadowlarks abounded in Nebraska's farm country, chances are slim that Catherine ever saw a pink flamingo except in a picture. She took artistic license when she paired the exotic bird with a spray of bluebells on a buff square, but the shapes fill the space gracefully and the colors are harmonious, as they are throughout the quilt. More realistic scenes are found elsewhere in the blocks, many of which tell little stories as mother birds feed their young and dogs chase cats or flush out birds from field and lake. A turtle examines a stand of cattails, butterflies display their painted wings, an inquisitive frog sits atop a toadstool, and a graceful salamander slithers through the flowers. What a joy to "read" this delightful work.

The quilt is made of sixteen large blocks, each composed of eight to twelve pieces of wool with an occasional cotton velveteen. All but the smallest of the pieces have an embroidered bit of nature's loveliness and wonder. Catherine employed myriad embroidery stitches in her quilt as well as using decorative beads. Heavy satin stitches describe the birds and most of the animals, carefully shaded with thread of different colors. Many variations of herringbone and featherstitch join the quilt pieces, for Catherine was very careful not to repeat pictures, colors, or stitches if at all possible.

The use of wool for such an elaborate quilt raises the question of why wool instead of the more customary silk? While many Nebraska Crazy quilts are made of wool instead of silk, wool Crazy quilts are usually utility bedcovers and very simply embroidered. Catherine and other quiltmakers may not have had a source for the silks found in so many of these highly popular quilts; and so substituted as many colorful pieces of wool as were available. A beautiful navy blue cotton border print backs this quilt; the choice of such a luxurious cotton shows the high esteem held for this lovely masterpiece.

Catherine was married in 1849 to a man of Swedish descent named Johnson. Her descendants do not know the year that she came to Nebraska, but she and her husband farmed for many years in Boone County, where their children were born. Although Catherine made many quilts, this one is the most outstanding, treasured by her descendants and passed to the firstborn of each generation.

In 1985, when the current owner, a great-granddaughter of the quiltmaker, submitted her quilt for hanging in the Kearney Area Arts Council Quilt Show, she noticed a quilt very similar to her own in the show. She later learned the maker was a daughter of Catherine, Eva Johnson Bernica, who had made a quilt for each of her seven children.[5]

Cathrine Levina Middleton Johnson, seated, with her children, Eva and James

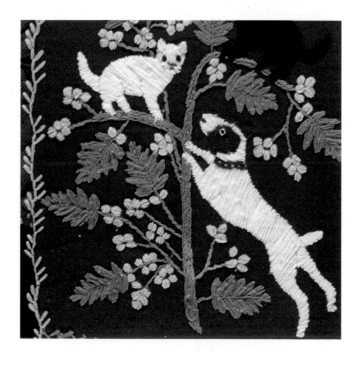

69 Crazy Quilt

Wool and cotton
65" × 73"
NQP 1580

Circa **1900**
Made by Catherine Levina Middleton
Johnson (1829–1916)
Made in Boone County, Nebraska
Owned by Eileen E. Paine

159

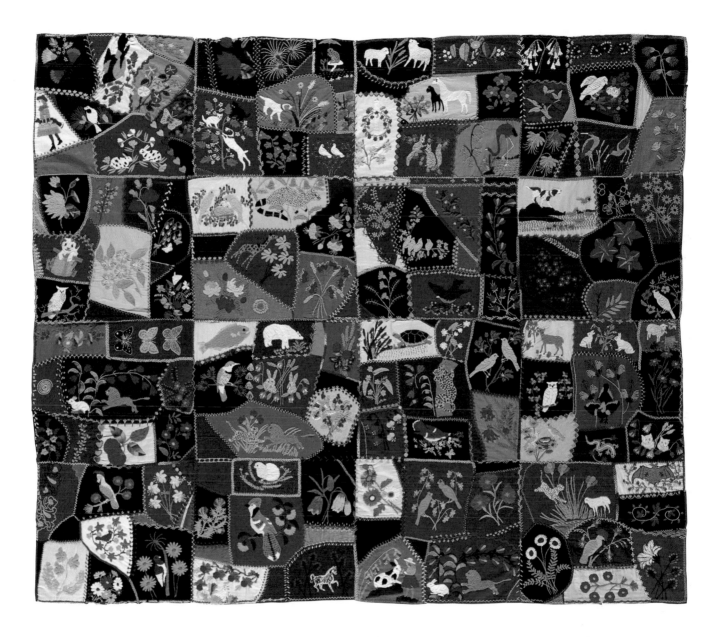

NINE LARGE blocks, each twenty-two inches square, are set together with featherstitching and embellished with countless other decorative embroidery stitches to make a lovely parlor throw for Emily Marie Bartle Moravec's bridal home. Emily, her mother, Veronica Jeannette Kavan Bartle, and her cousin Marie Zeminek Baehr, started this quilt in 1895, and finished it two years after Emily's wedding in 1906. The fabrics include dressmaking cuttings as well as new yardage from the Mercantile Store in St. Paul, owned by Emily's parents. Emily's mother brought her ends of bolts of fabric from the store almost every day; hence the silk taffetas, brocades, and velvets that make up this quilt represent the fashion of their day.

Cousin Marie and her husband lived for a while in Germany and Switzerland, where Mr. Baehr was a member of the diplomatic service under Presidents Theodore Roosevelt and Woodrow Wilson. From her European travels Marie brought back elaborate woven ribbons, which she gave to Emily and Veronica to place in the "Family Crazy Quilt." She also taught them some new embroidery stitches she had learned abroad. The quilt was backed in 1988

with a solid-color cotton fabric and bound with a lustrous satin ribbon.

Emily was the major quiltmaker in the family. Emily's mother preferred a position in the business world over domesticity, and after the death of her husband in 1902, she managed the family business with the help of her son, Edward Bartle, until her death in 1927. Veronica Kavan was born in 1859 in Leipzig, Germany. She came to America at the age of eight with her family and lived a short time in Iowa before coming to Omaha, where she married Frank Bartle in 1881. Veronica and Frank moved to St. Paul, where Frank was employed by a branch store of S. N. Wolbach, and seven years later they established their own general merchandise store.

Emily, one of four children, studied piano at Nebraska Wesleyan University in Lincoln. She married Louis Moravec, a pharmacist who owned the drugstore next to the Bartle Mercantile Store, and they raised their three sons in St. Paul. Emily continued to quilt and her children remember Trip Around the World, Double Wedding Ring, and Dresden Plate as her favorite patterns. She made many quilts for wedding and baby gifts and for other festive occasions. Emily died in 1949; her grandson and his wife are the present owners.

Emily Marie Bartle Moravec

Veronica Jeannette Kavan Bartle

70 Family Crazy Quilt

Silk
66" × 66"
NQP 3045

1908 (marked)
Made by Emily (Emma) Marie Bartle
Moravec (1884–1949), Veronica
Jeannette Kavan Bartle (1859–1927),
and Marie Zeminek Baehr (1858–1934)
Made in St. Paul, Howard County,
Nebraska
Owned by Dr. and Mrs. Daniel F.
Moravec, Jr.

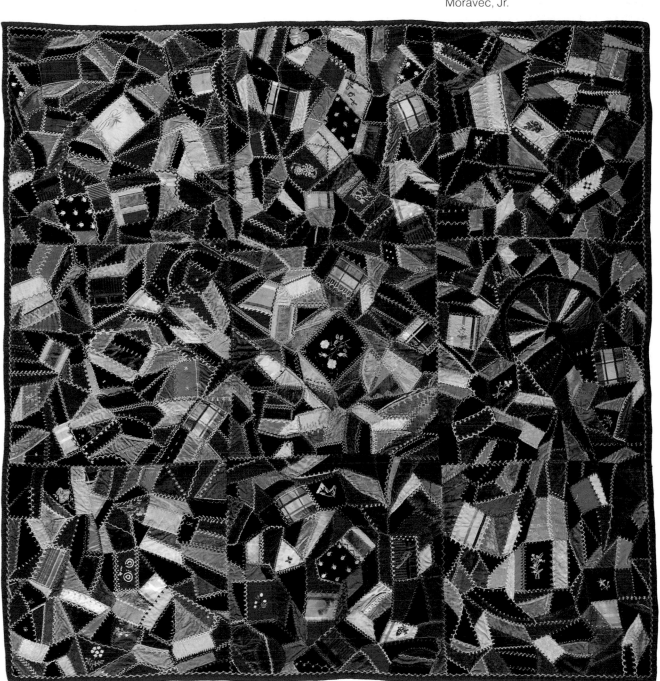

THE THIMBLE Club of Cairo, Nebraska, enjoyed making friendship quilts, so they willingly agreed when young Rose Marie Siek asked them to help her make a quilt to be presented to her mother, Margret Ruge Holtorf Siek, on a future birthday. Forty-four friends and relatives, all club members, made blocks and embroidered their names on this quilt. The fifteen-year-old Rose Marie herself embroidered the center block inscription, "Presented to Mamma The 21 of Sept 1910." Could the quilt have been a surprise? Even if it was not, it remains a charming and sentimental gift.

This friendship quilt has sixteen quatrefoil-shaped blocks built from four equal heart-shaped parts; the seams are covered with embroidery. Fourteen half-blocks placed around the edges complete the pieced part of the quilt. The unusually shaped finished blocks mounted in a diagonal pattern on maroon wool look like windowpanes of stained glass. The names and initials embroidered by Margret's friends in

gold thread stand out vividly against the dark wool lattice. The pattern for this distinctive Crazy quilt is called Hearts and Gizzards.[6] Unlike the more simply pieced versions, this quilt has each heart constructed in Crazy patchwork.

Each of the fan-shaped pieces contains dressmaking cuttings from the scrap bags of Thimble Club members. Many of the smaller bits and pieces could be used to make these little blocks. The design was a practical one for the thrifty seamstresses who saved even the tiniest cuttings of fabric, knowing they could and would be used at some time.

A variety of embroidery stitches embellish the quilt top. Embroidered stars, flowers, and butterflies join the more common herringbone and feather stitches. The many variations in stitches and design speak of the many pairs of hands that worked on their friend's quilt.

The quiltmaker and her family exemplify the large number of German immigrants who settled in Nebraska. The Sieks were among the earliest European settlers in the state, arriving in central Nebraska in 1869. About 40 percent of today's Nebraskans are descendants of German pioneers. Numerous Lutheran churches throughout Nebraska still continue their quilting societies and have long waiting lists for their services. Grandmothers and granddaughters quilt together, continuing a century-long tradition.

Margret Holtorf Siek taught her daughter Rose Marie to quilt when she was a young adult. Rose Marie passed her knowledge of quiltmaking and needlework skills to her daughter, Jessie Peters Hervert, who is the present quiltowner. Jessie plans to leave this heirloom to the fourth generation of family quiltmakers, Gwen Hervert Stengel, and so the Nebraska quilting tradition continues.

Mrs. Hervert spoke for all quiltmakers, past and present, when she told her project interviewer that "quilt pieces are little pieces of our lives." This quilt certainly embodies that sentiment.

Rose Marie Siek at age sixteen

71 Friendship Crazy Quilt

Wool and silk
74" × 68"
NQP 1521

1910 (marked)
Made by Rose Marie Siek Peters
(1895–1973) and Thimble Club
members
Made in Cairo, Hall County, Nebraska
Owned by Jessie Esther Peters Hervert

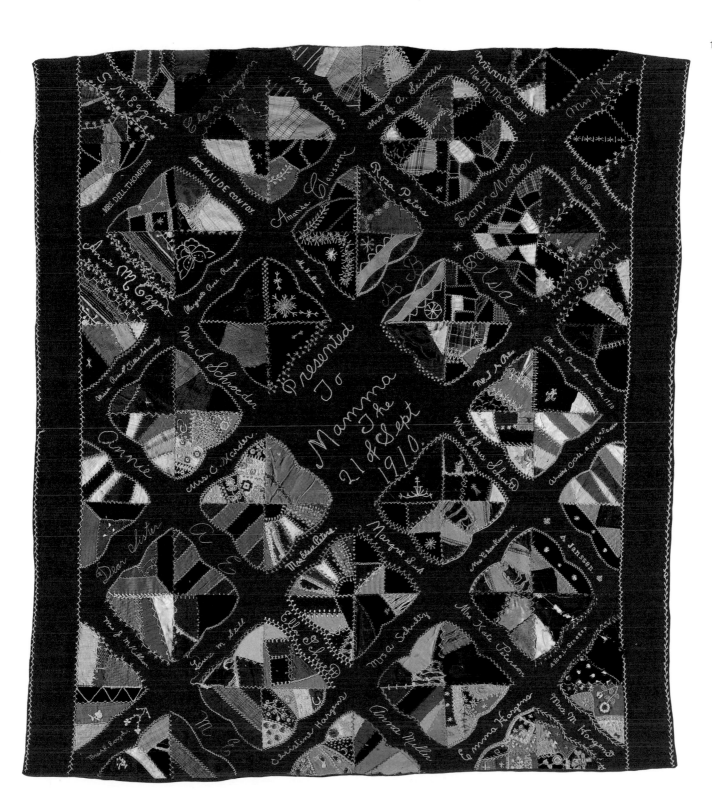

NINETEEN-YEAR-OLD Minnie Bruse went through the family scrap basket in 1923, looking for woolen fabrics that could be used for a warm and cozy quilt. Minnie was to be married in 1924, and she allowed herself a year to complete a pretty but practical hope-chest quilt. Although Minnie employed the basic techniques for making Crazy quilts, her 1923 quilt bears little resemblance to the more decorative quilts of the previous generation.

Minnie learned to sew from her Aunt Meta, an accomplished seamstress, and began at an early age to make her own clothes, including the dress in which she is pictured. Her father and mother were hard-working farmers from German and Swedish stock who wanted their daughter to finish high school in nearby Norfolk, since Hoskins offered schooling only through the tenth grade. The night before she was to begin eleventh grade in Norfolk, a rebellious Minnie refused to go and begged her parents to let her enroll in sewing school instead of high school. She persisted until they consented. She lived with a Mrs. Nitz, an artist, while attending sewing school.

Minnie used her sewing skills to enhance the family income over the years. She worked as a seamstress going from home to home, living with the family for whom she was doing the sewing; but she also found time for embroidery and stitchery of all descriptions. Her children especially remember her delicate cutwork embroidery pieces, and they recall how Minnie made Christmas gifts each year for all their schoolteachers. A daughter says that her mother's "hands were never idle," living the example of her favorite maxim, "Idle hands are the devil's workshop."

Minnie Barelman made quilts because she loved them. Patching and quilting used up scraps, but they also satisfied her creative urge and love of beauty. She obtained great personal satisfaction from quiltmaking, whether it was a doll's quilt for a child, a utility quilt from recycled workclothes, or a planned and carefully stitched bride's quilt for a family wedding. This quiltmaker quilted almost anywhere she could—at home with her friends and neighbors, with her church group, and sometimes with community groups.

This dowry quilt reflects the bittersweet sentimentality of young womanhood in transition from girl to wife. Minnie embroidered her friends' initials on the woolen patches so that they would never be forgotten. Although the quilt appears to have been unplanned, it possesses an intrinsic beauty of color and composition. What depth of artistry led this girl from the farm to divide her crimson scraps as she did, including no more than one to each square? The result provides a balanced intensity of color that pleases the eye as it brightens and warms the dark tones of the other wool pieces.

Thirty fifteen-inch blocks make up the quilt top, and the thick filler and cotton flannel back were tied tightly to it. All the scraps are essentially the same size and there are few curves, so the geometric precision of each block is an abstraction of the Nebraska agricultural landscape. One can visualize plowed land, the rich and dark topsoil ready for planting, and broken fields of corn and wheat. With a little imagination, the blue patches become farm ponds and Minnie's quilt becomes a view from the window of an airplane as it passes over Nebraska farm country.

Minnie Caroline Bruse Barelman

164

72 Crazy Quilt

Wool
88" × 75"
NQP 4649

1923 (marked)
Made by Minnie Caroline Bruse
Barelman (1904–1965)
Made in Hoskins, Wayne County,
Nebraska
Owned by Mylet Barelman Swanson

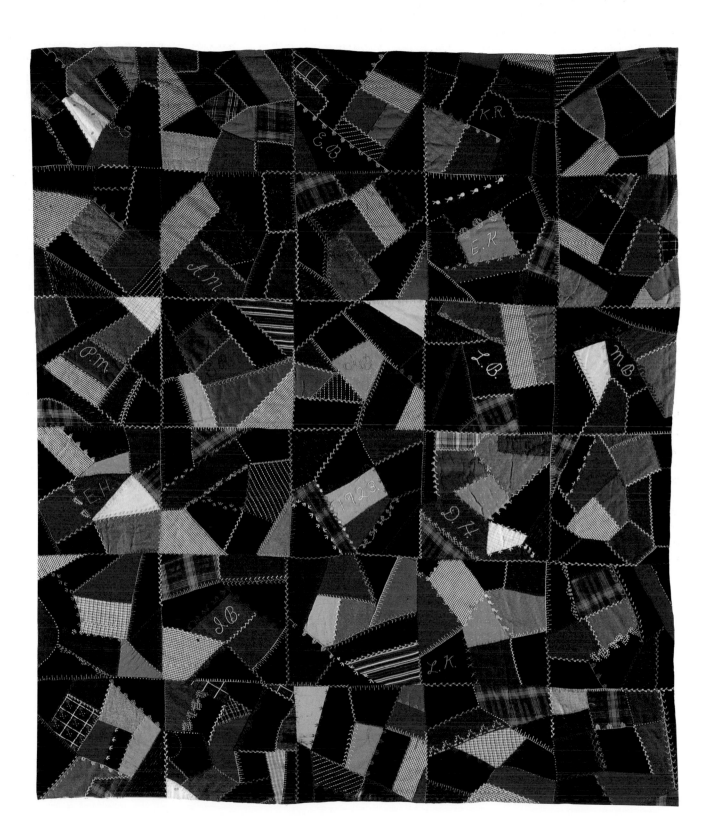

The Contemporary Quilt Revival, 1970—1990

by *Kari Ronning*

Although quilting suffered a period of decline during the 1950s and 1960s, the tradition persisted and now enjoys unparalled popularity in Nebraska. The craft was kept alive mainly by church quilting groups and by quilters who had established their skill in the earlier quilt revival of the 1920s and 1930s. As quiltmakers grew older, quilting once more became associated with age, as in the mid-nineteenth century when the women's magazines relegated patchwork to women whose eyes were no longer good enough to do "fine" needlework.

The patterns favored by this core group of quilters tended to reflect the tastes of the 1920s and 1930s. In the 1930s and 1940s four patterns—Grandmother's Flower Garden and its variations, Double Wedding Ring, Periwinkle, and Dresden Plate—accounted for more than one-quarter of the registered pieced quilts. These patterns continued to predominate even into the 1970s. Sometimes only the prints and brighter hues distinguish quilts of the 1950s and 1960s from those made in the 1930s. Appliqué quilts and embroidered quilts, especially cross-stitched, increased in popularity and were often made from commercial kits. Since embroidery was one of the most popular crafts of the 1950s and 1960s, some younger women probably came into quilting through such kits. The conservative tastes of the kits may also have helped to preserve traditional quilting designs, since they were premarked with feather wreaths and vines.

Many of the forces that helped revive quilting in the rest of the country helped revive it in Nebraska. The counterculture spirit of the late 1960s and early 1970s helped foster an interest in antiques and relics of the past, such as quilts. The related back-to-the-land movement emphasized making things such as bedcoverings for oneself instead of buying from large corporations. Quilts became quaint rather than dowdy. Rural cooperatives such as Alabama's Freedom Quilting Bee, the Mountain Artisans Cooperative of West Virginia, and TRACT of South Dakota capitalized on the desire for handmade items and achieved considerable commercial success.

Another influence, often overlooked, was the feminist movement. Women began to take pride in their history and to value traditional women's activities. In addition, exhibits such as "Abstract Design in American Quilts" at the Whitney Museum of American Art, New York, in 1971 helped validate quiltmaking as an art form worthy of the same respect as traditional "male" art. A new generation of quilters could take a new kind of pride in their work and give new respect to the past generations of quilters.

Feminism also spurred some women quilters to venture into the business world. As Eleanor Sienkiewicz, author of *Spoken without a Word* and founder of Cabin Fever Calicoes, wrote, "The pressure I felt as a mother to have gainful employment for pay was more social than economic. In a sense, it was 'women's lib' which encouraged my generation of quilt entrepreneurs."[1] Although women made the quilts, men usually sold them the fabric, the needles, the batting, and sometimes the patterns. Women quilters, frustrated by the difficulty of getting the supplies they wanted, opened quilt shops and mail-order businesses themselves to supply quilters' needs. One of the first and most successful of these in Nebraska was the Calico House in Lincoln, begun by Ann Gohde and Suzie Lewis in 1976 with one hundred bolts of fabric. Other Nebraska women designed and sold patterns to national markets.[2]

The mass media have been especially important in the recent quilt revival. An important development for quilters in Nebraska and the nation was the debut in 1969 of *Quilter's Newsletter Magazine*. It and other quilt magazines, such as *Quilt World*, *Creative Quilting*, and *Lady's Circle Patchwork*, have pictured the work of many Nebraska quiltmakers.[3]

A few books were also available to quiltmakers by 1970. Marguerite Ickis's *Standard Book of Quilt Making and Collecting*, first published in 1949; Ruby McKim's *101 Patchwork Patterns* (1931), reprinted in 1962; and reprints of Hall and Kretsinger's *Romance of the Patchwork Quilt in America* (1935), were the major pattern sources. In 1973 Beth Gutcheon published *The Perfect Patchwork Primer*, one of the first and most influential of a new generation of quiltmaking books. Many other books, magazines, films, and television shows have appeared since, keeping Nebraska quilters in touch with the ideas and techniques of quilters throughout the rest of the country and the rest of the world.

Until recently the Nebraska State Fair and, to some extent, county fairs were among the few places where women could display their quilts to an audience beyond friends and family, where they could see the work of other quilters and be judged by their peers. The fairs helped to set standards of design and workmanship as well as reflecting and transmitting fashions in quiltmaking. When interest in quiltmaking waned in the 1950s, the numbers of quilts and the variety of patterns at the

fairs declined also. By 1969, however, according to Louise Howey, needle-work supervisor for the Nebraska State Fair, there was "lots of interest in [the] quilts" on display.[4] In the following years the number of specialized categories in which the growing number of quilts could be entered increased to more than twenty, as did the number of premiums (cash prizes) offered. Prizes and ribbons are now awarded in such divisions as Best First Quilt, Best Non-Functional Quilt (wall quilts), Pride of Nebraska (quilts with Nebraska themes), as well as the usual pieced, appliquéd, and embroidered quilt types.

In 1973 Mary Ghormley, Louise Howey, Hazel Meyers, and Betty Voss met to form the Lincoln Quilters Guild and issued a call to others to join them. Interest in quilts had been rising; the time was right. About twenty-five women joined at the first meeting. This was to be a new kind of group in Nebraska—one relatively rare in the rest of the country at the time. The quilt guild is not a quilting bee or a sewing circle; its object, as the founders said, is "to promote the art of quilting and to learn more about it through study and sharing." More than twenty other local guilds have been formed throughout the state.

The following year, the Lincoln Quilters Guild held the first major quilt show in Nebraska. Old and new quilts from across the state hung at the University of Nebraska's Sheldon Memorial Art Gallery; a color catalog of the quilts was issued.[5] The show turned out to be the most popular one the gallery had ever had. Beth and Jeffrey Gutcheon held a workshop in conjunction with the show. They were among the first of the new traveling quilt stars to visit Nebraska. Now, nationally known teachers, collectors, artists, and scholars come to Nebraska regularly under the sponsorship of the various local guilds, enriching the environment of Nebraska quilters.

As the nation prepared for the Bicentennial, quilting became one of the most popular means of commemorating it. An authentic colonial craft, it required no obsolete or specialized skills or equipment as spinning and weaving did. The basic sewing skills learned in a home economics class would suffice to get started; the result was a product both useful and durable.

Bicentennial-inspired quilts account for a large proportion of the registered quilts made in the 1970s. Samplers, which had very rarely been made in Nebraska during the preceding hundred years, suddenly accounted for over 10 percent of the total number of registered quilts. Samplers were favored as a project in quilt classes as a means of introducing a variety of techniques in one quilt.

The number of appliqué quilts also increased in the 1970s. Many were representational quilts celebrating both the national bicentennial and the centennials of Nebraska towns. They showed scenes from history reminiscent of Chris Wolf Edmonds's "Washington at Valley Forge," or showed local scenes and buildings. The Lincoln Quilters Guild's quilt entitled "Nebraska Is America" adapted tile and mosaic designs from the state capitol building to create a prizewinner in the National Quilting Association's Bicentennial contest (Plate 75). Other quilts were graphic depictions of patriotism, with stars, stripes, the liberty bell, the Bicentennial logo and other popular symbols. Two other popular styles of appliqué were the nostalgic Sunbonnet Sue type and Hawaiian appliqué.

In 1977 the Lincoln Quilters Guild sponsored one of the first national quilt symposia; six hundred participants came from forty states.[6] The event featured a show of Nebraska quilts at Nebraska Wesleyan University's Elder Gallery, including some by Grace Snyder and Ernest Haight; a merchant's mall; and guest lecturers Michael James, Ronald and Marcia Sparks, Phyllis Haders, Jean Ray Laury, Jean Dubois, and Helen Squire. "Barn Dance," a quilt designed by Rosemary Seyler and made by guild members, was raffled. Contest entries of quilt blocks representing the state of Nebraska were displayed. The winner, "Nebraska Windmill," by E. S. (Bud) Dunklau of Lincoln, became the official Nebraska State block by virtue of a legislative resolution introduced by State Senator Shirley Marsh. It replaces an elaborate and virtually unused Nancy Cabot pattern called "Nebraska" from the 1930s (see Plate 100). Nebraska quilters, in increasing numbers, began traveling to other symposia and quilt conventions held throughout the country.

Quilters across the state have united to form many other quilt guilds. One of the most significant events was the formation of the Nebraska State Quilt Guild in 1985. More than one hundred interested quilters met in Fremont that year following a workshop and lecture by Jinny Beyer. They passed the hat for funds to begin organizing; in 1986 the first statewide convention was held. In a large, sparsely populated state like Nebraska, many quilters feel isolated. The aim of the state guild is to promote and encourage Nebraska's quilters; to this end it sponsors special events such as lectures and workshops, publishes a quarterly newsletter, and donates quilt books to local libraries. Members of each of the guild's three districts are encouraged to plan districtwide activities. The state guild also sponsors special awards and the Nebraska Quilters Hall of Fame to honor quilters, as they have Grace Snyder, Ernest Haight, Mary Ghormley, and Louise Howey. From the twenty-five Founding Mothers in 1985 to more than seven hundred members in 1989, the state guild has increased quilters' opportunities to learn and to be recognized for their work.

Today, quilters in Nebraska have unprecedented access to fabrics, supplies, and ideas. National chains as well as specialized local shops cater to quilters' needs. The number of quilts registered in the Nebraska survey more than doubled during the decade of the 1980s. No patterns predominate, though Grandmother's Flower Garden and Double Wedding Ring continue to be popular. Pattern books and commercial "original" designs and kits are widely available, but more and more interest is on the quiltmaker's development of a personal style.

Contemporary quiltmakers work in a wide variety of styles and formats. Wall

hangings have become increasingly popular as quilters' pride in their work and desire to show it have increased. Wall quilts also allow greater flexibility of design, since the geometry of the bed does not need to be considered. Miniature quilts, usually in traditional patterns, are made both for the love of smallness and as a response from those who despair of ever making all their favorite patterns.

Samplers formed one of the largest single types of quilts made in the 1980s—15 percent of the total. Increasingly sophisticated, no longer miscellaneous collections of blocks, the samplers are unified with carefully chosen color schemes; frequently there is a thematic or design focus also.

Many Nebraska quilters choose to continue to work in the traditional styles. The subtle or vibrant interplays of color distinguish the modern traditional quilt. The wide variety of prints and colors now available produce a constant challenge. Some quilters seem to want them all; scrap quilts, made for the love of the fabrics rather than thriftiness, have become popular, as, more recently, have charm quilts, where no two pieces are alike. Labor-saving techniques, such as use of rotary cutters and strip piecing, are frequently employed—but often, too, quilters choose to work entirely by hand.

Interest in appliqué by hand and machine has also revived in Nebraska. There is less copying of traditional floral designs and a wider variety of subjects and forms. Colors are chosen as freely as for piecework. Appliqué is used in the popular medallion style and is often combined with patchwork. Appliqué is no longer considered superior—more elegant and more artistic—than piecing. Quiltmakers now feel freer to experiment with both techniques.

Some quiltmakers have chosen to experiment with the basic stuff of their art, the fabric. A few quilters have begun to work with silk and wool. Still others have moved from the tradition of using 100 percent cotton to experimenting with novelty fabrics— especially lamé and other metallics. Some quilters, inspired in part by Jan Myers-Newbury of Pittsburgh, Pennsylvania, use fiber-reactive dyes on muslin to achieve colors not proposed by the Color Council of America.[7]

Hand quilting, too, has returned. In the 1970s quilters often took advantage of the fact that quilting in lines six to ten inches apart was sufficient for polyester batting. Now thin polyester batts and polyester-cotton batts with the best qualities of both materials make fine, close quilting easier. Elaborate designs, trapunto, and stipple quilting have returned to modern masterpiece quilts. The fineness of old-time quilting is legendary, but the average Nebraska quilt did not have many more than six to eight stitches per inch. Some modern quilters try for twice that many stitches.

Whether their fabrics are hand dyed or are manufactured prints and solids, quilters today play with color and light, experimenting with the different effects possible in their chosen medium. Most are avid readers of quilt books and magazines, which keep them abreast of the work done elsewhere. Most still prefer to work in variations of traditional styles, shying away from the more esoteric manifestations of the art quilt. They feel no need to astonish or perplex an audience. Working for their personal satisfaction, Nebraska quiltmakers today create to give pleasure and delight.

Vilma Hart Bednar at age seventy-nine

WHITE BALLS on a varicolored ground or varicolored chains on a white ground? The eye shifts back and forth across this quilt, which shows complex effects from very simple means. A five-and-one-half-inch nine-patch block is joined to a white square whose corners have been cut off and replaced with colored triangles, leaving an octagon, which the eye, at a distance, interprets as round. These two blocks alternate to form diagonal rows reminiscent of a Double Irish Chain.

The overall coloring of the quilt is subdued despite the sparks of red and yellow triangles; it reflects the palette of the 1950s. The effect is that of a scrap quilt, but while many scraps are used, their placement is carefully planned. Each nine-patch block has one dark or bright print and one medium print; there are very few light prints to distract from the snowball. Some fabrics have motifs of flowers, fruits, or stripes carefully centered. Even more careful planning shows in the placement of the triangles of the alternate squares; each matches the triangle of a block in the next row, offset by one.

A multicolored sawtooth border is framed by two narrow white borders. The edge is finished with "prairie points," triangles made from folded squares overlapping each other to form a zigzagged edge. This finish, occasionally seen in 1930s quilts, became popular in the late 1970s.

Hand pieced and hand quilted, this quilt reveals a maker who valued her art and delighted in creating unusual effects, at a time when patchwork was of little value.

One of the faithful Nebraska quilters who kept the art alive during the 1950s, Vilma Hart was born in what is now Czechoslovakia in 1880. In 1895 she went to Vienna to work as a maid. She stayed there for ten years before going back to Prague in 1906. An uncle had been to America and returned to Czechoslovakia to get his family. Vilma came to Chicago with them, where she stayed for a year while her aunt and uncle went on to Nebraska.

After coming to Gage County, Nebraska, in 1908, Vilma worked a year in Beatrice as a maid before marrying Lyman Bednar, a farmer, in 1909. During World War I she worked with a Red Cross group that did quilting; this may have been where she learned to quilt. She always did much fancywork—crochet, tatting, knitting—and dressmaking for her three children, but she did not make many quilts until after her husband died in 1928. In 1947 she left the farm she had managed and moved to Wymore to live. She continued to make quilts for her children and grandchildren. This quilt is one of three of this pattern made before her death in 1966. The words of her daughter apply to many women of her generation, "She was one who never sat with hands idle."

73 Snowball Nine Patch

Cotton
88" × 80"
NQP 82

Circa **1961**
Made by Vilma Hart Bednar (1880–1966)
Made in Wymore, Gage County, Nebraska
Owned by Valeria Bednar Thayer

THIS QUILT conveys a sense of great height and distance as if the viewer were another eagle, the mate to the dominating figure, which carries the legend, "God Bless America." The lavender of the sky suggests dawn, allowing the misty blue of some of the far hills to stand out clearly. The sharp peaks of the distant mountains soften to rolling hills, which gradually flatten to gentler curves. At the bottom, the subdued greens, grays, and blacks of the hill give way to a multitude of brighter, busy prints, in much smaller pieces, suggesting a crowded urban area.

Scattered among hills are some of the icons of American life—the white steepled church, a little red schoolhouse, a family farm complete with barn and silo, a covered bridge. A closer look reveals smaller, whimsical details: a butterfly above the city, two white dogs on a hill, and "Sunbonnet Sue" trudging up the hill to the school, followed by a white lamb.

The idea for the quilt arose when the maker felt the urge to make something for the Nebraska Centennial in 1967. As she thought about the state and its people, the image of the hills became the most vivid in her mind and she began with that, working with the fabrics she had on hand. She had fabric for the sky, then, she recalls, "I put the mountains in the background and just worked down from there as I found the colors." The appliqué, done by hand, is layered with no edges turned under; the acetate tricots and polyester double knits were cut to shape with pinking shears.

The quilt is finished with a sage green border and took about six months to complete. The colors and fabrics are representative of polyester double knits of the late 1960s and early 1970s. The spirit of the quilt captures the patriotism of the Bicentennial and its celebration of rural American life.

Audrey Christine Jones was born in 1910 in Missouri, where her father was a farmer. She attended high school in Missouri and then married William Woodward in 1929. They had three children and came to the Chadron area of Nebraska in 1936. She learned how to quilt from her mother but is reluctant to describe herself as a quilter, though she has made five quilts. Her husband became interested in piecing at one time and made eight or nine tops, including a Lone Star.

While Audrey was working on "The Hills of Home," she read of a quilt contest sponsored by *Good Housekeeping*, the United States Historical Society, and the Museum of American Folk Art in New York. The quilt was a state finalist for Nebraska and won a bronze medal in the 1978 Great Quilts of America Show in New York.

Audrey Christine Jones Woodward

74 "Hills of Home"

Polyester and acetate
77" × 58"
NQP 457

1976 (marked)
Made by Audrey Christine Jones
Woodward (1910–)
Made in Chadron, Dawes County,
Nebraska
Owned by Bertha Woodward Wood

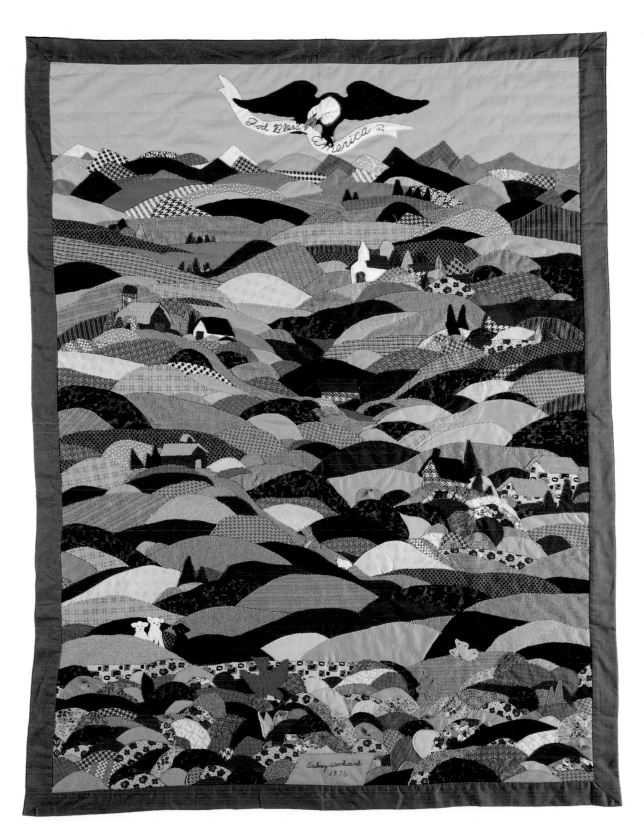

ORIGINALITY in color and design mark this unusual Bicentennial quilt, designed and made by members of the Lincoln Quilters Guild. The colors, instead of being red, white, and blue as so many were, are the natural colors of Nebraska—and America. The blues represent the water and skies, the golds are for the sun and the grains, greens for the grasses and foliage, rusts and brown for the earth. Such "earth tones," as they were called, were especially popular in the 1970s.

Quilts organized in a medallion set were rarely made in 1975; medallion-style quilts were more likely to have been made in the 1770s or the 1980s. In this quilt a series of pieced and appliquéd borders, all drawn from designs in the state capitol building, surround the American eagle.

The first two pieced borders are patterned after the mosaic floors of the capitol's entrance and main halls. The wide hand-appliquéd lattice is adapted from the ceiling of the Nebraska Supreme Court room, as is the oval quilting design in the wide rust border. This border contains many quilted images associated with Nebraska: a plow, a train, a covered wagon, the state capitol, corn, wheat, a steer, a windmill, and so on. The final pieced border represents arrowheads with a rising sun in each corner, a design adapted from the doors of the East Legislative Chamber.

As complex as the design sounds in description, and as complex as it is in symbolism, the quilt itself gives an effect of simplicity and openness, evocative of both the landscape and people of Nebraska at their best.

A committee of ten, chaired by Miriam Hecox, met in the spring of 1975 to discuss the creation of a Bicentennial quilt. They all wanted the quilt to work as a whole, rather than in separate images, so the medallion set was agreed upon. Someone suggested the state capitol as a design source, so, armed with graph paper, the committee went there to sketch possible designs. Jacqueline Dittmer, Nancy Koehler, and Miriam Hecox organized the ideas, and the whole was drawn on architect's graph paper by Frances Best and Ann Gohde. Louise Shaneyfelt and Jacqueline Dittmer did the drawings for the quilting and the eagle, which Mary C. Ghormley appliquéd.

To carry out the earth-colors theme, committee members combined their scraps, purchasing some fabrics especially for the borders. Miriam Hecox set the top together. The quilting was done by many members of the Lincoln Quilters Guild, with Floy Buell, Louise Howey, and Mary Ghormley doing some of the finest work. The overall average was eight to nine stitches per inch—a fairly high standard for a group quilting effort, especially since many members with little quilting experience wanted to participate.

Although the products of committees generally have a low reputation, the group projects of contemporary quiltmakers in Nebraska show how quilters, working together, can create works of art impossible for one person alone.[8]

75 "Nebraska Is America"

Cotton and polyester-cotton
102" × 100"
NQP 4918

1976 (marked)
Made by members of the Lincoln
Quilters Guild
Made in Lincoln, Lancaster County,
Nebraska
Owned by Sheldon Memorial Art
Gallery, University of Nebraska–
Lincoln

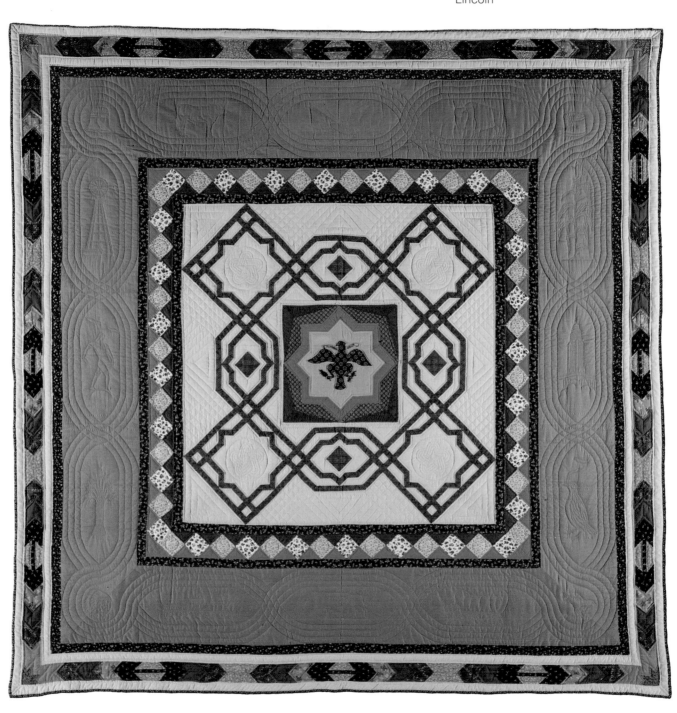

SIX-POINTED stars in a variety of red, blue, and yellow prints juggle baby blocks and diamonds in endless interlocking circles. Blink, and the large stars form circles linked by diamonds around another star. Blink again, and the stars and diamonds reform into straight lines slanting across the circle, bouncing from the edge to head in another direction. Yet another shift of perspective gives the illusion of large sixty-degree diamonds forming and reforming. Because the six-pointed stars are set on point, balancing, as it were, on the point of a diamond below, the quilt has a tension and energy that would be lacking entirely if the star seemed to stand solidly on two legs.

The pattern came from a batting wrapper, a long-time source for quilters. It resembles blocks such as Stars and Cubes or The Columbia, which also feature three-dimensional baby's blocks around a six-pointed star. The single diamond that seems to separate the cubes is unusual; it is vital to the sense of energy the quilt conveys.

This was not a pattern designed for ease of construction. Although it appears to be made with large diamonds consisting of two small white and two small colored diamonds, with cubes between, a closer look shows that the large star units share the tip diamond with the adjoining star. Piecing it would have involved endless setting of wide and narrow angles. The present owner, the maker's daughter, refers to this quilt as the "Crying Quilt" because the making involved so much ripping apart and redoing, causing many tears.

Helen Ursula Busek Stuchlik

The fabrics for the quilt were mostly scraps, largely dressmaking cuttings; however, some new ones were purchased for the quilt. It was outline quilted by that venerable Nebraska institution, a church quilting group, which charged thirty-five dollars.

Helen Ursula Busek was born in 1910 in Weston, Nebraska, to a farm family of Austrian-Czech descent. Her mother taught her to sew as a girl, to prepare for her future home. She attended high school for two years. In 1928 she married Edward Stuchlik, a farmer. They had four children. When her husband became an insurance agent, she became the secretary of the agency and remained so for thirty years, retiring in 1972. She made many quilts—about forty, her daughter estimates—before her death in 1980. Her favorite pattern was another one-patch, Trip around the World. Her daughter says that especially as Helen grew older, she sought perfection in her quilts. The "Crying Quilt" shows how hard she was willing to work to attain perfection and how close she came.

76 Stars and Cubes Variation

Cotton and polyester-cotton
95" × 86"
NQP 2447

1979
Made by Helen Ursula Busek Stuchlik
(1910–1980)
Made in Weston, Saunders County,
Nebraska
Owned by Charlotte A. Sousek

177

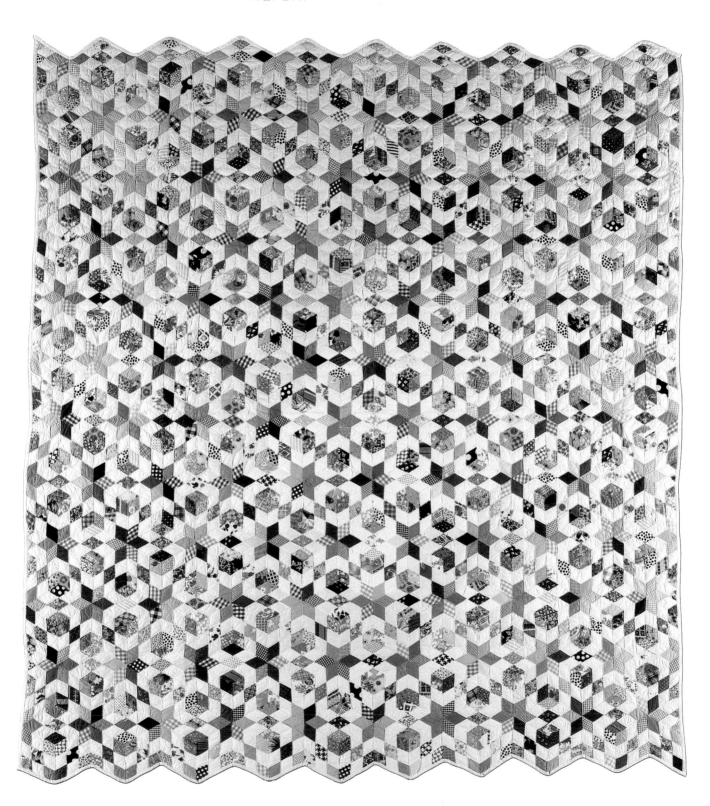

A THOROUGHLY Nebraska quilt, "Windmills and Brands" represents both a quintessential Nebraska scene in the appliqué work and Nebraska farmers and ranchers in the quilted brands in the alternate plain blocks. Each of the eighteen hand-appliquéd blocks is different, in color and fabric as well as in form, depicting the undulating lines of the Sandhills near the maker's home. The colors suggest the changing seasons, while the clear blue sky quilted with cloud shapes remains constant.

Rectangular blocks are very unusual in quilts, since most designs, even in appliqué, are symmetrical. Here the rectangle is the perfect format, echoing the vertical lines of the main image. The windmills, which dominate the design, are placed off-center, balanced by the hills and the expanse of blue sky.

The seventeen alternating plain blocks are quilted in the center with the maker's brand, "TW." In each corner a different brand is quilted, mostly those of neighbors and friends. She went through the state brand book for others, choosing those whose oddity appealed to her—one that looks like an outhouse, another shaped like an umbrella.

The fifteen-inch border is quilted in a diamondlike crosshatch pattern which echoes the crosspieces of the windmills. The windmills and hills are outline quilted with eight stitches per inch on a polyester batting. This is a quilt unmistakably modern in materials, subject, and design.

Ardyth A. Weers was born in Holyoke, Colorado, in 1938 into a farming family. The family moved to Venango, Perkins County, Nebraska, when she was young; she says she's lived there "forever." After college she went to Washington, D.C., to work for a year. "It was enough to tell me to go back where there was peace and quiet." She married Robert Triplette, becoming an active partner in their farming and ranching. She keeps the books, drives the truck, and runs the combine during wheat harvest.

The truck driving helped turn her to quilting, she says, "to give me something to do while I sit in line at the elevator," waiting to dump loads of corn or beans. She learned to quilt when she was twelve by watching her mother and by "the hard way," that is, by trial and error. She always signs her name and the date at the bottom of her quilts. She still uses her mother's quilt frame of old, hard two by two's and C-clamps set on chairs. Some of the patterns for her eight quilts came from quilt magazines and some from coloring books, especially those for a crib quilt for her grandson. Of her inspiration for this windmill quilt she says, "look at the hills—the Sandhills are all different; and I just always enjoyed windmills."

Ardyth A. Weers Triplette

77 "Windmills and Brands"

Polyester-cotton and cotton
109" × 84"
NQP 85

1981 (marked)
Made by Ardyth A. Weers Triplette
(1938–)
Made in Venango, Perkins County,
Nebraska
Owned by Ardyth A. Weers Triplette

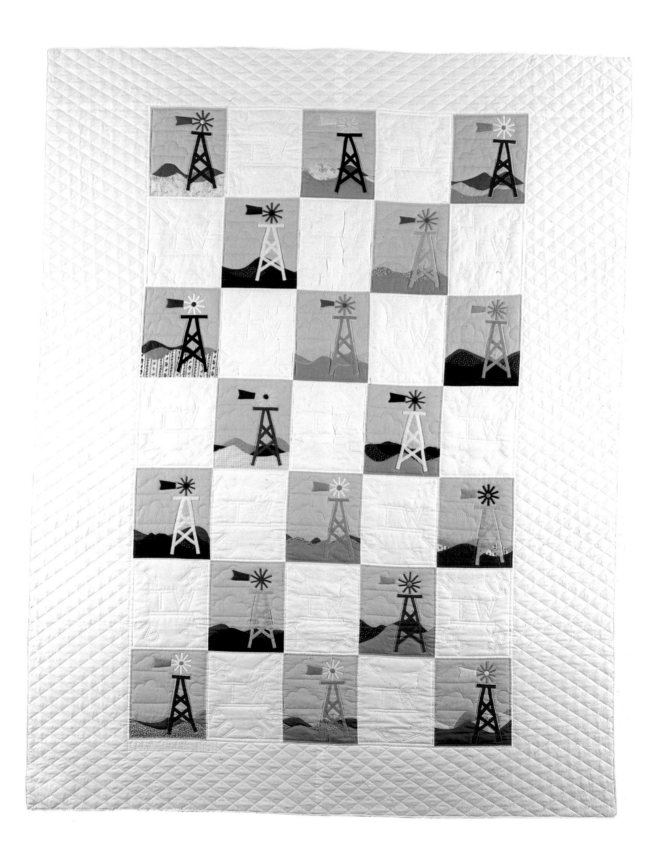

Carol Jayne Shaffer Dunklau

WHIRLING black spokes spin across the surface of this quilt, almost evoking images of tornadoes in their darkness and circular rnotion. The black and tan colors show how dramatic a neutral palette can be. The maker searched the fabric shops of the Midwest looking for black prints, which were rare in the early 1980s, because she was intrigued by the idea of a black non-Amish quilt. Ranging from microdots to small and large florals, the prints are set with a solid black where the blocks meet. The obvious black-and-white color scheme was discarded for more subtle neutral tans with black, green, and khaki figures. A rich red print at the center of the blocks sparks the entire quilt.

The maker used a sewing machine for the seams; the blocks were pieced on tear-away paper. The backing is muslin, like that of many traditional quilts. The quilting is done in the ditch, that is, close to the seams, and in parallel lines with nine stitches per inch. Workmanship of the highest quality has won this quilt many awards. It took "Best of Quilts," among other awards, at the 1983 Nebraska State Fair, first place at the National Quilting Association Show in 1984, and was featured in the *Quilt Art '86* calendar. It was exhibited at the Sheldon Memorial Art Gallery, Lincoln, Nebraska, in 1986–1987.

Carol Jayne Shaffer was born in 1936 in Lincoln, Nebraska, the daughter of a civil engineer, which may help to account for the precision of her drafting and workmanship. She learned to knit in the seventh grade and did many other kinds of handwork. In 1956 she married E. S. (Bud) Dunklau. When her mother-in-law needed a hobby for her spare time, Carol took her to the quilt show at the Sheldon Memorial Art Gallery in 1974, thinking it would be a suitable hobby for an older person.

Instead, it was Carol who vowed that some day one of her quilts would hang at Sheldon. She took lessons from Mary Ghormley in 1975–1976. Several years later her black Pineapple was a featured quilt at Sheldon's "Woven Threads" exhibit.

A collector of antique quilts, Carol prefers the look of traditional patterns and styles. She is especially attracted to patterns that have a sense of motion. Disliking a lot of white background in quilts, she chooses cotton fabrics in a broad range of darker shades to achieve the look of late-nineteenth-century quilts. Most of her twenty-five or more quilts are pieced by hand.

At the 1977 Quilt Symposium in Lincoln, Michael James showed her his one-stitch-at-a-time quilting method. Although she uses the same kind of needle and thread that she learned on, Carol likes to try different battings, patterns, and techniques. An accountant by profession, she keeps meticulous records and notes on all aspects of her quilts, as well as signing and dating each one.

Carol enters quilts frequently at the state fair, finding it an incentive to finish projects. Her quilts are prizewinners; they have taken five Best of Show awards at the fair. She says she is a perfectionist, which sometimes makes quilting less fun but always more challenging. With each new quilt she tries to excel. As she says, "I always feel that my best one's coming."

78 Pineapple

Cotton
106" × 83"
NQP 3035

1982 (marked)
Made by Carol Jayne Shaffer Dunklau
(1936–)
Made in Lincoln, Lancaster County,
Nebraska
Owned by Carol Jayne Shaffer Dunklau

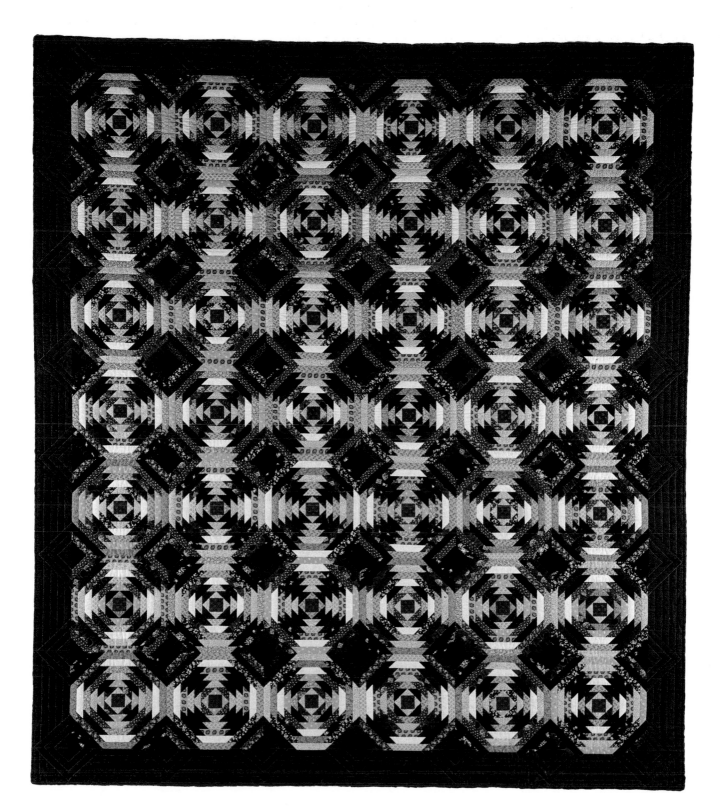

RAINBOWS OF scraps are spun around dizzily, breaking into jagged pieces as they spin. It is as though a vortex is trying to suck the color away into the darkness of the void beyond. The strong colors, however, particularly the streaks of sky blue, work against so ominous an interpretation. Perhaps instead this is life— colorful and chaotic—struggling to emerge from the nothingness.

Ruby McKim, in *101 Patchwork Patterns* (1931), calls this pattern "The String Quilt." McKim's string quilt is very orderly, with strips of even widths and a suggested color scheme of peach, coral, apple green, and ivory. It would form octagonal rings of graduated sizes instead of the fragmented whirl seen here. String quilts were designed to use up long narrow pieces of fabric such as neckties or cuttings along the selvedges of dress goods. They were often pieced on a foundation square, like Log Cabins. The pattern enjoyed a resurgence of popularity in the 1970s with the publication of Marjorie Puckett's books on the technique.

McKim says of the construction: "The pattern appears to be complex, whereas it is really not difficult, but just a bit tedious and exacting." The narrow pieces for this quilt were sewn over a newspaper foundation, which was later torn away. The irregular colors and shapes used here eliminate the need for careful matching of seams, giving much more life and movement.

A design such as this is related to the "contained" Crazy quilts, where a Crazy block is set with a uniform sashing. Jan Myers-Newbury of Pittsburgh is a contemporary quiltmaker who has used that format in her hand-dyed quilts.[9] Contained Crazy quilts may be interpreted either as the triumph of order being imposed on chaos or as chaos threatening to break out of the fragile bonds of order—depending perhaps on the optimism or pessimism of the viewer. Such ambiguity makes them especially interesting.

Edith Pearl Caddy was born in 1917 in Eagle, Nebraska. Her mother made many quilts and comforters for her family of ten, so Edith learned early. She made her first quilt for herself, a floral appliqué from *Capper's Weekly*, before her marriage in 1939 to Richard Schrader, a railroad engineer. They had three children. A baby quilt, begun for the first child and finished in 1949 for the third child, won the Best of Show award at the Nebraska State Fair. When her children were grown, Edith had more time for quilting. She joined a small quilting group in 1970 and began making the quilts she considers her best. She prefers piecing by hand for accuracy and by machine for speed. She likes to do full-size quilts rather than wall hangings. Nearly every year she enters quilts at the state fair. "Spiderweb," begun in 1978, was one of her award-winning entries. Her quilts have been hung in various shows, but she also enjoys "shows" at home, taking her quilts out and looking at them, remembering.

Edith Pearl Caddy Schrader

79 "Spiderweb"

Polyester-cotton and cotton
97" × 79"
NQP 898

1983 (marked)
Made by Edith Pearl Caddy Schrader
(1910–)
Made in Lincoln, Lancaster County,
Nebraska
Owned by Edith Pearl Caddy Schrader

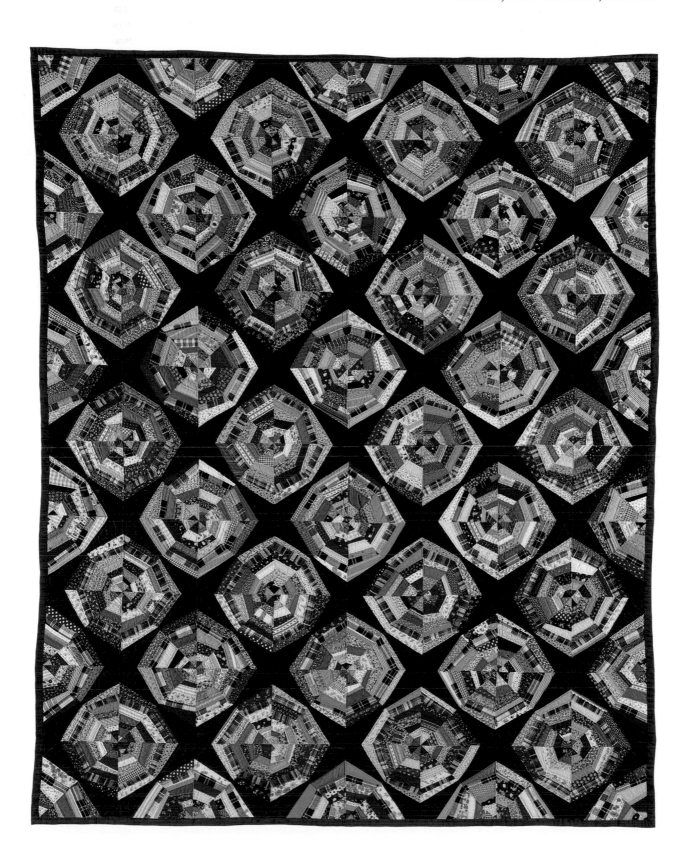

PULSATING with light and energy, this quilt lives up to its name. The orange-red of the central circle, like the molten core of the sun, simultaneously explodes into the rays of light and by its solidity and gravitational pull holds all that energy within a huge circle. The tension is evident in the entire design. The rays thrust outward but their tips mark the path of perfect circles.

Two related designs are used to convey the pulsating quality of the sun. The inner sun is based on traditional sunflower designs, with their large centers and relatively short rays. Small gold triangles edge the orange-red circle, mingling the short orange and yellow rays. The muted gold of the longer rays just beyond seems almost like a reflection cast by the more vivid inner colors. All this seems to float on a vivid yellow background formed by the inner points of the long yellow rays. This outer set of rays, long, narrow, and needlesharp, are in the Mariner's Compass tradition. The points of the yellow rays blend with the lighter yellow of the background, highlighting the sets of gold and orange points.

The lighter yellow background seems almost drained of color in contrast to the intensity of the sun. The background is enriched by the fine quilting (eight to nine stitches per inch) of feather wreaths, plumes, tulips, and rosebuds, in contrast to the simple outline quilting of the center. Cables embellish the quadruple border, which shades through the colors back to red-orange. The scalloped border follows the contours of the cable.

The source of the pattern for this quilt, which has won many awards at the Nebraska State Fair and county fairs, is said to have been the maker's mother. The pattern, probably a commercial one of the 1930s, was lost in the family for many years before it was rediscovered and remade in the 1980s.

Floy Elizabeth Lyle, daughter of the quiltmaker Lucy Bell Jordan Lyle (see Plate 22), was born in 1900 in Nehawka, Cass County, Nebraska. Her first quilt top, a Four Patch cut out by her mother, was made before she went to school. It was left as a top until after her marriage to Charles Buell in 1921, when her mother-in-law added on to it, making it a full-size quilt. Her first complete quilt, made soon after her marriage, won first place at the state fair. Floy remembered thinking, "Well, I can do that then," and the award gave her confidence to go on. She began piecing mostly for her family, though she was active in the quilting circles at her church.

In 1937 she was widowed with five children. Her eldest son, then sixteen, carried on with the family farm, where Floy lived until 1952, when she moved to Lincoln. Taught to knit, crochet, tat, and embroider by her mother, she became a needlework instructor in Gold's Department Store in Lincoln, where she worked for many years. Floy continued to make quilts and to quilt with her church sewing group at Trinity Methodist Church. The group became known for its high standards. Floy kept a practice quilt up for ladies aspiring to join the group; only those quilting more than eight stitches per inch could work on the quilts for others. The group often had more than a two-year waiting list of tops to be quilted. They raised thousands of dollars, much of it for Bryan Memorial Hospital.

Floy lost track of the number of quilts she made; she made them for her children, her seventeen grandchildren, and her twelve great-grandchildren, plus many more for her own satisfaction, since she always liked to try new patterns. Although she enjoyed quilting with friends and was an early member of the Lincoln Quilters Guild, she preferred to make her quilts by herself to maintain her own high standards.

Floy Elizabeth Lyle Buell, 1945

80 "Glory of the Rising Sun"

Polyester-cotton
105" × 91"
NQP 2676

1984 (marked)
Made by Floy Elizabeth Lyle Buell
(1900–1988)
Made in Lincoln, Lancaster County,
Nebraska
Owned by Wanda Buell Ross

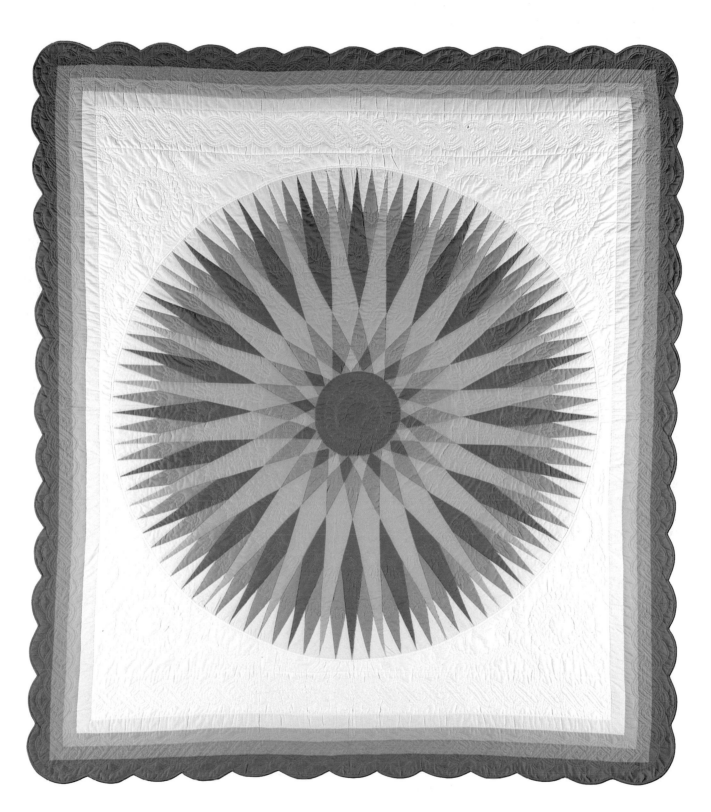

THIS MODERN version of a Lone Star reverses our expectations. Instead of a colorful star on a plain ground, here is a plain blue star, subtly streaked by the wear and wash marks of the blue jeans from which it is made, complete with pockets. The star needs to be strong, set as it is at the convergence of powerful forces in the multicolored print strips which form the background squares and triangles. The dark border surrounding the star keeps the vertical strips of the border from pressing in on the star.

The basic four-patch star, sometimes called Evening Star or Sawtooth Star, is a very old pattern, though seldom done on this scale. The strip-pieced background is modern, though done in a few eccentric nineteenth-century examples.

The maker likes to use fabrics that are not made especially for the quilter's market; this quilt represents her philosophy. Quilts made of denim jeans were made when recycling became fashionable, but seldom on so grand a scale. The prints are dominated by geometrics, especially checks. Note especially the blue-and-white gingham, which edges six of the points. It has been cut off-grain to give the effect of a folded or twisted ribbon, thus increasing the movement in the background.

Eleanor Doreen Kuntz, born in 1930 in Weiser, Idaho, grew up with a kind of familiarity with quilts that bred indifference, if not contempt. Her mother, a teacher, quilted, and Eleanor made utility quilts, but she couldn't see why anyone would want to go to all that work for a bed cover. When the coordinator of adult-education classes at Norfolk College asked her to teach a quilting class instead of one of her knitting or crocheting classes, she was surprised that anyone would need to be taught to quilt. Nonetheless she started the class, doing her best to keep one lesson ahead of her students. She became hooked; the name given one of her first real quilts was "Early Addiction."

Now Eleanor is a prolific quilter, making many of her sixty-plus quilts for the six children and fifteen grandchildren from her marriage to Charles Hunnel in 1948. Although she enjoys hand piecing, she likes the speed of the sewing machine, and she says the Olfa (or rotary) cutter "opened up a whole new vista of quiltmaking" for her.

Scrap quilts are her favorite. Some of the scraps she enjoys using come from her mother's scrap bag and her own, begun in the early 1940s. Eleanor uses those fabrics from quilt to quilt; such a fabric may be like a family gene, a hidden constant in very different creations.

She makes many original adaptations of traditional designs. Ideas for quilts come, she says, "like children being born"; their names are almost as important as children's names. Names come from the feeling conveyed by the design, like "Fiesta," another strip quilt; from the colors, like "Rag Bag Blues" or "Sandhills Summer," both Log Cabin quilts; others come from associations of the design, like "Daisies Don't Tell" or "Orange Blossom Special."

Eleanor Doreen Kuntz Hunnel

81 "Pockets and Patches"

Cotton and polyester-cotton
74" × 67"
NQP 602

1985
Made by Eleanor Doreen Kuntz Hunnel
(1930–)
Made in Johnstown, Brown County,
Nebraska
Owned by Eleanor Doreen Kuntz
Hunnel

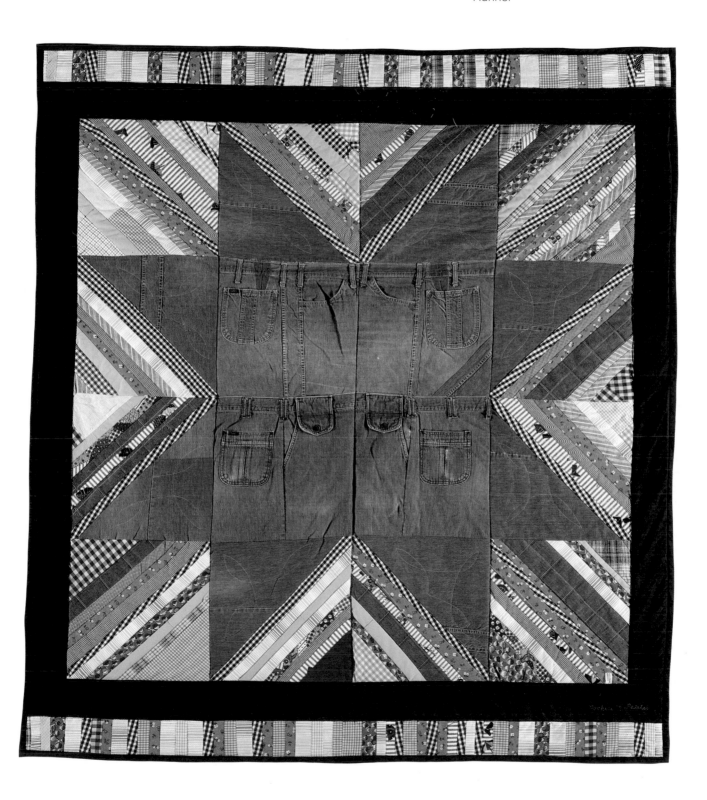

Jeanette (Jan) Lou Selk Stehlik

THEME, color, and design are integrated in this striking quilt. The darkness of the crosses, symbolic of sorrow and sin, is redeemed by the colors of the rising sun. At the center of the quilt is the cross in its simplest form, set on the lightest color. The square yellow block is transformed by long yellow triangles into an octagon, which is subtly echoed by a slightly different gold octagon. Four corner blocks of pink, orange, and gold prints in the Rebecca's Fan pattern radiate the light outward. Light seems to be shining through the open spaces of the blocks; the background colors of all the blocks are divided to increase the sense of gradual darkening as the design moves away from the center.

The quilting also radiates from the center straight to the edge of the quilt. It was done by a church group, with six to seven stitches per inch. The machine-pieced, twelve-inch blocks are quilted in the ditch. The blocks are traditional designs; but the setting, which incorporates both the sampler and medallion traditions, is original.

The maker says her favorite part of quiltmaking is "the symbolism and the color and the design and the thinking of unique and original ways to put an interpretation on the traditional designs." This quilt epitomizes both the maker's faith and her way of quilting.

Jeanette (Jan) Lou Selk was born in Beatrice, Nebraska, in 1933. Her mother quilted and Jan remembers being allowed to put some stitches on a quilt her mother was making with friends. The other ladies suggested Jan's stitches be pulled out, but her mother was proud of them and left them in. Jan's involvement in the 4-H Club developed her sewing skills. She recalls that a favorite childhood Christmas present was a grocery bag of fabric scraps. In the fifth grade Jan made a doll quilt, quilting it on a little frame her father made.

When she entered the University of Nebraska in 1951, she planned to major in art and home economics. Nearly twenty years later, after marriage and five children, Jan returned to complete her degree. As an art teacher she often uses quilts in her curriculum. She also teaches quilting classes and gives many lectures on quiltmaking throughout Nebraska and in Kansas and Iowa. Her weekly column, "The Country Quilter," is published in a Crete, Nebraska, newspaper. Her original pattern designs have won prizes in quilt-block contests and at the Nebraska State Fair.

Samplers with themes appeal to Jan. Her first serious quilt was a Bicentennial sampler; after her quilts on religious themes, she wanted to make a specifically Nebraska quilt. Unable to find such patterns in her growing collection, she designed her own and published them in a book, *Sod House Treasures* (1984). She now has another book as well as other quilts in the works and in her mind.[10]

82 "Quilt of Many Crosses"

Cotton
90" × 90"
NQP 1106

1984–1986
Made by Jeanette (Jan) Lou Selk
Stehlik (1933–)
Made in Dorchester, Saline County,
Nebraska
Owned by Jeanette (Jan) Lou Selk
Stehlik

189

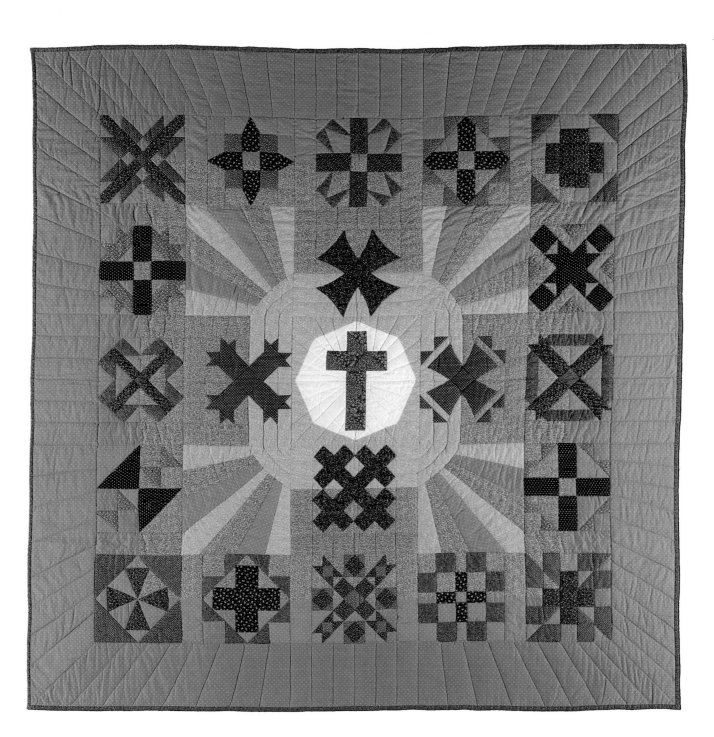

ONE OF the finest examples of pictorial quiltmaking in Nebraska, this quilt represented the state in the quilt contest sponsored by the Museum of American Folk Art in New York City to commemorate the centennial of the Statue of Liberty. Color, piecing, appliqué, and perspective design combine to show the hope represented by the statue without any obvious use of the symbol itself.

The viewer looks over the shoulders of an immigrant family as they stand on a wharf or pier, looking at what lies ahead. (Their immigrant status is suggested even in silhouette by the man's baggy trousers, the boy's cap, and the shadowy white of the woman's old-fashioned apron.) Earth-tone rusts, browns, and golds soften the blocklike effect of the walls and link them to the colors of the landscape beyond the door. The vertical boards of the pier lead the eye straight to the landscape, in contrast to the dark horizontal lines of the "ceiling" above. Light seems to stream though the door toward the family—so much so that one of the boys lifts his hand to shade his eyes.

The hand-appliquéd landscape is framed by the dark side of the fir trees around the door, echoing the dark lines of the family's silhouette. At the heart of the quilt lies a crystal-blue lake. Green, brown, gray, mauve, and golden hills rise beyond, fading into misty blue-gray hills at the greatest distance. The sky is full of light and promise, though its peach, mauve, and taupe colors are very unconventional for a sky.

A mix of solids, florals, checks, and stripes were purchased to fulfill the maker's conception of the quilt, which was hand appliquéd and pieced. It was quilted on a thin cotton batt with seven to eight stitches per inch. Parallel lines of quilting enhance the boards; radiating lines from the door increase the sense of perspective. Other quilting suggests the contours of the hills and the currents of the air.

A self-taught quiltmaker, Paulette Suder Peters became interested in quilts just before the Bicentennial. Her first project was a full-size Boston Common quilt; she had bought the batting first and saw the pattern on the wrapper. Then she began collecting the fabric for it. That project, like many of hers, was machine pieced; only recently has Paulette become interested in hand piecing. Her quilting has always been by hand, at first with a hoop, now on a large frame, which she says is much faster.

By the late 1970s Paulette and the friend with whom she learned the art of quilting had become quilt teachers in Elkhorn, Nebraska. They organized an annual show called the Spring Recital for their many students to exhibit their work. The Cottonwood Quilters, a guild based in Elkhorn, evolved from the classes as former students wanted to continue to meet and to learn. Paulette herself is a member of six quilt guilds, though she is most active in two. She is a past president of the Nebraska State Quilters Guild. She also stitches monthly with a small group of quilters of all ages and social and economic levels. One of the things she likes best about quilting is the bond it forms between women, past and present, and the generations to come.

At first Paulette made quilts in traditional patterns; then she began drafting patterns and altering them. She still occasionally reproduces old quilts, but now she prefers to work out original, usually thematic designs. She makes sketches, puts them aside, and returns later to develop the ideas. "The Promise" took a year to develop, though the work itself went more rapidly. She always has one quilt in the frame, another in the piecing stage, and another on paper. The sizes of her quilts vary; she says when the quilts tell her to quit, she quits. She does favor a size about fifty inches by sixty inches—large enough to be a major project and to allow her to work out ideas but small enough to complete. She has found that the pressure of a deadline, as for a contest, helps her to finish quilts.

Contests seem to bring out some of Paulette's best work. "The Promise" was a finalist in the Great American Quilt contest at the Museum of American Folk Art, New York, and it appears in the book *All Flags Flying*, by Robert Bishop and Carter Houck. Her prize-winner "Picture Books in Winter" in the museum's Memories of Childhood contest appears in Jacqueline M. Atkins's book of the same name.

Paulette is bothered when people call her work a hobby; she says she puts too much of her time and self into what she does. It is "an artistic outlet that I didn't know I had." When she finishes a quilt, she puts it in a closet because she "can't stand to look at it." Later, though, she enjoys taking the quilts out. Even if she sees imperfections, she doesn't fix them—it's time to move on to the next idea.

Paulette Aileen Suder Peters (see also page 202)

83 "The Promise"

Cotton
72" × 72"
NQP 4591

1986
Made by Paulette Aileen Suder Peters
(1940–)
Made in Elkhorn, Douglas County,
Nebraska
Owned by Paulette Aileen Suder Peters

191

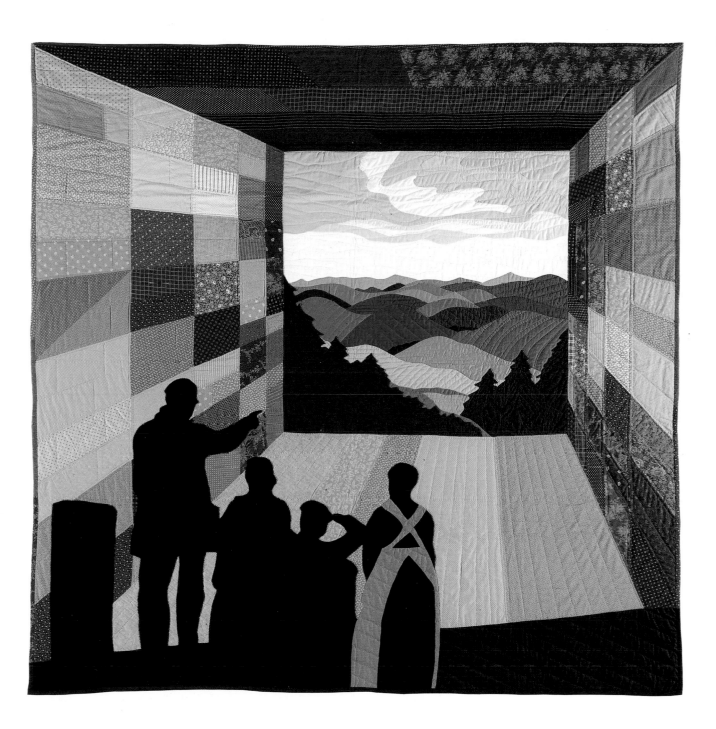

UNMISTAKABLY modern in color, design, and technique, this quilt has all the grace and charm of nineteenth-century appliqué. In fact, much of the quilt is pieced. The lotus flowers, in cream and two shades of pink, have the gentle curves of Joyce Schlotzhauer's curved two-patch system.[11] Their green stems and taupe leaves form a complex design around the simplicity of the central pink square. The central medallion is outlined in dark green, softening and defining the cruciform shape.

The central ground, instead of being the white typical in nineteenth-century appliqué, is a pink-sparkled taupe print. Four shaded-pink ribbon bows encircle the lotus wreath, filling the corners and subtly making the transition to the square shape defined by the black-and-taupe borders. The square is marked by the most important of the borders, a stylized band of lotus, recalling an art deco frieze. Since the base of each lotus touches the dark green border, it looks as though each one were floating motionless on dark, still water. The flowers are framed by a strong zigzagging line of taupe bars and green print squares against black dogtooth triangles. Another taupe border separates this from the final border, a delicate twist of pieced ribbon, to complement the ribbon bows of the center.

"Spring Lotus Flower" is all hand pieced, assembled, and appliquéd. Lotuses are quilted, like a reflection, in the plain areas, while the appliquéd areas are outline quilted. At the Douglas County Fair in 1987 it took first place for original design; at the Nebraska State Fair that year it took fifth place for pieced quilts. In 1990 it was featured in the "Quilt Art '90" engagement calendar.

The six-generation quilting tradition of her family was dying out when Dianne D. Duncan was born in 1948 in Clarinda, Iowa. Her mother had made one baby quilt; her grandmothers made utility quilts that were seeing heavy use. After her family moved to Omaha in 1958, there was no one to show her how to quilt. At the University of Nebraska she became an art major,

specializing in graphic design. In 1972 she married Brian Thomas and moved back to Omaha, where their three sons were born.

In 1979, when her first son was eighteen months old, she joined a sampler quilt class offered by Carol Uebner, a quilter and quilting teacher. Dianne likes deadlines; she completed the blocks for each session on time. Hers may have been the only quilt finished in the class.

Since that time Dianne has become deeply involved with quilts and quilt-making. She researches, collects old quilts, and presents programs on how to date them; she is active in the Omaha Quilters Guild and the Nebraska State Quilters Guild. Her quiltmaking is done mostly at home in her dining room, which she says explains why she doesn't entertain very often.

One or two or more quilts are always under construction at her house. She likes to adapt designs to make them her own. "Spring Lotus Flower" began

as a design for a forty-five-inch wall hanging. She designed borders to build it into the kind of large quilt she prefers. She keeps a log of the progress and honors won by each quilt.

Dianne's quilts usually begin with an interesting fabric to which she adds other colors. She says she prefers "muddy colors, rather than clear colors." Sometimes she has stacks of fabrics ready to go but no pattern with which they can be used most effectively. Viewers of her quilts agree she finds striking patterns to complement her unusual color combinations. What makes her quilts distinctive is the interplay of color, with which she loves to experiment. For a woman who is shy about entering her work in competition, Dianne has been well rewarded. She is most proud of her three quilts featured in "Quilt Art" calendars, of the Omaha Guild quilt "Star of the Heartland," which she "mothered," and of being a semifinalist in an international contest sponsored by *Quilter's Newsletter Magazine*.

Dianne D. Duncan Thomas

84 "Spring Lotus Flower"

Cotton
95" × 95"
NQP 3966

1986 (marked)
Made by Dianne D. Duncan Thomas
(1948–)
Made in Omaha, Douglas County,
Nebraska
Owned by Dianne D. Duncan Thomas

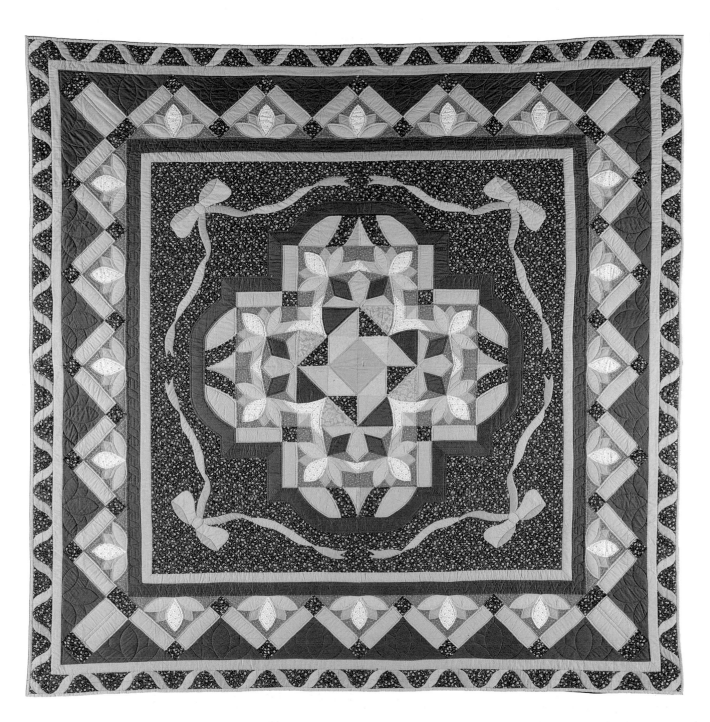

THE GREAT star in the center bursts forth in a blaze of light in this dramatic quilt, made by the Omaha Quilters Guild to represent the guild and the city. At the heart of the quilt in a circular shark's-tooth border is the hand-appliquéd Omaha skyline with the Missouri River flowing through it. The misty colors of the dawn sky reflect the colors of the star background.

Surrounding this circle are successive starlike "borders" of teal, purple, taupe, and a rich teal-and-maroon paisley. Each star is subtly different from the others. The taupe border, for example, follows the main points of the maroon star, but simplifies the lines, eliminating the two secondary points. The dark paisley star elongates further, bringing the four quadrant points outside the bounds of the unobtrusive taupe square. This starlike design was taken from the floor of the Western Heritage Museum building in Omaha.

The luminous quality of the quilt comes from the skillful shading of the chevron Log Cabin blocks. The Log Cabin blocks are set in a Trip Around the World fashion, shading from light pinks and greens to dark greens and purples at the corners. The entire quilt is quilted to accentuate the starburst and the radiating light.

This quilt has traveled widely: it was shown at the American Quilters Society show in Paducah, Kentucky, in April of 1987; it won third place at the Nebraska State Fair that year; in the spring of 1989 it traveled with an Omaha Playhouse production of "The Quilters" to Russia. At home in Omaha it hangs at the guild's shows as an emblem of the guild.

Thirty-one members of the Omaha guild worked on the quilt, putting in nearly three hundred quilter hours.[12] It began with twelve members of the Omaha Quilters Guild who met at Dianne Thomas's house in 1986 to discuss ideas for a guild quilt. The group wanted a quilt that would represent their city and quilters, and one that would represent contemporary quilt styles and colors. Thus, a pictorial sampler of Omaha scenes was ruled out as not representing quilting. The medallion format idea for the quilt evolved communally. One member suggested the star design from the Western Heritage Museum in Omaha (formerly the Union Depot, designed in 1921 by Stanley Underwood). Another member suggested the skyline scene from a Chamber of Commerce brochure; another suggested the shaded effect. Other members chose the colors and the many fabrics. The sky fabric was hand dyed for the quilt by a quilter-dyer in Ohio. Still more members worked on the construction.

The quilt links the past and present as well as the makers and their city. The Log Cabin blocks recall a time when Omaha was a settlement of rough timber buildings, contrasting thematically with the modern cityscape. A favorite of nineteenth-century quilters, the Log Cabin block is also a favorite for contemporary design exploration. The desire to create beauty with fabric, both symbolically and visually, is the common bond among all quilters.

85 "Star of the Heartland"

Cotton
98" × 97"
NQP 3941

1986 (marked)
Made by the Omaha Quilters Guild
Made in Omaha, Douglas County,
Nebraska
Owned by the Omaha Quilters Guild

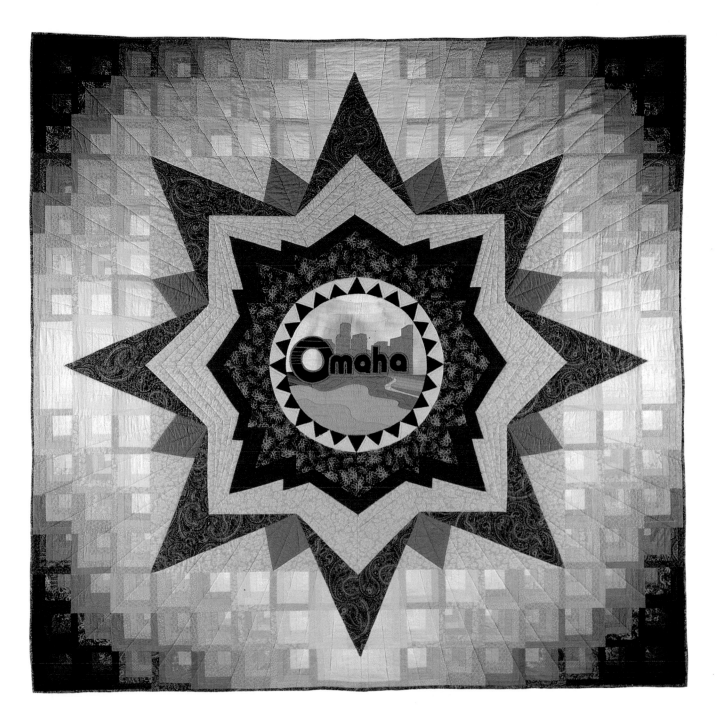

86 "Consider the Lilies"

Cotton and polyester-cotton
35" × 44"
NQP 2492

1987 (marked)
Made by Rhonda Mae Shanks McClure
(1954–)
Made in Wahoo, Saunders County,
Nebraska
Owned by Rhonda Mae Shanks
McClure

196

Rhonda Mae Shanks McClure

IN "CONSIDER THE LILIES," as in one of Monet's garden scenes, red flowers bloom mistily around a blue-and-yellow figure beneath a subtly shaded sky. The central panel of this wall quilt is a single piece of fabric, hand dyed by the maker and hand quilted in thread of varying colors to give texture and to suggest new forms. The impression of a painting is enhanced by the borders: a white mat, then a thin satin ribbon outer mat, and finally a white frame. The title of this work is taken from Matthew 6:28, "Consider the lilies of the field, how they grow, they toil not, neither do they spin." In this quilt of hand-dyed fabrics, the reference may be not only to the flowers but to the maker, who is herself a handspinner.

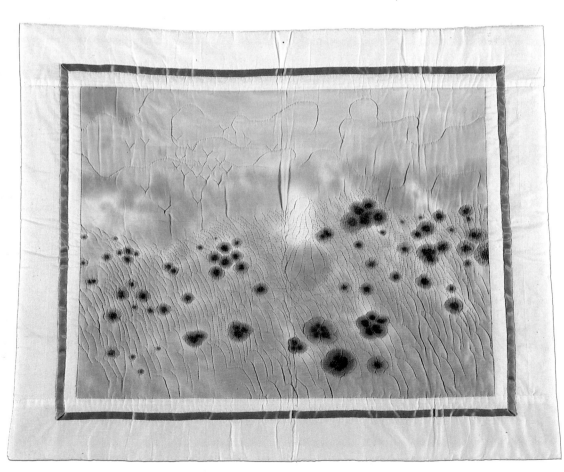

87 "There's Talk That Satan Is Among Us"

Cotton and polyester
45" × 45"
NQP 2493

1986 (marked)
Made by Rhonda Mae Shanks McClure
(1954–)
Made in Wahoo, Saunders County,
Nebraska
Owned by Rhonda Mae Shanks
McClure

THE SOMBER warning of the biblical passage "Beware of false prophets, which come to you in sheep's clothing, but inwardly they are ravening wolves," (Matthew 7:15) is undercut by the humor in "There's Talk That Satan Is Among Us," an original appliqué quilt. Each of the black-faced, white-flannel sheep has its own personality; some talk to each other, a few look aside, two sprawl on the ground, one turns his back sheepishly. The black and white of the sheep is sparked by the red of their heart-shaped ear tags, though two have turned their heads so the tags are hidden. The red tongue of the wolf appears to be just another tag, making him even harder to spot; perhaps it is the sheep on his right who is saying incredulously, "There's talk that Satan is among us."

Rhonda Mae Shanks was born in 1954 in Comstock, Nebraska; her father farmed and her mother became a postmistress. She comes from a family of quilters: she has a quilt made from blocks pieced by a great-grandmother; her grandmother quilted; an aunt made a quilt top for a high school graduation gift; her mother, Arlene Shanks, quilts and has designed unusual children's quilts for her grandchildren. Rhonda began quilting in her teens. Married in 1975, she graduated from the University of Nebraska–Lincoln in 1976.

Her husband, Donald McClure, is the shepherd for the university's field laboratory. Her involvement in the farm and his work has put Rhonda on to unusual paths. She has worked particularly with wools. She helps raise the sheep, spins the wool, and dyes it. Some of her wool goes to the Department of Textiles, Clothing and Design at the University of Nebraska–Lincoln for use by students. Rhonda uses much of the rest in a variety of ways, both for her personal satisfaction and

to sell. The inspiration for "There's Talk That Satan Is Among Us" was a series of soft-sculpture sheep and a wolf in sheep's clothing that she has made. She has become interested in working with silk also, particularly in dyeing experiments for both pictorial and geometric effects.

The history and heritage represented by traditional quilts appeal to Rhonda, but her interest in the fiber arts in general leads her to experiment often with new ideas, new materials, and new techniques. These quilts and her other fiber works have hung in various art shows, but someday she hopes to have a one-woman show which will surely showcase her wide range of talents and creations.

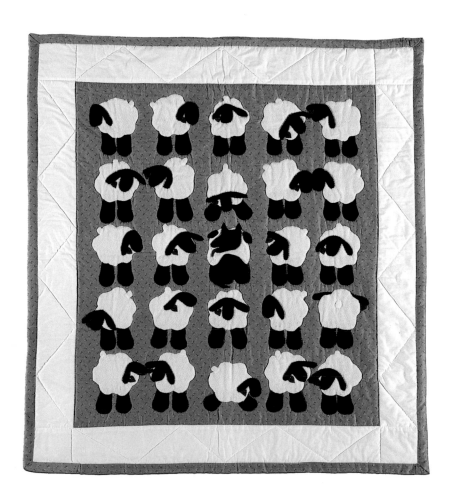

MORE THAN fifty women in the town of Benedict worked on this quilt for their town's centennial celebration.[13] It is a record of a community in fabric, a focus of civic pride, and a source of funds, since it was the prize in a raffle netting more than nine hundred dollars. The central medallion bears the logo of the town, framed in navy and white borders. Immediately surrounding it are twelve-inch blocks depicting contemporary places and buildings. Some of the buildings depicted are necessary and expected, such as schools, churches, and storefronts. Others, no less necessary, are offbeat, like the gas stations, the grain elevator, and the beauty shop.

The medium blue of the sky in each block and the strong rectangular shapes in each unify the quilt. The palette is limited mostly to neutral grays, browns, and greens, but it is enlivened by a few patches of white and red. Navy sashing and a white border frame it all. Some blocks are embellished with buttons, snaps, net, lace, or ribbons.

Pictorial appliqué quilts celebrating a particular locale or event have been popular since the Bicentennial, when the Putnam County (New York) quilt and the Onondaga County (New York) Bicentennial quilt, both made by groups of local women, took top prizes in *Quilter's Newsletter Magazine*'s contest. Pictorial quilts have a warmth, color, and charm that a display of photographs can never match. Seeing familiar objects in a different medium generates a special effect, which may help account for the success of representational quilts as fund-raisers.

The twenty-two outer blocks show buildings from the town's past. Having past and present scenes both on the quilt enhances its value as a record for the future.

One of the organizers and designers of Benedict's quilt, Ella Allen, had seen schoolhouse and house quilts in a *Better Homes and Gardens* quilting book, and suggested town buildings to the Centennial committee. With the idea approved, she contacted women in area churches and extension clubs and put a notice in the *York County Newspaper*. Some of the many women who responded had not made quilts before.

Each woman designed her own block, using photographs or her own sketches of the buildings. Many of the makers had sentimental reasons for their choice of subject. Members of the Lutheran and Methodist churches made the blocks showing their buildings. The block showing the old telephone building was made by a woman who had worked there. Other buildings were chosen because of family associations. Some of the designs are pieced, others appliquéd, others use glue and embroidery. Apart from the fabric for the sky and the dark blue of the windows, the fabrics came from each maker's scrapbag. Each block has its maker's name embroidered on it.

88 "Benedict Centennial Quilt"

Cotton and polyester-cotton
110" × 95"
NQP 868

1987 (marked)
Made by the women of Benedict, Nebraska
Made in Benedict, York County, Nebraska
Owned by Kenneth D. Miller

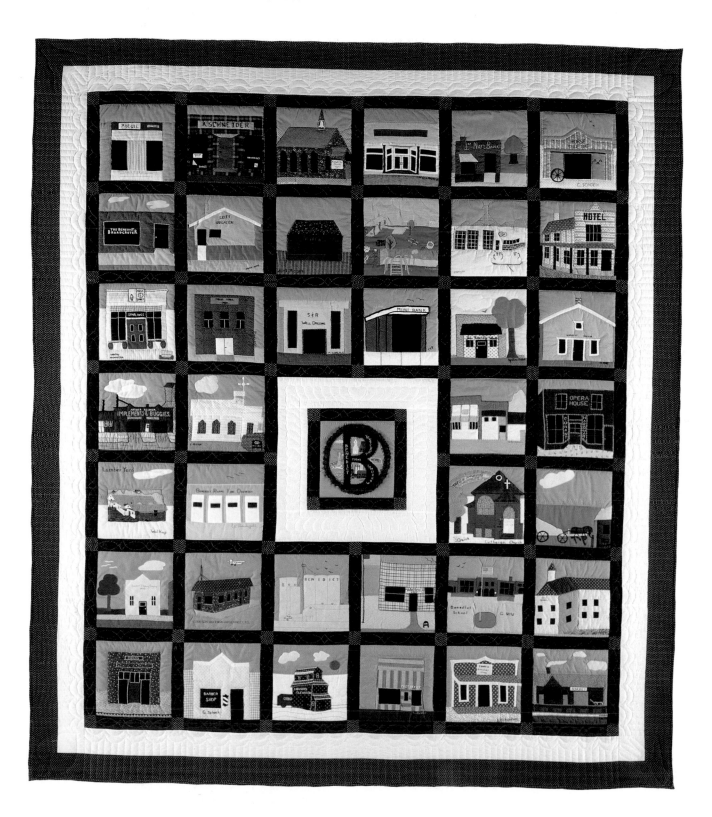

Joan Lucile Grass Schwalm

BOLD COLORS, fine workmanship, and unusual set mark this prizewinning quilt. Two different brick-red prints of very similar values blend to create an apparently solid circle edged with sharp thornlike points. The solid black spokes, tips balanced on the small triangles surrounding the center, dominate each compass.

The central compass block, a black square on point, is set in a brick-red square, which seems to overlap the successive white, black, and brick-red squares that complete the central medallion. The maker has successfully overcome the tendency of medallion designs to be square by her placement of the other four black-bordered compasses. Instead of centering each one on a side of the large white square, the compasses are placed on half the side, corners meeting. Thus, the quilt has gained in length, yet it retains its fourfold symmetry.

Narrow black and white borders and a wider brick-red border echo the pattern of the central medallion. Another narrow white border blends with the white dogtooth triangles of the final, expertly handled border, creating a fringelike effect.

The blocks are hand pieced, and the top is assembled both by hand and machine. The fine quilting at ten to eleven stitches per inch is done on a thin cotton and polyester batting. The straight lines of the crosshatching and parallel-line quilting form the background for the dominant circular motifs, which are outline- and echo-quilted. Cables run around the border.

Awarded Best of Show at the Nebraska State Fair in 1988, the quilt has been exhibited at Disneyland and the National Quilting Association show and has appeared in *Quilter's Newsletter Magazine*.

Joan Lucile Grass was born in Broken Bow, Nebraska, in 1936 and grew up in Tecumseh. Her father was the school superintendent. (Years later Joan made a quilt to commemorate her father's life and career.) Both of her grandmothers and several aunts quilted and did other handwork, but her mother did not; so Joan did not grow up with quilts. She learned to sew in the 4-H Club. Sometime before finishing high school she saw a quilt pattern she liked in a small pattern booklet and began piecing it. It was put aside for more than twenty years when she left for college to earn her degree in business education.

After her marriage in 1957 to William Schwalm, a mechanical engineer, Joan was busy with three children and many moves. Finally settled back in Lincoln, she happened to see the 1974 quilt show at the Sheldon Memorial Art Gallery. Intrigued by the quilts, she talked to Mary Ghormley, then took one of Mary's quilt classes. Shortly thereafter she joined the Lincoln Quilters Guild, in which she has been active ever since.

Her first quilt was a yellow Shoofly, now in her daughter's possession. Joan usually has several projects going at once; one of her large, complex designs can take several years to complete. She prefers hand piecing, though she sometimes sews long borders on by machine. Her quilting is done on a large frame.

When Joan begins a quilt she graphs the pattern out full size on large sheets of graph paper. Then she lays acetate film over the design to trace perfectly accurate templates. Sometimes the fabrics are purchased for a specific design; at other times she looks for a design to suit fabrics that have caught her imagination. Her favorite traditional pattern is the Mariner's Compass; this quilt shows how she carries on the masterpiece traditions of the past and brings the design into the present. Quilting is important to Joan; it serves as an outlet for her creativity and it has helped her through times of trial.

89 Mariner's Compass

Cotton
110" × 81"
NQP 3187

1987 (marked)
Made by Joan Lucile Grass Schwalm
(1936–)
Made in Lincoln, Lancaster County,
Nebraska
Owned by Joan Lucile Grass Schwalm
Detail on page 166

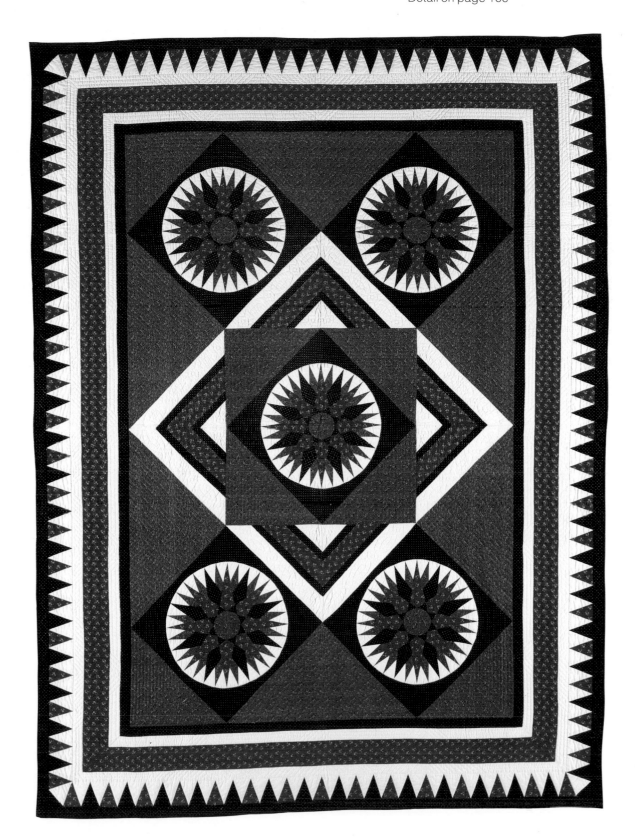

A KALEIDOSCOPE seems to have been translated into a quilt, or are we looking at a quilt through a kaleidoscope? Light has been refracted into a multitude of colors on different planes. The sharp angles of the triangles give movement; the dark areas, particularly, seem to be vibrating, shaking off medium-colored pieces that fall toward the light space beyond.

The basic module is a simple Nine Patch composed of eighteen triangles, divided diagonally into an area of light and medium-light prints and an area of dark and medium-dark prints. This module is given four one-quarter turns, forming blocks with light centers and dark corners. When the blocks are joined edge to edge, the dark corners form dark squares which seem to become the main design. A sawtooth border of dark and medium-dark prints which follows the directions of the blocks makes a unifying dark frame and helps to obscure the basic module.

Fundamentally, the quilt is a One Patch, composed of a single triangle template, a type most often associated with hand-pieced hexagons in the English manner. Though it is hand quilted (seven stitches per inch), this quilt is machine pieced, unlike traditional one-patch work. The subtle use of colors to achieve prismatic optical effects is very modern. Another contemporary feature is the use of "scraps," in this case, a wide variety of new yardage collected in recent years. The "scrap look," popularized in the 1980s by Jinny Beyer, influential quiltmaker and author of *The Scrap Look*, and Judy Martin, quilt designer and author of *Scrap Quilts*, gives richness of texture and color; it also gives quiltmakers a chance to use and display their collections of fabrics.

Paulette Aileen Suder was born in Council Bluffs, Iowa, in 1940. She grew up in Lincoln, Nebraska. Her mother was not interested in sewing, but Paulette learned to make clothing at school and to do embroidery and needlepoint. She attended college to become a nurse; in 1962 she married Terry Peters, an engineer. They have three children, now grown, leaving space for Paulette to expand her quilting domain.

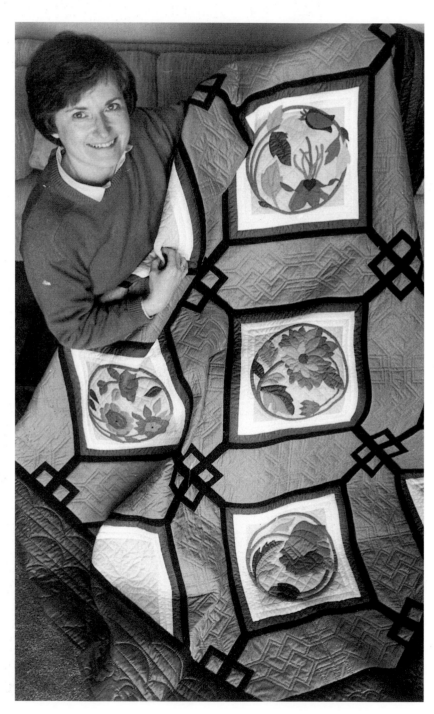

Paulette Aileen Suder Peters showing "Cathay," a quilt based on an oriental design. Courtesy of the *Omaha World Herald*.

202

90 "Scrapangles"

Cotton
74" × 53"
NQP 4599

1987 (marked)
Made by Paulette Aileen Suder Peters
(1940–)
Made in Elkhorn, Douglas County,
Nebraska
Owned by Paulette Aileen Suder Peters

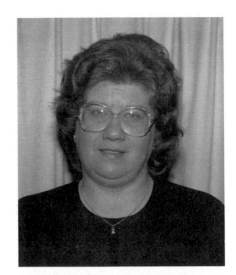

Sandra Annette Skoglund Anderson

THIS IS a playful quilt for both the calico cats and its cat- and quilt-loving maker. Seven rows of colorful cats play with bi-toned balls. Their ears and tails are perked, their embroidered eyes gaze steadily on the viewer. Suddenly, the viewer realizes that the black background on which the cats rest is a whole series of upside-down black cats, holding the same balls in their paws. Technically then, the quilt is an exercise in figure-ground reversal to create an optical illusion—but what fun!

The irregular green border gives hints of the third kind of cat to be found. Quilted cats stalk across the whole quilt. Included in the seven-stitch-per-inch quilting are the names of the maker's three cats. The cats were pieced by hand, their eyes and noses were embroidered, and the balls were appliquéd.

In this day of commercial kits and copyrighted patterns, the information network of quilters still flourishes. The basis of this design appeared in the *Los Angeles Times*. A woman in Utah saw it and made the quilt for an American Quilters' Society show. Sandy saw the slide and wrote to the Utah woman, who shared the pattern with her. Sandy modified it to make it her own (the original pattern had only two colors of cats). She has since shared the pattern with others.

Sandra Annette Skoglund, whose name reflects some of her French-German-Swedish ancestry, was born in 1950 in Columbus, Nebraska. Her father was a milkman, so the family rose early—a habit that enables her to accomplish as much as she does. Her grandmothers made quilts. Sandy particularly remembers the determination of one grandmother, who pieced at her treadle sewing machine even after she lost the sight of one eye and the other was failing.

When she was about twelve or thirteen, Sandy saw a picture of an embroidered Iris Garden quilt in *McCall's*. Although her grandmothers would not make it for her—one said if Sandy needed a bedcover, she'd buy a blanket for her—Sandy kept the picture. Sandy grew up in Norfolk and then came to college in Lincoln in 1968. Sometime after her marriage in 1970 to Ivan Anderson, she found a closeout sale of the Iris Garden quilt kit at a department store. That king-sized quilt, completed in 1975, was her first quilt project.

In the meantime, her husband's grandmother, a devoted quilter, introduced her to piecing and appliqué. Several other projects were completed before the Iris Garden. Sandy usually has several projects going at once, with ideas for more accumulating. She has an idea box for each one of her projects; in each she puts notes, fabric samples, sketches, and other ideas until there are enough to begin working out designs full size. She likes to "sew" on paper so she doesn't have to rip out fabric. She then keeps a journal of her project, with pictures, design notes, notes on problems and solutions, ribbons won, and so on. A prolific quilter, with more than fifty quilts to her credit, she especially enjoys hand-appliqué and miniature work and is always ready to try new ideas and techniques.

91 "Three Way Cats"

Cotton and polyester-cotton
87" × 72"
NQP 3292

1987—1988
Made by Sandra Annette Skoglund
Anderson (1950—)
Made in Lincoln, Lancaster County,
Nebraska
Owned by Sandra Annette Skoglund
Anderson

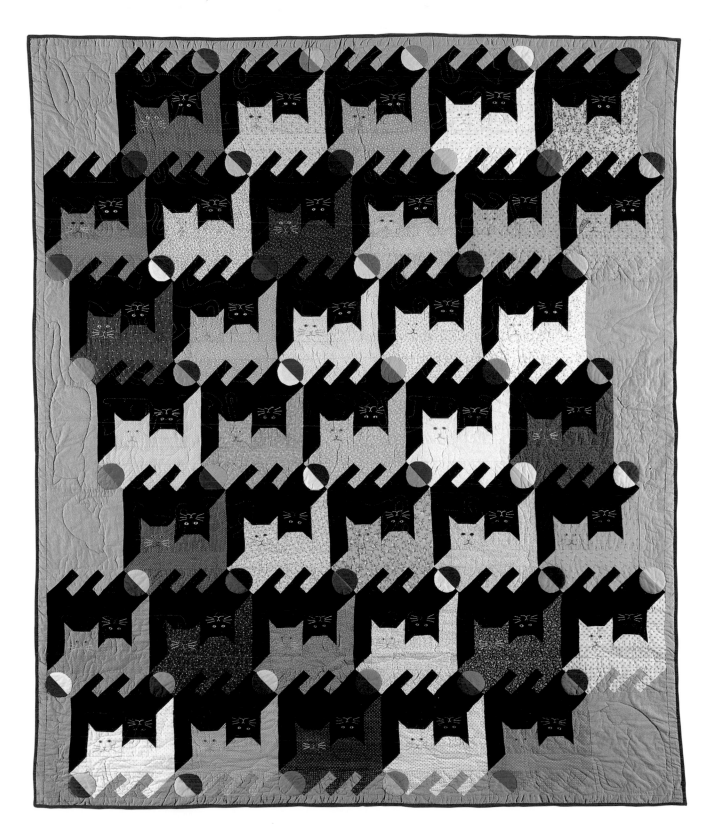

AN ORIGINAL design, subtle colors, fine quilting, and an intricate set distinguish this beautiful wall quilt, made to commemorate the Nebraska Quilt Project. The design was inspired by a star pattern seen on some old pottery in the Pine Ridge region of Nebraska while the maker was on the road with the Quilt Project. The maker wanted to create a Nebraska pattern as well as to preserve the memory of the experience in quilt form. The colors are the soft bluish green of spring in the Sandhills and the soft tan of its rocks and earth.

Based on the traditional Le Moyne Star, the large star appears at first to be a tan four-point star with gently curving sides. The curve is an illusion created by the wide angle made when the other four diamonds were cut at the wide middle into two isosceles triangles. One triangle is a dark green microdot; the other is divided into three light blue-green triangles and a dark green center triangle. This dark shape forms a secondary design resembling four pine trees around the softly shaded center.

The simply constructed, but complex-looking, diagonal set creates its own design. The nine patches at the intersections seem to bloom like flowers with a dark center and shaded petals. The dark green stripes of the triple sashing resemble a stylized vine on a trellis; through the openings we see the stars. The tan print strips in the sashing tie in with the tan stars. Each tan strip has the signature of a member of the Nebraska Quilt Project inked on it.

The entire quilt was hand pieced and assembled. The fine quilting has eleven to twelve stitches per inch. The design areas are quilted in the ditch; the border triangles are filled with a diagonal crosshatching that reflects the latticelike look of the main design. The quilt is a lovely tribute to Nebraska's land and quilts.

A Nebraska native, Mildred Ann Wesely was born in 1937 in Cedar Bluffs, Saunders County, Nebraska. One of three daughters born to a farming family, she was the tomboy, the one who helped her father with the livestock and other farm chores. Her love of this work accounts, she thinks, for her fascination with quilt patterns that have an animal theme. When Millie was about thirteen, her older sister began to embroider a state-birds quilt for her hope chest. Millie wanted to do it also, but since her embroidery skills were minimal, she used liquid embroidery paint instead. "It was terrible," she says. It was put away and forgotten for years. After her marriage in 1956 to Arsene Fauquet, she finished it. Since there were no quilters in her family to show her how to quilt, it was quilted in large stitches with doubled thread. She also embroidered a crib quilt for her daughter.

During the 1960s and 1970s, Millie occasionally made crib quilts as gifts and did other crafts and handwork. About 1983 a penpal sent her the pieces of a Weathervane block all cut out; while completing it Millie decided that hand piecing was what she wanted to do. Another friend, Sonja Schneider, became interested in quilting and invited Millie to a Lincoln Quilters Guild meeting. Made aware of the endless design possibilities, she became serious about quilting. She has taken many classes and learned from many teachers locally and nationally.

Beginning with traditional designs, Millie began to change them. She discovered that designing was what she really liked to do. She was involved in a successful pattern business, which proved to her that people liked her creations, but the business got in the way of her designing. Now she is assembling a portfolio with publication in mind. Some of her work has appeared in *Quilter's Newsletter Magazine*.

When she designs, Millie sometimes begins with a traditional pattern. More often she takes sheets of newspaper

and begins cutting until she finds a shape that pleases her, and then she begins to refine it. An award-winning Sunbonnet Sue block came about this way. For her 1989 Nebraska State Fair entry, she began drawing abstract lines for a six-inch block. As she put blocks together and rotated them, she saw figures emerging that reminded her of origami shapes of animals, so the design became "Origami."

Millie enjoys entering quilt and quilt-block contests; she likes the challenge, but not the deadlines. Contests and designing for publication give her the chance to share her creative gifts with others; that is the most exciting part of quilting for her.

Mildred Ann Wesely Fauquet

92 "Pine Ridge Star"

Cotton
41" × 41"
NQP 3718

1988 (marked)
Made by Mildred Ann Wesely Fauquet
(1937–)
Made in Lincoln, Lancaster County,
Nebraska
Owned by Mildred Ann Wesely
Fauquet

207

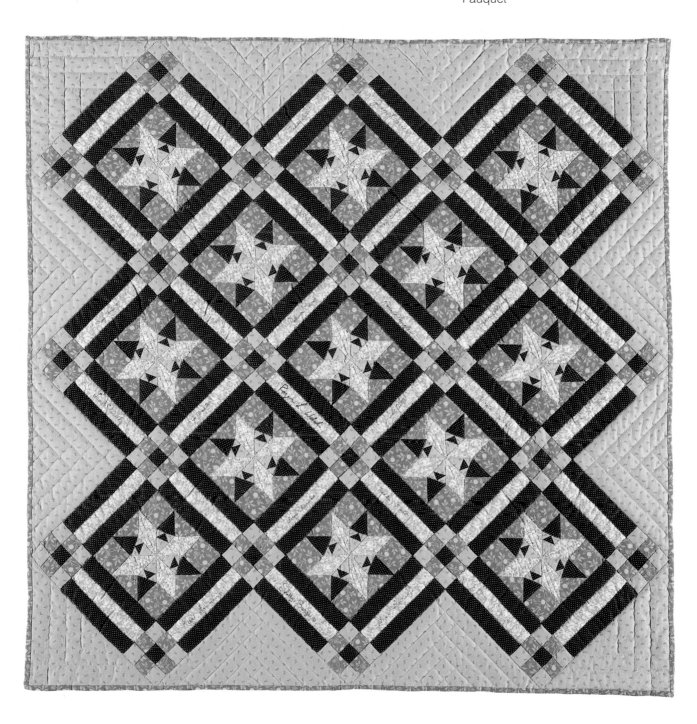

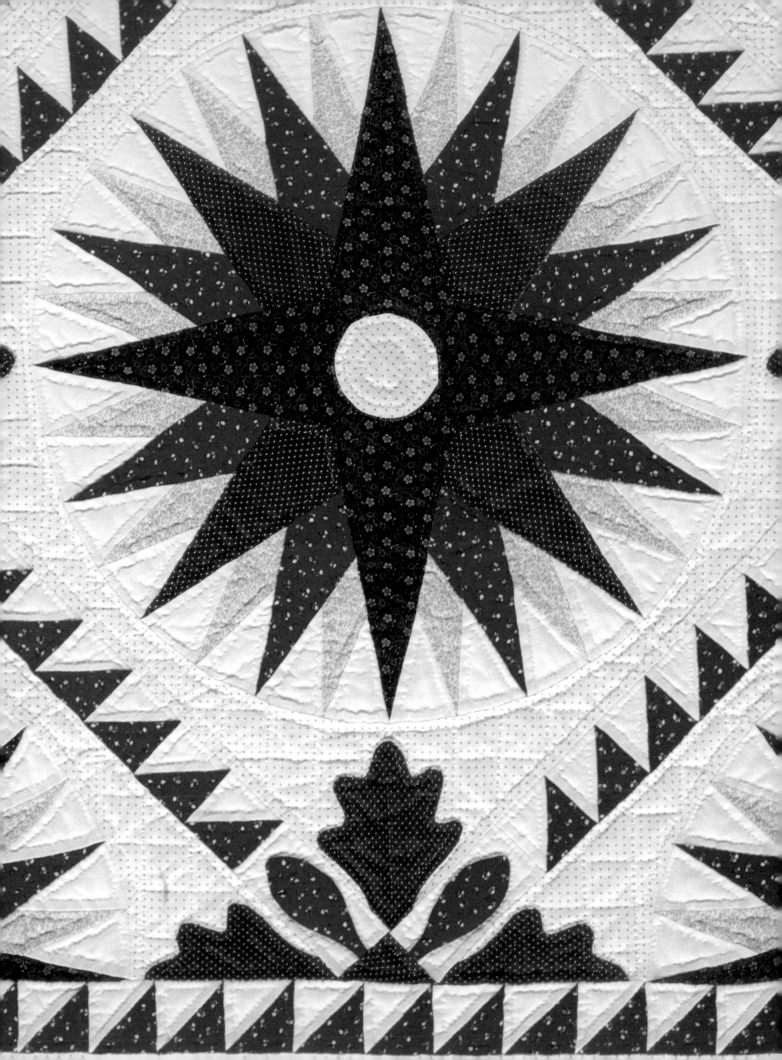

Nebraska Treasures

by *Margaret Frady Cathcart*

Generations of individual women and men have contributed to Nebraska's quiltmaking heritage and deserve public recognition for their significant contributions. During the course of the Nebraska Quilt Project five outstanding quiltmakers emerged who deserve special recognition. They are our "Nebraska Treasures," and the quilts selected reflect their unique talents and abilities.

Martha Hollins Allis was the maker of the first quilt known to have been made by a Nebraskan. Both quilt and maker deserve recognition of a singular nature for their historical significance to the quiltmaking traditions and cultural heritage of the state.

Grace McCance Snyder's brilliantly conceived quilts of thousands of pieces have astonished and inspired quiltmakers past and present, and her life, a western Nebraska version of *Little House on the Prairie,* is fascinating as well. She embodies the virtues of Nebraska pioneer women and becomes their spokeswoman through her autobiography, *No Time on My Hands.* Grace Snyder's life as daughter, wife, and mother was full and rewarding, and her lifework of quiltmaking brings honor to Nebraska, as it brought Grace many hours of joy from childhood onward.

Quiltmaking becomes masculine and modern in many of Ernest B. Haight's original designs. His quilts are far removed aesthetically from the favored Grandmother's Flower Garden and Double Wedding Ring quilts of the 1930s, when he began to make quilts. They are perfect puzzles rendered in fabrics, a form of textile engineering designed with drafting instruments on immense sheets of grocery-store advertising banners.

Louise Howey in her long quiltmaking career that spans sixty years from 1930 to the present represents the continuity of Nebraska quiltmaking. Louise was making quilts before most of today's quiltmakers were born, and her output never diminished during the 1950s and 1960s, when quiltmaking slowed throughout most of the nation. Louise looked at each new quilt pattern as a challenge, and her curiosity and love of working with bits and pieces of colorful fabrics led to the production of an archival collection of quilt blocks. Louise inspired and encouraged countless quiltmakers through her activities as a Nebraska State Fair judge and director of needlework exhibits.

Mary Campbell Ghormley has long been recognized by her peers for her notable contributions to Nebraska's quiltmakers. Mary's perfectionism produces awe-inspiring quilts that transcend time, while her willingness to provide programs for groups throughout the state illustrates her community spirit and commitment to sharing and increasing knowledge about quilts and quiltmaking. Her enthusiasm as quiltmaker and collector is infectious, and her knowledge of the folklore and history of quilts and quiltmaking is recognized state wide. These five Nebraska quiltmakers are truly Nebraska Treasures.

Martha Allis Hollins

THE EARLIEST quilt known to have been made by a Nebraskan and its maker, Martha Allis Hollins, have been recognized as state treasures since 1957, when the quiltmaker's daughter, Flora Nebraska Robinson, presented the Wreath of Roses quilt to the Nebraska State Historical Society in Lincoln. Martha, born in the river settlement of Bellevue, Nebraska, on November 15, 1840, was the daughter of Samuel and Emeline Allis, Presbyterian missionaries to the Pawnee Indians.[1]

Samuel was one of two young men who had come in 1834 from Ithaca, New York, to the future state of Nebraska, then unorganized territory, as missionaries to the Pawnees. In 1836, his fiancée, Emeline Palmer, traveled to what would become Nebraska with Marcus and Narcissa Whitman, Henry and Eliza Spaulding, and others. They were sponsored, as was Samuel, by the American Board of Commissioners for Foreign Missions of the Presbyterian Church in Boston. Samuel met Emeline and the Whitman party at Liberty Landing on the Missouri River on April 21, 1836, and two days later he and Emeline were married. The Whitman party bade good-bye to their young friends shortly after the wedding and pushed on to Oregon over the plains and mountains. Narcissa Whitman and Eliza Spaulding were the first white women to cross the Rocky Mountains. The Allises remained in the future Nebraska, where they reared Martha and her two brothers.

Martha spent her early years on the Pawnee Reservation in present-day Nance County. It is likely that Martha Allis began appliquéing her dower quilt in the late 1850s. Her marriage certificate, dated July 4, 1861, registered in Omaha, Nebraska Territory, states that she was a twenty-year-old bride. Martha's husband, William George Hollins, left shortly after their wedding to serve as an infantry officer in the Civil War, but he resigned his commission in 1862 and returned to Omaha to practice law. Martha and William later moved from Omaha to Minneapolis, Minnesota, where William died in 1889. Martha lived until 1913; she died at her daughter's home in Kenosha, Wisconsin. Her daughter graciously returned the quilt to Nebraska, its place of origin, where it has since been admired and enjoyed as part of the early history of Nebraska.

Martha's quilt is a variation of the Wreath of Roses pattern in Turkey red and green colors. Both pattern and colors were quite popular among quiltmakers during the mid-nineteenth century. Martha may have seen this pattern or a similar one on the quilt of an early settler, or her mother may have seen or even made a similar one in Ithaca, New York, before she moved to Nebraska. The fabric for the quilt possibly came from the fledgling community of Omaha, or Martha's father may have purchased fabrics for the family in the East during a trip in 1857.

All the cottons in the quilt are solid colors with the exception of a brown print used in clusters of flowers or grapes in the basket and a red-and-yellow print in the eagle. Each block is thirteen and one-half inches square and is set on the diagonal. A quilting design of plumes is used to form a circle around the blocks; diagonals are used on the border. The quilting stitches are eight to nine per inch. The appliqué flowers are attached with a neat, even buttonhole stitch, while the leaves and vines are secured with a hidden whipstitch. The tail, feet, and wings of the eagle have been embroidered with heavy brown thread. It is as stylish and up-to-date as any quilt that was made at the same time in the East. Martha must have been a proud as well as romantic young lady when she signed "M. A. Hollins 1860" below the eagle, anticipating her wedding day in 1861 when she could legally claim the Hollins name.

Martha Allis Hollins. Courtesy of the Nebraska State Historical Society.

93 Wreath of Roses

Cotton
77" × 77"
NQP 4058

1860 (marked)
Made by Martha Allis Hollins (1840–1913)
Made in Nebraska Territory
Owned by the Nebraska State Historical Society (no. 7874-1)

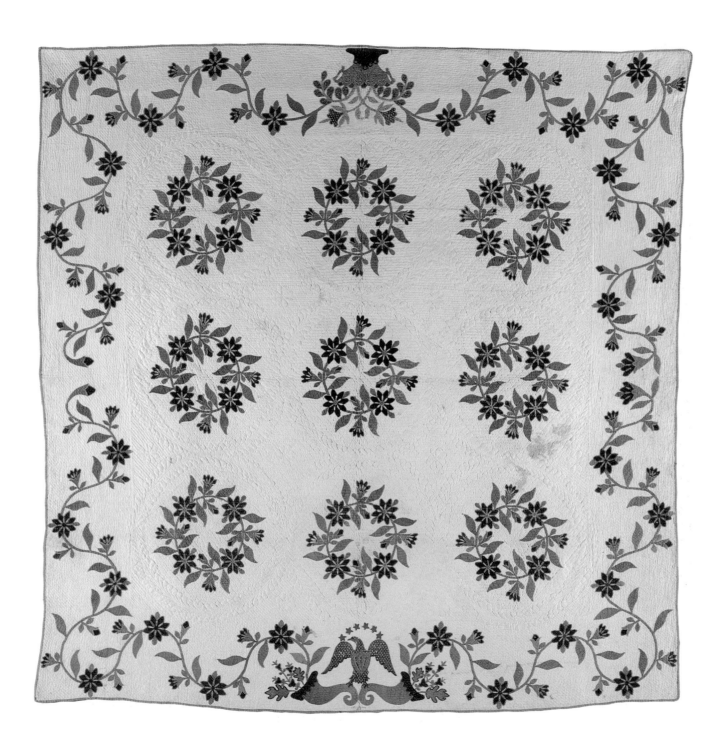

Grace McCance Snyder

THE QUEEN of Nebraska Quilters, Grace McCance Snyder, has been recognized from coast to coast for the technical complexity and quality of her quilts. Her quiltmaking ranges from embroidered quilts, such as the "Covered Wagon" quilt, the pattern for which she ordered from the *Omaha World-Herald* newspaper, through more demanding forms of appliqué, to the extremely complex pieced design of her most famous quilt, "Flower Basket Petit Point."[2] The technical achievements and comprehensive nature of her lifetime of work aroused the interest of quiltmakers nationwide, and consequently her quilts have been hung in numerous exhibits, including several one-woman shows. In 1986 she was named to the Nebraska Quilters Hall of Fame.

Those Nebraskans of past years who walked through the needlework displays of the Nebraska State Fair in Lincoln had the best opportunity to see and appreciate the remarkable quality and quantity of Snyder quilts. Grace had prizewinners in about fifty shows and fairs. Eighteen of her quilts hung in a long row one September fair week in 1951, and the nineteenth, an original design of more than one thousand appliquéd grapes with exceptionally fine quilting (ten stitches per inch), took the purple sweepstakes ribbon that year (Plate 94). She accumulated enough purple and blue ribbons to cover a bed, and the collection of magazine and newspaper clippings about Grace Snyder, her life and her quilts, fills a large scrapbook. Nellie Snyder Yost, Grace's daughter, affectionately edited *No Time on My Hands*, the autobiography of Grace as told to Nellie.[3]

In 1885, three-year-old Grace, her mother, an older sister, Florry, and the baby, Stella, joined husband and father on his homestead in Custer County, Nebraska, where he lived in a twelve-by-fourteen-foot sod house. Everyone in the family worked on the developing farm, and at age seven, Grace begged her mother for scraps, needle, and thread, so that she could stitch quilt blocks as she huddled for warmth in a strawstack while herding the family cows. The small Grace, who preferred outside chores, found she could combine "boys' work" with traditional feminine stitchery, which she also enjoyed.

Several years later when her schooling was completed, Grace left her familiar surroundings to teach school in districts distant from Custer County. Although homesick, the independence of earning her own money compensated somewhat for the loneliness. A salary of fifteen dollars a month plus room and board covered expenses with enough money left over to purchase brand-new yard goods for the first time, a new and thrilling experience for the young woman. The pleasure of planning patterns from whole goods instead of scraps added a new dimension to her quiltmaking.

Marriage in 1903 to a handsome cowboy, Bert Snyder, and life on his ranch in the Sandhills north of Sutherland brought many challenges to Grace during the early years of the twentieth century. Quiltmaking always filled what leisure hours she could find, however. A son and three daughters, Miles, Nellie, Beulah, and Flora, were born to Bert and Grace, but even raising a family on an isolated ranch did not slow her quilting. Grace carried a box of piecing with her constantly and often had one quilt in the frame while stitching blocks for another and cutting pieces for a third.

As a child, Grace had dreamed three dreams—to marry a cowboy, to look down on the top of a cloud, and to make the most beautiful quilts in the world—all of which were fulfilled long before her life ended: she had married

a handsome cowboy, she had flown above the clouds in airplanes large and small, and in the late 1940s she knew she had made quilts far finer than ever imagined. The dreams had come true, but Grace did not lapse into complacency. As long as she had ideas in her head, fingers still nimble, and pretty fabrics, she felt compelled to make quilts.

Grace Snyder's most famous quilts were pieced during World War II, including "Flower Basket Petit Point," made in 1942 and 1943. There are approximately 85,875 pieces in "Flower Basket," so small that four squares (eight half-squares) sewn together make a block about the size of a postage stamp (Plate 95).[4] The shading is produced by half-squares, triangles in differing shades which, when put together to form squares, give the effect of needlepoint embroidery. The border of the growing rose and the framing of the individual blocks are original designs. Grace spent sixteen months making this quilt and used 5,400 yards of thread. The quilt is lined but has no batting because there are so many seams on the back that they essentially form the filling. It was the purple sweepstakes winner at the Nebraska State Fair in 1944.[5]

Grace took the flower-basket pattern from a china plate manufactured by the Salem China Company in Salem, Ohio. The "Flower Basket Petit Point" quilt was well underway when conscience demanded she contact the company in case her copying their pattern infringed on patent or copyright laws. Her admission pleased rather than distressed the Ohio company and the owners sent her a complete set of the china as a token of their pleasure. The German artist Wendelin Grossman,

who had originally designed the flower-basket pattern, lived in Berlin, and he and Grace enjoyed a correspondence after the war.

Quiltmakers look at her cherry quilt (Plate 96) in awe, for it is a tribute to a remarkable talent and skill. Every one of the cherries, of which there are more than seven hundred, was appliquéd by eye alone into perfect one-inch-diameter circles. Blind stitches expertly secure the red cherries and green leaves to the nine muslin squares. Quilted rosettes with two feathered plumes surround each flowered block; the background is crosshatched with lines one-half inch apart using eight stitches per inch. The border of this quilt is exceptionally beautiful with its scallops, swags, and bunches of cherries. The elongated swag defining each corner adds visual interest to the overall design. The quilt is very similar to one pictured in a 1934 issue of *Good Housekeeping*.[6]

Grace McCance Snyder. Courtesy of the Nebraska State Historical Society.

94 "Appliqué Grapes"

Cotton
93" × 94"
NQP 4917

1951
Made by Grace McCance Snyder
(1882–1982)
Made near Sutherland, Lincoln County,
Nebraska
Owned by Alberta Elfeldt
Detail on page 212

214

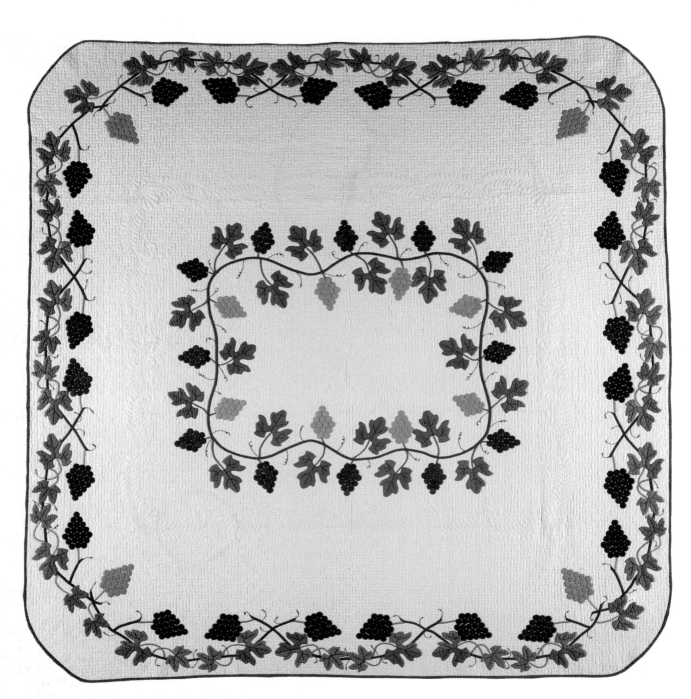

95 "Flower Basket Petit Point"

Cotton
92" × 94"
NQP 4017

1942–1943
Made by Grace McCance Snyder
(1882–1982)
Made near Sutherland, Lincoln County,
Nebraska
Owned by the Nebraska State
Historical Society (no. 7828-8)

215

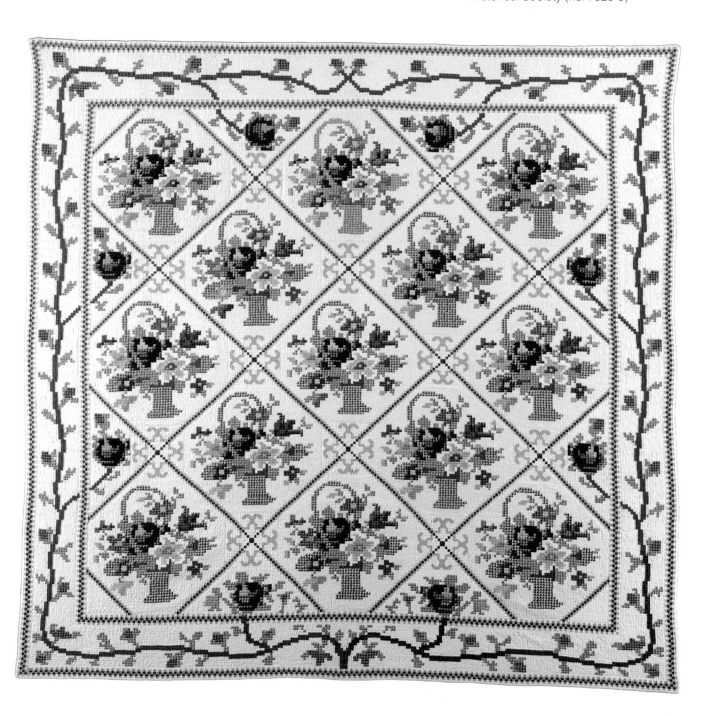

96 "Mrs. McGill's Cherries"

Cotton
90" × 90"
NQP 4916

Circa **1945**
Made by Grace McCance Snyder
(1882–1982)
Made near Sutherland, Lincoln County,
Nebraska
Owned by Josee L. Forell

216

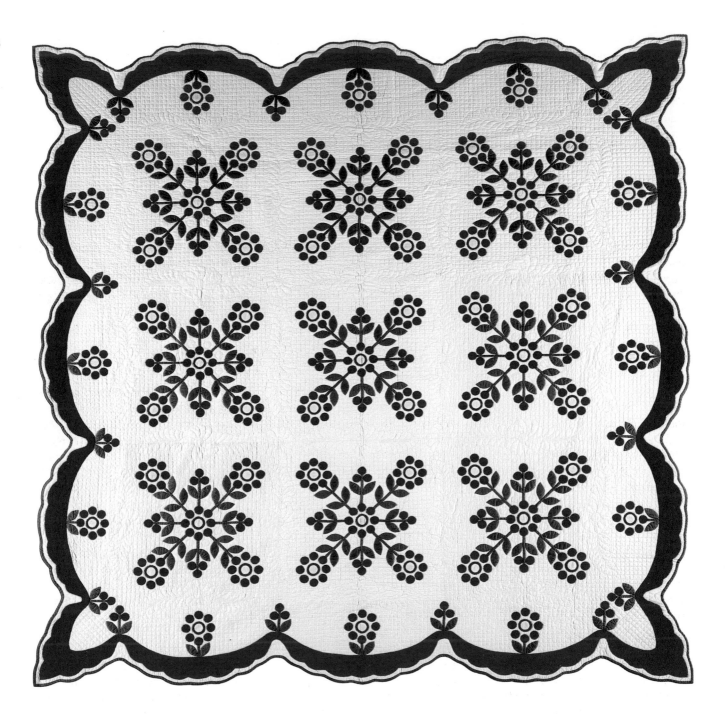

Ernest B. Haight

NEBRASKA'S most distinctive quiltmaker, Ernest Haight, belies the notion that quiltmaking is woman's work, and even more paradoxically, his involvement in the art resulted from his father's example and encouragement, rather than his mother's. His father, Elmer Haight, had been quilting with a local women's society for some time when he suggested that Ernest piece a quilt for each of his five children and that he, their grandfather, would hand quilt it. Ernest took up the challenge in 1936, and father and son together completed four of the quilts. The youngest daughter received the first quilt that was both pieced and quilted by her father, Ernest. What a memorable inheritance for the children of Ernest and Isabelle Haight of David City, Nebraska. Many quiltowners have a mother and grandmother's quilt in their collection, but few can claim one made by father, or even more rare, father and grandfather.

Ernest pieced many of his quilts on the treadle sewing machine that his maternal grandparents brought by covered wagon to Butler County about 1880. His mother, Dora, quilted for him after his father died, but she managed only one or two a year and could not keep up with his output of pieced tops. Thirty-five or forty tops stood in line for quilting in 1960, when Ernest and his wife, Isabelle, decided to confront the problem. As a first step Ernest replaced the old treadle sewing machine with a new zigzag model. Next he devised a method for quilting by machine. He explains his method in a booklet entitled *Practical Machine-Quilting for the Homemaker*, published in 1974. His method of machine quiltmaking requires fifty to sixty hours of piecing and quilting for each full-sized quilt. Binding on the machine takes another hour and a half. His pioneer ancestors and their quiltmaking friends would have been astounded at Ernest's speed of production.

The first Haights arrived at their Butler County homestead in 1880, and Ernest, born in 1899, grew up on the farm. He graduated from the University of Nebraska in 1923 with a bachelor's degree in agricultural engineering and was awarded the prestigious Phi Beta Kappa Key for outstanding scholarship. Love of the land pulled Ernest back to Butler County, where he farmed the family homestead instead of following an engineering career.

In 1928 Ernest married Isabelle Hooper, the pretty daughter of the Baptist minister in David City. Parents and children have shared love and talents for many years, encouraging each other in all their endeavors. In her 1988 interview with a member of the Nebraska Quilt Project, Mrs. Haight said, "The best crop we ever raised on our farm was our crop of boys and girls." Strong family ties continue to bind the family together and provide an emotional climate often associated with quilts, their makers, and owners.

"Kaleidoscope Star" (Plate 97) is the second quilt made by Ernest, the first in the series of four quilts pieced by him and hand quilted by his seventy-five-year-old father. In 1984 Ernest added a machine-embroidered inscription, "The second quilt pieced by Ernest B. Haight about 1937 / a special border design for a star pattern quilt / Hand quilted by Ernest's father, Elmer W. Haight 75 yrs. of age / Presented to his granddaughter, Mae Belle Haight, Sept. 1984." Ernest used his drafting skills to design this quilt and other variations of his single star pattern. The

"Kaleidoscope Star" has a strong art deco feeling, as do many of the Haight quilts. Its perfect symmetry duplicates the mirrored bits of broken glass in a kaleidoscope, so the quilt is well named. The narrow black sashing strips used to separate and outline this eight-pointed star became a Haight signature.

Ernest Haight admonished readers of his book who might want to duplicate the narrow black sashing to "remember this narrow strip does add a little extra width wherever it is used, and it is necessary to make a little correction by cutting *one-sixteenth inch* off the side of each piece in the block on the edge where the strip is used." Ernest preached accuracy and absolute precision, a part of his engineer's personality. His wife, Isabelle, remembers how Ernest called attention to what he considered a "lack of exactness" in her own early 1930s quilts. She retorted, "If you can do any better, prove it. Otherwise, keep still." Her husband took up the challenge and soon became the quiltmaker of the family as Isabelle followed other creative pursuits. Honed drafting skills, very sharp scissors, and a keen eye are among the prerequisites for making a Haight quilt.

"Patio Tile" (Plate 98) illustrates both the effective use of narrow black sashing and strips, and one more solved puzzle, a clever and new method of machine piecing. By age seventy-three, Ernest had discovered an efficient and accurate way of piecing his strong geometric blocks, anticipating methods used by quiltmakers in the 1980s. He found that by sewing larger-than-needed strips together and then cutting them to the desired shape and stitching them into designs, instead of

the customary method of sewing small precut pieces together, he could save time and have more hours to spend on the next project. "Patio Tile" is machine quilted in a crosshatch pattern and has a machine-embroidered inscription in the border: "Patio Tile / Original Pattern quilt made by Ernest B. Haight / Presented as Christmas gift 1986 to Mae Belle Haight."

Ernest made puzzles before he made quilts. He especially enjoyed carving interlocking wooden blocks and chains. He translated one of his wood puzzles to fabric to produce his red-and-white "Interlocking Squares" quilt (Plate 99). This machine-quilted and machine-pieced quilt illustrates his quilt and puzzlemaking analogy in that "[quilt] pieces have to match precisely. When you put them together you have a nice finished product. When they are spread apart, they're little more than scraps of material."

Ernest did not keep track of how many quilts he made over the years, but he quilted for fifty years (1936–1986) and, according to his wife, he gave away five to fifteen quilts each year. Therefore the total output would be well over two hundred quilts at a minimum and possibly nearly four times that number. Members of his immediate family received one each Christmas, as well as for other occasions. He also gave them to friends in his community and members of his church. For fifteen years he gave his good friend, the pastor of the David City Baptist Church, a quilt each Christmas. The Haights taught Sunday school and gave quilts to members of their class for graduations, weddings, and other special occasions.

Many Nebraskans have had the good fortune to see the Haight quilts at county and state fairs, where they consistently won prizes. Ernest has entered quilts in the Butler County Fair since the 1940s and began entering quilts in the Nebraska State Fair in 1967.[7] His quilts have also been exhibited throughout Nebraska at numerous shows. A ninety-day show at the Stuhr Museum, Grand Island, in 1971 featured twenty-five of Ernest's and Isabelle's quilts. Other shows include those at the Sheldon Memorial Art Gallery, University of Nebraska–Lincoln; Mid-America Arts Alliance Traveling Show; Lincoln Community Playhouse; and Nebraska Center for Continuing Education, University of Nebraska–Lincoln. In 1982 a very well attended one-man show at the Elder Gallery at Nebraska Wesleyan University featured nearly fifty quilts. Ernest is well known to quilters outside the state as well: he and his quilts have been the subject of numerous articles in *Quilters Newsletter Magazine*.[8]

Ernest Haight quilted to "relieve tension and to keep . . . out of mischief." The work was an extension of his interest in puzzles and his inherent drafting ability, and he stopped late in life, only when his health began to fail. Not surprisingly, Ernest Haight joined Grace Snyder as one of the two original members of the Nebraska Quiltmaker's Hall of Fame in 1986.

Ernest B. Haight and his wife, Isabelle, displaying "Bachelor's Puzzle," a 1968 Nebraska State Fair award-winning entry

97 "Kaleidoscope Star"

Cotton
86" × 74"
NQP 3417

Circa **1937**
Made by Ernest B. Haight (1899–)
Made in David City, Butler County,
Nebraska
Owned by Mae Belle Haight

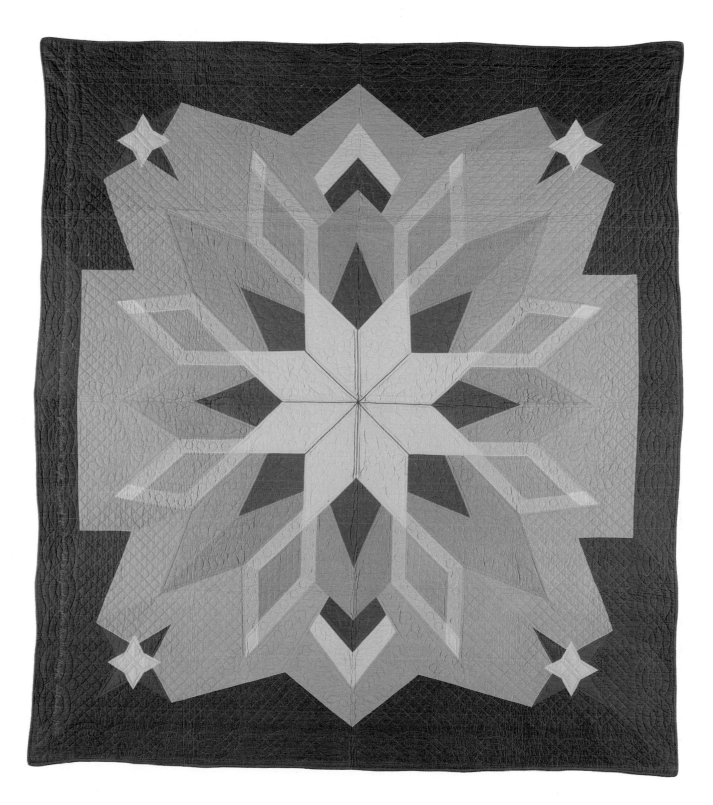

98 "Patio Tile"

Cotton and polyester-cotton
93" × 75"
NQP 3420

Circa **1970**
Made by Ernest B. Haight (1899–)
Made in David City, Butler County,
Nebraska
Owned by Mae Belle Haight

99 "Interlocking Squares"

Cotton
93" × 80"
NQP 3419

Circa **1970**
Made by Ernest B. Haight (1899–)
Made in David City, Butler County, Nebraska
Owned by Mae Belle Haight

221

Louise Howey

ONE OF THE most influential of Nebraska quiltmakers is Louise Howey. For thirty-eight years, from 1946 to 1984, she worked in various positions at the Nebraska State Fair: first as quilt judge, then director of the needlework exhibits, and finally as general supervisor of the Exposition Building. During the late summer weeks, when the colorful displays in the Exposition Building brought thousands of visitors, her geniality won friends throughout the state and her encouraging words touched the lives of many a participant and viewer.

Louise was one of the organizers and the first president of the Lincoln Quilters Guild, founded in 1973. She managed and coordinated the many vendors who participated in Quilt Symposium '77, sponsored by the Lincoln Quilters Guild. It was an important event in needlework history because it was one of the first meetings of its kind in the nation, bringing together nearly six hundred quiltmakers from all over the United States. In addition, Louise was an early member of the National Quilters' Association. She also belongs to the Nebraska State Guild, which in 1989 awarded Louise the Golden Needle Award for outstanding statewide contributions.

Louise credits her mother-in-law, Dove Electa Howey, for teaching her all she knows about quilting. Louise, a Lincoln native, married Lowell Howey in 1932, and the friendship between Louise and Dove flourished and led to the elder Mrs. Howey's living with Louise and Lowell for thirty-seven years. Dove helped her son's fiancée quilt her first Nine Patch before the wedding, and the pleasurable experience resulted in Louise's finding a lifelong interest. During the depression

years of the early 1930s, Louise and Dove quilted tops for twenty-five dollars each, a good price in those years.

The Howey quilt library had its start from Louise's needlework magazine subscriptions during the years of the Great Depression. For many years they were the only source of quilting patterns and information. Louise read and copied and experimented. After reading articles by the noted quilt authority Florence Peto in *McCall's* and *Woman's Home Companion* magazines, Louise wrote to her. An extended correspondence ensued that eventually led to a more systematized collection of written material and patterns. Her favorite books are *101 Patchwork Patterns*, by Ruby McKim, and *The Standard Book of Quilt Making and Collecting*, by Marguerite Ickis. She recommends using these classic books as sources for traditional patterns and techniques and the newer publications for inspiration and information on contemporary quilting. Louise generously shares her extensive knowledge and collections with anyone interested in quiltmaking.

Louise quilted steadily and somewhat alone in Lincoln through the many years before the quiltmaking revival of the 1970s. She participated during the late 1930s and 1940s in a chain letter with twenty-five quiltmakers in the United States and two or three in Canada. This led to an active pattern exchange, especially with two of the women, who had established a pattern shop in Missouri. After the shop and many of their original designs were destroyed in a fire, Louise was the only source of this valuable archive.

Patterns came from many sources, and Louise collected them all, not only from magazines and books but those printed on the batting packaging or ordered with a coupon from the batting wrapper and fifteen cents (later inflated to a quarter). In addition, she and her

mother-in-law made a sample block of every new pattern that appealed to them. This resulted in an archival collection of more than eight hundred quilt blocks as well as countless printed patterns.

The senior research associate for the American Quilt Research Center of the Los Angeles County Museum of Art in California, Sandi Fox, a former Nebraskan, is hard at work assembling a major collection of quilts, patterns, and publications. She learned of Louise's collection of printed quilt patterns from books and magazines dating back to the 1930s. They were so complete and spanned so many years that Sandi arranged to purchase them for the museum collection in 1989. This ensured that Louise's collection of patterns would be preserved and be made available to scholars nationwide.

Louise not only provided leadership for various state and local quilt organizations, she has generously contributed quilts for various fund-raising raffles, including ones for Lincoln's Children's Zoo and the Lincoln Quilters Guild Doll Quilt Auction. She recalls that the first quilt she donated for benefit purposes went to support a polio drive.

Louise has a daily schedule of quiltmaking. She spends about two hours a day quilting alone in her basement and pieces in the evening sitting with her husband. With the exception of string quilts, which she says make good tablecloths, all her work is done by hand. Louise prefers quilting on muslin and usually sets her quilts together with muslin as well as using it for backing. Mountain Mist has been her favorite brand of batting for many years, and many of her quilts have Mountain Mist labels, purchased many

years ago for ten cents a hundred, that record documentary information. Louise and Mother Howey used Clark's size 40 mercerized cotton thread and for many years sent to England for their size seven and eight needles, ordering ten or twenty packages at a time.

Louise does not know how many quilts she has worked on since 1932, but her conservative estimate is that she has pieced and quilted about three hundred. This does not include the quilts that she quilted for hire during the 1930s, the string quilts for table-cloths, or many, many baby quilts. She usually completes four to five quilts a year. Her daughter has twenty-three plus a number of string-quilt table-cloths; her son has twenty and her sister has eighteen. Her nieces and nephews have also been recipients of her generosity.

Stars big and small are among her favorite patterns and range from a scrap quilt containing dozens of four-inch Le Moyne Stars to a stunning Bethlehem Star, the pattern for which was adapted from a quilt featured in the Brooklyn Museum. The red, white, and blue Nebraska quilt (Plate 100), made in 1945, the year World War II ended, demonstrates Louise's patience and skill as a quiltmaker. It uses the complicated and therefore virtually unused Nancy Cabot pattern from the 1930s. Each twenty-inch block contains 180 pieces and is quilted with stars, bars, squares, and diamonds.

During the 1940s and 1950s, William Pinch, of Cleveland, Ohio, a commercial photographer who became interested in embroidery designs because of his mother's needlework, sold his personally designed embroidery patterns by mail order under the name of Rainbow quilt patterns.[9] Louise could not resist ordering some of his "Rainbow blocks" at thirty-five cents per eighteen-inch square; the

blank outlines challenged her embroidery talents. She made two quilts from his designs, one spotlighting basket designs (Plate 101) and the other featuring American Beauty roses. The colors and stitches for each embroidered block were chosen by Louise. When the embroidery work was completed, she outline quilted around each design and crosshatched the background with seven stitches per inch. Not yet satisfied, she quilted the border with fleurs-de-lis. As long as Louise has patterns, fabric scraps, and ideas, her hands will never be idle.

Louise Howey and her husband, Lowell

100 Nebraska

Cotton
96" × 75"
NQP 2968

1945
Made by Louise Howey (1911–)
Made in Lincoln, Lancaster County,
Nebraska
Owned by Louise Howey

224

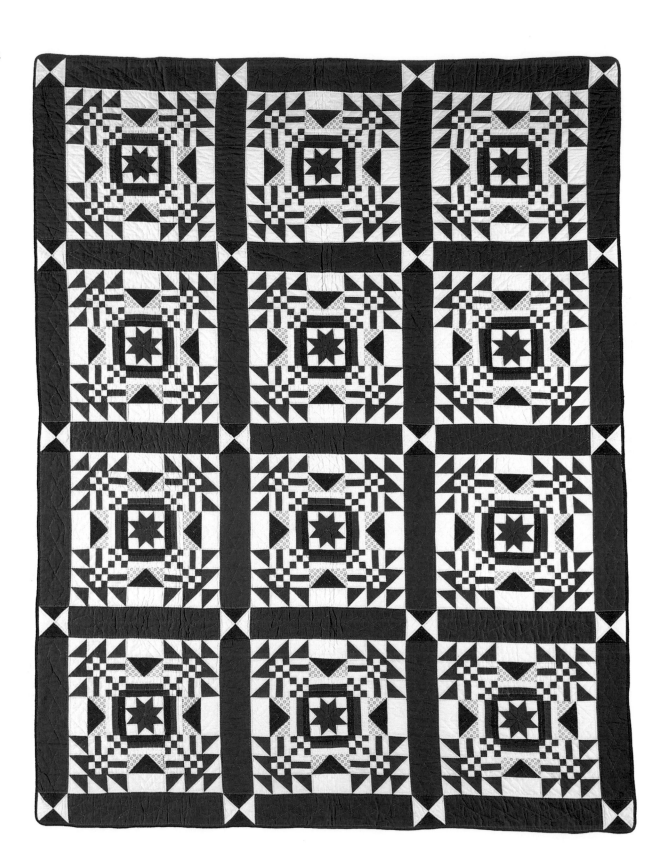

101 Embroidered Sampler

Cotton
98" × 74"
NQP 2965

1975
Made by Louise Howey (1911–)
Made in Lincoln, Lancaster County,
Nebraska
Owned by Louise Howey

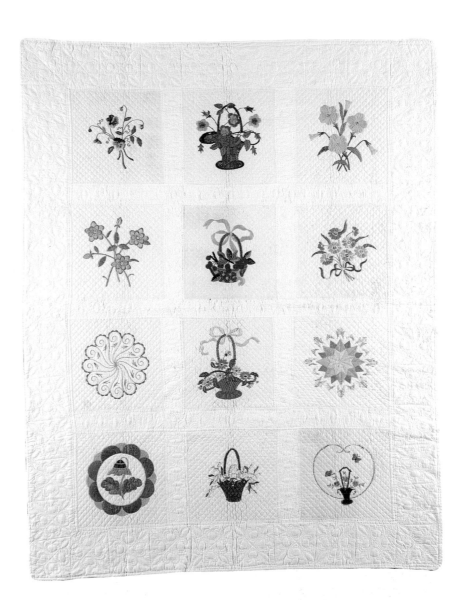

Mary Campbell Ghormley

MARY CAMPBELL Ghormley quietly influenced and stimulated Nebraska's quilt revival. Her involvement in quiltmaking began in the late 1950s and early 1960s. It was a time when the Ghormleys' home was filled with five growing children and their friends, so she had little time to devote to quilting in those early years. She did find time to make a few quilts during the 1960s, however, and bought her first books on quilting that would form the nucleus of an ever-growing library. From this beginning Mary became deeply absorbed in a consuming avocation that culminated in her statewide recognition as an exacting quiltmaker, discerning collector, knowledgeable speaker, and ardent supporter of quilting activities and education when she was named to the Nebraska Quiltmaker's Hall of Fame in 1987.

Involvement in the world of quilts during the early 1960s provided immediate joy for Mary, as well as leading her in new directions. Mary's desire for greater knowledge, plus a healthy dose of curiosity, led to a never-ending search for books and magazines on quilting. Initially she purchased even magazines with only a paragraph or two on quilts for her library because so little was available in the early 1960s, but what was available became the foundation of a large private library on the subject of quilts and their makers which she shares generously with friends and students.

In the late 1960s, while giving one of the state fair prizewinning quilts a thorough examination, she thought, "I wonder if mine are that good. I wonder if I could place at the Fair." In 1970 she entered a red-and-white quilt in the Goose Tracks pattern. Mary admired the entries from all over Nebraska and relished the pleasure of seeing her own quilt among the others. Her husband, Roger, checked the newspaper for the awards the day after the judging, and told Mary with pride that not only had her quilt been given first prize, it had won Best of Show. This seemed at the time beyond belief and marked a turning point in her quiltmaking endeavors.

Not only did she continue quilting, becoming better and better, but her involvement in the state fair led her to teach quilting. Although classes were available for every other form of stitchery and handwork, none were available for would-be quilters in Nebraska in the early 1970s. The original little sign on a state fair counter that read "Quilting Classes. Call Mary Ghormley" led to eight or nine years of teaching. In addition, throughout the 1970s Mary was a willing speaker for a variety of women's groups throughout Lincoln and eastern Nebraska. By sharing her enthusiasm, skills, knowledge, and quilt lore with numerous community groups and students, Mary has inspired many of the new wave of quiltmakers.

The women in Mary's classes and those who were spurred to try their hand at quilting through her early programs formed the nucleus of the Lincoln Quilters Guild, founded in 1973. Mary played a key role in the guild's organization, served as its second president, and was made a life member. Mary and fellow members of the Lincoln Quilters Guild assisted Frances Best in organizing in 1977 one of the first nationally attended quilt symposia, a highly successful event held at Nebraska Wesleyan University and attended by almost six hundred people from forty states and one foreign country (the Federal Republic of Germany). She is also a member of the Nebraska

Mary Campbell Ghormley

State Quilt Guild. Her quiet leadership continued in the Nebraska Quilt Project, where her commitment and unflagging enthusiasm provided a model for other project members as she traveled to every site to register quilts.

In 1987 Mary had a very well attended one-woman quilt show at the Elder Gallery, Nebraska Wesleyan University. She has continued to enter quilts and win ribbons in the Nebraska State Fair and has been a featured artist at various quilt shows. In 1988 her Mariner's Compass quilt was exhibited in the National Quilt Association show in Little Rock, Arkansas, where it received an honorable mention. Over the past twenty-five years, Mary has attended countless workshops, symposia, and quilt exhibits, and her participation in them, as well as her quiltmaking, show no sign of diminishing.

In terms of her own quiltmaking, Mary is a traditionalist, not an innovator. She prefers the old quilt patterns and shops for fabrics that resemble the printed patterns and colors of the past. Both of her quilts featured in this chapter transport us to the quiltmaking world of yesteryear. The pattern for her appliquéd quilt, Aunt Dinah's Delight (Plate 102), came from a Carlie Sexton pattern book. This was a mail-order pattern source popular during the 1920s and 1930s; its patterns have been reprinted and sold in recent years. Calicoes and muslins in solid colors are used for the skillfully appliquéd flowers attached with hidden stitches to the unbleached muslin background. Both reverse appliqué and appliqué are used to shape the flower buds, and a technically challenging swag-and-tassel border completes the design. Mary spent almost 170 hours quilting this prizewinner. Using a cotton quilting thread, she covered the quilt with feathers, crosshatching, and outline and parallel-line quilting patterns. In 1983 it won first prize among appliqué quilts at the Nebraska State Fair.

A Mariner's Compass quilt, made during the 1830s in Pennsylvania, graced the cover of a catalog for the collection of the American Museum near Bath, England. Mary admired the beauty of the quilt and set out to make as near a duplicate as possible. The drafting of pattern and templates was the combined effort of Mary and her husband, Roger. Once the templates were ready, Mary chose White Rose bleached muslin and calicoes resembling those of the nineteenth century for this dazzling pieced and appliquéd quilt (Plate 103). In keeping with the desired nineteenth-century look, Mary selected a Mountain Mist thin polyester batting and devoted more than 360 hours to quilting Mariner's Compass in crosshatch and outline patterns with amazingly uniform stitches. In 1987 it won the Best of Lot award in the Senior Citizens' Division at the state fair.

Each of these prizewinning quilts required more than a year to complete. Mary has kept a record of each of her quilts, both those made by her own hands and those purchased for her collection. She recommends as much documentation as possible and makes sure that every quilt she makes is labeled with her name and date.

While her quilts reflect her meticulous craftsmanship and sense of history, Mary's home reflects her passion for quilts and quiltmaking. It is a changeable feast of quilts old and new. Quilts are displayed at all times—on the wall, on beds, sometimes as table covers. They are rotated seasonally and are a delight to behold. Special blocks are framed, and Mary's collection of doll quilts invites guests large and small to sit on the floor and play. A basket of work in progress sits near her chair, and her library of quilt books and histories dominates a corner of the living room.

102 Aunt Dinah's Delight

Cotton
85" × 71"
NQP 2901

1983
Made by Mary Campbell Ghormley
(1919–)
Made in Lincoln, Lancaster County,
Nebraska
Owned by Mary Campbell Ghormley

228

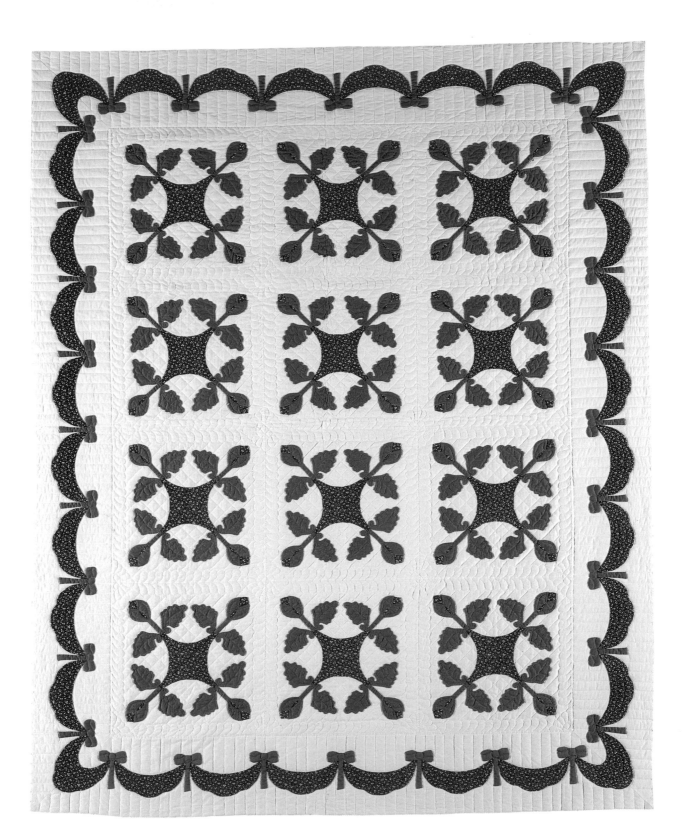

103 Mariner's Compass

Cotton
96" × 71"
NQP 2909

1986
Made by Mary Campbell Ghormley
(1919–)
Made in Lincoln, Lancaster County,
Nebraska
Owned by Mary Campbell Ghormley
Detail on page 208

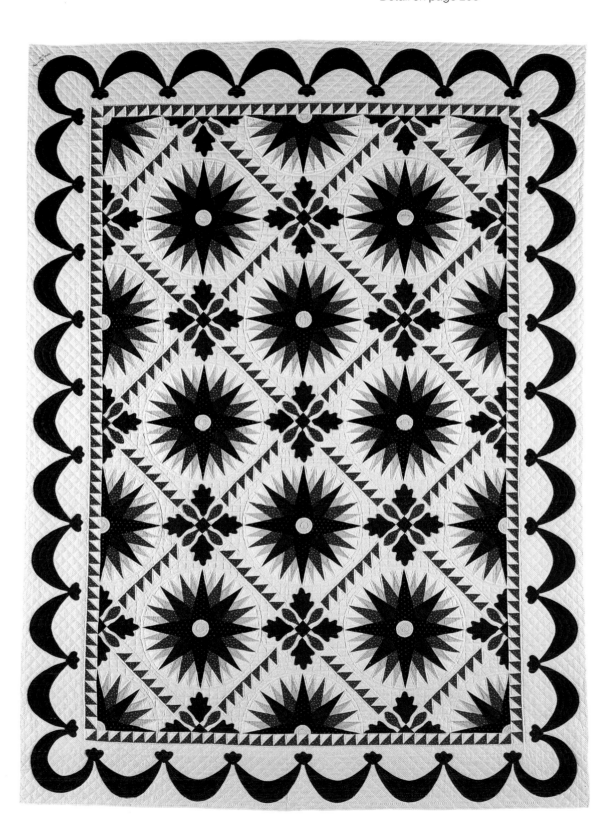

Afterword

THE LIFE STORY associated with each quiltmaker and quilt presented in this volume confirms that quiltmaking in Nebraska is an enduring form of creative expression as well as a practice of thrift and industriousness. Despite the challenges Nebraskans surely encountered during the years of frontier settlement, Nebraska women found time for quiltmaking, not out of necessity, but because of the great personal satisfaction derived from creating a useful object of beauty for their families and from demonstrating their needlework skills, their careful use of scarce resources, and their industriousness. Because quiltmaking reflects the values of Nebraska citizens who pride themselves on their resourcefulness, frugality, and capacity for hard work, quiltmaking remained a popular activity among rural Nebraska women well into the twentieth century. Even though it was considered passé by urban American women by the end of the nineteenth century, Nebraskans continued to make quilts. In summary, the women of Nebraska who made these quilts are representative of the population of the state demographically, reflective of women of their period socially, and typical of American quiltmakers in their quiltmaking practices. The quilts they made are valuable cultural artifacts that stand as beautiful examples of a folk art and powerful reminders of family traditions.

Notes

Quiltmaking Traditions in Nebraska: An Overview

1 Lillian J. Fitzpatrick, *Nebraska Place-Names* (Lincoln: University of Nebraska Press, 1960), p. 13.
2 James C. Olson, *History of Nebraska*, 2d ed. (Lincoln: University of Nebraska Press, 1966), pp. 3–4.
3 Nebraska Legislative Council, *Nebraska Blue Book, 1982–83*, p. 110.
4 Olson, *History of Nebraska*, p. 154.
5 U.S. Department of Commerce, Bureau of the Census, *Census of Populations*, 1860, 1870, 1880, 1890, 1900.
6 Olson, *History of Nebraska*, pp. 154–168.
7 Ibid., pp. 165–168.
8 U.S. Department of Commerce, Bureau of the Census, *Census of Populations*, 1900.
9 David Wishart, "Age and Sex Composition of the Population of the Nebraska Frontier," *Nebraska History* 54 (Spring/Winter 1973): 106–119.
10 John Mack Faragher, "The Midwestern Farming Family, 1850," in *Women's America*, ed. Linda K. Kerber and Jane De Hart Mathews (New York: Oxford University Press, 1987), pp. 116–131.
11 Olson, *History of Nebraska*, p. 197.
12 Dorothy Weyer Creigh, *Nebraska: A Bicentennial History* (New York: Norton, 1977), p. 185.
13 Ibid., p. 187.
14 Andrew J. Cherlin, *Marriage, Divorce, Remarriage* (Cambridge: Harvard University Press, 1981), pp. 20–21; Julie Roy Jeffrey, *Frontier Women: The Trans-Mississippi West, 1840–1880* (New York: Hill and Wang, 1979), pp. 57–58.
15 Carl N. Degler, *At Odds: Women and the Family in America from the Revolution to the Present* (Oxford: Oxford University Press, 1980), pp. 377, 383.

16 Olson, *History of Nebraska*, p. 173. Virtually all of those identified as Russians were Germans from Russia.
17 Ibid.
18 Taped interview with Sandra Anderson, Lincoln, Nebr., May 25, 1988.
19 Taped interview with Dorothy Boettner, Wahoo, Nebr., August 28, 1987.
20 Taped interview with Lena Burger, Dorchester, Nebr., May 30, 1987.
21 Taped interviews with Genevieve Young, Nebraska City, Nebr., September 11, 1987, and Ruth Sisler, Kearney, Nebr., June 24, 1987.
22 Pat Ferrero, Elaine Hedges, and Julie Silber, *Hearts and Hands: The Influence of Women and Quilts on American Society* (San Francisco: Quilt Digest, 1987), p. 16.
23 Taped interviews with Edith Belle Sims Frasier, Benkelman, Nebr., April 29, 1987; Peg Kildare, Ogallala, Nebr., April 27, 1987; and Ruth Davidson, Nebraska City, Nebr., September 11, 1987.
24 Susan Burrows Swan, *Plain and Fancy: American Women and Their Needlework, 1700–1850* (New York: Holt, Rinehart and Winston, 1977), pp. 48–59.
25 Taped interview with Marie Jahnke, Bancroft, Nebr., July 20, 1987.
26 Taped interview with Irene Alexander, Lincoln, Nebr., July 13, 1988.
27 Survey forms completed by Miriam Sukraw for Nebraska Quilt Project quilt no. 2364.
28 Kathryn F. Sullivan, "Pieced and Plentiful," in *North Carolina Quilts*, ed. Ruth Haislip Roberson (Chapel Hill: University of North Carolina Press, 1988), p. 99.
29 Joseph F. Stonuey and Patricia Cox Crews, "The Nebraska Quilt History Project: Interpretations of Selected Parameters," in *Uncoverings 1988*, ed. Laurel Horton (Mill Valley, Calif.: American Quilt Study Group, 1989), p. 160.

30 Supplemental information about Nebraska Quilt Project quilt nos. 380–386 provided by Mary Oba, Scottsbluff, Nebr., May 18, 1987.
31 Taped interview with Louise Howey, Lincoln, Nebr., October 30, 1987.
32 Taped interview with Jessie Hervert, Kearney, Nebr., June 24, 1987.
33 Taped interview with Katheryn Thomsen, Bancroft, Nebr., July 20, 1987.
34 A detailed summary and analysis of the data collected during 1987 is reported in Stonuey and Crews, "The Nebraska Quilt History Project: Interpretations of Selected Parameters," pp. 151–169. Data collected during 1988 have been analyzed and summarized in a similar manner and coupled with the earlier data analysis provide the basis for this interpretive section.
35 Barbara Brackman, "Dating Old Quilts, Part Six: Style and Pattern as Clues," *Quilter's Newsletter Magazine*, no. 170 (March 1985): 22–23.
36 Carleton L. Safford and Robert Bishop, *America's Quilts and Coverlets* (New York: E. P. Dutton, 1980), p. 33.
37 Brackman, "Dating Old Quilts," p. 24.
38 Patsy and Myron Orlofsky, *Quilts in America* (New York: McGraw-Hill, 1974), p. 253.
39 Barbara Brackman, *Clues in the Calico: A Guide to Identifying and Dating Antique Quilts* (McLean, Va.: EPM Publications, 1989), p. 170.
40 Penny McMorris, *Crazy Quilts* (New York: Dutton, 1984).
41 Margaret Vincent, *The Ladies' Work Table: Domestic Needlework in Nineteenth Century America* (Allentown, Penn.: Allentown Art Museum, 1988), p. 78.
42 Ibid., p. 73.

43 Heron, Adelaide E., *Dainty Work for Pleasure and Profit* (Chicago: Danks, 1891), p. 85.

44 Orlofsky and Orlofsky, *Quilts in America*, p. 63.

45 "Women Enjoy the 1931 State Fair," *Nebraska Farmer*, September 19, 1931, p. 8, cols. 1–4.

46 Brackman, "Dating Old Quilts," p. 25.

47 Brackman, *Clues in the Calico*, p. 24.

"Love Was in the Work": Pieced Quilts

1 U.S. Department of Commerce, Bureau of Census, *Eleventh Census of the United States, 1890; Schedules Enumerating Union Veterans and Widows of Union Veterans of the Civil War, Nebraska, Howard County, St. Paul Pct.*, E.D. no. 285, Sh. 1, line 5.

2 Telephone interview with Winona Ketelhut, December 1989; letter from Winona Ketelhut, January 12, 1990; U.S. Department of Commerce, Bureau of Census, *Tenth Census of the United States, 1880: Population Schedules for Lancaster County, Stockton Pct.*, E.D. no. 243, Sh. 6, line 2.

3 Letter from Margaret R. Seymour, August 3, 1989; U.S. Department of Commerce, Bureau of Census, *Thirteenth Census of the United States, 1910: Population Schedules for Lancaster County, Lincoln, Ward 5*, E.D. no. 73, Sh. 3, line 71.

4 U.S. Department of Commerce, Bureau of Census, *Twelfth Census of the United States, 1900: Population Schedules for Frontier County, Sheridan Pct.*, E.D. no. 178, Sh. 11, line 90.

5 Idem, *Thirteenth Census of the United States, 1910: Population Schedules for Nebraska, Hall County, Doniphan Twp.*, E.D. no. 99, Sh. 5A, line 30.

6 The patterns in this sampler quilt include: *row 1:* Double Nine Patch, Bear's Paw, Cut Glass Dish, Sixteen Patch, unknown, Honeycomb or Endless Chain, North Wind; *row 2:* Wrench, Pineapple, Rolling Stone or Single Wedding Ring, unknown, Bird's Nest, "Hattie" appliqué, Courthouse Square–Album; *row 3:* Log Cabin (diagonally set), Bear's Paw, Six Patch Basket, Capital T, Little Red House, Friendship Star, Savannah Beautiful Star; *row 4:* Wrench, Wheel of Fortune, Shoofly, Jacob's Ladder, Jacob's Ladder, Le Moyne Star, unknown; *row 5:* Mother's Choice, Rolling Stone or Single Wedding Ring, At the Depot, Crazy block, Ohio Star variation, Feathered Star; *row 6:* World's Fair, unknown, Sage Bud, Rolling Stone or Single Wedding Ring, Pineapple, Sixteen Patch, Flyfoot; *row 7:* Friendship Block, Big Dipper, Nine Patch, unknown, unknown Eleven Patch, Rolling Pinwheel, Double Monkey Wrench, Double Monkey Wrench; *row 8:* Old Maid's Puzzle, King's X, unknown, Pinwheel variation, Flying X variation, Peekaboo variation, Double Irish Chain variation; *row 9:* (½ blocks): Nine Patch, Girl's Joy, Star of Many Points, French Star, unknown, Log Cabin or Courthouse Steps, unknown.

7 U.S. Department of Commerce, Bureau of Census, *Twelfth Census of the United States, 1900: Population Schedules for Nebraska, Howard County, St. Paul Pct.*, E.D. no. 132, Sh. 10, line 28; idem, *Thirteenth Census of the United States, 1910: Population Schedules for Nebraska, Pawnee County, Pawnee City, Ward 2*, E.D. no. 153, Sh. 18A, line 24.

8 Brackman, "Dating Old Quilts," p. 25.

9 Carrie A. Hall and Rose G. Kretsinger, *The Romance of the Patchwork Quilt in America* (Caldwell, Idaho: Cafton Printers, 1935), pp. 78–79.

10 U.S. Department of Commerce, Bureau of Census, *Tenth Census of the United States, 1880: Population Schedules for Nemaha County, Lafayette Pct.*, E.D. no. 203, Sh. 9, line 18; idem, *Twelfth Census of the United States, 1900: Population Schedules for Nemaha County, Lafayette Pct.*, E.D. no. 98, Sh. 9, line 18, and *Washington Pct.*, E.D. no. 98, Sh. 15, line 93.

11 See Jane Bentley Kolter, *Forget Me Not: A Gallery of Friendship and Album Quilts* (Pittstown, N.J.: Main Street Press, 1985).

12 Telephone interview with Cheryl Christensen Beery, August 1989.

13 Letter from Mrs. W. H. Koon, August 7, 1989.

14 For another example of this unusual design, see Thos. K. Woodard and Blanche Greenstein, *Crib Quilts and Other Small Wonders* (New York: Dutton, 1981), p. 34.

15 U.S. Department of Commerce, Bureau of Census, *Tenth Census of the United States, 1880: Population Shedules for Saunders Co., Cedar Pct.*, E.D. no. 181, Sh. 23, line 31; idem, *Twelfth Census of the United States, 1900: Population Schedules for Lancaster County*, E.D. no. 54, Sh. 10, line 87.

16 Obituary of Dwight R. Cash, *Wahoo (Nebraska) Democrat*, February 20, 1936, p. 1; Obituary of Gertrude O. Cash, *Wahoo (Nebraska) Newspaper*, August 14, 1975, p. 12.

17 U.S. Department of Commerce, Bureau of Census, *Tenth Census of the United States, 1880: Population Schedules for Nebraska, Saline County, Brush Creek Pct.*, E.D. no. 222, Sh. 13, line 29; idem, *Eleventh Census of the United States, 1890: Schedules Enumerating Union Veterans and Widows of Union Veterans of the Civil War, Nebraska, Saline County, Brush Creek Twp.*, E.D. no. 22, p. 2, line 13; idem, *Twelfth Census of the United States, 1900: Population Schedules for Nebraska, Frontier County, Curtis*, E.D. no. 178, Sh. 6, line 62.

18 *Schedules of the Nebraska State Census of 1885, Population Schedules for Harlan County, Antelope Twp., Ragan Village*, E.D. no. 383, Sh. 7, line 47; U.S. Department of Commerce, Bureau of Census, *Twelfth Census of the United States, 1900: Population Schedules for Nebraska, Harlan County, Antelope and Scandinavia Twp., Ragan Village*, E.D. no. 94, Sh. 6, line 51; idem, *Thirteenth Census of the United States, 1910: Population Schedules for Nebraska, Harlan County, Antelope Twp., Ragan Village*, E.D. no. 117, Sh. 1A, line 19.

19 See Michelle Walker, *The Complete Book of Quiltmaking* (New York: Knopf, 1986), pp. 80–81, for a Welsh quilt in a similar design.

20 Telephone interview with Christine Nygren, August 1989.

21 Mrs. C. B. Larsen, "Some Reflections of My Life," memoir, Nebraska Quilt Project files for quilt no. 2292.

22 Letter from Florence Larsen, July 24, 1989.

23 Brackman, *Clues in the Calico*, pp. 131–132.

24 Barbara Brackman, "Blue and White Quilts," *Quilter's Newsletter Magazine*, no. 190 (March 1987): 22–25.

25 U.S. Department of Commerce, Bureau of Census, *Tenth Census of the United States, 1880: Population Schedules for Saline County, North Fork Pct.*, E.D. no. 223, Sh. 11, line 3; idem, *Twelfth Census of the United States, 1900: Population Schedules for Saline County, North Fork Pct.*, E.D. no. 115, Sh. 4, line 14; idem, *Thirteenth Census of the United States, 1910: Population Schedules for Saline County, North Fork Pct.*, E.D. no. 127, Sh. 6, line 13.

26 Examples of Double Wedding Ring quilts attributed to the nineteenth century may be seen in Dena Katzenberg's *The Great American Cover Up* (1971) and Karoline Patterson Bresenhan and Nancy O'Bryant Puentes, *Lone Stars: A Legacy of Texas Quilts, 1836–1956* (Austin: University of Texas Press, 1986), pp. 106–107; see also Robert Bishop's "The Double Wedding Ring Quilt," in *Quilter's Newsletter Magazine*, no. 211 (April 1989): 35–37. Brackman, *Clues in the Calico*, p. 168.

27 Telephone interview with Alice Vanden Bosch, January 18, 1990; University of Nebraska Alumni records; U.S. Department of Commerce, Bureau of Census, *Tenth Census of the United States, 1880: Population Schedules for Pawnee County, Clay Pct.*, E.D. no. 257, Sh. 11, line 16; idem, *Twelfth Census of the United States, 1900: Population Schedules for Pawnee County, Clay Pct.*, E.D. no. 125, Sh. 1, line 81.

28 James N. Liles, "Dyes in American Quilts Made Prior to 1930, with Special Emphasis on Cotton and Linen," *Uncoverings 1984*, ed. Sally Garoutte (Mill Valley, Calif. American Quilt Study Group, 1985), pp. 29–40.

29 *Commercial Advertiser* (Red Cloud, Nebr.) July 5, 1933, p. 1; *Weekley Advertiser* (Red Cloud, Nebr.) July 21, 1922, p. 1.

30 Virginia Gunn, "Template Quilt Construction and Its Offshoots: From Godey's Lady's Book of [*sic*] Mountain Mist," in *Pieced by Mother: Symposium Papers*, ed. Jeannette Lasansky (Lewisburg, Penn.: Oral Traditions Project of the Union County Historical Society, 1988), pp. 69–77.

31 Letter from Ruth Sisler, January 20, 1990; U.S. Department of Commerce, Bureau of Census, *Twelfth Census of the United States, 1900: Population Schedules for Nebraska, Hall County, Doniphan Twp., Doniphan City*, E.D. no. 86, Sh. 4, line 55, and *Lancaster County, Elk Pct.*, E.D. no. 36, Sh. 4, line 31; idem, *Thirteenth Census of the United States, 1910: Population Schedules for Nebraska, Lancaster County, Elk Pct.*, E.D. no. 40, Sh. 1A, line 31.

32 Anne Orr, "Easy to Make," *Good Housekeeping*, July 1938, p. 178. See also Plate 95 for the ultimate rendition of this style, Grace Snyder's aptly named "Flower Basket Petit Point."

33 Letter from Virginia Smith Stevens, July 3, 1989.

Labors of Love: Appliqué Quilts

1 Letter from Mary L. Bennett, July 1989.

2 U.S. Department of Commerce, Bureau of the Census, *Twelfth Census of the United States, 1900: Population Schedules for Nebraska, Gage County, Blakeley Twp.*, E.D. no. 46, Sh. 3, line 95; letter from Sara Dillow, July 25, 1989.

3 U.S. Department of Commerce, Bureau of the Census, *Ninth Census of the United States, 1870: Population Schedules for Nebraska, Saline County, Swan City Pct.*, Sh. 1, line 25, 28; idem, *Twelfth Census of the United States, 1900: Population Schedules for Nebraska, Thayer County, Chester Pct.*, E.D. no. 159, Sh. 7, line 51; idem, *Thirteenth Census of the United States, 1910: Population Schedules for Thayer County, Chester Pct.*, Sh. 9A, line 16.

4 Telephone interviews with Lois Wolfe, July 10, 1989, and January 1990; U.S. Department of Commerce, Bureau of Census, *Twelfth Census of the United States, 1900: Population Schedules for Nebraska, Butler County, Bone Creek Twp.*, E.D. no. 2, Sh. 6, line 76.

5 Telephone interviews with De Etta Edgar, October 4, 1989, and January 1990.

6 U.S. Department of Commerce, Bureau of Census, *Tenth Census of the United States, 1880: Population Schedules for Nebraska, Seward County, D Pct.*, E.D. no. 135, Sh. 9, line 25; idem, *Twelfth Census of the United States, 1900: Population Schedules for Nebraska, Seward County, C Twp.*, E.D. no. 142, Sh. 9, line 48.

7 Telephone interview with Helen Chalupnik, January 11, 1990.

8 Personal interview with Ivy Speidel, January 18, 1990.

9 Hall and Kretsinger, *The Romance of the Patchwork Quilt in America*, p. 190; Ruth Haislip Roberson, ed., *North Carolina Quilts* (Chapel Hill, University of North Carolina Press, 1988), p. 6; Judy Rehmel, *Key to 1,000 Appliqué Quilt Patterns* (Richmond, Ind.: Judy Rehmel, 1984), p. 147.

10 Telephone interview with Donna Christensen, January 18, 1990.

11 Telephone interview with Irma Cary, October 3, 1989.

12 Telephone interview with Antonette W. Turner, January 15, 1990.

13 David E. Scherman, "Willa Cather Country," *Life*, March 19, 1951, p. 115.

14 Telephone interview with Juliamae Dunn, January 14, 1990; letter from Juliamae Dunn dated January 15, 1990.

15 Telephone interview with P. J. Timken, September 29, 1989.

Stitches in Time: Embroidered Quilts

1 Jeannette Lasansky, "The Role of Haps in Central Pennsylvania's Nineteenth and Twentieth Century Quiltmaking Traditions," in *Uncoverings 1985*, ed. Sally Garoutte (Mill Valley, Calif.: American Quilt Study Group, 1986), p. 88.

2 Telephone interview with Ken Dermann, July 1989; U.S. Department of Commerce, Bureau of Census, *Tenth Census of the United States, 1880: Population Schedules for Nebraska, Otoe County, Osage Pct.*, E.D. no. 196, Sh. 9, line 37; idem, *Twelfth Census of the United States, 1900: Population Schedules for Nebraska, Otoe County,*

Osage Pct., E.D. no. 113, Sh. 4, line 78 and E.D. no. 115, Sh. 4, line 66.

3 The satin used for the whole-cloth top has warp yarns of silk and weft yarns of cotton.

4 Telephone interviews with Karen Schneider, September 25, 1989, and October 3, 1989.

5 For a complete list of the names on the Wahoo Presbyterian Ladies Aid Society signature quilt, see the notes on quilt no. 2420 in the Nebraska Quilt Project files, Nebraska State Historical Society, Lincoln; also available in Love Library, University of Nebraska–Lincoln.

6 Dorothy Cozart, "The Role and Look of Fundraising Quilts, 1850–1930," in Lasansky, *Pieced by Mother: Symposium Papers*, pp. 86–95.

7 Telephone interview with James Hanson, Director, Nebraska State Historical Society, July 18, 1989.

8 Virginia Gunn, "Crazy Quilts and Outline Quilts: Popular Responses to the Decorative Art/Art Needlework Movement, 1876–1893," in *Uncoverings 1984*, pp. 131–152.

9 Telephone interview with Harriet L. Cook Hanson, January 1990; U.S. Department of Commerce, Bureau of Census, *Twelfth Census of the United States, 1900: Population Schedules for Nebraska, Nemaha County, Washington Pct., Johnson Village*, E.D. no. 98, Sh. 4, line 9; idem, *Thirteenth Census of the United States, 1910: Population Schedules for Nebraska, Nemaha County, Washington Pct., Johnson Village*, E.D. no. 121, Sh. 3A, line 13.

10 Telephone interview with Kathryn L. Buck, January 1990.

11 For a complete list of the names on the Red Cross quilt, see the notes on quilt no. 3075 in the Nebraska Quilt Project files, Nebraska State Historical Society, Lincoln; also available in Love Library, University of Nebraska–Lincoln.

12 Cozart, "The Role and Look of Fundraising Quilts," pp. 86–95. See also Nancy J. Rawley, "Red Cross Quilts for the Great War," in *Uncoverings 1982*, ed. Sally Garoutte (Mill Valley, Calif.: American Quilt Study Group, 1983), pp. 43–51.

13 Telephone interview with Alice Wing Vanden Bosch, December 19, 1989.

14 Margaret Vincent, *The Ladies' Work Table: Domestic Needlework in Nineteenth Century America* (Allentown, Penn.: Allentown Art Museum, 1988), pp. 69–73.

15 Letter from Inez Tecker, February 4, 1990.

16 Telephone interview with Howard J. Laughlin, January 7, 1990.

17 Barbara Brackman, "Midwestern Pattern Sources," in *Uncoverings 1980*, ed. Sally Garoutte (Mill Valley, Calif.: American Quilt Study Group, 1981), pp. 3–12.

18 Grace Snyder, *No Time on My Hands* (Caldwell, Idaho: Caxton Printers, 1963; rpt., Lincoln: University of Nebraska Press, 1986), p. 527.

19 Thos. K. Woodward and Blanche Greenstein, *Twentieth Century Quilts, 1900–1950* (New York: Dutton, 1988), pp. 43–62, 79, 80.

20 Telephone interview with Dolores Lyne, January 1990.

21 Personal interview with Martha S. Tonges Krueger, January 1990.

22 The Elmwood women who embroidered the blocks were Eldean Bogt, Elaine Bornemeier, Pamela Bornemeier, Debra Dankleff, Marthena DeGarmo, Gweneth Drake, Marianne Fleischman, Olive Hall, Lucile Kuehn, Mary Miller, Jean Reinke, Lucille Rosenow, and Elsie Von Spreckelson.

23 The Elmwood Quilters were Lavina Backemeyer, Mary Halvorsen, Ella Kunz, Florence Stolz, Martha Vogt, and Elsie Wendt.

24 Letter from Maechelle Clements, August 10, 1989.

25 Personal and telephone interviews with Shirley Donaldson Sweet, August 1989.

"Little Pieces of Our Lives": Crazy Quilts

1 Memoirs of Clarissa Palmer Griswold as recorded by her daughter, Vera E. Griswold, circa 1940.

2 Charles H. Frady, "Fifty Years Gospel Giving on the Frontier," *Nebraska History* 10 (October–December 1927): 265–334.

3 There were thirty-seven members of the Ladies Aid Society in 1893. Their names, typed on the back behind the center block with the Ladies Aid Society inscription, are: Mrs. J. C. Penrod, Mrs. J. W. Williams, Mrs. L. B. Canfield, Miss Jo Williams, Mrs. Corl, Mrs. W. M. Copeland, Mrs. Overbay, Mrs. Dr. Smith, Miss Daisy Filley, Mrs. W. J. Bell, Mrs. G. T. Dixon, Miss Millie Corl, Mrs. J. H. Ramsey, Miss Lizzie Hobson, Mrs. Swain, Mrs. Persinger, Mrs. Cobb, Mrs. G. E. Moore, Miss Addie Stuff, Miss Lillie Stuff, Mrs. Esther Sherwood, Mrs. P. M. Hagerman, Mrs. H. D. McPherson, Mrs. O.E. Filley, Mrs. Grant Hanscom, Mrs. P. T. Lewellen, Mrs. G. M. Canfield, Mrs. C. E. Hollingsworth, Mrs. T. J. Bell, Miss Bessie Bloodgood, Miss Cora Wright, Mrs. Hobson, Mrs. Sumner, Mrs. Swartz, Mrs. Johanson, Mrs. Shank, Mrs. F. A. Stuff.

4 Taped interview with Dorothy Boettner, August 28, 1987.

5 Telephone interview with Eileen Paine, July 8, 1989.

6 Barbara Brackman, *An Encyclopedia of Pieced Quilt Patterns*, vol. 3, *Four Patch* (Lawrence, Kans.: Barbara Brackman, 1980), pp. 176–177.

The Contemporary Quilt Revival, 1970–1990

1 Eleanor Sienkiewicz, "American Quilts, Then and Now," *Quilter's Newsletter Magazine*, 15th Anniversary Issue (1984): 35.

2 For example, Mildred Fauquet, Ila Chatfield of Ila's Cozy Creations, Judy Fitzgerald of Sassafrass, Laura Rocke of Magic Threads, and Jan Stehlik, author of *Sod House Treasures*.

3 For example, Sandra Anderson of Lincoln in *Quilt World Omnibook*, Summer 1986, pp. 30–32, 55; Jeane Best of Lincoln in *Quilter's Newsletter Magazine*, no. 45 (July 1973): 11; Wilma Brinkhoff of Avoca in *Quilter's Newsletter Magazine*, no. 212 (May 1989): 40; Shelley Burge of Lincoln in *Quilter's Newsletter Magazine*, nos. 94, 163, 215 (September 1977, June 1984, September 1989): 21, 40, and 63, and the "Quilt Art '90" engagement calendar, p. 80; Wanda Dawson of Royal in *Good Housekeeping*, March 1978, p. 129; Diane Deahl of Lincoln in *Quilter's News-*

letter Magazine, no. 136 (October 1981): 39; Carol Dunklau of Lincoln in the "Quilt Art '86" engagement calendar, unpaged (February/March); Quilt World Omnibook, Summer 1984, pp. 16–18; Mildred Fauquet of Lincoln in Quilter's Newletter Magazine, no. 214 (July/August 1989), p. 40, Creative Quilting, March/April 1989, pp. 17, 56, and Craftworks/Quilting USA 2 (December 1988): 9; Judy Fitzgerald of Lincoln in Quilter's Newsletter Magazine, no. 199 (February 1988): 8, Quilt World, July 1988, p. 31, Crafts, July 1988, p. 39, Quilting U.S.A., December 1988, pp. 8–9, and American Quilter, Fall 1987, pp. 22–23; Marilyn Maurstad of Beatrice in Patchwork Patter, February 1989, p. 22, and Quilter's Newsletter Magazine, nos. 202, 217 (May 1988, November/December 1989): 32, 33, and 64–65; Jo Morton of Nebraska City in the "Quilt Art '89" engagement calendar, p. 16; Paulette Peters of Elkhorn in Quilter's Newsletter Magazine, no. 195 (September 1987): 49; Carol Roscoe of Bellevue in Quilter's Newsletter Magazine, no. 109 (February 1979): 16; Joan Schwalm of Lincoln in Quilter's Newsletter Magazine, no. 214 (July/August 1989): 35; Jan Stehlik of Dorchester in Quilter's Newsletter Magazine, no. 215 (September 1989): 38; Dianne Thomas of Omaha in the "Quilt Art" engagement calendar, 1986, 1988, and 1990; Quilter's Newsletter Magazine, no. 210 (March 1989): 36; Carol Van Hoosen of Stromsburg in Quilter's Newsletter Magazine, no. 98, (January 1978): 21.

4 Louise Howey, State Fair Record Book, 1967–1974.

5 Sheldon Memorial Art Gallery, Quilts from Nebraska Collections, (Lincoln, Nebr.: Sheldon Memorial Art Gallery, 1973).

6 Quilter's Newsletter Magazine, 15th Anniversary Issue (1984): 12.

7 The Color Council of America is composed of designers, industry executives, and color consultants who meet to forecast fashion colors for their subscribers, who include apparel and textile manufacturers, design firms, and paint manufacturers. The Color Council's forecast of colors influences every-thing from clothing and cars to kitchen accessories, and thus has limited the colors of commercial fabrics available to quilters.

8 The committee members were: Frances Best, Jacqueline Dittmer, Ann Gohde, Jean Harnsberger, Shirley Joliff, Nancy Koehler, Louisa (Lou) Lessman, Miriam Hecox Peterson (chairwoman), Louise (Lou) Shaneyfelt Davidson, and Adele Wohlers. The top was made by Frances Best, Retta Bettenhausen, Floy Buell, Velda Coffey, Emily (Millie) Corkill, Jacqueline (Jacky) Dittmer, Mary Ghormley, Ann Gohde, Jean Harnsberger, Shirley Joliff, Nancy Koehler, Lou Lessman, Imagean Lind, Mary Mignon, Hope Partridge, Esther Pauley, Miriam Hecox Peterson, Ruth Ronning, Joan Schwalm, Emogene (Genie) Sullivan, Virginia Welty, and Joanna Winter. The quilt was set together and quilted by Marcille Ansorge, Floy Buell, Sally Campbell, Velda Coffey, Millie Corkill, Jacky Dittmer, Mary Ghormley, Jean Harnsberger, Ruth Hicks, Louise Howey, Marie Johnson, Nancy Koehler, Imagean Lind, Wilma McKeag, Kathy McKie, Hazel Myers, Hope Partridge, Miriam Hecox Peterson, Kari Ronning, Ruth Ronning, Laura Rosecranz, Joan Schwalm, Genie Sullivan, Mary Jane Sweet, Bernice Underdahl, Elizabeth (Liz) Wannamaker, Virginia Welty, and Joanna Winter.

9 Michelle Walker, Complete Guide to Quiltmaking (New York: Knopf, 1986), pp. 56–57.

10 Letter from Jan Stehlik, January 15, 1990.

11 Joyce Schlotzhauer, The Curved Two-Patch System (McLean, Va: EPM Publications, 1982) and Curves Unlimited: Expanding the Curved Two-Patch System to Soften Shapes and Create New Patterns (McLean, Va.: EPM Publications, 1984).

12 The quilters were Linda Banner, Mary Barnett, Carol Bell, Gaylin Bergers, Jill Bergers, Mary Lou Beshilas, Ann Bronson, Michele Burge, Linda Creveling, Martha Eubank, Ruth Finlayson, Lorraine Fitzgerald, Patricia Kennedy, Mary Knapp, Peggy Kramer, Megan Legas, Rita Lukes, Judith McClure, Shirley Ott, Peggy Pennell, Lorraine Peterson, Barbara Sales, Ann Schmidt, Marilyn Seidel, Karyl Smith, Cynthia Sommer, Diane Thomas, Carol Uebner, Charlene Weiss, Katie Wilson, and Judith Zinn.

13 The Benedict women whose sewing skills and clever ideas resulted in a variety of unique quilt blocks were Marie Alms, Karen Bolton, Ethel Doremus, Mary Doremus, Theresa (Terri) Doremus, Donna Folts, Cinda Hild, Louise Hild, Patricia Hirschfeld, Margie Holmes, Frances Huegel, Anna (Annie) Leif, Fay Lytle, Jean Lytle, June Moore, Elsie Nelson, Dorothy Nienhueser, Miriam Hecox Peterson, Ramona Petro, Gladys Phillips, Byrdine Pickrel, Janice Pickrel, Kathy Quick, Donna Redman, Venecia Reetz, Imo Richardson, Michalena (Marge) Richardson, Syndi Richardson, Laura Phillips Schneider, Gina Schoch, Judy Schoch, June Sohl, Athla Tankersley, Lucile Walkup, Alice Wilksen, and Joyce Wright. The quilters were Ella Allen, Joan Bittinger, Helen Blender, Karen Bolton, Doris Campbell, Floyda Clayton, Grace Dovenbarger, Marjorie Ehlers, Phyllis Hankel, Elma Heiden, Elizabeth Herron, Betty Hirschfeld, Margie Holmes, Frances Huegel, Malinda Junge, Evelyn Kaeding, Annie Leif, Jean Lytle, Shirley Morris, Ellen Myers, Miriam Hecox Peterson, Gladys Phillips, Venecia Reetz, Imo Richardson, Marge Richardson, Judy Schoch, Rose Sherman, Athla Tankersley, and Alice Wilksen.

Nebraska Treasures

1 The source of information about this quilt and its maker is an article by Gail DeBuse Potter, "A Note on the Samuel Allis Family: Missionaries to the Pawnee, 1834–46," Nebraska History 67 (Spring 1986): 1–7.

2 "Flower Basket Petit Point" was featured on the cover of Quilter's Newsletter, no. 9/10 (July 1970): 24, and is pictured or mentioned in numerous issues of Quilter's Newsletter Magazine, including no. 11 (September 1979): 14; no. 71 (September 1975): 19; no. 182 (May 1986): 22–23; and no. 186 (October 1986): 47.

3 Snyder's No Time on My Hands was the primary source of information about her life and quiltmaking experiences.

4 This number, a result of a careful count by a research assistant from the Department of Textiles, Clothing and Design, University of Nebraska–Lincoln, is somewhat lower than the 87,789 pieces reported by Grace Snyder in *No Time on My Hands* (p. 527).

5 Telephone interview with Nellie Snyder Yost, November 1989.

6 Anne Orr, "Make-It-Yourself Ideas for Summer," *Good Housekeeping*, May 1934, p. 96.

7 Vivian Ritter, "Ernest B. Haight—Nebraska's Quilting Farmer," *Quilter's Newsletter Magazine*, no. 191 (April 1987): 22–23, 25.

8 Some of the issues of *Quilter's Newsletter*, later called *Quilter's Newsletter Magazine*, in which Haight is featured are nos. 16 (February 1971): 6–8 and cover; 17 (March 1971): 7–9; and 191 (April 1987): 22, 23, 25.

9 "The Meetin' Place," *Quilter's Newsletter Magazine*, no. 117 (November/December 1979), p. 13.

Selected Bibliography

Beyer, Jinny. *The Scrap Look: Designs, Fabrics, Colors, and Piecing Techniques for Creating Multi-Fabric Quilts.* McLean, Va.: EPM Publications, 1985.

Bishop, Robert, and Carter Houck. *All Flags Flying: American Patriotic Quilts as Expressions of Liberty.* New York: Dutton, 1986.

Brackman, Barbara. *An Encyclopedia of Pieced Quilt Patterns.* Rev. ed. 8 vols. Lawrence, Kans.: Prairie Flower Publishing, 1984.

Bresenhan, Karoline Patterson, and Nancy O'Bryant Puentes. *Lone Stars: A Legacy of Texas Quilts, 1836–1956.* Austin: University of Texas Press, 1986.

Clark, Ricky. *Quilts and Carousels: Folk Art in the Firelands.* Oberlin, Ohio: Firelands Asssociation for the Visual Arts, 1983.

Creigh, Dorothy W. *Nebraska: A Bicentennial History.* New York: Norton, 1977.

Degler, Carl N. *At Odds: Women and the Family in America from the Revolution to the Present.* Oxford: Oxford University Press, 1980.

Ferrero, Pat, Elaine Hedges, and Julie Silber. *Hearts and Hands: The Influence of Women and Quilts on American Society.* San Francisco, Calif.: Digest Press, 1987.

Finley, Ruth E. *Old Patchwork Quilts and the Women who Made Them.* Philadelphia, Penn.: Lippincott, 1929.

Fisher, Laura. *Quilts of Illusion: Tumbling Blocks, Delectable Mountains, Stairway to Heaven, Log Cabin, Windmill Blades, and Other Optical Designs.* Pittstown, N.J.: Main Street Press, 1988.

Fitzpatrick, Lillian J. *Nebraska Place-Names.* Lincoln: University of Nebraska Press, 1960.

Gutcheon, Beth. *The Perfect Patchwork Primer.* New York: McKay, 1973.

Haight, Ernest B. *Practical Machine-Quilting for the Homemaker.* David City, Nebr.: Ernest B. Haight, 1979.

Hall, Carrie A., and Rose G. Kretsinger. *Romance of the Patchwork Quilt in America.* Caldwell, Idaho: Caxton Printers, 1935; rpt. New York: Bonanza Books, n.d.

Havig, Bettina. *Missouri Heritage Quilts.* Paducah, Ken.: American Quilter's Society, 1986.

Holstein, Jonathan. *The Pieced Quilt: An American Design Tradition.* New York: Galahad Books, 1973.

Ickis, Marguerite. *The Standard Book of Quilt Making and Collecting.* New York: Greystone Press, 1949; rpt. New York: Dover, 1959.

Jeffrey, Julie Roy. *Frontier Women: The Trans-Mississippi West, 1840–1880.* New York: Hill and Wang, 1979.

Kolter, Jane Bentley. *Forget Me Not: A Gallery of Friendship and Album Quilts.* Pittstown, N.J.: Main Street Press, 1985.

Lasansky, Jeannette. *In the Heart of Pennsylvania: 19th and 20th Century Quiltmaking Traditions.* Lewisburg, Penn.: Oral Traditions Project of the Union County Historical Society, 1985.

———. *Pieced by Mother: Over 100 Years of Quiltmaking Traditions.* Lewisburg, Penn.: Oral Traditions Project of the Union County Historical Society, 1987.

———, ed. *Pieced by Mother: Symposium Papers.* Lewisburg, Penn.: Oral Traditions Project of the Union County Historical Society, 1988.

MacDowell, Marsha, and Ruth D. Fitzgerald, eds. *Michigan Quilts.* East Lansing: Michigan State University Museum, 1987.

McKendry, Ruth. *Traditional Quilts and Bed Coverings.* New York: Van Nostrand Reinhold, 1979.

McKim, Ruby. *101 Patchwork Patterns.* 1931; rpt. New York: Dover, 1962.

McMorris, Penny. *Crazy Quilts.* New York: Dutton, 1984.

Martin, Judy. *Scrap Quilts: Techniques Plus Patterns Old and New for Making Quilts from Collected Fabric.* Wheatridge, Colo.: Moon Over the Mountain Publishing, 1985.

Olson, James C. *History of Nebraska.* 2d ed. Lincoln: University of Nebraska Press, 1966.

Orlofsky, Patsy, and Myron Orlofsky. *Quilts in America.* New York: McGraw-Hill, 1974.

Puckett, Marjorie. *Patchwork Possibilities.* Orange, Calif.: Orange Patchwork Publishers, 1981.

Rehmel, Judy. *Key to 1,000 Appliqué Quilt Patterns.* Richmond, Ind.: Judy Rehmel, 1984.

Roberson, Ruth Haislip, ed. *North Carolina Quilts.* Chapel Hill: University of North Carolina Press, 1988.

Schlotzhauer, Joyce. *The Curved Two-Patch System: A Quilters Exciting Discovery for Creating Pieced Flowers, Foliage, and Other Patterns.* McLean, Va.: EPM Publications, 1982.

Sienkiewicz, Elly. *Spoken without a Word.* Washington, D.C.: Turtle Hill Press, 1983.

Snyder, Grace. *No Time on My Hands.* Caldwell, Idaho: Caxton Printers, 1963; rpt. Lincoln: University of Nebraska Press, 1986.

Vincent, Margaret. *The Ladies' Work Table: Domestic Needlework in Nineteenth Century America.* Allentown, Penn.: Allentown Art Museum, 1988.

Walker, Michelle. *The Complete Book of Quiltmaking.* New York: Knopf, 1986.

Woodard, Thos. K., and Blanche Greenstein. *Crib Quilts and Other Small Wonders.* New York: Dutton, 1981.

———. *Twentieth Century Quilts, 1900–1950.* New York: Dutton, 1988.

The Nebraska Quilt Project Committee

Sites and Local Coordinators

Joanna Baxter

Frances Best, *Director*

Michele (Shelley) Burge

Patricia Caudill Cole

Jean Davie

Carroll Dischner

MonaJeanne Easter

Mildred Fauquet

Mary C. Ghormley

Pat Hackley

Heddy Kohl

Marlene Marx

Mary Obrist

Janeese Olsson

Hope Partridge

Kari Ronning

Sonja Schneider

Jeanette (Jan) Stehlik

Doris Von Seggern

Virginia Welty

Lois Wilson

Lincoln, March 13, 1987
Coordinator: Frances Best

Ogallala, April 27, 1987
Coordinators: Louise Tietjen, Maxine Dolezal

Benkelman, April 29, 1987
Coordinators: Daisy Fries, Inez Tecker

Scottsbluff, May 18, 1987
Coordinator: William Arthur

Chadron, May 20, 1987
Coordinators: Elva Bartels, Lloy Chamberlin

Bassett, May 22, 1987
Coordinator: Donna Peterson

Dorchester, May 30, 1987
Coordinators: Jeanette Stehlik, Susan Weber

St. Paul, June 22, 1987
Coordinators: Janet Hruza, Marjorie Schimonitz

Kearney, June 24, 1987
Coordinator: Mary Bennett

Red Cloud, June 26, 1987
Coordinator: Susan Schultz

Bancroft, July 20, 1987
Coordinator: Ruth Canarsky

Blair, July 22, 1987
Coordinators: Irma Holstein, Lorraine Peterson

Wahoo, August 28, 1987
Coordinators: Ruth Lindquist, Susan Williams

Nebraska City, September 11, 1987
Coordinator: Mary Jo Morton

Lincoln, March 30, 1988
Coordinator: Mary C. Ghormley

Lincoln, May 2, 1988
Coordinator: Jeane Moore

Lincoln, May 21, 1988
Coordinators: Leola Bullock, Barbara Kelley

Lincoln, May 25, 1988
Coordinator: Janelle Johnson

Lincoln, June 4, 1988
Coordinator: Evelyn Nelsen

Lincoln, June 11, 1988
Coordinator: Janet Botsford

Lincoln, June 15, 1988
Coordinator: Dorothy Wolverton

Lincoln, March 8, 1989
Coordinator: Marlene Marx

Omaha, March 11, 1989
Coordinators: Marjean Sargent, Dianne Thomas

Lincoln, March 23, 1989
Coordinator: Gail Potter

Papillion, April 1, 1989
Coordinators: Dianne Thomas, Marjean Sargent

Omaha, April 15, 1989
Coordinators: Marjean Sargent, Dianne Thomas

Omaha, May 4, 1989
Coordinators: Marjean Sargent, Dianne Thomas

Elkhorn, May 20, 1989
Coordinator: Mary Sumnick

238

Financial Support

The Nebraska Quilt Project gratefully acknowledges the financial support provided by the following agencies, organizations, and individuals:

Granting Agencies

American/International Quilt Association, Houston, Texas
Cooper Foundation, Lincoln, Nebraska
National Endowment for the Arts, Folk Arts Program, Washington, D.C.
National Quilting Association, Inc., Ellicott City, Maryland
Nebraska Committee for the Humanities, Lincoln, Nebraska
Rogers Foundation, Lincoln, Nebraska
Steinhart Foundation, Inc., Nebraska City, Nebraska
Woods Charitable Fund, Inc., Lincoln, Nebraska

Quilting Guilds

Aurora Quilters Guild, Aurora, Nebraska
Autumn Retreat Quilters, Omaha and Lincoln, Nebraska
Calico Quilt Club, Columbus, Nebraska
Candlelight Quilters, Beatrice, Nebraska
Cottonwood Quilters, Elkhorn, Nebraska
Country Crossroads Quilt Guild, Kearney, Nebraska
Country Piecemakers Quilt Guild, Norfolk, Nebraska
Heritage Needlework Guild, Nebraska City, Nebraska
Kearney Quilters Guild, Kearney, Nebraska
Lincoln Quilters Guild, Lincoln, Nebraska
Nebraska State Quilt Guild, Omaha, Nebraska
Omaha Quilters Guild, Omaha, Nebraska
Prairie Piecemakers, Fremont, Nebraska
Prairie Pioneer Quilters, Grand Island, Nebraska
Thayer County Quilters Guild, Hebron, Nebraska

Businesses and Local Organizations

American Society for Engineering Education, University of Nebraska–Lincoln
Automatic Printing, Omaha, Nebraska
Bethlehem W.E.L.C.A., Wahoo, Nebraska
Cass County Extension Clubs, Louisville, Nebraska
Center for Great Plains Studies, University of Nebraska Lincoln
Century Guild of First Presbyterian Church, Lincoln, Nebraska
Civic Nu-Comers, Lincoln, Nebraska
Faith United Church of Christ, Women's Fellowship, Lincoln, Nebraska
FirsTier Bank, Lincoln, Nebraska
First Presbyterian Church, Presbyterian Women, Lincoln, Nebraska
Grand Council of Cryptic Masons of Nebraska, Whitney, Nebraska
Hickman Senior Center, Hickman, Nebraska
National Bank of Commerce, Lincoln, Nebraska
Panama Senior Citizens Group, Panama, Nebraska
Senior Citizens Center, Firth, Nebraska
Senior Citizens of Bennet Center, Bennet, Nebraska
University of Nebraska–Lincoln Faculty Women's Club Collectors Group
Words, Etc., Lincoln, Nebraska

Individuals

Ursula M. Ahlman, Norfolk, Nebraska
Margrethe P. Ahlschwede, Lincoln, Nebraska
Evelyn Ahrens, Minden, Nebraska
Ruth Albert, Lincoln, Nebraska
Irene Alpers Alexander, Lincoln, Nebraska
Helen Lamb Allen, Ralston, Nebraska
Joan L. Webster Allen, Enid, Oklahoma
Anonymous, Lincoln, Nebraska
Joanna Baxter, Lincoln, Nebraska
Anne Charlotte Best, Lincoln, Nebraska
Bill and Frances Best, Lincoln, Nebraska
Jeane Marie Best, Avon, Connecticut
Paul William Best, Lincoln, Nebraska
Helen Bonneau, Lincoln, Nebraska
Doni McGrew Boyd, Lincoln, Nebraska
Nancy L. Calvert, Lincoln, Nebraska
Sally Holmes Campbell, Lincoln, Nebraska
DeMarus K. Carlson, Crofton, Nebraska
Mrs. Harold Clausen, Columbus, Nebraska
Patricia Cole, Lincoln, Nebraska
Maxine Coufal, Cotesfield, Nebraska
Kay Cynova, Grand Island, Nebraska
Jean Davie, Lincoln, Nebraska
Carroll Dischner, Lincoln, Nebraska
Barbara Dunklau, Hermosa Beach, California
Carol Dunklau, Lincoln, Nebraska
E. S. (Bud) Dunklau, Lincoln, Nebraska
MonaJeanne Easter, Lincoln, Nebraska
Katherine A. Endacott, Lincoln, Nebraska
Janet Eskridge, Lincoln, Nebraska
Mildred Fauquet, Lincoln, Nebraska
Martha Fink, Lincoln, Nebraska
Idonna Florell, Lincoln, Nebraska
Jeanne Garvin, Lincoln, Nebraska
Charlotte Gaylor, Omaha, Nebraska
Roger and Mary Ghormley, Lincoln, Nebraska
Martha Aitken Greer, Lincoln, Nebraska
Pat Hackley, Lincoln, Nebraska
Jean Harnsberger Memorial, Lincoln, Nebraska
Diane Harris, Norfolk, Nebraska
Charlotte Henline, Port Huron, Michigan
Virginia M. Hill, Eagle, Nebraska
Irma Holstein, Blair, Nebraska
Paula Hottovy, Dwight, Nebraska
Louise Howey, Lincoln, Nebraska

Frances D. Hull, Lincoln, Nebraska
Eleanor Hunnel, Johnstown, Nebraska
Elva Janak, Walton, Nebraska
Carol S. Jenks, Syracuse, Nebraska
Mrs. Milo Jeppesen, Blair, Nebraska
Patricia Jones, Lincoln, Nebraska
Suzanne Kalish, Lincoln, Nebraska
Suzanne Kohmetscher, Lincoln,
Nebraska

Arline Kraft, Lincoln, Nebraska
Kathy Kuehn, Lincoln, Nebraska
Janet Kugler, Holdrege, Nebraska
Richard Larrick, Red Cloud, Nebraska
Dorothy M. Lawver, Omaha, Nebraska
Irene LeBaron, Lincoln, Nebraska
Lou Lessman, Lincoln, Nebraska
Ruth Lindquist, Wahoo, Nebraska
Marilyn Lockard, Lincoln, Nebraska
Lynn Lux, Broken Bow, Nebraska
Rogene Mann, Greenville, South
Carolina
Marlene Marx, Lincoln, Nebraska
Margaret Masek, Gering, Nebraska
Shirley Mason, Sandy, Utah
Ruth Massengale, Lincoln, Nebraska
Marolyn Merchant, Lincoln, Nebraska
Colleene Minnick, Riverton, Nebraska
Marion Dredla Moravec, Lincoln,
Nebraska
Evelyn O. Nelsen, Lincoln, Nebraska
Ruth Wertz Nuss, Lincoln, Nebraska
Mary Obrist Memorial, Lincoln,
Nebraska
Mrs. Duane Olson, Lincoln, Nebraska
LaDonna Pankoke, Lincoln, Nebraska
Mildred Barratt Parker, Kearney,
Nebraska
Hope Partridge, Lincoln, Nebraska
Paulette Peters, Elkhorn, Nebraska
Miriam Peterson, Benedict, Nebraska
Phyllis Phalen, Omaha, Nebraska
Jana Prescott, Omaha, Nebraska
Julie Prescott, Omaha, Nebraska
Eleanor Preston, Gering, Nebraska
Kari Ronning, Lincoln, Nebraska
Kenneth and Margaret Rose, Lincoln,
Nebraska
Elizabeth Ross, Bancroft, Nebraska
Mrs. Elmer Ross, Nehawka, Nebraska
Bernice Sanderson, Los Angeles,
California
Ida Sandin, Lincoln, Nebraska
Sonja Schneider, Lincoln, Nebraska
Edith Schrader, Lincoln, Nebraska
William E. and Joan Schwalm, Lincoln,
Nebraska
Evalyn C. Slepicka, Geneva, Nebraska
Ruth Snyder, Lincoln, Nebraska

Jan Stehlik, Dorchester, Nebraska
Donna Stratker, Nebraska City,
Nebraska
Linda Striman, Lincoln, Nebraska
Donald and Donna Svoboda, Lincoln,
Nebraska
Dianne Duncan Thomas, Omaha,
Nebraska
Marilyn Thomas, Lincoln, Nebraska
P. J. Peters Timken, Lincoln, Nebraska
Fay Timmerman, Grand Junction,
Colorado
Doris Von Seggern, Lincoln, Nebraska
Diane Wagner, Lincoln, Nebraska
Arthur and Virginia Welty, Lincoln,
Nebraska
Lois Wilson, Lincoln, Nebraska
Mrs. Anton Wohlers, Chadron,
Nebraska
Margaret Vance Wolfe, Grand Island,
Nebraska
Nellie Yost, North Platte, Nebraska
Margery Zamzow, Grand Island,
Nebraska

The Authors

Patricia Cox Crews, born and reared in the Shenandoah Valley of Virginia, learned to sew and knit about the same time she learned the alphabet, all from her mother. She graduated from Virginia Polytechnic Institute and State University in 1971 with a major in textiles and clothing. After earning a master's degree in textile science from Florida State University and a doctorate from Kansas State University, in 1984 she joined the faculty of the University of Nebraska–Lincoln, where she is an associate professor of textiles. She teaches history of textiles, textile conservation, textile dyeing, and physical analysis of textiles and is the author of a number of articles related to the preservation of textiles.

Ronald C. Naugle is Huge-Kinne Professor of History and chair of the Department of History at Nebraska Wesleyan University, where he has taught since 1966. A native of Indiana, he attended Purdue University, where he received his bachelor's and master's degrees. In 1976 he received a doctorate in American studies from the University of Kansas, where he concentrated on American social history of the late nineteenth century. He has been involved in numerous community oral-history projects throughout Nebraska and has written several articles related to Nebraska and Native American history, including the script for a national television documentary entitled "White Man's Way." Working with the Nebraska Quilt Project inspired him to design his first quilt for the fiftieth wedding anniversary of his wife's parents.

Frances (Frankie) Allen Best, a native Nebraskan, cites Neligh as her hometown. Her grandparents came to Nebraska during the 1880s; her mother's family settled in the town of Brunswick. Frankie is a graduate nurse. Her interest in quilting was stimulated by a teenage daughter who first studied quilting from books and then took a class taught by Mary Ghormley. Wanting to share her daughter's interest, Frankie also took Mary's class. An early member of the Lincoln Quilters Guild, she organized one of the first national quilt symposia, the Lincoln Quilt Symposium of 1977. She started organizing the Nebraska Quilt Project in 1985 and has served as its director since then.

Kari Ronning has been interested in the history of women and their artifacts since her high school days. After graduating from the University of Nebraska–Lincoln in 1971, she earned a master's degree from George Washington University and in 1980 received a doctorate in English from the University of Nebraska–Lincoln, where her area of study was women and popular culture. She began to make quilts in 1973 and has served as president and vice president of the Lincoln Quilters Guild. She lectures professionally on quilts and their patterns to quilting groups, church groups, and general women's organizations. She has worked with the Nebraska Quilt Project from its beginnings in 1985.

Margaret Frady Cathcart, born and raised in Long Beach, California, pieced her first doll quilt at age six while recovering from chickenpox. She has been making quilts ever since. Her early art education, combined with a love of color, texture, and pattern, led to a seven-year stint as owner of a needlepoint shop. She graduated from the University of Nebraska–Lincoln with a major in history in 1979, went on to earn a master's degree, taught at Nebraska Wesleyan University, and is now pursuing a doctorate. Both her paternal grandparents and her husband's great-grandparents came to Nebraska by covered wagon in the post–Civil War period. When Margaret and her husband returned to Nebraska in 1959, their first Nebraska home was built over the original Butler County soddy where one of the quiltmaking grandmothers was born.

Elizabeth Weyhrauch Shea has been a resident of Lincoln, Nebraska, since 1961. She attended Lindenwood College in St. Charles, Missouri, from 1969 to 1971 and graduated from the University of Nebraska–Lincoln in 1973 with a dual major in elementary and special education. She taught special education for five years, then returned to the University of Nebraska–Lincoln and graduated in 1989 with a master's degree in textiles, clothing and design. She has served as president of the Lincoln Needleworkers Guild. She is currently pursuing doctoral studies at the University of Nebraska–Lincoln while continuing to develop her expertise in the area of textile design.

Joseph Stonuey has received a bachelor's degree in art history and is completing work for a master's degree in textiles and clothing from the University of Nebraska–Lincoln. His interest in Nebraska's textile heritage was sparked by the fact that his maternal great-great-grandparents were early settlers in south-central Nebraska. He currently lives in New York City, where he is the education coordinator for the McCall Pattern Company and a freelance writer.

S. and L. Co. O. M. & E. U.
Promenade
Dancing on the
bridge 1 – 30
you know i

Index of Quiltmakers

Index of Quilts